# THE ELEVEN ASSOCIATES OF ALMA-MARCEAU

*THE OLD SCHOOL WRITERS CIRCLE*

**Anomie**SP

*The Eleven Associates of Alma-Marceau*

Written and edited by The Old School Writers Circle
Designed by Modern Activity, London
Illustration, p.256 by Concetta Gallo Price

First published in 2020 by Anomie Special Projects,
an imprint of Anomie Publishing, London and Swindon, UK
www.anomie-publishing.com

ISBN: 978-1-910221-19-8
© Anomie Publishing, 2020

Cover image:
Leonardo da Vinci, *The Mona Lisa* (begun c.1503) (detail)
From the collection of the Louvre, Paris
Photo © RMN-Grand Palais (Musée du Louvre) / Michel Urtado

Repro by DPM, London
Printed by EBS, Verona
Distributed by Casemate Art

4

I

# THE PAINTING COMPETITION

I was a pretty average kid in most respects. Some people say I was old before my time – a wise head on young shoulders my gran used to call me. The summer that changed my life was only a few years ago, but it feels like much longer than that. I guess a lot has happened since then, and I've definitely changed – I know that for sure. It's natural, I suppose, especially after everything that had happened. It was a strange few weeks. It was like the world opened up for me, and after it had just come crashing down. I hadn't been abroad much before – a couple of school trips and family holidays. Leaving school is such a significant moment in your life – it's a very abrupt and somewhat rude cut-off point for adolescence – suddenly you're an adult. You're just an adult in the world. It's no one else's job to look after you anymore. You can drink, you can drive, you can get married and have children, you can get a job, you can go anywhere you like, anytime. And it happens overnight – one day you're wearing your uniform, sat on a bus, carrying a bag with your packed lunch in it, made by your mum or dad. The next you're wearing jeans and sitting with a mug of coffee trying to figure out how you're going to earn a living, or how to get the money together to go to university. And wondering what the hell you're going to do with your life.

I wasn't in the car with my mum and dad that morning. They were on their way to an old friend's fiftieth birthday celebrations in Glasgow for the weekend, and had taken the day off so they could make an early start. I made my way to school on the bus. I remember being called out of a maths class. I had to go to the secretary's office. The policewoman who was waiting for me there told me that the brakes must have failed on the lorry that hit them. It came straight across a junction at high speed and smashed right into the driver's side of the car. I didn't even get to see them, to say goodbye. It has never felt like that was really the end. I mean, I know that they're gone and they're not coming back, but it still feels like it isn't true, somehow. I miss them so very much.

I had been in the middle of my GCSE exams at the time of the accident. My grandfather lived nearby, and while he was due to move into a retirement village just a few streets away, it made sense for me to live with him at least until I'd finished my exams, so he put all that on hold. These living arrangements just sort of carried on throughout sixth form without us ever

really discussing it. There was legal stuff going on as well – it was too complicated for me to get my head around, and neither of us could bear to talk about it. We kind of pretended everything was normal, even though we both knew it wasn't. I was sixteen at the time of the accident, so I was too old to need to be adopted or put into care or anything like that, but I wasn't in any emotional state to start living on my own. That said, I did have to grow up pretty quickly during those two years – Grandad was in the early stages of dementia, and the whole point of him moving into a retirement flat was so that he didn't have to deal with lots of the day-to-day practicalities of running a house. So I took charge of most of the cooking, the shopping, the washing, the cleaning, the bills and all of that grown-up stuff.

I got through the last two years of school okay, considering. I wasn't an exceptional student, but I did well in French, much to my surprise, and always loved the art classes and English literature. I was interested in the other subjects, and enjoyed thinking about what I was learning, but it didn't seem to take a hold in my memory. It's strange what sticks and what doesn't. I assume it's the same for everyone, to differing degrees. I could memorise song lyrics or the titles of paintings at the drop of a hat, but could I remember the difference between covalent and macromolecular bonding in chemistry class? No, I could not. I would read and reread the pages of the book, and found it intriguing, but it ultimately passed me by. I guess we're all good at the things we're good at, and everyone's brains are wired slightly differently. I didn't think my brain was wired that differently. Even though some say I see things differently to most people, I'm still not sure if I think that's true.

I didn't have many friends at school. It's not that I was unpopular, exactly, it was just that I didn't seem to be the kind of person to attract interest from others. I guess I am naturally quite shy, and after the accident, I closed off from the outside world even more. Some people said I was quite awkward in my outward manner ('a nerd who was no good at computers' was one insult I remember clearly) and it's true that I would blush as soon as anybody was looking at me. That's something some of the other boys seized upon, and there was a small group in my year who did their best to make my life miserable. I remember walking home from school through the park one afternoon while they were playing football. I was eating a bag of chips and as I walked past, one of them kicked the ball at me so hard that it caught me completely by surprise. I stumbled and having my hands full, fell to the ground and dropped the chips all over the path.

'Oi, orphan boy! Pass us the ball back!' shouted the ringleader. I could see them walking towards me.

'And clear up that bloody mess you freak, or are you just going to run home to your mummy? Oh, I forgot – she's dead,' added another.

I heard footsteps behind me and felt a hand on my arm, helping me to my feet, and turned around to see a boy looking me in the eye. A second boy

had scooped the ball out from behind me, and he kicked it as hard as he could in the direction of the gang, over their heads.

'There's your ball back!' he shouted. 'Sorry, I'm not very good at football,' he added, smiling at them. They hurled some insults back and fortunately backed off. While there were four of them, they obviously didn't fancy their chances against the three of us. I knew these boys – they were twins, Chris and Eddie, in the year below me, and they lived at the other end of the street from me. They were quite tall and strong for their age, thankfully. I knew them because their mother was the community nurse that had been assigned to visit my grandfather after my parents had died. They knew what had happened to our family and had clearly taken pity on me.

'Are you alright, Adam?' asked Chris. It was easy to tell them apart because Chris had an Afro, but if the brothers had had the same haircut, it would have been much harder as they were near enough identical.

'I'm fine,' I replied. 'Thank you – thanks for helping me out.' I picked up the worst of the chips and threw them in a bin as we carried on our way. My elbow was grazed and bleeding, as was my wrist, but it could have been worse. The twins walked and chatted with me all the way home before carrying on to their own.

\* \* \*

I always felt at home in the art department at school, and enjoyed talking with the teacher, Mr. Stoner, who I realise now was also very supportive to me during that difficult time. He let us put music on while we worked, and even drink smoothies and eat snacks at our desks, which was totally not allowed in other classes. He would let us use our phones during lessons to look things up, which was completely against school rules. Yes, he was a pretty chilled-out person, but he was also really inspiring and opened our minds to loads of things that wouldn't otherwise be covered on your average school curriculum. He was a complete Francophile, and his love of all things French made a big impression on me. Maybe it explains why I did so well in French classes. I seemed to be able to pick up vocabulary and understand the grammar where I have failed to do so with other languages.

One morning, Mr Stoner announced that we were going to do a new project in which we had to paint one of our relatives in a particular style from art history. I decided to do mine in an Impressionist style. I couldn't bring myself to paint my mum or dad, so chose my grandfather as my subject instead. It was Grandad who used to take me round the museums and galleries when I was young – he was babysitting really, giving my parents a break for a few hours on a Sunday afternoon, or during the school holidays. I used to love it and it instilled in me a deep love of the history of painting. I must have been seven or eight when he first started taking me out, and it

went on until long after I started secondary school. We would take the bus into town and he would take me round the galleries within the municipal museum, showing me examples of different kinds of painting and explaining what made them the movements that they were. He'd tell me what was going on in the paintings, and when he didn't know the real stories, we'd make up our own silly versions together and giggle. 'Use your own eyes first,' he used to say, 'then read the books after.' At the end of each gallery visit, he'd take me for an ice cream at the local parlour. They were ridiculous – the glass was bigger than my head. Sometimes he'd buy me a book or catalogue from the shop at the museum, related to one of the artists whose work we had looked at that day. And I'd stay up late in bed, reading it and making my own sketches from it until my mum and dad came to switch off the lights and say goodnight. I had the makings of a small library by the time I left school – I used to love just looking at the pictures and trying to memorise the names of the artists who had made them.

'The best five works will be entered for a national competition open to all sixth formers run by the British Council of the Arts,' said Mr Stoner, 'so make sure you put some effort in!'

Grandad liked the painting I made of him. Impressionism was his favourite period in art history, and along with the Renaissance, which he had studied as a young man himself, it was the period he knew most about – the lives of Monet and Manet, Renoir and Degas, how Courbet had been a key figure in the early days, how Cézanne had come along and really shaken things up, and how a group of radical independent painters eventually managed to overcome the conservative French art world before going on to become one of the best loved movements today. Grandad loved talking about the music halls and circuses around Paris in the second half of the nineteenth century, about the growth of modern Paris under the control of Napoleon III and Baron Haussmann, and about the cult of the controversial composer Richard Wagner and his impact on the avant-garde scene in Paris in those decades. I didn't really understand it all at the time, but I liked hearing him talk with such passion. So I tried to capture all this in my portrait of him. I didn't think I had done a particularly good job of it, but I enjoyed painting it. I depicted Grandad as if he was the ringmaster in a Parisian circus, surrounded by show horses and clowns, elephants and bears. In the background was a band, playing music as the performance unfolded.

The next week, we all had to present our paintings in class. I had mine out on my desk to make some finishing touches to it before the lesson began. Mark, one of the group of boys who had kicked the football at me, walked past and paused to look at my painting.

'That's pretty good, you know,' he said. I was a little surprised by his kind words.

'Oh, thank you,' I said. 'It's of my grandad.'

8

'Cool,' he answered. A few minutes later he called me from the other side of the room.

'Do you want to see my picture?' he asked.

'Of course,' I said, so I got up and went over to where he was sitting. He had made a painting of his older brother as a boxer in a Pop Art style inspired by Peter Blake.

'That's really good,' I said, enthusiastically. 'I really like the colours, and the expression on your brother's face is just brilliant!'

'Thank you very much,' he said. 'It doesn't really look like him, but Stoner won't know that!'

I walked back over to my desk and could see that there was a large brushmark of blue paint through the middle of my painting, and the water glass had been knocked all over it. It was completely ruined. It must have been one of Mark's gang who had done it in the few seconds I had been away from my desk. They must have planned it. I knew it was out of character for him to have been so nice to me. I couldn't believe I had been so gullible. I was, of course, pretty upset about this; I did my best to not to show it, though I could feel myself blushing. Not only had they ruined my painting, but they'd made me look a fool too. The time came for us to show our works to Mr Stoner, and when he arrived at my desk, he could see that my picture was ruined.

'Whatever happened here, Adam?' he asked.

'I had an accident,' I replied, knowing that the gang would be listening to every word. 'Just as I was finishing it.'

'Well that's a pity – it seems like it was looking pretty good until then. Not to worry, there's another week or so until the competition closes, so if you want to try again, I'll look at it and mark it first thing on Monday morning before deciding which works to send off.'

That evening I told my grandad what had happened in the art class.

'What a bunch of mean pillocks!' he said, genuinely upset for me. I didn't know what a pillock was, exactly, but I got the gist. 'Why, I'd like to punch them all on the nose, one by one. And when I'd finished, I'd do it again. Don't let them get the better of you, my boy. Well, what are you waiting for?'

I looked at him confused.

'Go and get your paints out while I make us some sausages and mash.' He disappeared for a few minutes and returned with some books from a box in the dining room. 'Here, these might help.' He'd brought me a selection of books on Impressionist painters I'd not seen before. There were quite a few paintings and drawings of circuses and fairgrounds among them, which gave me some new ideas. I made some sketches, thinking through how I could improve upon the composition I had made first time round, and after dinner I made a start on a new piece of canvas board. I worked on it every evening

that week, adding more and more detail to the circus ring and the animals, and by Sunday evening it was finished. It was much better than my first attempt at the painting and I was pretty pleased with it this time. I handed it in to Mr Stoner the following morning at the doors to the staff common room.

'This is fantastic, Adam! Well done. You've clearly put in lots of time – look at all those colours and details. Brilliant. It's a really beautiful image and completely captures the spirit of the Impressionists in a composition that is entirely your own. I will definitely be including this as one of the school's five entries for the competition.'

I was pleased with his feedback and happy that he thought it was good enough to enter for the competition, but I didn't really think about it much again after that. Which is why it came as a complete surprise when just a few weeks later I found a letter waiting for me on my desk in the art room one morning. It was from the British Council of the Arts informing me that my work had been selected for inclusion in an exhibition of work by sixth-form pupils from schools around Britain that would be shown in a museum in Paris that summer. But that wasn't all. The letter went on to say that I had been awarded first prize for my painting, and as well as having my work featured, I was invited to spend three weeks in Paris as an intern, working on the exhibition. They would offer me my travel costs, an apartment in the ninth *arrondissement*, and a daily allowance for three weeks, culminating with the opening of the show and a couple of days of invigilation.

I couldn't believe it. I hadn't even really known what the competition was about, so I only found out about the prize right there on the spot. It was hard to take in. I don't think I had ever won anything before, and while I enjoyed painting, there were other pupils who were a lot better at art than me, even just in my class. Mr Stoner also said that he thought it would be good for me to get away from Birmingham for a while over the summer, just to take a break from everything and have a think about what I wanted to do next. I hadn't applied to university and didn't have anything lined up, apart from a half-promise of some part-time work in the leisure centre in the autumn, helping to run indoor cricket classes in the evenings for local kids. I hadn't even really thought about what I was going to do with my summer, so that decision was pretty much made for me. I hadn't been able to see past the end of my exams, I suppose, and Grandad hadn't pushed me on making any decisions. Wow, three weeks in Paris! And the summer was just a few months away. I think having my exams had been something to cling on to for the past two years – it gave me a purpose and stopped me from thinking about the accident and life without my parents. And with this news I finally felt I had something to look forward to again – there would be life after the exams.

## STIRCHLEY ELECTRONICS

It was Saturday morning, the day before I was due to go to Paris. I got back in from the supermarket with a couple of bags of shopping to find Grandad standing in the dining room, facing through the old French doors and staring out into the garden though looking up towards the sky. He was always smartly dressed – tweed jackets were a favourite, as were woollen cardigans, an ironed shirt, chinos, Argyle socks and freshly polished chestnut brown shoes. He was holding an envelope in his hand.

'Are you okay, Grandad? What's that you've got there?'

'Oh, nothing, dear boy. I'm fine. Just a reminder from a friend, that's all. Let's have a cup of tea, shall we, David?'

David was my father's name, and Grandad occasionally called me this by mistake. I never said anything, and he'd usually use the right name again soon after. I don't think he ever thought I was my dad, he just got the names confused, thinking back to a time when my dad was the age I was. He had really struggled with my parents' death, and it certainly didn't help with his already diminishing mental faculties. Some days he seemed to have forgotten about the accident, and asked me when David and Janet were coming to see him. But I had the impression that this was more a profound sadness – almost a part of him that was refusing to accept or to come to terms with what had happened, rather than a straightforward inability to remember the past. It's hard to explain. I guess it's just a combination of old age and bereavement.

We decided to drink our tea out in the garden, in part because Grandad wanted to inspect his hydrangeas. He had a walking frame, but preferred to use his old stick, which he'd had for as long as I can remember even when he didn't really need it. The arthritis in his knees had occasionally flared up for some years, and he seemed to like the reassurance that a stick offers when out on his own around town. I think he also enjoyed the drama of waving it around in the air from time to time, whether to scare pigeons or to convey his anger at minor misdemeanours conducted by members of the public – able-bodied drivers parking in disabled parking spots, for example, or idiots throwing litter on the ground. When he first got given his walking frame, I remember him telling me that walking frames made you look old and frail, but walking sticks made you look respectable, 'even if you weren't', which

made me chuckle. He had always made me laugh, and I was pleased that he seemed to have retained his sense of humour even in these twilight years.

Sure enough, the hydrangeas were out in full bloom already, and they looked pretty amazing. They were bright pink and must have numbered in the hundreds, clustered along the length of the border. We sat side by side on the bench, and although it was mostly overcast, we could feel a gentle summer breeze. He pulled a pipe out from his shirt pocket, and after some prodding and patting, lit it. I didn't mind the smell too much. It was nicer than cigarette smoke, anyway. And because I associated the scent with him, I kind of liked it.

'So tomorrow's the big day, Grandad,' I said. 'I'm off to Paris tomorrow morning.'

'Of course you are, of course you are,' he replied.

'I'll only be gone for three weeks.'

'Oh, I hadn't really thought about that,' he said. He looked a little dejected about the prospect of me not being around.

'But the good news is that Sophia will be coming round to see you more regularly – you know, the community nurse you like. The meals on wheels people will also be coming round four days each week instead of two, remember?'

'Oh god,' he groaned. 'I hope they aren't doing their infamous beef bourguignon again next week. You'd have thought they would want to lengthen, not shorten, the lives of their customers. And they served it with spaghetti! I ask you. If I were to boil my shoelaces in my own bathwater it would taste more French than that muck!'

'Oh, come on now, it's not that bad. It looked rather nice, I thought.'

'When you're in Paris, eating real beef bourguignon, Adam, you will discover what I mean. On that day, I hope you will raise a glass of wine to me.'

'Ha! Okay, Grandad, I will definitely do that. I'm going to see the Louvre while I'm in Paris,' I said, knowing he would love the idea of this.

'Marvellous,' he replied. 'That's absolutely marvellous. I love the Louvre – so many wonderful paintings. You can get lost in there for days. Make sure you take a whistle and some Kendal mint cake with you, my lad!'

I sniggered at his silly joke.

'But seriously, though, when I worked for the ministry back in the day I spent quite a bit of time in Paris.'

As a young man, Grandad had worked for the foreign office for almost fifteen years as their chief hand courier. After leaving school, he had basically been a postman for the different British embassies around the world, carrying important documents by hand back and forth to the governmental offices in London. He spent a lot of time in planes, trains and automobiles, often in far-off lands. He only left his job when Gran became pregnant with my dad, and when he received the offer of a job with more regular hours in Birmingham, they left their lovely flat in Maida Vale to settle down for good in a pretty

semi-detached Victorian house in the Birmingham suburb of Selly Park. He partly chose this spot so he was near to the cricket ground in Edgbaston.

'I was quite involved with British intelligence in Paris, in fact,' he said, lowering his voice and looking over his shoulder as if to make sure nobody else was listening. I'd heard many stories of his travels – how he had narrowly avoided a plane crash in the Ukraine because his train to the airport had been held up by hundreds of wild horses, and how he had drunk a whole bottle of whisky from dusk until dawn with a famous British film star while he was working in Malta – but this was the first time he had spoken of espionage. I wasn't sure if he was joking.

'The French and the British were sharing a lot of intelligence relating to the Russians at the time,' he explained, 'and I was part of a very complicated process of passing on information, and particularly misinformation. As a named official with a title and a clear role, all of the agents from all of the different governments knew that I was a courier of confidential documents, you see, and if they really wanted to get their hands on the materials I was carrying, they had their ways and means of doing so. We were aware of this risk, however, so often I would carry bogus documents with information that would deliberately mislead or confuse. We had a whole network of people involved to make sure our information made it only into the right hands. But who to trust? It was really rather exciting for a while.'

'Wow!' I said, impressed by this anecdote. 'Is that true?'

'Oh yes, Adam, it's completely true. The British government had a flat in Paris that I could stay in when I was working over there, very close to the Louvre, so I used to pop in for an hour or two whenever I was waiting around for my next parcel and instructions. I'd make little drawings of things that I found interesting – sculptures from ancient civilisations, textiles from the Arab world, and things I liked in paintings from the Renaissance.'

'I never knew that. So that's how you know so much about art history.'

'Oh yes,' he continued. 'I even used to sell some of my drawings and illustrations to magazines, gazettes and journals, would you believe. There were a lot of journalists connected to the embassies and to the government, and I often used to collect and deliver parcels to them. I got to know some of them – we'd be in the same apartment block, or eating in the same restaurant – and one of them was a commissioning editor and publisher called Peter Aldridge, who sat down at my table one evening with a glass of wine while I was drawing. He thought it would be good to have some illustrations in his portfolio of publications and asked me if I'd like to have a go. So I did. He used to pay me for every one of them they used, and he'd regularly leave briefs for me in London as I was there so often.'

'I'd love to see some of your illustrations,' I said, with real enthusiasm.

'Hmm,' said Grandad, clearly thinking hard. 'It's all so long ago. And the problem is that I've had to throw so much away ready to move into the

retirement village. Anything I've still got will be buried in that pile of cardboard boxes in the dining room. I might have a few magazines buried in my chest – I'll see if I can dig them out for you.'

'This must have been from the mid 1960s through to the late 1970s, is that right?'

'Yes, that would be about it. I did my last delivery in Madrid in 1982, the day of the World Cup final.' He poured another cup of tea from the pot, and nearly spilt it as he suddenly jolted.

'What is it Grandad, are you okay?' I asked.

'I do have one of my illustrations here! Yes, and of course, it is the one that is perhaps most famous, and of which I am most proud. How could I have forgotten when it's right in front of my very eyes. And with you going to the Louvre as well. How silly I am. What an old fool!'

I followed him back inside where he picked up from the coffee table a small round metal tin, a couple of centimetres high. It was the red of an old tin soldier, and the lid had a beautiful illustration on it of a pipe like the ones you see at a Middle Eastern restaurant – highly decorative, like an antique candlestick holder, or lampstand. Out of the pipe came a cloud of smoke, and in the smoke was a face, formed of the smoke itself. In an arc around the bottom of the design was some Arabic text.

'What does it say?' I asked.

'It says "A Face in the Clouds",' he answered.

'And you drew this?'

'Yes I did, in Paris in 1968, in the middle of the student uprisings.'

'But why is it in Arabic?' I asked.

'Because it was for a colleague from north-east Africa. His name was Abdul – I forget his surname now – and he was the lead courier for the Egyptian embassy in Paris. Sometimes we had to exchange envelopes and parcels. He used to stay in an apartment not all that far from mine, and one evening he invited me out for a drink. He took me through the backstreets to a tiny bar owned by an Egyptian friend of his. They served very good, very thick coffee there, and beautiful delicate pastries – *feteer meshaltet* they were called – funny I can remember that, but not the fellow's name! – but of course one of the main reasons people went there was to smoke shishas.'

'What's that?' I asked.

'The shishas? Why, the hubba bubbas, the hubbly bubblies, the hookahs of course.'

'Oh I see – those Middle Eastern smoking pipes, like on the tin.'

'Exactly,' said Grandad.

'So how come you drew one of those, and how did it end up on a tin?'

'Well, Abdul knew that for a little while I had been doing illustrations for a British news and politics journal that was published in Egypt, and he told me that his brothers were launching a new tobacco company in Cairo called

"*Wajah fi Alghuyum*" – "A Face in the Clouds" in English – and that they needed a picture to go on the tins, so I sketched out an idea right there, on the back of a drinks mat in the café. He loved it, and asked me to work it up into a final design, so after I left him that evening, I went back to my apartment and played around with it for a while. I had already sketched the face during an afternoon I had spent in the Louvre. It was in a painting I saw in there. I won't tell you which painting – maybe you can find it when you go there – and I'll tell you when you come back if you haven't worked it out for yourself.'

'There must be a lot of paintings in the Louvre,' I said, laughing.

'There are, but there aren't many quite like this one,' he replied, with a broad grin on his face.

'That sounds like fun. I will definitely keep an eye out for your face in the clouds when I visit the Louvre, Grandad. I haven't seen a round tin like this for tobacco before, though – was this the fashion at the time?'

'Well you're right, most of the tobacco tins were more rectangular. As Abdul's family business wanted to promote the tins in Europe, as well as supplying a lot of smokers in the Arab world, they designed a series of promotional tins so that they could fit one round shisha coal inside. In the red tins was the shisha – tobacco mixed with molasses and different flavourings – and in the blue tins was the coal. Usually the coals come in long tubes and the tobacco in larger tins or packets, but these were promotional gifts, I suppose. There were beautiful old-fashioned round lighters too – I think they're very rare now. I use my tin to keep mints in,' and he removed the lid to reveal a thin piece of white paper folded over some round mints underneath.

'Here, take the tin with you to remind you of me while you're in Paris,' he said, handing it to me.

'Are you sure, Grandad?' I asked.

'Of course, my boy, of course. It might help you to find the face in the clouds while you're in the Louvre.'

So I took the tin from his hand and popped it into my jacket pocket. Just at that moment Grandad's mobile rang.

'Hello. Yes? ... Oh really, you do? Oh that's wonderful, thank you so much. I'll be down as soon as I can.'

'Who was that, Grandad?'

'It was Alice from Stirchley Electronics. She has some replacement parts for that old wireless I've been working on. I'm going to take the bus down there now.'

'Would you like me to come with you?' I asked.

'Well, only if you have the time. It would be nice to have your company, my boy, thank you. Let's go.'

We jumped on the bus – it came quickly and we only had to go a few stops from Grandad's house along the Pershore Road. We got off very close to the electronics shop. Grandad had been an amateur radio enthusiast since he

was a boy. I had never fully understood exactly what this entailed, but there seemed to be two main strands – building and repairing wirelesses and radios, and then broadcasting and listening to other people on special frequencies reserved for non-commercial use. As a boy I'd often either see him sitting in his garden shed with a soldering iron and some bits of coloured wiring, or in the spare room in the house with a big old-fashioned pair of headphones on, in front of the radio and a small microphone on the desk next to a pot of tea. I'm not really sure who he was talking to, or what he had to say to them, but it mostly seemed to involve other amateur radio enthusiasts, or hams as Grandad called them. He was still a member of a local wireless club – it was a working men's club between Stirchley and Cotteridge, not far from the recycling centre. The venue was shared with a number of other clubs and societies, including the Kings Heath and Kings Norton Telephone Exchange Association, the Stirchley Electronic Music Club, and the South Birmingham Model Railway Society, though the last only really came because their own premises didn't have a licensed bar. Grandad would sometimes take a bus up the high street and spend an afternoon or evening with his friends at the club – beyond the bar was a function room, where meetings and talks would take place. He was considered a bit of a rebel because he'd fought for the wireless club to open up to female members – this was back in the 1980s. He said that anyone who was interested in radios should be welcome, which didn't go down terribly well with the old guard. But Grandad 'didn't care a hoot' what they thought of him, and with his friendly, warm, easy-going charm, gradually convinced them that this was something they had been pushing for themselves.

The Stirchley Wireless Club was, conveniently and perhaps not coincidentally, only a short walk away from Stirchley Electronics, a small shop that had been there at the end of the high street since the 1950s. It looked to all intents and purposes as if it had been derelict for more than twenty years, but it was, in fact, still open for business, six days a week. It had yellow window panes – hard to believe, I know, but yes, on either side of the entrance, each pane of glass was a deep, sickly yellow, covered by a mesh grill permanently installed over the frames. You could just about make out the outline of some old electronic equipment through this frontage – a cine projector, a metal detector, a Mini Moog, an old pair of walkie-talkies, and, for some unknown reason, a set of bongos. Once inside you found yourself surrounded by a strange museum of defunct audio-visual technology – old Hammond organs and synthesisers from the 1970s and 1980s, Midi racks, drum machines, magic lanterns, old games consoles, electron microscopes, you name it. I remember going in there with Grandad at least once or twice before, and looking at it every time I went past on the bus. The shop had been owned by a friend of his, Alfred, who had died just a few years back. Alfred's son had taken over the running of the shop, though he was not really as passionate about it as his father had been. But Alfred's granddaughter, Alice, was

completely obsessed by old electronic equipment. She had one of those minds that can just store huge amounts of information – she could read something once and commit it to memory permanently. Her head was like a vast hard drive. I had been at the same school as Alice since primary and she was unusual even then – times tables, poetry recitals, and, of course, she was brilliant on the electronic keyboard. She brought in a mini-Theremin once to show and tell, which she had made herself (with a bit of help from Alfred). At sixteen she had been made the youngest, and first ever, female president of the Stirchley Wireless Club, and was also chair of the Stirchley Electronic Music Club. Lots of the boys – and some of the girls too – had quite a crush on her at school, but she didn't seem particularly interested in boys or friends, unless of course they were also interested in diodes and transistors.

I could understand Alice's interest in old electrical and electronic equipment – that was kind of cool, if a little unusual – but what I couldn't fathom was how she managed to run this as a viable business in the twenty-first century. I mean, if anyone went in and asked for computer repairs or peripherals, she'd generally redirect them to a small independent computer shop just down the road. While she could repair mobile phones in the blink of an eye, there was no sign outside to say that this service was offered, so really it just looked like a second-hand shop for dead technology. I could imagine her running Stirchley Electronics as a hobby at the weekend, but how could she possibly earn a living from it? She couldn't have had more than two or three customers a day, and I can't figure how repairing a pad underneath a key on an old electronic keyboard was going to provide her with a living wage. But she always seemed bright and well dressed, so must have been managing somehow.

Grandad opened the door and an old-fashioned bell rang as he did so. I hadn't been inside the shop for quite some time, but it hadn't changed much. It was filled from floor to ceiling with the usual unusual and eclectic instruments and machines. There were old photographs on the wall of radio telescopes and early night-vision systems. It had a smell like nowhere else – the odour of the kinds of metal they don't make any more, of old leather, and early heavy-duty plastics. While it was kind of musty and stale, it was not an unpleasant smell – there was something quite wondrous about it in a way. I was staring up at an impressive set of 1980s disco lights when Alice came through from the back. I hadn't seen her for some time and her look was very different. She had a blonde bob, bright red lipstick, black eyeliner, and was wearing a black-and-white woollen cardigan with a psychedelic green blouse underneath.

'Well, well, well!' she said, 'Mr and Mr King. What a pleasure to see you both. How are you Adam? It's been a while since we've seen you in here.'

'I'm okay, thank you, Alice.' I felt I was standing awkwardly, couldn't remember if I had put any deodorant on, and suddenly became worried that she might think I was staring at her. 'You're looking well,' I added, instantly regretting sounding like her aunt or something.

'Why thank you!' she answered with a warm smile. 'You're not looking bad yourself.' I blushed.

'I'm guessing you've come in for those parts, George. Blimey – you got here in a flash.'

'Ah, there's life in this old dog, yet, my dear.' It was one of Grandad's favourite sayings, and it always made me cringe to hear it. 'Thank you for getting them in for me. There should be a seven-pin nickel valve header, a tabbed locking washer and a Bulgin 1K anode – is that right?'

'All there, and in decent condition too.'

'Marvellous, marvellous! She's marvellous, Adam – never lets me down.'

'What's that machine over there?' I asked. 'It looks like an old rifle.'

'Aha,' said Grandad. 'I remember my own grandfather using something like that to blow ducks out of the water!'

'Well it is a kind of gun,' said Alice, coming out from behind the counter, laughing. 'It's a chronophotographic gun, made by a Parisian gentleman called Étienne-Jules Marey in the early 1880s. So yes, it shoots, but only images.'

'What, to make moving images?'

'Kind of – it could take up to twelve frames per second, and record them within one image, so you can see the movement of animals, birds in flight, that sort of thing.'

'And that was before motion film cameras?'

'Yes, a good five or six years before Louis Le Prince made the first motion picture. Marey, like Muybridge, was one of a long line of people who developed the technology that was the precursor to cinematography.'

'Incredible. And what's this one?' I asked, spotting a curious kind of keyboard sticking out from a kind of white cabinet, with a few knobs on a grey metal panel on the left. It only had a couple of octaves on it, which I had never seen before.

'Now that, Adam, is a Mellotron. The Mellotron 400 to be precise. It's a tape-replay keyboard. This one's from the mid 1970s.'

'What does tape-replay mean?' I asked, intrigued.

'It's a kind of early sample-based keyboard. Each note is connected to six feet of audio tape with pre-recorded sounds on it.'

'That sounds crazy!' I exclaimed.

'It proved really popular with bands, especially until synthesisers came on the scene,' Alice explained. 'This one is owned by a French synth-pop band called Push Le Button. It had been kept in a basement for some years before they found it. They need it repaired in time for a concert in Paris in a couple of weeks' time, so I'm doing my best to fix some of the rubber pinch wheels and felt pads. They were built well so luckily it doesn't need much. A couple of the tape heads need replacing too, and two or three of the tapes could do with some TLC.'

'I'm going to be in Paris for the next few weeks,' I said.

'Oh how cool!' she replied. 'You should go to their gig – it's in a club called Flipper, I think the email said. I'll send you the details.'

'That would be great, thank you.'

'Are you going over to the Stirchley Wireless Club meeting this afternoon, George?'

'Well,' said Grandad, 'since we're here we might as well pop in for a swift pint. I hear they've got beers on tap from the new micro-brewery down the road, which sound like they ought to be tested out, just for quality control, you know.'

'It would be rude not to,' Alice replied, grinning. 'Oh, and this is for you, Adam,' she added, handing me a faded multicoloured cardboard box.

'What is it?' I asked.

'It's an instant camera, from the 1980s. You put the film in here and it prints pictures out as you take the photograph.'

'That's pretty cool, thank you,' I said. 'I'll take some pictures at the gig.'

We said our goodbyes and made our way slowly up the road to the club. It was a red-brick Victorian building, and despite looking a little tired, had quite a grandiose façade. The main entrance in the middle had a set of steps up, with large windows on either side. On the first floor were three taller, thinner windows with curved arches over the top. Above them were three smaller windows jutting out from the roof. The ground floor was basically a pub, with a thick, dark-red floral carpet, large heavy curtains and lots of round wooden tables with simple metal chairs. Downstairs in the basement was a stage and dancefloor for performances – brass bands, magicians, comedians, cabaret, whatever. The defining feature of the room, however, was an incredible Compton Theatre Pipe Organ which Grandad told me was from the late 1930s. The whole thing was illuminated yellow, orange and red, like a giant Art Deco lamp. I remember being entranced by it as a little boy. As we made our way through the bar to the staircase behind, we could hear that the organ was in use, so we walked downstairs to listen for a minute or two.

'It must be Hubert,' said Grandad. 'You can always tell when it's him playing.'

'How can you tell, Grandad?' I asked, impressed.

'He only knows how to play three tunes,' he replied, with such a broad grin on his face that he had to enlist his own tongue to help pull his dentures back into place. The piece we were listening to was a melancholy but pretty tune.

'You can't beat the sounds of the Compton, Adam,' said Grandad, clearly enjoying Hubert's performance. 'They don't make organs like that anymore.'

'It does sound amazing,' I replied. 'What's the tune he's playing?'

'Ooh now,' said Grandad, 'I do know it. Hang on. It'll come to me in a minute...'

'Don't think about it and you'll remember it,' I said.

We made our way, very slowly, to the first floor, where the Stirchley Wireless Club and other societies would hold their meetings. These rooms looked like old school classrooms, and in this particular room there were shelves displaying examples of wirelesses, radios and gramophones from all different decades. They went back as early as the 1890s. There were what looked like a number of pieces of Victorian and Edwardian furniture underneath, though I knew their secrets. Grandad had shown me how each one was actually a different piece of musical equipment. One was called The Modernola, a cylindrical wooden cabinet with an actual lamp designed to go on top. Inside was a phonograph – a precursor to the gramophone. Another was the Pathé Supreme – a wooden cabinet on elegant legs with an ornate panel on the front with two doors below. The only thing that gave it away as being a machine was a handle on the side, like on an old barrel organ. There were black-and-white photographic prints in frames on some of the walls, showing antique amateur radio studios in people's front rooms and sheds – presumably belonging to fellow enthusiasts with whom members had established regular radio contact over the years. There were pictures of large radio masts and huts in the middle of landscapes.

That afternoon there were two men and two women sitting at the tables with various pieces of electrical equipment around them. They must all have been in their mid eighties. As we walked in through the door, one of the men looked up to see who was coming in.

'Here he comes. If it isn't everyone's favourite *hamateur*, George King.'

'Good day to you, Edward, how lovely to see you.' Turning to me he explained, 'Edward and the gang here are the real radio and electronics specialists, you see, Adam. Edward calls me a "hamateur", which I find an endearing term for my lack of skills at fixing old wirelesses or being able to pick up the broadcasts and transmissions I'm listening out for!'

'But he is still dashingly handsome,' added Margot, whom I had met before, along with her twin sister Cecily. 'And so is his grandson – the very likeness of George as a young man – how nice of you to come and pay us a visit,' she said. 'Would you like a biscuit?' She offered us posh chocolate-covered biscuits made at the factory round the corner, which Grandad and I gladly accepted.

'Hello Margot, hello everyone,' I said.

'You're just in time,' said Edward.

'In time for what, old bean?' asked Grandad.

'Why, for this afternoon's broadcast from Moscow.'

'Ah, of course,' said Grandad. 'I forgot you're still a Trot!'

'The world would have been a better place under Trotsky than under Stalin,' countered Edward.

'Yes, you're undoubtedly right. What are we going to be hearing over the radio waves from Moscow?' asked Grandad.

'Well,' said Cecily, quite excitedly, 'our friends in Moscow have prepared for us an hour of Russian avant-garde music from the late-nineteenth and early-twentieth centuries.'

'Yes,' continued Margot, as if finishing her own sentence, 'the notes provided say there will be pieces by Avraamov, Roslavets and Scriabin, alongside the usual celebrated names, and also some readings of the poetry of Mayakovsky.'

These names meant nothing to me, but the twins sounded like they were looking forward to the broadcast.

'And this broadcast is just for you?' I asked.

'Sort of,' replied Timothy, the other chap sitting at the table in front of an old mahogany wireless with a can of beeswax polish. He spoke very slowly, which Grandad later explained was due to a degenerative medical condition. 'Anyone listening on this particular frequency will be able to hear what we are hearing. We will be preparing our own broadcast of old and particularly rare gramophone records from Europe and the USA to play for our friends in Moscow, Paris, Berlin, Istanbul and so on next weekend.'

'That's really interesting,' I said.

'These four are all very clever, Adam. I don't understand half of the things they do in here. They can always seem to help me with anything I can't fix myself, though.'

At that moment one of the bar staff appeared with three pints of locally brewed bitter and two large glasses of sherry. He had clearly been well briefed by the wireless club members. They called the social club 'the last homely house' as it was quite some way before you would reach another pub or bar due to the Quaker origins of the surrounding villages. It was also a nod to Tolkien, who had attended a secondary school nearby.

'Look at the time, Grandad, I'd better get back home and pack for tomorrow. Are you going to stay here? Would you like me to book a taxi to pick you up later on?'

'Oh, that's kind, son, thank you,' said Grandad. 'Yes, I think I'll stay here for a pint or two with this bunch of Commie sympathisers and listen to this Russian broadcast. I'll get the bus back later on. See you for cocoa.' Cocoa was Grandad's code word for brandy.

Just as I was about to make my way out of the door, he shouted: '*Waltz for the Afterlife!*'

'Sorry, Grandad, what's that?' I said, turning back round to face him.

'*Waltz for the Afterlife* – that was the tune Hubert was playing downstairs earlier on.'

'Ah, I knew you'd remember it!' I said, and with that, I headed off.

\* \* \*

The next morning I had to get up early to take the coach to London. I made some tea and toast for me and Grandad, who was, unusually, still in bed, so I took it up to his room. His mobility was decreasing due to the arthritis and he knew that he'd either need to move into the retirement village soon or we'd have to bring a bed downstairs and turn the front room into a bedroom. He stirred as I opened the door, which creaked pretty loudly. He said it was the penultimate line of defence against any intruders, the last being 'a knuckle-duster' made with his false teeth! I put the tray on his bedside table before walking over to the windows to open the curtains a little. As I leant over the chest of drawers, I noticed the envelope Grandad had been holding yesterday morning. A postcard was sticking out of it. I couldn't help but take a look. On the front was a picture of the Sphinx and the Pyramids in Giza. On the reverse were some words handwritten in capital letters: OPEN THE DOORS / WHOSE KEYS? What an odd message to bother to send by post. He'd said it was a reminder, so maybe it was something to do with the working men's club. I put it back as I had found it.

'Tea – a gift from the gods,' he said, slowly coming round. 'Hand-delivered by my very own angel. Thank you, Adam.'

I plumped the pillows behind his head and sat on the edge of the bed.

'Did you sleep okay, Grandad?'

'Not bad, thank you, lad. Though I didn't half have some odd dreams after all that Russian music.'

'I thought I'd better wake you up as I need to leave now to catch the bus to the coach station in Digbeth.'

'Oh, okay, Adam. Well, before I forget, you'd better take this.' And he pulled a card from his bedside drawer with my name on it.

'Happy birthday, Adam,' he said.

'You remembered, Grandad! Thank you.' And with that I started crying. It was my eighteenth birthday, and his was the only card I got.

'Oh come on now, lad, you're a man now,' he said, with a kindly smile. 'Take care of yourself and come back and tell me about all the adventures you'll doubtless have. Go easy on the *pastis*!'

I didn't know what that meant, but it sounded funny, so I laughed. I noticed he actually had a tear in his eye too. I don't think I'd ever seen that before. He was born a Yorkshireman, you see.

'I promise I'll call you every weekend. Don't forget to keep your mobile switched on and charged up, so I can reach you. And you can call me any time you like. If you need anything, or just want to talk, you call me, Grandad. You will, won't you?'

'Of course I will,' he said, smiling and nodding. 'And if you get into trouble in Paris, you just give me a call. I might be well into retirement, but there's still some life left in this old dog yet – so long as I can carry my walking stick, that is!'

## AN ENGLISHMAN IN PARIS

I remember being out of breath and blinking in the hazy sunshine of a warm summer evening in the Place de Clichy. I had just emerged from the steps of the Métro station with a large, awkward, and – somewhat embarrassingly – ladybird-patterned suitcase to find myself on a bustling street corner in the middle of Paris, but despite the mass of people determined to get past me, I couldn't help but stare up and around at the grandeur of the buildings that greeted me, shining in the golden sunlight. Everything here looked so old, so untouched – only the signage of businesses and shop windows gave away the city's existence in the present moment. Looking up to the immaculate clear blue sky, I took in the ring of smart, slate-grey attic floors capping the austere beige façades with their ornate ironwork balconies. I was, in that instant, starting my love affair with Paris, though at that precise moment I was too preoccupied with digging my phone out from my pocket to realise it.

I knew very little of Paris – indeed, despite my passion for France, I had very limited knowledge of the country in general, but was looking forward to trying out all the French I had learnt, and not just with my teacher at school. This time it was going to be for real, no role-play. A cool breeze swirled through the streets, and I found myself standing in the shade, which was a welcome relief as the sweat accumulating in my armpits and down my back had reached the point of no return after several hours of travelling, made worse by the fact that I had left England wearing clothes better suited to the English climate. I glanced at my phone, waiting for the signal to return, so that I could pull up a street map and get my bearings. I began to take in the street around me; I caught a strong smell of fish and turned to see that I'd had my back to a restaurant specialising in seafood – there was a display of lobsters, crabs, langoustines, mussels and clams in trays filled with ice right there in the open doorway. How gross, I thought to myself – who would ever want to eat such ugly things? And what a stench! I was more used to battered cod from the fish and chip shop.

My map now operational, I took a moment to work out which side of the road I was on, and so which direction I needed to go. I was looking for a '*foyer des jeunes travailleurs*' – a guest house for young working people that was to be my home for the next three weeks. I did not have to go far, as the building was just around the corner on the Boulevard de Clichy. It was my first

encounter with Paris's boulevards, which are grand, spacious, tree-lined avenues wide enough for an army to pass along. I dragged my case a couple of hundred metres until I reached a bar by the name of Le Violin Noir, to the side of which was a pair of imposing wooden doors and a buzzer. Pausing only to locate the correct buzzer, I pressed it and was allowed in.

I found myself in a lobby, in the centre of which was a tall, black, cast-iron cage ascending into the ceiling. I'd never seen anything like it. At the base was a thin door with a small glass window, and to one side I noticed a black button on a square metal plate. I quickly realised that this was a lift, but it could barely have room for one person inside, and certainly not for my ridiculous suitcase too. On the other side of the lift shaft was a staircase, curling round with minor theatrical effect. While modest in size, the stairs had a gentle sense of grandeur about them – solid stone with inlaid fragments of pastel-coloured tiles. On the wall to my right was a large, old-fashioned wooden rack filled with individual letterboxes, labelled with small cards of varying ages with names written on them, or in some cases typed. On the left-hand wall was a noticeboard, covered in assorted sheets of paper with lists, maps and all manner of information. These were faded to differing degrees of yellow and brown, according to how long they had been pinned up there. At the back and underneath the staircase was a door with four panes of glass, through which I glimpsed a courtyard with greenery, and to the right of this was another, inward-facing wooden door with a hatch built into it at eye level. The hatch opened and a woman's face peered through. She must have been in her late fifties, and, as if to fulfil the stereotype, she had a pair of spectacles halfway down her nose.

'*Oui?*' she said, in a formal but not unfriendly manner.

'Oh,' I said, '*bon soir, madame, je m'appelle Adam – Adam King*.'

'King, King, King,' she replied slowly, evidently looking down at a list of names. 'Ah yes, the new English boy. You're here for the museum, is that right?'

'Yes, yes I am,' I said, relieved that I was expected.

'Welcome to the Foyer Place de Clichy. Here is your room key. You're in room forty-five, on the fourth floor. No smoking, no drugs, no sub-letting, no parties, no noise after eleven at night – the walls are thick, but not that thick, so keep your voice down if you don't want everyone to know your dirty little secrets. There is a fire escape at the far end of each floor, rubbish bags should be placed in the chute next to the fire escape, and don't block the toilets. If you block the toilets, the experience will be so horrible for you, not to mention for everyone else in the building, who will despise you for ever after, that you will not do it again, I can assure you, so my sincere advice is not to do it the first time. There is a communal lounge at the back of the courtyard, open twenty-four hours, and reception is always staffed. Here is a key for your letterbox, and here is a card with the foyer's address, wi-fi code, phone number for reception, and an emergency mobile number for the concierge in

case they are out doing the rounds when you need them. If it's Jean-Claude's shift, make sure you really need the thing that you want before you bother him though, he has had forty years to gradually turn his fondness for his job, and indeed, for life in general, to bitterness, regret and despair, and I am quite sure he will completely lose his mind one of these days and garrotte one of you young people with the belt from his trousers. The belt is essential for holding his trousers up, so it would be a particularly unsavoury way to die. And finally, here is your swipe card for the front door and communal lounge, please don't let anyone in you don't know; there are enough burglars in the building as it is, so we don't want any more coming in off the streets. Any problems, please don't ask.'

I realised that I must by now have the expression of a surprised ape, but I managed to thank the lady, who smiled aggressively before shutting the hatch abruptly. This was my first encounter with Madame Violette Pompadour. I looked at my case, then at the bijou lift, and decided to put the case in, send it up, and race up the stairs to meet it. I reached the fourth floor, completely out of breath, just as the lift was arriving, grinding with the sound of nineteenth-century engineering as if in a mine shaft in a museum of industrial heritage. In my haste to get the lift, I almost ran head-first into a young woman coming towards me on the landing.

'Oh, I'm sorry, *pardon*,' I said breathlessly as she recoiled.

'Hey there,' she said, smiling. 'Is the building on fire or maybe you are being chased?'

'I'm so sorry,' I said; I could feel myself blushing. 'I was rushing to collect my case from the lift.' I pointed behind her. She turned round and pulled open a heavy metal concertina door to reveal the lift, with my case inside.

'No panic,' she said. 'And that's quite some case you've got there! *Incroyable!*'

My face must have descended through further shades of crimson as the bright red case and its unmistakable black spots stood there beneath spotlights inside the lift for what felt like an eternity.

'Thank you,' I replied, dragging my case out onto the landing beside us. 'My mum used to call me "ladybird" because ladybirds always used to nest in the frames around my bedroom window when I was little, and in the spring there was a constant parade of them around my room, up the curtains, on my bed. I think she thought it was funny to get me the case when she saw it.' I stopped as I realised I was babbling.

'That's cute,' said the young woman.

She held out her hand to me. I took it, and as I did so I knew that I was offering her a sweaty palm. I cringed a little as her cool, elegant hand took my hot, wet little fingers in hers. She politely ignored the hand situation.

'I'm Natalie,' she said. 'You must be in room forty-five.'

'How did you know?' I asked.

'Well, it's the only room that's free on this floor. The last guy moved out just two nights ago and they said it was an English boy who was coming in next, so I'm guessing that's you.'

'Yes, I'm Adam; nice to meet you, Natalie.'

'I'm your neighbour in forty-six, and on the other side is François. He's the oldest guy in the foyer and is only allowed to stay until the autumn.'

'Why's that?' I asked.

'You have to be under thirty to stay in the FJTs. It's a shame he's leaving, everybody loves him. I wouldn't be surprised if he doesn't buy a flat in the building next door – he'll be so homesick! Anyway, let me help you into your apartment.'

I opened the door and Natalie dragged the case in behind us. The room was small but homely, with a beautiful parquet floor, a couple of small grey velvet dressing chairs and a coffee table, a narrow desk with a heavy old-fashioned angle-poise lamp, and a basic kitchenette in the corner behind the door. A small shower, along with a toilet and the world's smallest washbasin, was in the opposite corner, and hardly seemed like a separate room, blocked off as it was by a partition wall that ended a foot below the ceiling, and sporting a swing door like a saloon bar in the Wild West. On the wall was a single, faded photograph of a smiling woman wearing a bonnet, a white blouse and a black bow-tie, standing on a balcony overlooking the streets of Paris.

'There's no bed,' I said, looking around.

'*Attend*,' said Natalie, magically pulling one down from the middle of the wall. '*Et voilà!* You must put it up every time you want to eat your dinner, and pull it down every time you want to sleep. It is one or the other, never both!' She laughed as she sat down on the end of the bed. I was only now really able to get a good look at her. She was a fraction taller than me, maybe five foot ten, had big black frizzy hair held back by a thick bright pink hairband, and was either quite dark-skinned or of mixed parentage. She had an almond-shaped face, a dainty long nose, thin lips, a high forehead, a long neck and striking green eyes. She was slender but seemed strong, like she might be good at sports, an impression enhanced by her clothing, which could have been intended for sporting or fashion purposes, the fluorescent synthetic fabrics, stripes and spots combining across various layers of clothing to form a dizzying look as if she was in a pop video inspired by the 1990s.

'How long have you been here?' I asked.

'I moved in last September, when I started my course in the performing arts.'

'Oh wow!' I said. 'That sounds amazing. So you do singing, dancing, acting?'

'All three at the moment,' she replied, evidently pleased that I was both interested and impressed. 'Next year I can decide whether to specialise or to continue to do combined studies. What about you, what are you doing in Paris?'

'Erm,' I said, suddenly feeling a bit geeky, 'I'm doing an internship at the contemporary art museum.'

'That sounds cool,' she said, and staring at me quizzically, continued, 'I hope you don't mind me asking, but how old are you?'

'I'm eighteen,' I blurted. I could feel myself blushing again as I realised I'd probably sounded a little too keen to impress upon her my adult credentials. She smiled.

'That's very young to do an internship abroad, isn't it?'

'I suppose so,' I replied. 'I won a painting competition organised by the British Council of the Arts for sixth formers across the UK. Part of my prize is to help the BCA organise an exhibition at the Musée d'Art Contemporain of the shortlisted students at the end of July, so I'm here in Paris for the next three weeks.'

'You must tell me when the exhibition opens and I will come and see it,' said Natalie.

'Of course!' I said. 'It would... it would be amazing... er, really cool if you can come.' I couldn't have been more self-conscious if I tried. I could sense myself standing there right in front of her, blushing, sweating, babbling, stammering. I could smell my own deodorant, and beneath it, my own sweat, and I could hear my breathing. Natalie caught the slight flicker in my eyes that gave away my flustered internal state.

'Listen, why don't I let you unpack and get settled in. Then if you're hungry, why don't you join me for some dinner? I'm just meeting another friend from the FJT to go for some couscous at a restaurant round the corner.'

Rallying myself, I replied, 'Thank you, yes, I'm starving.'

With that, she jumped up from the end of my bed. 'I'll knock on your door in half an hour or so.' She smiled and closed the door. She seemed to breeze around with an enviable natural confidence. I was on a high as I unpacked my case. I couldn't believe I had such a trendy neighbour. And she wanted to hang out with me. She must have been in her early twenties, and I had never really spoken to a girl that age (apart from my babysitter). Come to think of it, I didn't really know many girls at all. Having finished my exams just a few days ago, I suddenly didn't feel like a schoolboy any more. The rules had changed.

\*\*\*

Natalie knocked on my door as promised, and we walked down the stairs together.

'We'll be meeting my friend Amira in the lobby. She's so lovely, I'm sure you'll get on like a house on fire.'

And sure enough, there she was, looking at her phone as we arrived at the foot of the stairs. Amira was clearly a young Muslim woman, dressed in a full-length djellaba flowing from her neck to the floor, which was jet black but covered in large, bright yellow printed flowers with orange centres.

The tailoring was minimal but elegant. A black headscarf was wrapped stylishly around her head and neck, leaving just her face exposed. She had large brown sunglasses on, bright pink lipstick and, putting her phone back into her yellow clutch, she greeted us with a beaming smile.

'*Salut*,' she said. '*Amira. Enchantée*.'

'*Salut*,' I said, offering my hand to shake hers. 'Adam.'

'I'm sorry but my English is not so good as Natalie's,' she said.

'It sounds good to me,' I said, 'and better than my French.'

'We can walk to the restaurant,' said Natalie, 'it's not far.'

We stepped out into the warm evening air as the sun was setting. The golden light fell on the tops of the buildings, leaving a gentle pink trace in my eyes when I looked away after staring at it. As we strolled we chatted, and the two girls did everything to put me at ease and to make me feel welcome. I felt relaxed for the first time in months, and I quite forgot my worries and cares. Amira was even more bubbly than Natalie, laughing a lot, smiling ceaselessly and talking nineteen to the dozen. She spoke in a mixture of English and French, especially when she didn't know the English words, but I was able to follow pretty much everything she said – although my brain was straggling several sentences behind – and Natalie was able to assist whenever the language barrier came down for a moment.

'How come your English is so good?' I asked Natalie.

'My father is from the Ivory Coast and my mother is Scottish,' she answered. 'I grew up speaking both languages from an early age. I'm very glad they took that approach with my upbringing.'

'The thing that I find strange,' said Amira, 'is that so many Muslims speak French and English, but so few Westerners learn Arabic. Why don't they teach Arabic in schools? And Chinese – surely these would be as much use today as Spanish or German or English? So many people speak Arabic and Chinese, and the economic growth in places where they do is very great. Don't you think that would help to address some of the problems of the world?'

I was doing my best to process her ideas, and at high-speed, while walking. They seemed perfectly reasonable, and it struck me just how different this was to the kind of conversation I'd have been having back at school. I now also felt a curious sensation – a mix of embarrassment and shame – that my very limited knowledge of other languages had left me with only basic means of interaction. Plus, what Amira had said about the scale of the Arabic- and Chinese-speaking areas and their place in the world order made me feel that English was not the all-powerful golden ticket I had perhaps assumed it to be. In the space of those few seconds, those few steps, those few words, I became aware not just of how much I had to learn, and to think about, in the world, but of differing world views, and just how small and insular Britain must sometimes seem from those other positions.

We arrived at our destination, and I was taken aback when we turned off the road, through a small gateway and into the grounds of what looked like a mosque.

'Erm, is this a mosque?' I asked.

'*Oui*,' said Amira, 'it is! It's a mosque. How do you say? A real mosque, a live mosque. The main entrance is on the other side. There is a restaurant that is, how do you say, open for the public. Natalie and me, we like to come here. They have tagines; they are so amazing, and the sweets, they are very good too.'

I wanted to ask what a tagine is, but I was distracted by the view. As we were standing still I had a brief opportunity to look around the courtyard, which was like something from a different world. A colonnade surrounded it, with climbing vines wrapping themselves around the pillars, and ornate grey tiles with an endlessly repeating geometric pattern covering the whitewashed stone walls up to the deep, inset windows. In the middle of the courtyard was a pool with garden islands in neat rows, filled with exotic plants and trees, like an oasis. Around this was a regular garden with little round tables with mosaic tabletops interspersed between ancient-looking trees with knotted trunks and branches weaving a path towards the evening light.

'Have you ever eaten *Maghrébain* food before, Adam?' asked Amira.

'I don't think I've heard of it,' I said, a little sheepishly.

'It's the food of Morocco, Algeria, Tunisia and so on,' explained Natalie, 'it's the cuisine of North Africa, though many dishes are common across parts of the Middle East.'

'Oh, I see,' I said, feeling even more embarrassed that I didn't know this, though slightly reassured now that I had a grasp of what they meant.

'Couscous!' I exclaimed.

'Yes! Couscous,' replied Amira. 'Do you like?'

'I've only ever had cold couscous in a tub from the supermarket,' I said.

'Well, tonight you will try something that is closer to the real thing, okay?'

I wasn't complaining. The smells that were coming out of the restaurant doors were as otherworldly as the courtyard in which we were standing, and as we walked through the tables and among the diners, into the covered colonnade, a large, elderly waiter spotted us and came straight over. He had warm eyes and a friendly smile, and beautiful pale brown skin.

'*Bon soir mademoiselle Amira, comment allez-vous?*'

'*Bon soir, Mammoul*,' replied Amira. '*Très bien, merci, très bien.*'

'*Vous avez un nouveau client, ce soir?*' he asked, which I understood meant that he thought I was a client of Amira's, of some kind.

'*Non*,' she answered, '*mais on lui donnera le même service, s'il vous plaît.*' So I knew I wasn't a client, whatever that might mean, but I also knew I was going to be treated as if I was one. I decided this was probably a good thing. He then said something to her in what sounded like Arabic, in response to which she nodded.

We took our seats – it was a large table with a brass tabletop that looked like a huge tray, covered in detailed decorative patterns. It glinted in the yellow light of the lamp hanging overhead, and there was a softer red glow from the outdoor heater that was beside us and already switched on in anticipation of the cooler evening air. A paler, white light hit the table coming in from the garden courtyard. Within moments the waiter reappeared carrying a tray, and placed five small glasses on the table, along with a bowl of white sugar cubes and an ornate brass pot that matched the tabletop. It was the kind of pot a genie might burst out of, like something not only from a far-off land, but also from a distant time. It was steaming and I soon caught the delicious scent of mint. Natalie poured us each a glass of hot mint tea. I had tried a teabag of mint tea in a coffee shop once, but this was nothing like that. It was sweet and rich and tasty, without a bitter aftertaste. I think I drank mint tea for the whole of the evening.

What proceeded to emerge from the kitchen can only be described as one of the most delicious meals I have ever had. I guess I hadn't eaten in many restaurants before – pizzerias and balti houses, mostly. I discovered that the 'service' Amira usually laid on for her clients involved a sample of lots of different dishes, almost like a tapas. We had a delicious lamb and tomato soup, some fish chermoula – very spicy marinated grilled fish that set my mouth on fire – deep-fried potato balls in harissa sauce, and a mixed meat tagine with couscous. I'm not sure what all the flavours were, but think there might have been cumin in there, coriander perhaps, maybe even cinnamon. And that was just for the main course, as we were then treated to various gorgeous pastry desserts, filled with syrups and rosewater and ground pistachios. It was so tasty I wanted to carry on eating and eating, but while my eyes said yes, my stomach was waving the flag of surrender.

During the dinner, I discovered quite a lot about Natalie and Amira, especially Amira as she hardly stopped chatting all night. I had never met anyone like her before – she was born in France to Moroccan parents, and while her parents were still married, they lived separately. Her father lived in Paris, while her mother had returned to the family's home city of Marrakesh. Occasionally her father would travel to Morocco and visit his wife, staying with her and various other family members for a few weeks. And from time to time Amira's mother would come to Paris and stay with her husband. It seemed strange to me – there had been no falling out, they got on fine and just lived pretty independent lives. I picked up that Amira's mother had grown tired of living in France – she didn't like the flat they lived in, and so as soon as Amira was sixteen, she'd packed her bags and left. Amira seemed to be close to both parents, and to her brother Youssef too. He lived between Marrakesh and Paris. He was a couple of years older than Amira, and had a number of businesses. I didn't quite get to the bottom of what these were, but the main one seemed to involve importing various goods from North Africa and the

Middle East into France. He also worked as a co-director of Amira's business, which I learnt was a kind of travel agency.

'That's right,' said Amira. 'I arrange for French people with money to go on "*authentique*" vacations to Morocco. They are bourgeois bohemians – *bobos* we call them – you know, middle-class people, they like travel and world music, they like to read novels about exotic places. They are, *en général*, kind people who are interested in foreign cultures and who like to experience new things – authentic, real kinds of things. They don't want normal package holidays to beach resorts, or city breaks to generic hotel chains – they want to see the "real" life of Moroccans. So that's what I do, I arrange bespoke holidays for these people; they stay in towns and villages, usually living with Moroccan families. I pay the families to host them and to spend time with them, cooking, baking bread, milking the goats and making cheese, or doing whatever each family does, so long as it's vaguely traditional, and a little bit *pittoresque*. I don't send them to the families that work in the abattoirs, or at the hospital, for example! Most of my family is from the Djebel Sahro, south-east of Marrakesh, up in the mountains. We arrange walking tours for them – places off the usual tourist routes. I pay the hosts good money – what I give to the families for a week is the equivalent of more than two months' income, so they are very happy to work for me in this way. Some of them are relatives or friends of relatives, which helps. I arrange the visas, travel and transfers, I sort out any problems that might come up. It works very well. I organise holidays for around sixty French people to Morocco each year, and the business is growing. I started three years ago, and my plan is to have over one hundred tourists going out there each year by the end of next year. That would mean I could make enough money for a deposit to buy my own flat here in Paris, and later one in Marrakesh too. That is my dream. Don't get me wrong, I love to be in the foyer, but I know it is only temporary. We all have to move out eventually. It's like a stepping stone you could say – for young people to get started in life, and it's amazing for that.'

I was pretty impressed. She was only a few years older than me and she was running her own business – an Internet start-up, in effect. She had an app that you could download to your phone and see all the different places you could go and things you could do. Even pictures of the host families. The reason Amira was so well known by the restaurant staff – and it turned out also by many of the regular customers – was that she would often meet new and prospective clients at the restaurant to discuss their trips or to sell them a holiday. It made perfect sense, of course – a warm summer evening, a pot of fresh mint tea, some delicious North African food, all in a beautiful Moroccan-style courtyard. And she was a very convincing sales rep too – a young, smartly presented French Muslim woman who could speak Arabic and really sell the idea. Her bubbly personality and enthusiasm for Morocco were

infectious. If I'd had a couple of thousand Euros to spare I'd have booked myself onto one of her packages there and then!

She seemed to be quite a celebrity, in fact, with three people coming over to our table to say hello during the course of the evening. One couple had been on one of her holidays, so stood alongside us for quite some time describing their trip in great detail. Needless to say, Amira dealt with them with both charm and grace, like a true professional. Another member of the public who came over just as the sun finally set was the sister of one of the host families over in Marrakesh. She was out for dinner with her three young sons and a number of other family members, celebrating the birthday of one of the boys. She gave Amira a big hug and they spoke in Arabic for a couple of minutes. She seemed to assume that I was a new client and nodded politely at me. It felt curious being unofficially pigeon-holed as a bobo tourist, but then I imagined the host families in Marrakesh must feel similarly pigeon-holed in their roles as 'authentic' exotic villagers. I gathered that some of the hosts actually lived in cities, with regular office jobs, and that the hillside homes they owned were more like old family heirlooms or holiday homes of their own these days.

But it seemed that Amira's success had also been noticed by people who were perhaps not so ready to celebrate her achievements. The atmosphere around the restaurant gardens was buzzing by now. All of the tables were full, there were gas-fired lamps dotted around, and the air was filled with the smell of tobacco and sweets emanating from the traditional hookah pipes that had been coming out in considerable numbers as people finished their meals. At one table, just fifteen or so metres away, sat three men in their early- or mid-thirties, one in a suit and two of them wearing jeans, T-shirts and leather jackets. They looked either North African or Middle Eastern, with stubble that made me feel very much like a boy. They sat with their backs to a wall, all facing out towards the garden and the pool that separated us from them, taking it in turns to use the pipe. I noticed that they had been staring at our table for some time, and talking to each other as if they were talking about us. I didn't get the impression that they were saying particularly nice things, though I couldn't be sure. Natalie had obviously noticed too, as she asked Amira if she knew who they were and why they kept on looking over at us.

'Oh, don't worry about them,' said Amira, smiling. 'I know who they are – well, sort of. One of them – the one in the middle – he's worked with my brother for a long time – he does shipping and logistics for one of my brother's companies. The guy on the right has only recently started working with my brother. I'm a little less certain about him. I wouldn't be surprised if he thinks it's not right that I run my own business. Or maybe he doesn't think it's appropriate for me to be sitting here talking with a young man. He might have conservative views about Muslim women, and that's fine for some people, I respect those men and women who lead their lives that way. It's just not for everyone. I live my life as a Muslim in my own way. This is Paris in the

twenty-first century and I'm not so unusual here. The other man – I've seen him around here for years, but I don't really know who he is or what he does. I must ask my brother about him. He's very handsome, I'll say that, but he does seem to be staring a lot, doesn't he?'

We drank some tasty, if rather thick coffee, and I was reminded of my grandad drinking strong coffee with his Egyptian colleague in Paris all those years ago. I liked the thought – it made me feel like I had, in some small way, connected with Grandad's time in the city. Amira insisted on paying. I really tried hard to pay my share, but she just wasn't having it.

'I would not dream of it!' she said, beaming. 'It is your first night in Paris. Remember to tell your friends and family about my holidays!'

'Oh, I will,' I promised. 'They sound wonderful. Perhaps one day I might be able to go on one myself, when I have a job.'

While we were waiting for the bill to arrive the three men who had been staring at us walked past our table on their way towards the exit. The first, the man in the suit, paused and greeted Amira in Arabic. He didn't acknowledge Natalie or me, yet he didn't seem especially rude – his manner was quite polite, in fact, though he seemed on edge, somehow. Amira replied and they had a short conversation. The other two men were looking at me, so I smiled and nodded my head. No reaction. I sipped my empty coffee cup. As the conversation seemed to be drawing to an end, I looked up again, and the two men actually seemed to be frowning, not directly at us, just standing looking elsewhere and frowning. I felt a little uncomfortable but as I didn't understand the conversation and wasn't part of it, I hoped their mood was nothing to do with me. Natalie didn't seem bothered in the slightest – she was busy looking at her phone. One of the two men standing idly pulled out a packet of cigarettes, then a lighter, out of his pocket. My eyes were immediately drawn to it because it was round, red, shiny and reminiscent of the tobacco box Grandad had given to me. I followed it into the air as the men lit their cigarettes, and just before it went back into the one guy's jacket pocket, I got a short though clear look at it. Sure enough, it was one of the old Face in the Clouds lighters. As he put it in his jacket he saw me looking at it, and looked down at it, then back at me. He held me in his gaze for a moment, as if he was wondering something about me, though I couldn't imagine what.

'Is everything okay, Amira?' I asked.

'What do you mean?' she replied.

'Well with those men – what were they saying?'

'Oh, nothing much – they said they have a lot of work on at the moment. My brother's been expanding one of his import companies with some new partners. It's been causing some complications and has meant some long nights doing all the additional paperwork and logistics, but nothing they can't sort out. The second man is a new business partner and the last guy is one of the people that's been brought in to help with the extra workload.'

'He *was* very good-looking,' added Natalie, without looking up from her phone. 'Chiselled. Rugged. Enigmatic. But a bit grumpy,' she laughed, and Amira joined in. I just smiled.

'He had a cigarette lighter with him – a red one. Is there a tobacco brand called A Face in the Clouds here in France?'

'A Face in the Clouds? No, I don't think so,' said Amira.

'Like this old box,' I said, pulling Grandad's tin of mints out of my jacket pocket.

'Oh, Wajah fi Alghuyum!' she exclaimed. 'Yes, it is a brand that's smoked by quite a few Maghrébains here in France. It was an old brand that was recently resurrected – they are making vapes as well, now, you know, the liquids and all that stuff. My brother imports that brand into France and around the French-speaking world. It's one of his most successful products, I believe, the market is growing fast for this brand. But your tin is old, Adam. You don't smoke do you?'

'No,' I replied, 'it's an old tin my grandad keeps mints in.'

'Do they sell Wajah fi Alghuyum in England?'

'I don't know,' I said. 'I hadn't heard of it before my grandad gave me the tin.'

'What a strange coincidence that you have a tin of that exact brand. It is obviously destiny that our paths should cross in life – how serendipitous!'

'You won't believe this, but it was actually my grandad who designed the picture on the tin.'

'No way – *c'est pas vrai!*' said Amira. 'This illustration is – how do you say? – cult? It's like a really cool brand, you know, *légendaire*. They are talking about stopping all the branding of cigarettes in Europe, which is a pretty radical idea, non? Maybe it is a good idea to discourage people from smoking, but it would be a blow for my brother and for Wajah fi Alghuyum if that happens. Let me look at your tin. Look, it is almost identical. They must have taken the old design and basically just reused it when they relaunched the brand. I must introduce you to my brother some time. He will be interested to meet the grandson of the man who designed the Wajah fi Alghuyum tin.'

'Oh yes, that would be fun. I'd like to meet him, and can't wait to tell my grandad.'

The three of us walked back through the beautiful streets and I felt a world away from home and my past life. I said goodnight to Natalie and Amira and went into my room. I pulled my bed down from the wall, made it up with the duvet provided, and fell asleep almost as soon as I lay down.

## A DAY AT THE MUSEUM

I woke to find a beautiful sunny morning waiting for me behind the shutters. I had no provisions in the apartment – not so much as a bottle of water – so had a quick shower behind those weird saloon doors and got dressed ready to go. (Every time I came out of them I whistled the tune from *The Good, the Bad and the Ugly*!) I retraced my steps to the Métro and jumped on line thirteen as far as Miromesnil, where I changed onto line nine. It was only a couple of stops to Alma-Marceau, the station nearest to the museum. The Métro smelled different to the London Underground. By the end of my stay in Paris that summer, that smell was well and truly embedded in my subconscious and will forever be connected to my time in the city.

I came up the steps from the station and found myself on a large square, mostly comprising busy roads, some of which turned into a bridge, which I later discovered was the Pont de l'Alma. It was from here that I got my first glimpse of the Seine, and of the Eiffel Tower. The river was treelined as far as the eye could see, and there were tourist boats out on the water – it was only nine-thirty in the morning. Although it was still quite early the conditions were already ripe for a trip down the river, and as the summer season was whirring into motion, who wouldn't start the day this way if they could? I couldn't wait to explore the city on one of these boats – flies they call them, *bateaux mouches*, not that they resemble insects.

I got my bearings and walked away from the bridge up the Avenue du Président Wilson. While the boulevards and buildings here were not all that dissimilar to those around where I was staying, there was a greater sense of grandeur in this part of the city. Looking at the map on my phone, Alma-Marceau was on the borders of the eighth and sixteenth *arrondissements* – the districts that spiral outwards from the centre of Paris. This didn't mean much to me at the time, but you gradually get a feel for the city that is shaped by these numbers and their beautiful names. I was standing between Champs-Elysées and Trocadéro. How poetic that sounded. I made a mental note to remember to look them up later on to find out why these places were named the way they were. How did people manage before the Internet? I guess they bought a guidebook. Actually, that sounded quite appealing – yes, I'd buy myself a good old-fashioned guidebook, and I could tick off all the things I'd see during my trip.

As I made my way up the Avenue, my eyes were drawn first to the pretty little tended gardens lining the pavements in front of the distinguished terraced apartments that give the boulevard its almost regal elegance. You could imagine important politicians living in these places, sitting ministerially behind large polished wooden desks adorned with bronze ornaments. There was something about the proportions of these blocks that made them so Parisian – the long, thin windows and doors opening onto the little wrought-iron balconies, the understated decoration around the top of each window. Standing just in front of the doors of one block I saw an elderly lady dressed simply, though almost entirely in black – a plain black jumper, a plain black skirt down to her knees, strange sort-of-flesh-coloured stockings, and black leather shoes. She had dark hair, though it had a slight orange tint to it that suggested it was dyed, a suspicion reinforced by looking at the deep wrinkles across her face, and by her hands, which looked permanently clenched with arthritis. She looked, in her own way, very smart. She was holding an old-fashioned wooden broom, with which she began sweeping the path and steps outside her building. She looked up as I was walking past, and as I was staring straight at her at that moment, I thought it appropriate to greet her, so called out, *'Bonjour madame',* to which she replied, *'Bonjour jeune homme'.*

As I carried on past the next block, a young woman not much older than me walked out of the pair of smart dark doors and down the path towards me on the pavement. I could instantly see how pretty she was, and with a natural, graceful, stylish air, she seemed the epitome of what I imagined a young French woman to be like. It's funny how quickly you can form an impression of someone. Your brain must be processing so much information every time you meet someone new – from how they look and dress, the sound of their voice, the things they say, how they move – thousands of tiny pieces of data that build up to create a picture of a person that determines your response to them. And you might do this in an instant, or over the course of a lifetime. Likewise, they must be formulating the same kinds of impression of you. She looked up and caught me staring at her, so I looked away instantly, not wanting to seem rude. I could feel myself blushing but styled it out, I think, as I continued on my way. I could hear her walking just a few steps behind me, so I sped up a little. As I passed the end of the block, the Eiffel Tower emerged on the horizon to my left as the rays of sunlight cast my shadow onto the ground in front of me and a little to the right. Seeing the Tower again had caught me by surprise. I hadn't expected it to be visible again, though thinking about it, it made complete sense, I had only walked a short way along a street running parallel to the river – the buildings had just been hiding it from view. It was a lovely feeling, the gentle warmth of the sunshine, and the dappled light on the Avenue as it fell among the leaves on the trees.

Within just a few metres I was clearly entering the museums quarter, as I was suddenly surrounded by immense, imposing buildings with banners and

noticeboards outside advertising the exhibitions taking place within. There were museums of fashion and textiles, for modern art, contemporary art and lots more besides. I followed the signs round the side of a building called the Palais de Tokyo towards a wing dedicated to the Musée d'Art Contemporain. I found the front doors and followed the instructions in the email I had received to look for a smaller door a few metres away to the left. This was the staff entrance, and having been buzzed in, I made my way through to reception. I was excited and a little nervous to be there. I stood at reception for what felt like ages, but it must only have been half a minute or so. The receptionist was there, looking intently at his computer screen. He did not acknowledge me, but not wanting to interrupt whatever he was doing, I just continued to stand there.

'*Oui*,' he said, really slowly, without looking up.

'*Bonjour monsieur*,' I said, standing forward to the desk. '*Je m'appelle Adam King et j'ai rendez-vous avec Mademoiselle Honfleur à dix heures*.'

And still without looking up, he pointed in the direction of the lift.

'*Troisième étage, à gauche*,' he said.

As I was waiting for the lift, I thought how I would never ignore somebody like that. Eye contact is a basic courtesy, surely. I had managed to get the information I needed without him even looking at me, though, just as he knew what I needed without having seen my face. I found what I assumed to be the door to the offices I'd been directed to, and peered through the small round window. I could see a large room filled with desks and computers, with people milling about. The door was locked so I pressed the buzzer, and the door was released almost instantly. A young face leant to one side of a computer screen and smiled.

'*Bonjour!*' she said, chirpily. '*Vous êtes…?*'

'Oh,' I said, '*bonjour. Je m'appelle Adam King et j'ai rendez-vous avec Mademoiselle Honfleur à dix heures*.'

'*Ah d'accord*,' she replied, sounding as if my name and appointment rang a small bell. 'You are the winner of the competition of the British children?'

'Yes! Yes, that's right, I am.'

'If you would like to take a seat, I will let Mlle Honfleur know that you are here,' she said, still smiling, and holding her hand out towards a small seating area behind me.

This area was full to bursting with boxes, but also with lots of books arranged haphazardly in piles. There was a coffee table, also covered in books and catalogues for artists and exhibitions. There were a few names I recognised, but most of the artists were new to me. I was daunted by the idea of how much I had to learn about art, and the young woman's comment about being a British child had reminded me that I was still in that bracket, but I was also excited to have access to all of this information. We didn't have books like these in our school library, and looking through, I didn't really

understand what a lot of it was supposed to be about, or to mean. Some of it seemed really strange to me, but I was curious to find out more; I wanted to understand. After looking through some of the catalogues, my painting of Grandad suddenly seemed so basic.

At that moment, Mlle Honfleur came over to greet me. She must have been in her early thirties, had lightly tanned skin, dark bobbed hair and thick-rimmed spectacles (these were clearly all the rage in the Paris art world as I had already spotted a few people wearing similar glasses in the offices). She was wearing a swish grey trouser-suit that could well have come directly from the future, and she was a wheelchair user. Her wheelchair was super modern and looked like it could be used for sporting purposes as well as for business at a moment's notice. A pair of crutches was attached at the back, built into the design, so it was likely she had some mobility in her legs.

'Hello, Adam, it's a pleasure to meet you. My name is Juliette Honfleur, but please call me Juliette. I work here at the Musée d'Art Contemporain and am the person responsible for the collaboration with the BCA on their exhibition with us here. Later in the week I will be going over to their offices – they are in a different arrondissement – and I will introduce you to the team there. If you follow me now, I will quickly show you around the offices and then take you to meet Emilie, who is the assistant curator and person who will be managing you while you are here with us this summer.' Emilie, it turned out, was half-American, half-French. She had completed post-graduate studies in New York and then started working for a leading commercial gallery in the lower East Side. She was confident and spoke really quickly. She clearly had enormous energy, and seemed kind of pumped up, as if on a permanent coffee high. She was quite formidable, in fact, and I think she had already decided I was a bit dim. Of course, every question she happened to ask me, I didn't know the answer to, or couldn't give the answer she wanted to hear. No, I didn't know how to use a spreadsheet. No, I couldn't really write French well enough to send out emails. No, I hadn't heard of the artist who they currently had an exhibition of downstairs. I felt like a bit of a waste of space, and Emilie made it clear that this was how she felt about me being there too.

'Okay,' she sighed, 'well let's get you started on chasing up all the teachers and little children who have not yet completed their forms and sent over their works for inclusion in the exhibition.'

Although I didn't realise it at that moment, this one task was going to take up the majority of my time for the next week and beyond. I sat down with my list and made a start. By the end of my first day, I think I could safely say that it was more interesting looking around an exhibition than working in an office making an exhibition. What I had enjoyed, though, was seeing images of the works by the other sixth formers that were going to be included in the show. I thought several of their works were better than mine – quite

a lot better, in fact. I liked the idea that at the end of the process, we would have all these works up on the walls for people to see. I was going to become quite familiar with word processing and spreadsheets, there was no doubt about that.

At half-five a bell briefly sounded through the loudspeaker system in the museum, and most of the people in the office stood up and started collecting their things ready to leave. A handful of people stayed at their desks, but Emilie, who was going out, told me that I could leave now, and that I should come back at ten the next morning. I think she only told me she was going out so that I knew that I wasn't invited. I left the museum and started walking back down the Avenue. On my right, there was a neoclassical portico with lots of tall columns surrounding an open square that faced out onto the river. I was looking up at the architecture and failed to spot a skateboarder crossing my path towards the stairs leading down to the terrace. I noticed him from the corner of my eye, but too late for me to move out of the way or for him to stop. So the pair of us ended up on the floor with our limbs awkwardly entwined.

'Sorry!' He coughed. '*Je suis très très très très desolé,*' he said, clearly feeling very apologetic.

'*Moi aussi,*' I replied, '*j'avais la tête dans les nuages!*' I hadn't been looking where I was going, so I felt it was just as much my fault. We helped each other up and brushed ourselves down. I could now see that there were more young people on the terrace with skateboards, doing some pretty cool tricks, so we stood and watched for a moment. The skateboarder I had bumped into flicked his board up into his hands. He smiled at me.

'*Tu es skateur?*' he asked.

'*Un petit peu,*' I replied.

'You're English?' he said.

'Yes, is it that obvious?' I asked, laughing.

'Oh no, you speak pretty good French, but I thought I could detect an English accent underneath,' he said, kindly.

'How come your English is so good?' I asked.

'My father's kind of American and my mother's French. My name's Antoine,' he said, offering me his hand to shake.

'Adam,' I replied, 'Adam King.'

'So what are you doing in Paris, Adam?'

'I'm doing an internship at the museum over there, I just started today. I won a painting prize. I'm going to be here for the next few weeks.'

'Hey, that sounds pretty cool,' said Antoine. 'So you're into art?'

'Oh yes,' I replied, 'I love art. Maybe I'll study it at university next year. There's so much amazing art to see in Paris – I can't wait.'

'That's great. I'm a huge fan of contemporary art – and art history too. I love the Museum of Contemporary Art – I see most of the exhibitions there as it's practically on my doorstep. My mother likes to collect art and antiques,

so I sometimes go with her to see shows and to the auctions.'

'Amazing,' I replied. 'I'd love to go to an auction one day – they always look so dramatic in films.'

'So do you know lots of people here in Paris?' he asked.

'No, not yet,' I answered, smiling at him. 'I've only just arrived. I met a couple of people at the foyer where I'm staying, so I've made a start!'

'Listen,' said Antoine, 'I'm having a party in my apartment tomorrow evening, why don't you come along? There'll be some food and drinks, so you don't need to bring anything, and I'll have my decks set up to do some mixing. I only live just down this road – give me your phone number and I'll text you the address.'

'Oh wow, thank you!' I said. 'It would be great to meet some new people.'

That was very nice of him, I thought. I was a little taken aback that he would invite me to his party having only just bumped into me, quite literally, there on the street. Why would he be interested in me? He seemed like a really decent guy. I mean, you can never really tell on first impressions, but he had a kind face and smiling eyes, and his voice was gentle. I realised I was becoming more chatty than I was with strangers back home. And it was still only my first full day in France.

Not having eaten since last night, I was by now absolutely starving, and needed some supplies for the apartment, so set about finding a shop on my way home. I found one near to the FJT, and as I was coming out I spotted a man sitting outside Le Violin Noir, smoking and drinking a coffee. It was the man from last night, the one with the Face in the Clouds lighter. He was clearly facing towards the entrance of the FJT, as if he was keeping a lookout for someone. As I walked up to the doors, I turned to him and nodded with a polite smile. He looked away as soon as he realised I had seen him, taking another puff on his cigarette. It was a bit odd, actually, as if he was just trying to pretend that he hadn't really seen me, but clearly we'd made eye contact and we both knew that.

As I went up in the lift, I was going through all of the reasons I could think of as to why he was there. Maybe he just happened to live nearby, and went in regularly to have a coffee. Perhaps he was madly in love with Amira, and was hoping to have a moment alone with her. Or perhaps he wanted to have a go at her for holding such liberal values. Maybe he was told to spy on Amira by her brother. Or maybe he was planning to blackmail her, or to do worse to her. Well, if he was there to do harm to Amira, now I had seen him, that would make things more complicated for him. When I reached our floor, I knocked on Amira's door, then Natalie's. There was no sign of either of them, and I didn't have their mobile numbers, so I slipped a note under their doors with my own on, asking if they were okay and whether they might be free to meet up later in the week. Then it crossed my mind – surely the man couldn't have been there to follow me? What could he possibly want with me?

# THE PARTY

The next day at the museum was pretty uneventful. I sat in the back corner of the offices with a computer that was on its last legs. It was clearly one that had been gradually demoted to use by interns, and the keyboard was really dirty. Emilie was doing her best not to interact with me unless she absolutely had to. I thought that she felt having to do an exhibition of schoolchildren's art was beneath her, and that she was used to working with super-cool high-profile international artists. If I had a question for her, she gave the impression that firstly, it was a stupid question, and secondly, it was beneath her to have to answer me. Occasionally Juliette would come past and stop to ask how things were going. I smiled and said that everything was coming along nicely, that we were making good progress with the missing artists and paperwork. Whenever she came over, Emilie would start smiling and say something like, 'Oh yes, Adam's doing really well,' as if she and I were getting on famously and she had taken me under her wing. I guess it was my first taste of office politics. It reminded me of the classroom at school.

The museum gave me a packet of '*tickets restos*' – vouchers that you could use in cafés and restaurants in exchange for food and drink. It seemed to be quite common in France, or at least in large organisations. Strolling around the neighbourhood at lunchtime, I found a lovely little Scandinavian delicatessen. I sat at a chair outside on the street and looked at the messages waiting for me on my phone. To my relief, I found messages from both Amira and Natalie. They were absolutely fine, and were both free that coming Thursday evening, so we made a plan to meet. I had also received a message from Antoine, with the address for the party at his flat later on that evening. My Parisian social life was beginning to take shape. I posted some pictures of the museum and the entrance to Alma-Marceau Métro station to my social media account on FrendHub. I don't know why I bothered really, as I didn't have many followers. I mostly posted pictures of paintings I liked. As I scrolled through my feed, I saw adverts for vintage radios and for tagines. That was odd, I thought, I hadn't even searched for these terms on a browser. It was as if my phone was spying on my daily life. I knew they collect data on everything we do online these days, but there were lots of odd coincidences that made it feel like the phone was actually listening, as well as tracking the sites I visited.

After an admin-filled afternoon, it wasn't worth going back to the foyer before the party, so I went and sat in a bar down near Alma-Marceau and read some sections of the guidebook I'd bought from one of those funny little hexagonal newspaper kiosks they have out on the streets of Paris. In the guide I read that these kiosks had been created as part of Baron Haussmann's regeneration of the city under Napoleon III in the mid to late 1850s – a regeneration that was desperately needed to transform what had essentially been a medieval city into a modern, imperial capital, and one of the most beautiful cities in the world. It might sound a little strange, but I was excited just to be sitting there, reading about Paris and its history. While I was in the bar, surrounded by old photos of Paris – the Belfort Lion in Place Denfort-Rochereau, the Bath of Apollo in Versailles, Sacré-Coeur and so on – I wrote a postcard to Grandad; it had a picture of the Arc de Triomphe in the 1920s.

I was keeping an eye on the clock, and as it turned seven I thought it would be okay to make my way the short distance back up the road to the party. I noticed a couple of very smart-looking cars parked outside the blocks of apartments, one of which had blacked-out windows. I could only begin to think how exclusive some of the residences round here must be. But the skateboarder lived in one of these apartments, so maybe there was quite a mix of people in each block. I checked Antoine's message to make sure I had found the correct building and door number, and it was only then that I realised this was the very block where I had seen that young lady come out of the front doors yesterday morning. How strange that I should have noticed that actual building. I walked down the path towards the door and it was here that I saw there was only one buzzer. Perhaps there was a concierge for the building, and buzzers for the separate apartments inside. I pressed, gave my name to the person at the other end, and heard the click of the lock opening. I went through into a beautiful lobby made almost entirely of white marble. There was indeed a concierge there, a young woman. She was tall, and I could see that she was wearing expensive clothes – like you see on a catwalk. She also had a perfume on that was beautiful though overbearingly strong. I could see she was wearing jewellery – you could hardly miss it, in fact; a prominent necklace, a number of bracelets on her wrists, and several rings on her fingers. If those were real diamonds and pearls, she must have been wearing a year's salary for a concierge.

'You are here for Mr Marionette's dinner party, yes?' she asked. She sounded Russian, or perhaps from the former Soviet bloc.

'Er, for Antoine?' I asked, wondering how she had known to speak to me in English. Perhaps my name and accent over the intercom had given it away, or perhaps she had been briefed that an English boy would be coming along.

'Please feel free to leave your jacket and I'll put it in the cloakroom for you. So please then carry on through to the antechamber.'

An antechamber? That didn't sound like your average student flat.

42

I wasn't entirely sure what an antechamber was, in fact. I went through a set of heavy wooden doors with big, shiny brass hinges and handplates and found myself in a large room. The overall impression was that it was rather grand: high ceilings, and not cluttered in the slightest. All the furniture looked very modern, and these contemporary lines contrasted with the grandeur of the architecture. The whole room was painted in a matt black colour – the walls, the window frames, the doors and even the fancy decorative mouldings that were featured all around the perimeter of the ceiling. An original white marble fireplace stood out against all the black. A handful of people were standing around talking, and my eyes soon focused on Antoine, pulling a bottle of champagne out of an ice bucket. But he didn't look like a skateboarder now – he was dressed in a sports jacket, shirt and waistcoat with a cravat. He looked very dapper indeed.

'Adam,' he exclaimed, 'you made it; so pleased you could come!'

He filled a glass and offered it to me.

'Do you like champagne?' he asked.

'I don't know,' I replied. 'I've never tried it before.'

'Well you'll have to tell me what you think of it,' he said. 'I'm glad to be witnessing you trying it for the first time!'

Some of the other people had by now turned round to look at me. I self-consciously took a sip. It was a strange sensation – a little bitter, and very bubbly, which I guess explains why people call it bubbly! I didn't particularly like it, but I didn't want to disappoint him, or those watching me, so I raised my eyebrows and did my best to sound delighted and to look pleasantly surprised.

'Ooh,' I said, 'now that is special!'

'I'm so pleased you like it,' said Antoine as he topped up my glass. 'So how are you getting on at the museum?'

'Oh, I'm really enjoying it,' I said. 'It's interesting to go behind the scenes and find out what's involved in making an exhibition.'

'So you might have found your vocation in life already?'

'Maybe!' I said. 'Is this your apartment?' I couldn't stop myself from asking.

'Yes, well, it belongs to my mother but it's mine to live in. She lives upstairs and I live down here.'

'Wow,' I said, hardly able to disguise my surprise. 'It's very nice of you to have invited me. What is it you do, Antoine?'

'Well, now, that's not a simple question to answer! I do a mixture of things – I'm studying part-time, I'm starting up my own business and I'm working on a couple of creative projects with my friends.'

'What are you studying?' I asked.

'I'm doing a post-grad course in business ethics. I'm particularly interested in working with companies that are aiming towards total ethical practices, so my research is looking at the history of ethics in business, and at what companies are currently doing in this area.'

I didn't really know what he was talking about. I realised it was my turn to say something. There was a slightly awkward pause. Time was passing. Come on, I said to myself, just ask something – anything! 'So is your own company going to be ethical?'

'Absolutely,' he replied. 'I'm working with an organic farm and an environmental engineering company to develop technology for large-scale fruit and vegetable production in small, even densely urbanised spaces. It's IT-driven precision farming that is entirely sustainable, runs on biofuel, and is carbon neutral. The model works on a not-for-profit basis, with salaries at double the minimum wage, a salary ratio of twenty to one of director level to entry level, a final salary pension scheme, gender equality in pay, two-year maternity and paternity leave, and a variety of other staff and business policies to do our best to ensure that the company works in complete harmony between the land and the people.'

I wasn't entirely sure what he'd just said, but I was blown away. I met a skateboarder yesterday and here I find him drinking champagne and talking about a business venture that sounded like some kind of utopian dream. I'd thought I would be offered a beer and some crisps, or maybe a slice of pizza. Antoine started introducing me to some of the people in the room, and as he was doing so, others kept arriving. There must have been close to a dozen. The people seemed to be between twenty and thirty and were well dressed, some of them in fashionable street-wear, others in more formal clothes as if they had just come from work. They looked like quite serious people, but they were also laughing and smiling, and I was curious to find out who they all were.

'How do you all know each other?' I asked Antoine.

'Well, first and foremost we're friends. Most of the time, at least. Some of us studied together at college, some are friends of friends. What we have in common is that we're all passionate about trying to change society for the better. There are so many things that are disappointing, disillusioning, disheartening, depressing in the world today, and while we realise we can't solve all the world's problems, we try our best to effect change through the things that we do in our personal and professional lives. So many young people just seem to want to party, to go clubbing and to get out of their heads. Don't get me wrong, we like to party too, but that's not what every Friday and Saturday night is for us. Once a month we try to meet up for dinner here to discuss ideas about politics, culture, current affairs and so on, and to listen to the different projects that we're all working on. I think everyone is working on something most of the time, from small projects for charities to making documentary films for online TV channels, putting on music nights or designing new apps. We call it "The Association of Alma-Marceau", and because at our first meeting there were eleven of us, we call ourselves "The Eleven Associates of Alma-Marceau". This name was also inspired by a group of socially minded French business people and pacifists around the beginning

of the nineteenth century who wanted to rebuild the economy and local political power after the Vendée war. We were really impressed by what this group achieved in a period of just ten years and thought we would try to emulate them in some way. So here we are, eighteen months on, enjoying our eighteenth party.'

'Wow,' I said, realising that I risked sounding like a broken record.

'Come,' said Antoine, 'dinner will be served soon. We'd better start making our way through.'

And with that, he walked over to another set of double doors and opened them out into a huge room that was at least double the size of the one we had just been standing in. This room was completely white, the exact opposite of the antechamber. The floor was made of interlocking wooden blocks in intricate square patterns. There was a long dining table down the centre of the room – the longest I'd ever seen in a house – set for dinner but like in a restaurant. Glass panelled doors at the end led out to a garden space. The chairs around the table were angular but with elegant proportions and velvet upholstery. They didn't look cheap. Nothing looked cheap, come to think of it. Who was this guy? It was still light outside, but there were already candles lit and the brass wall lights were on, glowing a warm gold against the white walls. There was a beautiful aroma of food being cooked. As I looked around I noticed three people, two men and a woman, who were dressed in waiters' uniforms. They were very smart. All three of them looked like they must have been in their sixties.

People began to take their seats. There were name cards on the tables indicating where everyone should be seated.

'Please,' said Antoine, 'come and join us here in the middle – you're our guest of honour this evening,' he continued, with a kind smile.

'I don't know about that,' I said, more than a little embarrassed and wondering why he'd decided to invite me at all.

'I will introduce you to the others, but don't worry, I won't expect you to remember everyone's name.'

I'm glad he said that as I definitely didn't remember everybody's name that night, or who did what. I got to know the people sitting nearest to me at the table the best, and they all seemed lovely. There was Anne-Sophie, who was studying for a PhD in renewable energies; Armand, who had just finished a Masters degree in sociology, looking at multiculturalism in France; and Stéphanie, who was working as an editor for an American online media and broadcasting company. In her spare time she was helping Armand to make a documentary about the housing blocks in the outskirts of Paris where many Black, Middle Eastern and other minorities live in poverty.

The starters arrived in front of us – plates of crudités, but that doesn't do justice to what was on each plate. It was like an abstract painting of thinly sliced vegetables – radishes, strange-coloured carrots, courgettes, fennel,

onions, all marinated in the most delicious vinaigrette. There was a small glass of dry white wine served just to accompany this dish. What kind of a party was this?

'We are also working to develop content with Anne-Sophie,' said Stéphanie. 'She is really good at all the social media stuff, so while we're out filming on location in *la banlieue*, the suburbs on the outskirts of the city, we are also making very short parallel content that can be used almost like a social media real-life drama. It's not staged or scripted, we're just following a group of people around who are likely to be featured in the documentary, and using additional material to make a new kind of viewing experience.'

'Do you worry that you'll turn some of these people into short-term celebrities?' asked a woman called Suzette. 'They'll get famous before going back to where they were before it all began.'

'It's possible,' said Armand, nodding. 'It's something we will have to be wary of, for sure. Similarly, we don't want to glamorise the ghetto. That's also a risk. These are precisely the kinds of issues I'm interested in, though. The medium of documentary can become an instrument that affects the very subjects it seeks to study. Sociology is often an active agent for social change, however, not just a discipline for analysing society. It is also the basis of social work, of social policy, of government legislation.'

'I hadn't ever really thought about it before,' I said, pondering all of this.

'Why would you?' asked Armand. 'It's easier just to be entertained than to want to engage with important issues. The media wants you to consume and to pay for it, that's all.'

'But there's so much free content today,' said Suzette. 'As a musician, it's getting harder for people to earn a living from their work. Nobody expects to pay for music these days, unless it is some streaming service that pays out miniscule royalties. It's great that you can hear so much from the world of music at the touch of a button, but it has also made music a cheaper commodity.'

'True,' said Anne-Sophie. 'And it's not dissimilar in the world of images – wouldn't you say? Everyone is a photographer these days, and we are living in an image-saturated world. With the explosion of digital images that has taken place over the past generation – our generation – images are a new kind of currency: we shape and trade our identities through images all day long today. We narrate our own lives through photographs for others to watch like a TV show. Images have become more important for us, for our identities, our personal and professional lives, but at the same time the more images there are, the less value they have. It is not just the professional image-makers – the artists, photographers, journalists, illustrators, designers, filmmakers – who make iconic images known the world over today, it is also the everyman. You can post a picture from your bedroom that ends up in front of a million people's eyes within a matter of hours.'

'It's also a question of the speed of images, I think,' replied Suzette. 'Images used to be slow to make, slow to reproduce, slow to disseminate. Now they are so quick. You can broadcast an image you have taken seconds ago – or even live stream. We are all authors, we are all broadcasters, we are all publishers.'

'And not enough editors!' said Stéphanie.

'And I guess there's also a question of the speed of consuming images,' continued Anne-Sophie. 'We process images so quickly these days – god knows how many still and moving images we must each see in an average day – hundreds? Thousands? Some images have taken no time at all to make, others might have taken hours, weeks, months. Think of a painting that's taken an artist a lifetime to paint, or to get to the point of being able to paint. We might glance at it for just a few seconds and then give the same amount of time to a photo of a celebrity.'

'Or a puppy trying to chase its own tail,' said Suzette.

'People used to talk a lot about becoming desensitised to the media, to news, to images of disaster and desperation,' added Armand. 'I think there's some truth to that. There are so many images competing for our attention at any moment, and seeing funny, trivial pictures is maybe a way for some people of avoiding having to deal with all the important and often miserable stuff of life. Social media is today's opiate of the masses.'

'I'd say opiates are the opiates of the masses these days,' said Suzette.

I was mulling over all this as the main course was served. For the vegans and vegetarians, an asparagus risotto, made with a stock using all the off-cuts from the vegetables we had just eaten for the starter. For the meat eaters, there was a type of steak I was informed was called chateaubriand, served with béarnaise sauce (I never quite figured out what this was), potato dauphinoise, miniature carrots glazed with honey, and salted green beans. It was the poshest meal I had ever had in my life, and the first time I had eaten steak of that kind; I was more used to it accompanied by kidneys and gravy in a pie. This fine dining malarkey was definitely something I could get used to, however. The conversation too was all very interesting – wide-ranging, opinionated, but what I could follow of what they were saying made perfect sense to me.

'Does the Association have a political agenda?' I asked.

'Absolutely,' Armand replied. 'Personally, I want to encourage a much greater level of understanding about the issues that are shaping our society today, and to help bring about change. We all do. That's why we're all part of the Association of Alma-Marceau.'

'Do you all have the same political views?' I replied.

'Perhaps in a broad sense,' said Anne-Sophie. 'I guess we are all liberal to some degree. But then I think these old categories and definitions are changing a lot at the moment. We have views that span the political spectrum,

that don't sit neatly with one party or another. We have views that go well beyond national borders, but we are also interested in facilitating change on a local level.'

'Are you activists?' I asked. All three of them laughed.

'Ha! Well, perhaps in some ways I suppose we are,' said Anne-Sophie. 'We are not afraid to join a march if there are protests we agree with. I marched for climate change last year, for example, and I think most of us were at a parade for LGBTQ+ in the spring. I will be joining one next week about public space being sold off to private corporations for development. I think protesting definitely has its place within the democratic system.'

'Though the democratic system is breaking as late capitalism becomes ever uglier,' added Armand.

'True,' said Stéphanie. 'Perhaps we need new models for politics and society.'

'That sounds quite radical!' said Suzette.

'In some ways, yes, in other ways it is a natural response to society and to politics when the old mechanisms for protecting the interests of the people are becoming outdated and ineffectual due to the pressures of the constant desire for profit, and while major corporations and the super-rich are able to move money around off-shore accounts in order to make their tax payments more "efficient".'

'Did someone say "radical"?' A man from the other side of the table interjected loudly. 'Why of course we are all radicals! We're borderline anarchists! We all want to smash this puny existence, destroy this pathetic hegemony, crush this kleptocracy!'

'Oh shush, Henry. You will scare off our young friend here. He's only joking, Adam, don't pay any attention to him,' said Anne-Sophie, shaking her head and frowning at him. Henry sounded English to me, and clearly wasn't going to be suppressed so easily.

'What!' he exclaimed. 'What? An impressionable and upstanding young man such as this – we must mould him to our cause, shape him in our own image, and soon we will have him fighting with us on the barricades. He will lead us to our noble deaths, for the glory of France.'

As he continued his monologue, the guy sitting next to him started to sing La Marseillaise. It was quite a performance, and soon Henry was standing on the table, imploring us all to take our swords and to be prepared to die by them. Despite his silliness, he looked rather impressive surrounded by this beautiful interior, illuminated by candlelight and the fading light of dusk. As the other guy sang, one of the women started banging the table like a military drum in time to the singing. The performance came to an end with Henry hurling himself from the table onto the floor and simulating a slow and decidedly melodramatic death. On his third and final pretend death, everybody cheered, whistled, clapped or rattled their cutlery.

At that moment the waiters began to serve dessert – a gorgeous round chocolate almond cake with a chocolate cream, milk chocolate shavings and a shot of a brown liquid that I discovered was called Amaretto. It was a taste sensation, and beautifully served. As we ate, the conversation continued to flow, covering yet more amazing and often confusing subjects, from nuclear fusion to the rise of populism around Europe, from ideas to solve the plastic catastrophe in the oceans to strategies for dealing with youth unemployment and the housing crisis. I'd been aware of these topics, of course, but here was a group of bright young people with something interesting to say about them, and with actual plans to try to change them. They were more interested in the world than they were in themselves. They all seemed so confident, so balanced, so well-informed. I felt a light switch on inside my head – maybe it is possible to accomplish incredible, life-changing things, as opposed to just being resigned to how awful the world is. Maybe we're not completely powerless, or not yet. My brain was teetering on the brink of overload, as was my stomach. Once everyone had finished their desserts, Antoine stood up.

'Ladies and gentleman, while our wonderful waiters this evening bring the cognac round, for anyone who hasn't yet had chance to meet our special guest this evening, please allow me to introduce you to Adam King, a young gentleman from England who is working on an exhibition on behalf of the British Council of the Arts at the Musée d'Art Contemporain this summer. Adam is a prize-winning artist and, of course, is most welcome among us.'

I remember feeling a little embarrassed as Antoine spoke, but also had, for the first time, a sense of my internship bringing with it some status – a reason for people to take an interest in me. All I'd done was make a painting.

'I suggest,' continued Antoine, 'that we make him an honorary member of the Association of Alma-Marceau while he is here in Paris. Don't forget we have the *Nuit Blanche* festivities taking place on Friday – I've been putting together a schedule for the evening's entertainment.'

I hadn't heard of a Nuit Blanche before. It turns out it's a 'White Night' – an evening when lots of cultural organisations like museums and galleries stay open through the evening and into the night. It's like a festival that brings the public out to see exhibitions, performances, events and so on. Antoine told me that a couple of the members were organising an evening of live electronic music performances on the Sunday and I'd be welcome to come along to that too. My diary was getting fuller and fuller.

I had noticed that one seat at the far end of the table had remained empty all evening. The place was set, though, so I had wondered if someone who had been planning to come had been unable to at the last minute. The mystery was soon solved, however, when a young woman came out of the kitchen, taking off her apron as she walked into the dining room and over to the empty chair. One of the waiters brought through a plate of food for her and filled her glass with wine. I recognised her instantly – she was the same

attractive young woman I had seen that morning coming out of the front doors of the building. She seemed hot, tired and flustered, but was smiling. Antoine, who was still in the middle of his speech, saw her coming over, and interrupted himself to say:

'... and a big thank you on behalf of everyone here to Alicia for the meal she has cooked for us this evening, and to her assistants. It has been, as always, exquisite!'

There was a spontaneous round of applause and cheering from the other Associates around the table.

'Is Alicia your chef?' I asked Antoine, after he had sat down.

'Yes, well, she's my mother's chef. When my mother's working away, as she is at the moment, Alicia cooks for us. She is a Michelin-starred chef who grew up in Poland in a famous family of chefs there, then trained in one of Paris's top restaurants. Like many star chefs, she got snapped up by a private client. She basically works when my mother wants her to – it might be just her for breakfast, or a lunch with a couple of her clients, or a dinner with a dozen of her friends and guests. The hours are quite variable, but she prefers this lifestyle to working in a restaurant with sixty covers for eighteen hours a day, six days a week. It means she can really focus on making beautiful food presented immaculately. She's particularly into locally sourced and seasonal food, organically and ethically produced. We are working together on the farming business. She also has the dubious pleasure of being my girlfriend, or rather, I have the genuine pleasure of being her boyfriend.'

'Oh,' I said, 'that's nice.' There was probably a small flicker of disappointment in my eye as I realised she already had a boyfriend. Of course, I knew nothing about her personality at all, just that she was pretty, seemed modest and now I had discovered she was amazingly talented at cookery. Anyway, it was at least good to think that she was dating someone so kind and interesting as Antoine, and I hoped I would meet someone special soon too. I also realised that when I'd seen her that morning, I'd assumed she was French – she had conjured in my mind the image of the quintessential young French woman – but she was Polish. I guess this only goes to show how easily we project our ideas onto people and onto things, whether for good or for ill. We are quick to make assumptions based on appearances, or our idea of appearances.

'What does your mother do for a living?' I asked.

'She's a property developer,' replied Antoine. 'She builds and owns an international portfolio of commercial and residential properties.'

'That sounds impressive,' I answered.

'Well, she started off buying a run-down old house in Islington in the early 1990s when she was around my age, did it up, sold it a couple of years later and made quite a lot of money from it. She reinvested the money she made into more properties in areas of London and Paris she felt were up and

coming, and got some investors on board to back her doing it on a much larger scale. A few years ago, she paid off all of the investors, took total control of her business, and is now completely her own boss. That's when she bought this place. As well as regenerating older properties, she was keen to build new eco properties that are as green as possible. She's got some pretty radical ideas about rents and ownership. I'll have to tell you more about them when things are quieter, or maybe you'll get a chance to meet her while you're in Paris. You should come round for lunch one day later this week, Adam; I'll show you some of my mum's art collection if you'd like.'

'Oh, yes please.' I said. 'I'd love to see that!'

The Associates were by now quite animated and the noise levels had been steadily increasing. Antoine was receiving requests to DJ, so he duly got up and walked down to the other end of the room where he had a laptop and a set of decks hooked up to a small sound system. We followed him down. As it was a Tuesday night and the folding doors were open onto an immaculate back garden terrace area, Antoine kept the volume fairly low and the music was pretty chilled. Some of the Associates sat outside in the darkness in the evening air on furniture that looked almost comfortable enough to be used indoors. There were candles in storm vases on the ground and warm lights festooned from the branches of small tropical-looking trees. A couple of the Associates were smoking cigarettes and they looked so very French. To be honest, the whole evening couldn't have been much more French.

I asked the Associates quite a few questions as the evening went on and as my confidence grew. It must have been pretty boring for them to answer a lot of them, but they were all patient with me. My head was spinning with their ideas and outlooks on life, not to mention the champagne, wine and cognac. Just last week I had been sitting at the kitchen table reading the local newspaper, wondering what to do – whether to get a job in a bar or try to pursue a career teaching children cricket. I knew within two days of arriving in Paris that I wanted to go to university to study art and art history, and I also felt completely energised to try to do something meaningful with my life, to make a difference. I didn't realise it, or acknowledge it at that time, but I was awestruck by this 'association' of young people. They were so ambitious, and with such high ideals. What I definitely knew that evening, however, was that life was going to be far more exciting with the Eleven Associates around, and that there was no need to settle for a quiet, boring existence. Life was out there for the taking.

\* \* \*

It was getting late, and although the party was still in full swing, I didn't fancy paying for a taxi home across Paris so decided to make a dash to Alma-Marceau to catch the last Métro back to the foyer. I left the group in the

garden and popped back inside to go the toilet. As I was standing there, I caught part of a conversation through the open frosted window behind me. I soon realised that they were discussing me. One of them asked who I was – I didn't recognise her voice. I heard another woman reply that I was some kid Antoine had picked up on the street. The first woman asked if I was homeless! The second laughed and said no – I was an art student. Then a man said that Antoine was always going round befriending waifs and strays, and that he should be more careful about who he introduces to the group. The second woman said she didn't think I was 'a risk'. *'Bien sûr,'* replied the man, *'mais il y a des yeux qui nous regardent, quand même.'* There are eyes watching the Eleven Associates? What did he mean by that, I wondered?

I thanked Antoine and said goodbye to anybody I passed on my way back through the apartment. The receptionist fetched my jacket and bade me goodnight. As I made my way out onto the Avenue du Président Wilson, I noticed one of the smart black cars with blacked-out windows turn on its headlights and start its engine. As I walked down the road it seemed to be pulling slowly away from the kerb and following me. I turned around to look at the vehicle, and of course couldn't see who was inside, but I stared at the windscreen as if I could anyway, so that they knew I was aware of them. My heart was racing. Was it that Middle-Eastern guy again? Whatever would he want from me? Or was it 'the eyes' that were on the Eleven Associates? The car was definitely following me, there was no doubt in my mind about that. But if they had not wanted me to know, they had been pretty clumsy turning the lights and engine on like that. Surely if they had wanted to follow me without me being aware, they would have waited thirty seconds then got out and followed me on foot. These and many less logical thoughts went through my head as I walked briskly on. Thankfully, the car carried on past me as I ran down the steps to the station. But then maybe it was just in my head – had it been a mere coincidence that the car happened to be pulling away as I left the party?

VI

A SURPRISE ANNOUNCEMENT

The next couple of days were quiet. I was mostly on the phone and email all day, chasing up paperwork and works of art that hadn't yet arrived for the exhibition. We needed to get images and captions with dimensions together so the curators could start working on the exhibition design and preparing the brochure to accompany the show. Each morning as I went in the man at reception ignored me, but I decided that the best policy was to always make a point of saying, '*Bonjour monsieur*,' to him in a loud and friendly voice, and smiling at him. By Thursday morning he was starting to raise his eyes when I greeted him, though without actually moving his head. Nevertheless, I felt this was some kind of minor breakthrough; I would eventually wear him down with politeness.

Emilie continued to be unimpressed by my presence in her life and took every opportunity to let me know. She seemed to take particularly long intakes of breath through her nose before speaking to me, and tilted her head like she was bored and waiting for me to say something idiotic every time I had to ask her about something. And believe me, I tried to keep those questions to a minimum. She felt like a mean older sister, like she had been instructed to babysit me but just wanted to go and hang out with her cool friends. She definitely made sure I knew who was boss, and that my very existence was an affront to her. Juliette came over to our area in the offices around ten to pick us up to head over to a meeting with the team at the British Council of the Arts.

'Before we go, can I just ask you both what you think about this painting?' asked Juliette, holding up a small painting in an old frame.

I knew instantly that Emilie would not like being lumped into a pair with me. I was right.

'Adam – what do *you* think about it?' said Emilie, clearly wanting to put me on the spot.

'Erm,' I said, staring at the picture. It was abstract, an off-white background with some straight yellow and black lines and coloured squares on it. 'Well. Er. It looks a bit like a children's set of building blocks, or a pattern from a colouring-in book...'

There was a moment of silence. Juliette raised her eyebrows and tilted her head a little as she looked first at me, then at the picture. I could feel

Emilie staring at me with an expression of confusion and disbelief mixed with derision. I'm sure she sniggered as she sniffed.

'Oh,' said Juliette. 'Well, yes, I see what you mean, all the clearly defined rectilinear shapes and bold primary colours. But I was wondering if you know who it's by, and what style it is an example of?'

I could feel myself going red and realised how childish I must have sounded. Juliette had been kind, but even she seemed to think my answer was silly.

'It looks like a mature work by Piet Mondrian or one of his followers,' said Emilie, with an air of confidence. 'It's certainly affiliated to the De Stijl movement within wider early twentieth-century geometric abstraction.'

'Very good,' said Juliette. 'You're absolutely right.' Emilie had a smug look both of pride and vindication on her face. She must have been delighted now it had been publicly proven that I was just a kid who didn't know anything about art.

'Well, almost right,' continued Juliette. 'It is, in fact, a fake.'
Emilie rolled her eyes.

'It's quite a good one. It's one of a number of fakes targeting this period that have entered the international market over the past twenty years. This one was actually in a small private collection in Ukraine and was consigned to the modern art museum next door for an exhibition, where it was identified as a fake. The owner was distraught and said she did not want it back. This painting will be sent off for forensic analysis and might end up being used in the court case against a ring of counterfeiters who are accused of being behind this and other fraudulent works.'

Juliette received a text notification that a taxi had arrived and was waiting outside for us, so the three of us made our way downstairs. Juliette was by now on her crutches and made light work of getting her chair into the boot and herself into the car. I received a text from Antoine, asking if I wanted to pop round for a spot of lunch and to see his mum's art collection. I said yes, hoping that this meeting wouldn't overrun.

It was exciting to be driving on the streets of Paris. I was starting to get a feel for the area around Alma-Marceau, and around my studio flat, but had not really seen much of the city. As I was mostly travelling on the Métro, I didn't have a sense of how the different areas connected above ground, and on this lovely sunny morning I felt like I was living my best life as a young professional. I had my shades on, the window down, and a great view of the streets of Paris. Juliette asked me how I was getting on, and I gave her a quick update on the progress made on the list of works since Monday. Emilie gave me a big smile, but I knew it was fake – in fact it hardly concealed her blatant disdain for me. But Juliette didn't seem to notice. As it happened, the journey was pretty short, just over the river at the Pont de l'Alma and eastwards through the heart of Invalides – the area named after the hospital established

by Louis XIV to care for injured soldiers, according to my guidebook. It was pretty grand – spectacular even – and predated Haussmann by a couple of centuries. I began to realise just how much major urban planning there had already been in Paris before him.

We arrived at a building that looked as you might imagine an embassy in Paris to look. It was smart and austere with little bits of ornamentation such as sashes and cherubs in the keystones above the doors and windows. A Union flag was flying from a balcony on an upper floor in the centre of the building. Inside it felt a bit like the foyer in a civic library. The receptionist greeted us – politely, I might add – and called upstairs to let the arts team know that we had arrived. The receptionist led us through to a meeting room on the other side of the lobby. We were soon joined by Susan Farnsworth, Director of Arts, and her assistant, Andrew Lakeland.

'Juliette!' said Susan. 'How lovely to see you!'

'And you too, Susan,' replied Juliette as Susan leaned in to kiss her on both cheeks. They seemed genuinely pleased to see each other.

'Emilie,' Susan nodded towards her with a smile.

'Good morning, Susan,' she replied.

'And so you must be Adam,' she said, holding me in her gaze for what felt like ages. Indeed, I began to feel quite self-conscious as she reached out her hand to shake mine without taking her eyes off me, or even blinking.

'A pleasure to meet you, Ms Farnsworth,' I said, unsure whether she was a miss or a missis. It was the first time I'd realised how odd it is to have to identify whether a woman is younger or older, or single or married, when addressing her formally. Being a mister, age and marital status don't come into it.

'Please,' she said with a smile, 'call me Susan. So you are our prize-winning artist, well, well, well.'

I couldn't figure out why this was so meaningful for her, or why it mattered to her what I was like. Perhaps she was just being polite and showing that she was taking an interest in me.

'How are you settling in? Is everything okay at the foyer?'

'It's all perfect, thank you,' I replied.

'And I'm sure Juliette and Emilie are taking good care of you over at the museum?'

'Oh yes,' I said, 'they've been most kind.' I looked Emilie in the eyes as I said this, and smiled at her. She smiled back, clearly wanting to throw off the shackles of civilisation and beat me with a stick, but in that moment there was nothing she could do about it. 'We really love your painting, Adam.' said Susan. 'Such a great late-nineteenth-century-style circus scene – it made me think of a painting by Georges Seurat, as well as works by Degas and Toulouse-Lautrec. And the ringmaster is a portrait of your grandfather, is that right?'

'Yes!' I exclaimed, surprised that she knew this about my work, and knew the painting by Seurat too, which Grandad had shown me in one of his books.

She'd clearly read the notes that had been submitted with the picture and remembered them.

'Please, do take a seat everyone. We have some tea and biscuits coming for us in a little while, and we'll be joined by some other team members at eleven, as there are a few other matters for us to address that will involve some other departments.'

Juliette seemed slightly surprised, clearly only expecting the five of us to be in the meeting, but she nodded and smiled. We proceeded to discuss the plans for the exhibition, and I was pleased to hear that my painting was going to be professionally photographed the next day along with a batch of the works already received. My painting was going to be used on the posters for the exhibition, on the front of the brochure, and across the advertising and social media of both the British Council of the Arts and the Museum. How exciting! With only two weeks to go before the opening, things were suddenly getting urgent, and it was interesting to see the machinery start to whirr into motion. I discovered that for most exhibitions such things happened much further in advance, but as this was only a relatively small display, everything was on a much smaller scale than for their big blockbuster exhibitions in the main gallery spaces.

'And in terms of the plans for the private view...' said Juliette.

'Ah, well, if we could perhaps hang on until the other team members arrive before we move on to that,' Susan interrupted.

At that precise moment a considerable number of people came into the room. Five came in at once, followed by another six or seven, and then a woman by herself. Juliette seemed quite taken aback, especially as the woman who arrived last turned out to be the Director of the museum. Juliette clearly had no idea that she was due to attend this meeting. The Director smiled and nodded towards her as she sat down. Another woman, who also had an air of importance and authority, seemed to take over chairing the meeting.

'Thank you all for coming and for being on time,' she said. 'For anyone who doesn't know me, I am Antonia Black, Deputy Chief of Mission at the British Embassy in Paris, and in case you are wondering why my team and I are here –' she gestured with her hand to three men and a woman sat around her '– it is because you are going to have some very important guests at your exhibition opening in just two weeks' time. I am delighted to announce that Their Royal Highnesses the Duke and Duchess of Clarence will be opening the British Council of the Arts' "Centenary in France" celebrations and officially opening the exhibition at the Musée d'Art Contemporain.'

Juliette and Emilie were clearly taken by surprise. After the initial shock had passed, both were smiling, as it meant this was going to be a very special occasion. I realised that my painting of Grandad was now going to be seen by royalty too. And not just any old royals – this couple were the most glamorous and popular pair of royals in years. I confess I didn't really know what my

thoughts were about the monarchy – my parents had both been life-long monarchists, as had Grandad and Grandma on my father's side, but my mother's parents had been dead set against the monarchy, feeling they were the ultimate symbol of elite privilege within the British social system. I hadn't fully formulated my own opinion – I thought both positions were valid. This royal engagement in Paris would certainly get me thinking harder about which side to come down on, or whether to remain on the fence.

'This is very exciting news for all of us at the Musée d'Art Contemporain,' said Mme Béchour, Director of the museum. 'It will be an honour to receive the Prince and Princess at our institution.'

She had clearly already been briefed, as had Susan.

'Naturally this means that there will be a lot more security involved in the event,' Antonia Black continued, 'and a considerably higher level of cross-team communications and co-ordination on everything from catering to press. The very first thing I will need to ask you to do is to sign these non-disclosure agreements, as, of course, absolute confidentiality and complete discretion are going to be needed until the public announcement of the engagement is made just a few days before the event. As everyone here will be aware, there is a heightened security threat across Europe at present from a number of international terrorist groups, and although we have no reason to suspect that this event would be a particular target for any of these groups, we do need to be extremely vigilant due to the high-profile nature of our visitors.'

The meeting went on for quite some time. Various people listed seemingly endless matters that needed to be addressed: schedules, budgets, logistics. I remember thinking that it was all kind of interesting, but also a bit boring if I was honest. I didn't ever figure out who everyone was, but it was apparent that some were from the French government and security services, including two men, whom I had not failed to notice were both tall, ripped and handsome, like Action Men in suits. I became particularly aware of this because Emilie kept on looking at them across the table, and one of them kept looking back at her. While Emilie was totally annoying, I could see that she was good-looking and wore clothes that made sure to show off her physique, so I guess there was just some basic attraction between the pair of them. Isn't it boring how attractive people tend to go for other attractive people, even when they might be completely horrible? But I was getting ahead of myself in my thoughts – they'd only made eye contact, for goodness sake. Their boss was a woman in her mid-fifties, Claudelle Laroche. She had bright red hair and big glasses, so was pretty memorable.

Luckily the meeting was scheduled to finish at a quarter to one and as lots of these people had other meetings to attend, it was called abruptly to a halt by Antonia while some poor French civil servant was in the middle of trying to make arrangements for the guest list for French politicians. This meant I would be back just in time for my lunch appointment with Antoine.

The lunch with Antoine was superb, which is not surprising considering it had been made for us by Alicia. The weather was still sunny and mild, so we were able to sit outside in the terraced garden. It was a beautifully fresh salad of thinly sliced fennel, small wedges of orange, lettuce and carrot ribbons with sea salt, black pepper, olive oil and red wine vinegar. It was unlike any salad I had ever had back home, and yet it was so simple. I made a note of the ingredients in my phone and took a picture of it. Then came a butterflied chicken breast that had been char-grilled on a griddle, accompanied by some cubes of roasted potatoes with sprigs of rosemary on top and a dollop of French mustard alongside a small pot of home-made ketchup. It was divine. For dessert, a rum and raisin ice-cream which Alicia had also made from scratch for us that morning. Antoine pulled out a bottle of red wine for us to have a glass with our main dish, and I noticed that the label was dated 2002. Who has a bottle of wine like that to go with their lunch? On a weekday! I was in seventh heaven.

'Did you enjoy that, Adam?' asked Alicia, smiling.

'Oh, yes, very much so,' I replied. I realised I was blushing a little. 'It was so tasty. It must have taken you quite some time to prepare.'

'Oh, not long, really; that was quick and easy compared to most services. And I got to enjoy eating it with you both too, which is always a bonus.'

She was so nice, her manner gentle and kind. I had to try hard not to think about how much I liked her. It just wasn't cricket for me to like someone else's girlfriend.

'Come,' said Antoine as he finished an espresso that had only just appeared in front of him. 'I promised I would show you some of my mother's art collection.'

He led me back through the apartment into the lobby area, on through a pair of doors and up an impressive flight of stairs. There were large works of art on the staircase – the largest photographs I had ever seen, in fact. They must have been nearly two metres high, and each was framed and behind glass. As we ascended, it became clear that they must have been part of the same series, as they each depicted views of immense housing complexes.

'They're of major real estate projects over in China, Singapore, Macau and Malaysia,' explained Antoine. 'The artist is famous for documenting the modernisation of these countries. Did you know that there are hundreds of new towns and cities being built in Asia at the moment, each with capacity for hundreds of thousands of new residents?'

'Like Telford?' I said without thinking, realising he probably wouldn't have heard of it.

'Yes, hundreds of massive new cities. These countries are rapidly urbanising, industrialising, expanding. We have no idea of the scale really –

it's so alien to us in our little European countries. Just one of these new cities might be larger than Greater London. It's hard to imagine. And of course, building a city from scratch means you have the capacity to design it from scratch, so there are lots of new ideas about how to do this. The best of them are cities of the future.'

'And are these photographs of building projects that your mother has worked on?' I asked.

'These ones, no,' replied Antoine, 'though the photographer has taken shots of some of the complexes and zones my mother has worked on in Singapore and Malaysia.'

'They're incredible photographs,' I said, impressed by both the scale and beauty of the images. 'Though it's also kind of depressing and terrifying too. The apartment blocks here all look so uniform, so bleak, almost like a prison.'

'The buildings in this picture had literally just been finished when the photograph was taken, so the landscaping around the blocks of flats had not yet had a chance to be completed or the trees and bushes they planted time to grow. It's also interesting what a difference just having curtains up can make – these flats partly look so austere because there is no one living in them yet.'

'I hadn't noticed that,' I said, looking more closely. 'Yes, I see what you mean.'

'But you're right, there is a real uniformity in the conception of the site. It is effectively a grid of blocks of the same type, and that is not really like anything we have here in France, certainly not on that scale. Even in the most brutalist, utilitarian of housing estates here there was always an attempt to break away from the grid, simply to encourage some sense of individuality, of humanity.'

'I hadn't realised there was so much that could be said about a photograph,' I said. Antoine smiled.

'I think the best art can really challenge us to think about the society around us. Believe me, my mother can talk about these photographs for a lot longer than I can. It would be worth listening to her speak about them some time if you happen to be here when she's in town – she's learnt a lot from studying these large-scale "new area" cities and has been thinking hard about how to apply successful aspects of them to some of the long-standing problems we have with mass housing in the West. She has so much to say about urban transformation, but people don't seem to pay much attention to her here. Sure, there are a few architects and urbanists who respect her, but lots of them just ignore her.'

'But why?'

'I hate to say it, Adam, but I think it's partly because she's a woman.'

'Really? In this day and age?'

'Yes, it's pathetic. I remember her telling me about so many meetings in which she got patronised, ignored, closed down or manoeuvred around by men. Don't get me wrong, she's been treated that way by women too, but the

majority have been men, and it's a patriarchal system they're operating within. If you're not obsessed by maximising profit above everything else you're treated as if you're some kind of fool.'

'It sounds like she's doing just fine on her own terms,' I said, looking back down the elegant staircase.

'Yes, but imagine what she could achieve if she had influence within her sphere beyond the projects she initiates herself.'

'Surely it's just a matter of time. I imagine people who have new ideas are usually treated badly, at least to begin with.'

'You're a bright boy, Adam,' said Antoine, 'and I hope you're right. I think my mother's vision for how to transform the HLMs around Paris and in other major cities around France and beyond would be worth exploring.'

We had been standing at the top of the staircase for some time, leaning over a handrail. We turned round to face a pair of white doors with a serious security panel to the side. It had a camera, a code pad and a flat screen onto which Antoine placed his hand. A green light flashed on the screen. He positioned his eye in front of the camera and a second green light flashed. He then typed in a code on the pad and the doors opened automatically.

We walked into a beautiful lobby area in which an olive-green velvet chaise longue and two small matching boudoir chairs were arranged neatly around a simple mid-century lacquered wooden coffee table. Although I didn't know all the different styles and periods at the time, or the words for all the different kinds of objects, I took it all in. My English teacher once told me that I was obsessed by detailed descriptions in my creative writing, and it certainly came in useful for describing an apartment like this. The floor was a herringbone parquet in the shape of diamonds, the walls completely white with nineteenth-century mouldings. There were wall panels floor to ceiling, and in the centre of one hung a small painting in a thin gold frame.

'That's not by...?' I paused, not wanting to sound stupid again.

'Go on... have a guess,' said Antoine.

'...by Renoir, is it?' I asked in disbelief.

'Spot on! It's a study of a young woman he made for a painting that's in a museum collection in Russia. Isn't it gorgeous? That peach-coloured background with the emerald dress.'

'Her eyes and her lipstick really pop out of the picture,' I added.

'She was an actress. She's in several of Renoir's major works.'

'And this one,' I said, turning to a picture on the opposite wall, 'it's not by Matisse is it?'

'Good guess, but not quite!' said Antoine. 'It is a picture of Matisse's wife, but it's not painted by Matisse. Can you guess who it might be?'

'Er, no,' I replied, 'tell me.'

'It's by André Derain.'

I was coming to the realisation that Antoine's mother wasn't just wealthy,

but super-rich. I mean, who has original paintings by Renoir and Derain just hanging on their landing?

'She's a huge fan of French painting of the late-nineteenth and early-twentieth centuries, so when anything comes up at auction that she likes, she tries to get it. I sometimes go and bid for her – it's really good fun!'

Antoine held out his hand to guide me through into a room that faced onto the Avenue du Président Wilson. It must have been right above where Antoine had his anteroom. It was stunning in there – it seemed so much more mature and sophisticated than Antoine's apartment. Don't get me wrong, Antoine's place was very tasteful, but this was the next level. The room was the palest dove grey. The walls were also panelled floor to ceiling though in here the decorative mouldings had been picked out in gold paint. The gold was not bright and shiny, but rather matt, and with a pewter undertone. In between two of the moulded panels was an ornate gold mirror, the colour of the gold matching that of the mouldings. The ceilings were so high, the proportions of the room so elegant. The next thing my eyes fell on was a large antique urn on the floor with a huge display of cherry blossom branches coming out of it. There was an antique chest of drawers with intricate marquetry and gold key holes, a Persian rug on the floor, and luxurious curtains. There were side tables with smaller oriental vases on them, and a Rococo wall clock placed between two of the windows. The furniture was a mixture of modern white upholstered sofas with eclectic silk cushions, a set of expensive-looking modern armchairs and a couple of carved antique wooden chairs with ornate armrests. The overall feel of the room was soft – soft tones and soft textures.

The anteroom opened onto a drawing room in which the centrepiece was another imposing period white marble fireplace. On either side were two simple wooden plant stands, each supporting an immense glass cylinder vase containing a spectacular display of foliage that reached almost to the ceiling. The wall panels each contained two or more paintings, so there were over a dozen in this room alone.

'All of the paintings in the drawing room are by women,' said Antoine. 'Ever since she started collecting, my mother has been keen to make sure there are as many works by women as by men in the collection.'

'They're all so amazing, Antoine. I love them!' I said, gushing with enthusiasm. 'There are so many different things here but they're so carefully put together.'

'I'm so pleased you like them. Yes, she loves art and design from so many different periods and places. She is genuinely passionate about styles and genres, fashions and history, about creativity and the designed world. I think if you're an architect or in the property business you have to be interested in interior design, and if you're interested in interior design, you have to be interested in art.'

'Antoine,' I said, 'I'm so sorry but I'm going to have to dash to get back to the museum – they'll be expecting me and I need to get a move on with the preparations for the exhibition. Can I come back and see more of your mother's collection of art and antiquities another time?'

'Of course,' he replied. 'You must come back to see her library; it's full of art books. You're welcome to use it while you're here in Paris. Plus there are another two floors to show you, and you haven't even seen half of this floor yet.'

I was stunned. The quality of everything she owned was obvious. And it was all so suave and elegant. Nothing looked crass or out of place. Yes, this was a lady with real taste, and with the money to match. Everything had been so carefully chosen and positioned – 'curated' I think they say. Maybe I wanted to go into museum studies, or to work in an auction house. I was certainly inspired by my first encounter with a private collection.

<p style="text-align:center">∗∗∗</p>

The afternoon at the museum flew by. A variety of senior members of staff were suddenly to be found in the main open-plan offices following the morning's meeting at the British Council of the Arts, and there were new meetings being booked in left, right and centre. The whole place felt energised as it knew that the eyes of much of the world would be on the museum in just a fortnight's time. I thought even Emilie was being nicer to me, although I wasn't expecting that to last. When the alarm rang for the end of the day, it caught me by surprise, and as I made my way out of the building into the warm summer air, I had quite a spring in my step.

When I got back to the foyer I freshened up before making my way over to the common room for the first time. The quad was pretty simple, a gravel path around a small grassed area. A few people were lying on the lawn with books, chatting or with their headphones on. Most of the lawn was in shadow for most of the day, but the sun was so bright that it was still light, with the added benefit of being nice and cool.

The common room had the doors open to the quad to let some air in. There was an air-conditioning unit inside, but it looked to be on its last legs and had possibly always struggled to keep on top of the situation. There was really no hope that it could serve a whole room of that size on a hot day even with only a few people inside. The chairs were comfortable, but while you could see that some decent money had been spent to acquire them twenty or more years ago, they now looked tired and were in need of some serious re-upholstery. Some of them were neatly arranged in small configurations, others were left where they had last been used. Some faced a television screen that was permanently tuned to a music video channel. There were some notice boards full of posters for bands, plays and exhibitions, and adverts for everything from language classes to yoga sessions and bongo lessons.

It was a bit scruffy and dated like my room, but it had its own charm. I didn't have to wait long by myself as Natalie soon turned up, bouncing with energy. She practically vaulted over the chairs on her way to come and sit beside me.

'Hey, how are you, Adam?' she said.

'I'm good, thank you, Natalie. Great to see you. How was your day?'

'Really good. I've just had a street dance workshop. I think I could get into doing more of that. We're working on a project to make a promotional video for a music track, so we have to work together to style our own look, hair and make-up, secure a location and set, sort out the crew and the equipment, choreograph a routine, record and edit it. There are three groups and it's kind of a competition to see who can produce the best one.'

'That sounds like a lot of fun,' I said. 'I can't wait to see the finished results.'

'Well you won't need to wait long; we're going to be performing the dance routine and screening the video in the Jardin des Tuileries at the Nuit Blanche tomorrow night. You must come along – it starts at eleven.'

'I'd love to, thank you,' I replied. I set a reminder to text Antoine to ask if he would mind if I attended Natalie's performance, or to see if the Eleven Associates would like to come and watch it too if their schedule allowed. I knew Antoine had been making careful plans for the evening for quite some time so didn't want to mess with his arrangements.

'And what have you been up to, Adam?'

'Well, I've had quite an eventful day and it sounds like the private view for our exhibition is going to be quite an event.'

'Oh yeah, of course, the royal couple – they're going to be there, right?'

'But... how did you know that?' I asked. 'I've just had to sign a confidentiality agreement about it, so how come you know already?'

'Oh you know, I heard it announced somewhere that they'd be in Paris later this month, so I assumed they'd turn up to your exhibition.'

'I see,' I said, a little disappointed that my exciting secret had been blown apart within a few hours of having sworn myself to secrecy in front of the French and British governments and security services. 'Well, I don't think anybody's supposed to know yet, so please keep it under your hat.'

'Sure,' said Natalie. 'It's no big deal. I mean, I guess it's a big deal for the British people and for some of the magazines and news channels over here, but I'm not the kind of person to come along and wave a flag, if you know what I mean!'

At that moment, a song came on the television and Natalie jumped up, quite taking me by surprise.

'Come on,' she said, 'this is the track that we're doing the video project for. You can help me work on the routine.' With that she pulled me up out of my seat and cleared a space between the chairs for us both. She spread her legs and put her hands on her hips.

'That's it,' she said, 'just follow me and do your best to keep up!'

As I'm not the most coordinated of people, this was at best mildly embarrassing for me, at worst completely cringe-worthy. But, it was, I have to say, good fun. Natalie was doing all these really cool moves, twisting and rotating, moving her arms in ways that mine were not built to replicate and her footwork was insane. Everything she did just looked cool, and I was acutely aware that everything I was doing did not. I tried to copy one particular move that involved turning a foot inwards and then the body follows it round, but somehow managed to end up on my bottom on the floor. Natalie seemed to find this hilarious and was laughing in my face as she pulled me up. Her laughing set me off too.

'You're a natural, you're a natural,' she said, clearly taking the mickey.

'Would you like me to join your dance crew?' I asked, smiling at her.

'Maybe with a bit more practice!'

Just as the song came to an end, Amira arrived. She looked amazing again. That evening I asked Amira about Arab women's fashions. She said that someone had told her there are over a hundred ways to wear a sari in India, and that there were many different kinds of djellaba too. She explained some of the variations and varieties to me, and all the different types of veils and headscarves in the Muslim world – niqabs, burnous, haiks, burqas, hijabs, al-amiras, chadors, khimars and so on. I couldn't tell you which is which, but the way she described them was so beautiful. I said I wanted to see an Arab fashion show. Natalie said she would volunteer to be a model if Amira would help her to wear some of the different outfits, so Amira said she would bring some of her clothes over to Natalie's room one evening and we could do our own fashion parade. We ordered in pizzas – which was a bit lazy as the restaurant was only three doors up the road – and sat together in front of the television in the common room eating and chatting. They were both really interested to hear about Antoine and his mother's apartment block, and about the Association of Alma-Marceau.

'But are you sure it's not a cult, Adam?' asked Amira. 'It sounds like some weird secret society. They haven't made you do any strange initiation rituals or anything, have they? No naked ceremonies or animal costumes, that kind of thing?'

'Ha! No, they seem really lovely, Amira. I think they genuinely want to help to improve society, and their ideas for doing it are pretty amazing, actually. I was really inspired by some of the things they're doing – businesses, journalism, broadcasting, social media and so on. And they're all so cultured.'

'Are any of them handsome *and* wealthy?' asked Natalie, with a big smile.

'Probably,' I replied. 'Though they're from a whole variety of different backgrounds.'

'They sound like they'd make me feel thick,' she added.

'Oh no, they're all really down to earth,' I said. 'Well, there's one English guy who's quite full of himself, but even he's funny.'

'Well,' said Amira, 'it sounds like you've found yourself a whole load of new friends in just your first week here in Paris.'

At that moment Amira's mobile started ringing. She picked it up and had a conversation in Arabic. Natalie and I heard our names mentioned. Amira seemed a bit put out by the conversation.

'What is it, Amira?' asked Natalie. 'Who was that?'

'That was Youssef. He's had a big delivery arrive late and needs to get it unloaded tonight. He seemed pretty desperate. I said I'll go over to the warehouse to help him. I told him I was with you two. He said if you want to come and help too, he'll pay you sixty Euros each.'

It was a bit of an abrupt end to our pizza night, but as Natalie and I were strapped for cash and keen to earn a bit extra, we agreed we'd go and keep Amira company and help out too. We popped back to our rooms, got dressed into some heavier-duty clothes, and headed off to the Métro. It turned out to be a Métro followed by a bus, as there was no stop close to the warehouse in the north of Paris. I had watched the beautiful Haussmanian streets change to giant concrete viaducts, tunnels, walls and high-rises. Things suddenly started to look like the 1960s, 1970s, 1980s and not much since. There were edge-of-town hotels and lots of gigantic billboards advertising companies I had never heard of. There were light industrial estates, and carparks overgrown with weeds. Yes, we had definitely left central Paris, and for the first time it felt like I was out of my fantasy world and back in real life. It must have been after nine by the time we arrived at the warehouse, and as the light faded, it was starting to get much cooler. Youssef was standing at the back of one of three enormous lorries at the front of his warehouse. Although he looked tired and a little stressed, you could see from his features that he was related to Amira, and had the same glow about him. He was relieved to see us.

'Thank you for coming,' he said, and seemed to mean it. 'We're a bit low on manpower tonight, as you can see – just me and the boys here. The drivers have gone for some food, and will then return to sleep in their cabins.' I could see a short chain of three men – one in the back of the lorry, one waiting to receive boxes from him, and one inside the warehouse putting them into position. I soon noticed that it was the three men we had seen in the Moroccan restaurant the other evening. Youssef was operating the tail lift at the back of the lorry. It was then that I realised that each lorry was basically a giant shipping container.

'There's a lot of stock to move. We've been at it for almost an hour already and we're not even halfway through the first lorry.'

I got up into the back of the lorry and found myself standing next to the man I'd thought might be following us. My heart jumped, but I greeted him calmly with a smile and he nodded at me.

'What would you like me to do first?' I asked.

'Take a box from the left-hand side and start another chain with the women.'

'Amira,' said Youssef, 'if you can take over on the tail lift, I will help moving the boxes of stock inside.'

This system seemed to work well, and we effectively doubled their work rate. Youssef seemed to relax a little now. We spoke as we worked, but it was just a few words here and there as we were all hard at it. We worked for over two hours without a break. We were nearing the end of the back of the third lorry, and as I placed one of the boxes onto the tail lift, I slipped and almost fell off the edge. The man with me – Ammon was his name – grabbed my arm and stopped me from falling. He looked me straight in the eyes and said:

'You must mind your step.'

His words were so deliberate and pointed it was as if he was warning me, or threatening me, but in the context of falling over and him helping me up, I simply smiled and thanked him as I caught my breath. As I continued to go back and forth inside the lorry, I was racking my brains to try to figure out why he might have taken a dislike to me, or to be spooking me out, following me around and now telling me to watch out. We eventually lifted the last of the boxes off and jumped down to follow the others into the warehouse. It was approaching midnight by now, and we were all pretty tired and grubby. Natalie was standing next to the other Egyptian guy, Hager. She had been working alongside him all evening, and I could see from her expression that she was not enjoying herself.

'Are you okay?' I asked her.

'I'm fine,' she replied, quite curtly, so I knew she wasn't fine, but she didn't want to say anything.

'Amira – are you okay? Not too exhausted?'

'Me? No way, I just I had to press a button all evening,' she replied with her usual charisma.

Youssef had been checking off the inventory as it came inside. A few of the boxes were open where he had evidently been doing spot checks to make sure it was the right contents, and I could see that the delivery was of packets of Wajah fi Alghuyum tobacco. There were different colour ones – red, blue, green and a particularly beautiful one of black with gold.

'Why are they all different colours?' I asked.

'They are all different flavour molasses mixes,' Youssef explained. 'Some combine the tobacco with molasses with flavours like strawberry or vanilla, others are tobacco-free. There are dozens of flavours now, even hashish flavour. Look.' He pulled out a box of the green coloured packets. They had a cannabis leaf on the tin.

'But it's not real hashish?' I asked, slightly confused.

'No, of course not, it's just a flavour that is like hashish. If it were real of course I wouldn't be able to import it!'

66

'Though I'm sure we would be wealthy men if we could,' added Asim, laughing coarsely.

'Ah, I see, so you can get cannabis-flavoured molasses, with or without tobacco in it, and you sell it, Youssef.'

'Well, in general my company distributes it and then retailers and other wholesalers sell it, but yes, I'm part of the supply chain. We recently started fulfilling direct customer orders, so we are now also a point of sale – customers can order cartons of ten packs or more online and we use our own new courier team to deliver them to people's doors. While it's only a small percentage, a growing proportion of our customers purchase this way, and it means the margins are higher for us as we cut out the wholesalers and retailers. My new partners have been leading on all these developments.'

'I see,' I said, getting my head around all these things.

Of course, I had heard these words – wholesaler, supply-chain and so on, and had a decent idea of the meaning of the actual words – but had never really had to think about them in any depth. Why would you? But this was the international language of business, and again was the kind of stuff that marked out the adult world from that of adolescence and childhood.

'You've worked really hard tonight, Adam, I'm impressed. If you'd like to do some more shifts for me, I'd be happy to pay you.'

'Thank you,' I replied, 'I'd be happy to do a few while I'm here, though I'm only in Paris for a few weeks.'

Ammon said something to Youssef in Arabic – perhaps he didn't like the idea of me working with him. Then the other man, Hager, joined in the conversation. It started to sound more like an argument. Asim joined in too. Youssef's phone pinged.

'Listen, Amira, Adam, Natalie,' said Youssef, pulling away from the conversation with his colleagues, 'your taxi has arrived and it's getting very late.' He pulled out his wallet and gave Amira a wad of Euros. 'This is payment for your friends for tonight, and money for the taxi. Get me a receipt and make sure they invoice me for my accounts.'

Amira took the money, gave him a kiss on the cheek and we all made our way outside, bidding the men goodnight as we went. As soon as we'd got into the taxi, I asked Amira what the argument had been about.

'Oh, they were just saying that they can manage with the usual team of people – they got caught out this evening because the lorries were delayed. Usually there are more men working in the warehouse.'

'So did that guy, Ammon, not want me around?' I asked.

'Well, he didn't think they needed you, and Hager agreed with him. Asim said you seemed like a nice and trustworthy lad and could be handy to come in to help out when needed, but I think the Egyptian guys are more used to working with other Muslims, if I'm honest with you. I don't know that for certain, but that was the impression I had, reading between the lines.'

Interesting, I thought, so that's how it feels to be discriminated against for nothing other than your race. It had never crossed my mind before, and I realised how lucky I was not to be overlooked or ruled out on a daily basis like so many other people.

'And you, Natalie, you looked like you were annoyed in the warehouse back there,' I said.

'That man, Hager or whatever his name was, he was so rude. It was like he hated me being there, or having to work next to me, or something. I swear he was cursing under his breath. When I stopped for a moment to take a break and have a stretch, he started having a go at me! I couldn't believe it. I only had a quick look in one of the open boxes to see what was inside and he practically jumped down my throat, like I was trying to steal or something. I was furious. I only came here to help out and he was treating me like I was some kind of criminal. I tell you, I nearly walked out of there so I didn't punch him in the face.'

'I'm so sorry, Natalie,' said Amira. 'I'll speak to Youssef about that tomorrow. There was no need for that.'

Natalie started to calm down and we sat in silence for a while. As we were driving along in the darkness, I noticed the driver switching to full beam and back as we went along the road. At one point it looked like he was almost flashing the lights. I caught the taxi driver's eyes in his rear-view mirror. He held my gaze for a moment before looking back at the road. I think I was starting to become a bit paranoid – had he been looking at me strangely? It felt like he had been trying to take in my face, as if committing it to memory. Had he been flashing the lights deliberately? Amira was sitting in the front with him looking at her phone so she presumably hadn't noticed anything out of the ordinary. I was probably just tired, and standing with Ammon for the best part of three hours had done nothing for my nerves. Yes, I was a bit on edge. I was going to ask Amira about Ammon but the moment seemed to have passed, so I kept it to myself. When my head finally hit the pillow around one in the morning, I was out like a light.

## THE NUIT BLANCHE

I was on autopilot at the museum the next day. I remember sitting quietly and just going through the motions with my spreadsheets and emails. I had received a text from Antoine to say that he was adding me to a group on FrendHub with the other Associates, which really made me feel like one of them. He was making arrangements for the Nuit Blanche that evening and was planning to start at the museum where I worked followed by an aperitif in the courtyard café. He was aiming to fit a lot in so he had laid on private-hire cars to drive us around. I was so excited I could hardly think about anything else. When the alarm finally sounded for the end of the day, I went straight outside and met up with several Associates who had already arrived. We made our way through to the galleries where the current temporary exhibition was on.

Walking through the doors, I was surprised to find myself standing in what felt like a stage set of an old office. There was no natural light, just a bright, naked bulb suspended from the middle of the ceiling above an old wooden desk. There were lots of grey filing cabinets along one wall, an old-fashioned free-standing fan in the corner, and an old film projector whirring away facing the back wall next to another door. The footage was of people walking in the street, unaware that they were being filmed. It was as if the camera was filming from above, from an upstairs window of a building, or rather, from a number of windows as there were several different angles from which the film was shot. The footage looked old because it had been taken on some kind of old camera, and was flickering a lot. It also seemed to be at an odd speed, though I couldn't work out if was speeded up or slowed down. Then the footage showed people inside a building, walking around corridors and through doors. I got the shock of my life when I suddenly saw my own face on the screen. It was only up for an instant and was pretty grainy, but there was no doubt about it. It was a close-up of my face. But how had they done that? The footage continued with blurry shots of different people walking around, and then Armand's face appeared on the screen, followed soon after by Anne-Sophie's, both of whom were standing next to me watching the film.

'That is so creepy,' said Anne-Sophie. 'They've been filming us outside and all through the museum.'

'But how are they projecting it onto the wall while we're here?' I asked, completely confused.

'I would imagine,' said Stéphanie, 'that this projector is not actually an old film projector. If you look closely, you'll see that the film never goes through the lens – the tape is just going round in a loop on the two spools. It's a digital projector disguised as an old analogue one.'

'You're absolutely right,' said Antoine, holding the exhibition guide in his hands. 'The artist has used some facial recognition software combined with recorded footage in and around the museum that works almost in real time. When visitors stand watching the screen, they are being filmed and their faces are added to the footage from other cameras that have been filming them over the past few minutes. The algorithm does its best to find footage of the same people to mix in alongside images of everyone else who happens to be around.'

Sure enough, in the middle of the wall where the film was being projected a small black dot could be seen – the camera that was filming our faces as we watched.

'That's so clever,' I said. 'It looks like it was filmed ages ago.'

We walked through the door at the back into a much larger space. It felt like a military dormitory, or possibly a prisoner of war camp – dozens upon dozens of bunk beds, all with the same basic bedding and grey blankets. It was very dark in there too, though the walls were floor-to-ceiling digital screens projecting grids of black and white faces, fading in and out, reappearing in different positions around the grid. These looked like all the faces that had been flashing up in the footage in the office-like room we had just left. Because each face had been filmed staring intently at the projection, there was a really odd atmosphere to them – nobody was smiling as they would for a formal portrait or a photograph taken for fun. We'd all been caught at a moment of concentration, staring at what was to become an image of ourselves before we knew it. What we saw in the projection was ultimately us looking unknowingly at the projection. At certain moments, all the screens would flash up footage of the room we were now in, from lots of different angles. It was impossible to see individual faces in the darkness, but it was evident that our group of six was being projected live on the screens. The room itself had become the image, and we had become the work of art, its subject and its imagery. Seeing ourselves surrounded by these bleak and unsettling bunk beds from outside ourselves changed our relationship with the space, and with the footage. We weren't just viewers now, we were protagonists, actors in the artist's film.

In order to exit the gallery, each visitor had to pass through what looked like the electronic gate you get at the passport control at an airport, the one with iris recognition technology. One at a time we had to stand still, wait for a camera to take our picture, and then the gates opened so we could leave. Once on the other side, we entered a room that was completely empty apart from a large photocopier-printer. As we walked past, a piece of lightly gridded graph-paper came out of the copier, with an image of our face plotted in

thousands of pixels on it. At the bottom of the sheet was a long sequence of zeros and ones. Our faces had been converted to binary. An invigilator standing next to the photocopier was encouraging visitors to take the sheet of paper with them. I folded mine up and put it in my pocket.

'That was mind-blowing,' I said when we were back in the corridor.

'I thought you'd like it,' said Antoine. 'A couple more Associates have arrived in the café, so shall we go and meet them?'

We nodded and made our way outside, chatting all the way about the exhibition we had just experienced. Everyone had different takes on it. Antoine pointed out that on the exhibition guide it said that if you visited a website for the project and typed in your email address and a code, it would automatically send you a digital file of your portrait. I did it right away. They were going to pick five hundred faces at random at the end of the project and make a digital catalogue out of them.

<center>∗ ∗ ∗</center>

Antoine ordered a couple of bottles of champagne and we raised a toast to the Nuit Blanche. I was sitting next to Henry, who was indeed British.

'Ah, the little English fellow! How the devil are you?' he said, chortling to himself.

'I'm very well, thank you, Henry. And yourself?'

'I could be better, but then I could be worse, so that's a perfectly acceptable median,' he retorted.

'I'm glad to hear it,' I said, not entirely sure quite what to make of him. 'How long have you been living in France?' I asked.

'I came over to study here almost five years ago and decided to stay. I met a special guy, then found a job, and now I've no easy way of extricating myself from this wonderful predicament.' He was grinning from ear to ear.

'Sounds great,' I replied. 'And what is it you do for a living?'

'If you can call it living!' he said. 'I always wanted to be an actor but I'm afraid I sold my soul and work for a large banking group, mostly doing IT stuff. It pays the bills and then I try to spend as much time not sitting in front of a laptop as possible, until, that is, one of these bloody Associates needs my help with some infernal project or other.' He laughed. 'Can you just build me a website, Henry? I need a new app developed, Henry! Why isn't my laptop working, Henry?' He was putting on a thick French accent as he impersonated his fellow Associates, which resulted in the man next to him bashing him over the head with a rolled-up magazine.

'That, er, is not 'ow we speak zee English, *quoi*,' his friend said, deliberately making his own accent thicker.

'How did you find the Eleven Associates, or did they find you?' I asked.

'It was an ill-fated day,' said Henry, as if he was in some amateur

<center>71</center>

dramatics production. 'There I was, minding my own business in a café late one night, drinking myself to oblivion, and this guy here pulled up a stool alongside me and asked, 'What is a boy like you doing in a nice place like this?' How could I resist engaging in conversation with such a charmer? I knew as soon as I saw him that it was love.'

'Well, you fancied me,' said the guy sitting next to him, who turned out to be called Sebastien. 'I just took pity on this skinny – how do you say, lanky – Englishman sitting all alone drinking cheap wine.'

'How very dare you?' said Henry, indignantly. 'I'll have you know I paid a lot of money for that bottle of wine.'

'Yes, but the barman, he saw you coming,' said Sebastien, a big smile across his face. 'He normally sells it a lot cheaper.'

'That scoundrel!' said Henry. 'Why, I'll find him and teach him a lesson!'

'Yeah, yeah, yeah, I've heard it all before, *mon amour*, your threats are as empty as your drinks cabinet.'

Sebastien was the art historian Antoine had mentioned to me yesterday. I was really looking forward to chatting with him about his research, not least because I was starting to think more seriously about what I might want to study.

'You're an art historian, aren't you?' I asked.

'Yes, that's right, I am,' he replied.

'I think I'd like to be an art historian – is it what you hoped it would be?'

He smiled. 'You know what, Adam, I guess it is. I do enjoy it, most of the time, at least.'

But before I got a chance to pursue the conversation with him – and we'd barely had time to finish our drinks – Antoine started banging the ice bucket with a spoon to get everyone's attention: the taxis had arrived. They weren't your average taxis, either. They were white limousines – three of them, identical. We jumped in and they took us to the next venue selected by Antoine for our Nuit Blanche. We stopped off in the fourteenth arrondissement around Montparnasse at a private art foundation called Montrouge. Antoine told us there would be a short performance starting in just ten minutes, so we had to dash around the exhibition of digital animations and motion graphics. They were like special effects you see in movies, but they were created as free-standing works of art. There must have been a dozen or so monitors around the exhibition space, each presenting a show-reel of dozens of these short animations. There were dragons emerging out of the illustrations on a woman's dress, flying around in a blaze of fire and a cloud of smoke; my favourites, though, were colourful, gloopy abstract shapes morphing into tangible objects briefly before returning to abstractions. The animations were so realistic; I hadn't realised that the technology had become so advanced.

The concert took the form of three young women with laptops standing in front of a large screen. We took our seats as the lights went

down. As I understand it – and I'm not sure I did completely – the performers were doing some form of VJ-ing, whereby digital animations and audio materials were being triggered, generated and modified in real time. The sounds and the imagery were changing in tandem – a variety of patterns, colours and shapes. It struck me as very clever, and beautiful too. Some of the sounds were quite caustic or piercingly loud, which I was less keen on, but it was another new experience for me and a concert unlike any I had been to before. The screen faded to black and the sounds died out with an echo into silence. The audience clapped and then waiters started appearing with trays of white wine. We each took a glass and stood in little clusters in front of the screens around the exhibition, discussing the animations. The Associates really seemed to take an interest in everything that was going on. Henry was clearly more theatrical than the rest of them, but even his full-on personality was good-natured, mostly. The crowd was quite well-to-do and cosmopolitan too. Antoine made his way around the groups of us in the gallery, his hands around the shoulders of the Associates who happened to be in front of him.

'Hey guys, sorry to rush you when you're clearly all having such a good time, but we need to move on to the next venue if we're to keep on schedule for the evening.'

We finished up our wine and made our way outside and back into the limousines. I felt like a pop star. There were quite a few people on the street outside the gallery, and some of them were looking at us as we got in. I suppose we must have looked quite a spectacle. I was one of the last and thought it would make a great photograph, so I went round the other side of the cars to get the limousines in front of the large metal and glass building. As I was framing the picture, I spotted someone in the crowd outside the gallery taking a photograph of us at the same time. It was a young woman, with short dark hair and a pair of shades on. She had a digital SLR, not just the phone on her mobile, so she was clearly someone who was more interested in photography than the average person in the street. I jumped in the car, which was ready to leave, and while we were travelling I posted my picture to my social media site, FrendHub. I could see that Chris and Eddie had started following me, so I followed them back. Armand, who was sitting next to me in the car, saw me posting the picture I had just taken.

'Ah, so you are on FrendHub too. What's your username on there?'

'Erm,' I said, having to think for a moment, 'AdamK2001.'

'That's a rubbish username, Adam, how terribly boring,' said Henry, who was sitting on the other side of me. 'I, for example, go by the name of HoorayHenry, as it reflects my aspirations to the upper echelons of society. Armand here uses the name ChArmand, because he is so naturally charming. Give me your phone, I'm going to change your name to something that sounds much more interesting.'

And with that he took the phone from my hands.

'There,' he said, 'TheYoungBaron. Isn't that much more mysterious, more enigmatic? I mean, who would I rather want to follow or to meet – AdamK2001, who sounds like a robot from a warehouse, or TheYoungBaron, a continental gentleman of noble standing with a *nom de plume, a nom de guerre*, no less?'

'Well,' I said, a little unsure about this new avatar for my daily existence, 'I guess it does make me sound more interesting than I actually am. I'll have to find a picture to go with it. Maybe I could use that pixel portrait of myself from the museum earlier. I'll see if it's arrived yet.' Sure enough it had, so I popped it up as my new portrait picture and posted it too. So there I was, in an instant, pretty much a new person with a new identity with which to face the world. Almost instantly a message came up from Eddie: *The YoungBaron?*

\* \* \*

It was just a short journey to our next destination, a strange street in the thirteenth arrondissement, which mostly seemed to have been built in the late 1980s and early 1990s. Lots of the buildings had porticos overhanging the street. Concrete pillars and a lot of glass were the style and materials of choice. Many seemed empty, and those that were in use kind of looked like they weren't – the branding of the companies inside these buildings wasn't very clear to the outside world. Maybe they didn't want to be seen. The occasional restaurant brought some signs of humanity to this otherwise soulless stretch of the street, though it was only when we reached the other end that some of old Paris reappeared, with a parade of interesting little boutiques, cafés and businesses. Among them were two or three commercial art galleries – I discovered from Alicia during the course of the evening that these were privately run spaces that sell work to their clients, to private collectors, to museums and galleries. It's not the kind of art that most normal people can afford – the cheapest thing I saw that evening was a framed watercolour with a price tag of two thousand Euros. The galleries had clearly put their heads together to arrange private views during the Nuit Blanche, so there was a buzzing crowd along the street, standing around holding bottles of beer. They spilled over into a public square on the opposite side of the road. We made our way round the galleries and their exhibitions.

On entering the third gallery, I could sense something was out of the ordinary. There were a lot of people in there, as there had been in the other two galleries – they were relatively small, the size of an average shop unit. It was an exhibition of expressionist-style paintings, made by a young Frenchman, depicting scenes from French military history, some glorious, others quite the opposite. In front of one particular painting, a group of people were standing so as to obscure the view of anyone wishing to see the picture.

'What's going on?' I asked Alicia.

'I'm not sure,' she replied as she picked up a press release. One man was filming the group of people and another photographing them. The group was a real mix, some younger, some older, and even one elderly woman. They were a variety of ethnicities, and they were mostly dressed in casual clothes. They didn't give the impression of being wealthy collectors, anyway.

'The press release says there is a painting depicting a French atrocity in Algeria during the War of Independence in the 1950s and early 1960s. That will be it. Let's listen – the guy with the camera is interviewing one of the people who've come with the group.' Alicia and I listened as best we could. I caught some of it, but my French was not good enough to get the nuances.

'Ah,' she continued after listening carefully for a while. 'Now I understand: this group of people is blocking the painting in protest against the French government, which has often avoided formally apologising for the imprisonment, torture and murder of Algerian citizens. The interviewer asked if they were protesting against the painting or against the French government. The interviewee said both. The interviewer asked why they were protesting against the painting. The painting depicts a young university student who was accused of conspiring against the French military and was taken away, never to be seen again. The group does not believe it is right that an artist should make money from representing this woman in a painting. The interviewer asked if the painting is not helping to raise awareness of these issues and the young woman's cause. The interviewee said that the painting romanticises the death of the woman, and turns her presumed murder into a public spectacle, into entertainment, into an object to be looked at and sold. The group will stand in front of the painting every day during the course of the exhibition, and they are inviting volunteers to come down to the gallery to take shifts.'

I didn't know quite what to make of all this. I liked the fact that people were taking a stand about something they felt was important, and I was interested that a painting was causing this kind of a political reaction among the public. I also liked the fact that they were not looking to vandalise the work, or to have it removed. They simply wanted to dominate the position of the viewing public in the exhibition, to demonstrate that they thought the painting should have a veil drawn over it. But taking such action would surely result in the painting being seen by thousands more people than would otherwise have known of it. Hadn't they achieved the opposite of what they wanted – to stop or discourage others from looking at it? I guess their action had largely been symbolic, and in doing so they would draw press attention to the still very politically sensitive subject of how the French acted in Algeria half a century ago. As it happens, during the course of the exhibition the painting was damaged – the canvas defaced with a can of spray paint. Someone decided to take more direct action.

While the atmosphere was tense in the gallery, there was no real sense that any trouble was going to start. I did my best to see the other works in the

exhibition, though my view was largely blocked by the sheer density of people packed into the little gallery. I caught a glimpse of the particular painting in question. This, like the other paintings in the show, was so close to abstract it made me think further about the issue. Black and grey brush marks swirled around the canvas, blurring the imagery so that it was not entirely clear what was what. You could hardly make out the figure of the young Algerian student in the painting. It was almost as if it was the very idea of the painting depicting the victim that was the problem, rather than the imagery itself. But perhaps this expressionist treatment of the subject seemed disrespectful. I remember realising so clearly in that moment how painting can be controversial not just for the image itself, but how it is depicted. More importantly, I began to appreciate that who is painting a picture, and who is viewing it, are equally important. Would the response have been different if it had been painted by an Algerian artist, or a French Algerian artist? Painting is political, I resolved, and it's not just about what can be seen in a work.

'What do you make of the paintings, Adam?' asked Sebastien.

'Oh,' I said, caught off-guard. 'I don't know. I'm not really sure.' I felt really embarrassed. There was so much that I wanted to say about the works in the exhibition, but how to turn all those thoughts into spoken words, and on the spot? 'I really wouldn't know where to begin,' I said. 'Some kind of art historian I'd make.' I laughed sheepishly.

'Ha,' said Sebastien, 'don't worry; sometimes it's better to think for longer about paintings before speaking about them.'

Alicia and I received a ping on our phones. It was Antoine, giving us all details of a restaurant nearby where we would be having dinner. As we made our way out of the gallery and a short way down the street, I realised that there were a number of Asian restaurants on the road – Korean, Japanese, Vietnamese, and we were bound for a Thai restaurant. I was starving by this time, so when the first fragrant dishes began arriving at our tables, I couldn't have been happier. Antoine ordered some bottles of wine for the table. I wasn't all that used to drinking – I'd only just turned eighteen, remember, so I was not very experienced at pacing myself. After a couple of glasses, I was definitely feeling merry. The conversation was flowing at the table – everyone thought my new avatar was ridiculous but better than my old name – and during the meal I found myself followed on FrendHub by all Eleven Associates, who'd all now turned up. I realised I still hadn't spoken to half of them properly yet. I was enjoying getting to know Alicia, Henry and Sebastien tonight, and I was already growing fond of Anne-Sophie, Stéphanie, Suzette and Armand. As for Antoine – I guess I just totally looked up to him. He was everything I wanted to be, or to become. Antoine's profile name, ingeniously, was MarieAntoinette – a spoonerism of his actual name, Antoine Marionette. This sometimes resulted in him being called 'Marie'. This didn't suit him at all, which is why everyone found it so entertaining. I just thought it was

funny that his regular surname meant 'puppet'.

At precisely a quarter to ten Antoine ushered us out of the restaurant and back into the limousines. The evening had been timed with military precision.

'Where are we heading next?' I asked, now fully in the swing of the evening's festivities.

'Now that would be telling,' replied Antoine, grinning. 'All I can tell you is that we are going somewhere special, and it is near the Jardin des Tuileries so we will be there in time for your friend's performance at eleven.'

'Oh, thank you so much for remembering that, Antoine. I don't know if everyone will enjoy it though.'

'I'm sure we will, Adam, I'm sure we will,' he replied kindly. 'And anyway, it is usual for almost every member of the Association to have a different opinion on every topic, so I really wouldn't worry.'

The chauffeurs took us up past the Grand Mosque of Paris, down the side of the Botanical Gardens, and along the Quai Saint-Bernard. This took us north-west, following the Seine for pretty much the rest of the journey. It was a journey I shall remember for the rest of my life – looking out of the open window of a limousine, seeing the river and all the beautiful sights of the city of Paris by night. We took a left and stopped in a small street with lots of little cafés and restaurants. Antoine led us past several of these before taking us through a small unostentatious dark-red wooden door – the kind within a larger gate, so you have to step over the bottom as you go through. This proved difficult for more than one of the Associates at this stage of the evening. Once inside, there was a small courtyard, and on the right-hand side was a gorgeous old-fashioned bar, with lamps outside, a black-and-white tiled floor, thick textured wallpaper the colour of mint, lots of ferns and tropical plants, and elegant old dark wooden chairs and tables. As it was a Friday night in central Paris, the bar was heaving with customers. A waiter spotted Antoine coming towards the bar, which looked like something out of an Impressionist painting. It was gleaming with mirrors and bottles – beautifully designed bottles, both in terms of the shapes of the glass and the labels on them. I hadn't spotted the name of the bar, but what had struck me was how many of the spirits they had on display were green. That seemed unusual. I couldn't think of any green spirits, apart from that sour apple drink. He pointed upwards, and Antoine nodded before heading up a black, cast-iron spiral staircase. When we reached the top, we found a private room waiting for us, and on the table was a selection of curious apparatus – some glass vases with tiny taps on either side, which seemed to be full of iced water, a lot of matching glasses (Pontarlier glasses I gleaned during the course of our time in the bar) and a knife-like silver spoon, with a delicate pattern cut out of it in the shape of an eye, resting on the top of each glass. Bowls of sugar cubes were placed at intervals around the table.

77

'What is this place?' I asked, as we took our seats.

'Why, this is an absinthe bar, Adam. It's one of the oldest bars in Paris, and was one of the first to sell absinthe at the very end of the eighteenth century.'

'What is absinthe?' I asked, at the risk of sounding completely ignorant.

'It's a delicious green spirit, made with fennel, wormwood and anise. It has a flavour like aniseed. Come, try a glass.'

There was just one, oval table in the room, and it was a bit of a squeeze to all get around it, but we managed. The ceiling was low, the windows had thick glass panes and thick black lead around them, and there were small sconces providing atmospheric illumination for us. Each glass had a small measure of the green spirit in it, precisely filling a little bulb-shaped section at the bottom.

'It's quite a ritual,' said Antoine. 'Take a sugar cube using these little tongs. Place it carefully on top of the silver spoon. That's right, in the middle there. Then place the glass underneath one of the spigots and slowly pour the iced water over the sugar cube so that it dissolves into the glass.'

I followed his instructions to the letter, and watched, with amazement, as the emerald green spirit started to turn milky, cloudy even, like the pale mint colour of the wallpaper, in fact. When everyone had done likewise, I took my first sip.

'How much alcohol is in this?' I spluttered.

'Yes, it is quite strong, I think.'

'Are you trying to murder me?' I asked with a smile.

'Not yet,' replied Antoine. 'We've got your friend's dance performance to watch first.'

'The flavour is really strong too... it's very nice, a bit like aniseed balls, I suppose... but more bitter. It's sweet and bitter at the same time.'

'Tell me what you see when you look at the glass,' said Sebastien.

I looked at the glass. 'Well, the glass itself is beautiful, dinky yet elegant, and in it the milky green drink is now completely opaque. It started off a translucent rich emerald green, glinting with the light reflected and refracted by the lamps, and had swirls of white swimming through it for a while, like delicate ribbons in the wind.'

'So,' he replied, 'it seems you can describe the things you see perfectly well – quite eloquently, in fact. It's the starting point for you becoming an art historian right there. You know, Adam,' Sebastien continued, tapping his glass, 'this drink has quite a mystique about it.'

'How do you mean?' I asked.

'Well, it was a very famous drink in the late-nineteenth and early-twentieth centuries, and was especially loved by the avant-garde – by painters, poets and so on. You'll find a number of paintings featuring absinthe, by painters like Manet and Degas.'

'What was it about the drink that they liked so much?'

'I guess it was partly because it was so strong. It was a cheap way for people to get drunk, so if you didn't have much money, it was a drink that tasted nice and with which you could, how do you say in English, get wasted!'

'Oh I see, yes, you could seek to escape from the world by drowning your sorrows.'

'There is also a myth surrounding absinthe that suggests it is hallucinogenic. I'm not sure if there's any truth to this, or if it was just part of the propaganda that was used to eventually get the drink banned across much of the Western world, but the idea of it being like a drug has certainly played a part in the drink's mythology.'

'Of course,' Henry joined in, 'if you're going to get off your face on something as strong as absinthe, I would be surprised if you didn't start seeing things, hallucinogenic properties or not. Plus, the very idea of it being mind-altering puts you in the mood for dark poetry, mystical paintings, symbolism and all things definitely not modernist. It's a drink for reminiscing, for regrets and for disillusionment. It's a drink for self-pity, and for losing oneself in one's own mind. It's a drink for the shadows. It's for escaping the present, for not having to think about the real world, about the future, about progress. It's a drink by which to take flight with the green fairy.'

'That's often what it's called, Adam, *la fée verte*,' said Sebastien. 'It's only been legal again here in France for a short while, having been banned for almost a century. It was often blamed for many of France's social problems. This bar was one of the first to serve it in France over two hundred years ago, and was one of the first to start serving it again.'

'Come on, Adam,' said Henry, holding the bottle of absinthe in his right hand, ready to pour. 'One for the road.'

'I'm not sure,' I said, holding my glass close to my body and sensing myself slurring a little, 'I've had quite a lot to drink this evening.'

'Good,' exclaimed Henry. 'That's the idea.' And with that he seized my glass and foisted another measure upon me before topping up his own and Sebastien's.

A waitress came in through the door carrying a tray of bottles, bowls and decorated buckets. It turned out that she was a mixologist with a speciality in absinthe cocktails. She gave quite a performance, announcing the title of each cocktail before proceeding to make it in front of us. The names were hilarious – Corpse Reviver, The Green Beast, The Jaded Lady, La Tour Eiffel, Foaming Fairy, Fourth Degree and my absolute favourite: Death in the Afternoon. The glasses kept on coming around the table like a cocktail carousel, and if I hadn't been drunk on arrival, I was certainly well on my way now. The Eleven Associates were also feeling the effects of the green fairy and the volume levels were rising in tandem with everybody's spirits. There was a lot of laughter, the sound of glassware, of cocktail shakers and little bottles of mixers being

opened, and from outside, an old-fashioned fairground carousel could be heard from the Tuileries. It was doing a good trade during the summer months, especially during a Nuit Blanche when locals, families and holidaymakers were all out for a good time. There was a Ferris wheel next to the carousel, with a long queue of people waiting to get on. I watched as the mixologist chopped and zested lemons and limes and fresh mint, measured out spirits and poured them into gleaming receptacles. Beyond gin, white wine, whisky and champagne, there were ingredients as surprising as fresh eggs, rosemary, parsley and double cream. It was like opening a door into another world, and I was quite happy to go through it.

$$* * *$$

We dashed, as well as twelve drunk people can dash, across the Pont Royal – a bridge spanning the Seine that took us straight over to the Tuileries. The park was teeming with people, and in the darkness I could see row upon row of trees – all in straight lines, like a procession in single-file. The iron gates were so pretty, and there were balustrades all around, which caught the light and cast shadows on the sandy ground. There was a stage area set up in the middle of the gardens, with a massive pair of speakers. To the left were the Ferris wheel and the carousel, both in full swing. It felt like a real public party; there were still some families out and about, even though it was getting late, and everybody looked like they were having a good time. There were neat rectangles of grass all around, and the occasional neo-classical nude sculpture on a plinth. It was a very prim and proper garden. It had originally been the garden of numerous French kings, so it was perhaps not surprising it had such a regal air, despite the monarchy having been done away with so long ago. Anyway, tonight it was Natalie's turn to rule, and it was not long until she appeared on the stage with her fellow dancers. A digital screen behind them played what I imagined must be the new video she had been working on. The dancers on the stage were perfectly synchronised to what they were doing on screen. It looked very professional to me. I made my way up to the front of the crowd that was standing in front of the stage, hoping that Natalie would be able to see me and know that I was there. She was too involved in the routine to notice me during the performance. I'd lost the rest of the Associates, but Antoine had sent another message out to everyone telling us the details of some bar nearby where he would have a table reserved for us from quarter past eleven, so I hung around to watch the end of the performance. It went down very well with the crowd, who applauded, cheered and whistled at the end. The dancers were clearly all on a high, and were smiling as they tried to catch their breath and take in the atmosphere. I watched Natalie come down some steps to exit the stage, and I managed to catch her before she went backstage.

'Natalie!' I shouted.

'Adam, you made it! What did you think?'

'You were amazing!' I gushed. 'You nailed it!'

'Yeah, we did, I think,' she said, clearly pleased that I was so enthusiastic. 'It all came together. The rehearsal this afternoon was a total disaster, but they say it's often that way – a bad rehearsal then a good performance.'

'Did you hear that reaction from the crowd?'

'It was so nice. I haven't performed in front of an audience that large before. It really gives you a buzz. I'm on such an adrenalin high.'

'I bet you are,' I said, grinning at her.

'You're in a smiley mood – have you had a good night?'

'Yes,' I replied, 'it's been an incredible night, and it doesn't look like it's over yet. I'm with the Eleven Associates of Alma-Marceau – we're meeting in a bar across the road in a little while if you'd like to come with us?'

'Oh that's very sweet of you, thank you. I'm going on somewhere with the rest of the dancers to get some food – we couldn't eat before the performance but we're ravenous now. Listen, I'll catch up with you in the foyer over the weekend, right?'

'Sure, that would be great. I want to watch the video again too, I didn't get to take it all in during the live performance.'

As I was speaking, I spotted a couple walking past us, and recognised the woman. It was Susan Farnsworth, the Head of the British Council of the Arts, whom I'd met just the day before.

'Good evening, Mrs Farnsworth,' I blurted.

'Oh, good evening, Adam,' she replied politely. 'How very nice to see you out enjoying the festival this evening. And a good evening to you, too, Natalie.' And with that, she and the man accompanying her continued on their way. He looked Middle Eastern or North African. I was confused though.

'How do you know Susan Farnsworth, Natalie?'

'Oh, yes, right,' she replied. 'Of course, yes, that is a coincidence, isn't it?' She paused briefly. 'She was responsible for a project with the British Council of the Arts that I worked on a while back.'

'Ah, of course. It is a small world, isn't it?'

I said goodnight to Natalie and made my way in the direction of the bar to join the others – Le Bar de L'Europe. It was packed to the rafters, and I struggled to see where they were sitting, so I started making my way around the different tables to see if I could spot them. I was getting close to the bar, and sitting at a table right next to me was none other than Emilie. She was looking at her phone. She seemed a bit the worse for wear, like she was totally hammered. I wished I'd just looked away and pretended I hadn't seen her, but I thought that would be rude. I'll just say hello, I thought.

'Hi Emilie,' I said, smiling at her. She looked up from her phone and gave me what can only be described as a scowl.

'Listen,' she said. 'Why don't you turn around, walk out of this bar, and fuck right off?'

I couldn't recall ever being spoken to that way by an adult. It's different with your friends, of course, but she wasn't a friend, and she wasn't joking.

'Oh, I'm sorry to have disturbed you,' I said. 'I was just leaving now, so have a good weekend.' Just as I was turning to make my way out, I saw a man arriving back at the table with two drinks, presumably one for her and one for him. He nodded at me without smiling, as if to acknowledge me. It was that guy from the meeting yesterday – the security guy from the French government. So I was right. I knew they were eyeing each other up in that meeting.

I made my way out of there sharpish. What was I going to do now? I couldn't join the Associates. I wondered about just going back to the foyer, and started walking down the road. There were still lots of people milling about outside, and there was music playing in the gardens. I noticed a poster advertising the Louvre's participation in the Nuit Blanche. It said that the museum was open for free during the festival, and open until midnight. It was right there in front of me, opposite the Tuileries. My first chance to see the Louvre – I had half an hour or so to spare, and could maybe join the rest of the gang a bit later on. I texted the group as I walked over towards the museum's famous glass pyramid. It was stunning, surrounded by a huge courtyard itself flanked by three sides of a giant and impressive neoclassical building, with fountains all around. There were stars visible in the sky above, and the moon was shining brightly. There was no queue outside so I walked straight in. I descended into a huge reception area and looked up to marvel again at the night sky through the glass ceiling. The floor was shiny and beige, like being in an Egyptian pyramid, if they had been made in the future. I soon started to get a sense of just how huge this museum is. There were signs leading off in all directions and I suddenly realised there was no way I was going to get around everything in just half an hour. Well, I thought, I'm here for a couple more weeks yet, so I can come back again. And with that, I plumped for a wing called Denon, which seemed to cover quite some ground, from ancient Egypt to ancient Greece, from eighteenth- and nineteenth-century French art to Italian and Spanish painting.

The corridors were long and wide. Everything about the place was grandiose, giving a real sense of the power and affluence of Paris throughout history. I quickly gathered that the museum was built on the ruins of a medieval castle that had once dominated the Parisian landscape, and had been a royal palace before the Revolution. As I strolled through the galleries of French painting, I saw some works I had seen in reproduction – *The Raft of the Medusa* by Géricault, *Liberty Leading the People* by Delacroix, and *The Oath of the Horatii* by David. I was overawed, starstruck in a way. These were paintings my grandfather had shown me pictures of, and now here I was, standing right in front of them. I pretty much had the gallery to myself.

It didn't feel real, somehow. Indeed, I was feeling slightly delirious as I walked from painting to painting, stopping to stare at the many gigantic canvases, displayed in such beautiful rooms. I was genuinely moved by the sheer quality of the paintings surrounding me. I was, however, also feeling thirsty by now. I wanted to come back, to see everything properly, and sober.

As closing time was fast approaching, I resolved to find a toilet and to drink some water before seeing if the Associates were still nearby. As I was walking down the corridor, some security guards and invigilators were encouraging people to start leaving the museum. I turned my head to the left and looked through the open doors of one of the galleries, and noticed a cluster of people standing in front of one painting – just that one, no others. I was curious to know what they were looking at so attentively, so I popped in to get a closer look. The group of people must have numbered around a dozen, and as I approached, four very fashionable Japanese girls turned towards me. They were all holding their mobile phones and snapped a couple of selfies on their way out of the room. It looked like there were some people in fancy dress enjoying the night's festivities. Three men were dressed in identical outfits – as albino monks, each walking with a limp. I carried on towards the remaining cluster of viewers. Of course, I said to myself, as I saw which painting they were looking at, it would have to be *The Mona Lisa* that was still drawing a crowd at ten to midnight. I kind of didn't want to see it; it was such a cultural cliché. But part of me really did want to see the real thing. I was so close, it would be stupid not to even *look* at it. An invigilator reminded the visitors that it was time to leave, and as more of the small crowd dispersed dutifully, I seized my opportunity to stand in front of it. I hadn't realised just how small it is. But it did have something special about it – an air of mystery, just like people say. It was definitely more special to see it in the flesh than in reproduction. There was a certain tactility about the cracked surface, an indescribable finesse in the layers of paint, the subtlety of the artist's touch. I was drawn to the landscape behind the Mona Lisa – it was so rich, so beautiful, so dream-like. The sky dissolved into the distant mountains, and streams flowed through sinuous valleys below. I was gazing at the horizon, where what looks to be a mountain lake hovers just beneath the sky.

Then I saw it. A face in the clouds. As clear as day.

On the very edge of the painting, where the clouds merge with rocky mountain tops, an angelic, cherub-like face in three-quarter profile stared in towards the Mona Lisa, its lips pouting as if to blow the wind. I could not believe how visible the face was, just sitting there on the horizon, hidden in plain sight. There was no mistaking it. I wondered how I had not seen it before, all those times I had looked at the picture in books. Grandad's face in the clouds. I had spotted it within half an hour of visiting the Louvre. Had he known about it all these years? I could feel my heart racing. But maybe I was hallucinating, or just drunk.

VIII

## LOOKING AT THE INVISIBLE

The next morning, or perhaps I should say afternoon, I woke up with a bona-fide hangover. It was not a sensation I was used to, and I had no intention of making a regular habit of it. I didn't really remember getting back to my room, and as I slowly and agonisingly came round my memory was catching up with some of the last events of the night. I recalled meeting up with the Eleven Associates after the Louvre; I know there was gin involved, and shots served from bullet holsters by young men and women wearing Wild West outfits, or the minimum that would be required to constitute a cowboy and cowgirl outfit. I remember dancing, badly, in a circle with some of the group, and Anne-Sophie and Alicia laughing with me. So how did I get home, exactly? Well, that I still couldn't quite figure out. Anyway, I felt rough, and after a hot shower, made my way downstairs to the Violin Noir for a bad cup of tea. I needed two teabags to make it taste vaguely like a British cup of tea. I also needed sugar – two – today. I was hungry so I ordered a *salade royale* – a salad composed primarily of meat. I had no idea what I was eating, but boy did it taste good. If I had known what I was eating, it might have changed how I felt about the meal, as it turns out that I was chewing my way through a combination of chicken hearts, duck gizzards, smoked duck, fatty pork cubes and small blocks of *foie gras*. Not the average menu back home. Anyway, without thinking too hard about eating a plate of warm offal, it had definitely hit the spot, and played a significant role in bringing me back into the land of the living that Saturday afternoon.

I had to get back to the Louvre. I needed to go and see if I could still make out the face in the clouds I thought I had seen the previous evening. Had it just been the absinthe messing with me? When I arrived at the museum, there was a long queue snaking its way around outside the glass pyramid. There was nothing for it but to join the queue. As the sun came out from behind some clouds, I started to get warm, then very warm, and soon after, very thirsty. Once finally inside I queued again to get a drink from one of the cafeterias inside the Louvre concourse, which was full to bursting with tourists from all around the world. Finally I was ready, and made my way through the crowds to stand in line to have a minute with *The Mona Lisa* once again. The excitement and awe among the assembled visitors was palpable, the chattering, jostling and vying for a chance to snap a selfie with perhaps

the most famous painting in the history of the world, was shared by young and old from all four corners of the Earth. It was interesting how many people smiled at some point while they were in front of her. I watched the viewers as they stared, if only briefly, at this little rectangle that had come to symbolise the ultimate painterly achievements of humankind. It is said it had once hung above a bathtub.

Even from several metres away I could see the face in the clouds. I couldn't *not* see it. It was just there. And it did look pretty similar to Grandad's illustration for the shisha tin. The face in the clouds in Leonardo's painting struck me as beautiful and enigmatic, like people endlessly say about the Mona Lisa's smile. I tried to take a photo, but with the protective glass and the mass of bodies squirming around me, I decided I would be better off going to the gift shop to get some postcards or posters, which I did on my way out. It was impossible to *un-see* it now.

I wandered the streets for a while, aimlessly, just thinking about the face in the clouds. I mean, what are you supposed to do in a situation like this? I wanted to speak to my grandad most of all, so I put in my earphones as I strolled around the banking district. It wasn't all that busy because it was the weekend, which meant I could speak freely and hear what he was saying. I rang his mobile and got through after just a few rings.

'Good afternoon,' came Grandad's voice.

'Grandad, it's me, Adam,' I said. My name should have come up on his phone, but he didn't seem to have got the hang of that yet. I suppose after fifty years of using a landline it was going to take some time to get used to using a mobile. He and my gran had only really started using them in the past few years. As they were at home most of the time, they didn't really have much need for them. But because my mum and dad had been getting increasingly concerned for them in their old age – worried about one of them being out for a walk and having a fall in the park – my dad had pretty much forced them both to have one, and worked hard to get them used to charging them up and keeping them switched on.

'Oh, Adam, how lovely to hear you. Why haven't you come to see me this weekend yet?' 'Grandad, I'm in France; I'm in Paris – did you forget?'

'Oh, of course you are, my boy, of course you are.'

'Are you okay Grandad? Have you had a good week?'

'What? Hang on a minute, let me turn my hearing aid on. What was that you said?'

'Have you been okay this week, Grandad? Is everything alright?'

'Oh yes, everything is shipshape and Bristol fashion here my lad, never felt better. I've been working on my latest project – repairing an old wireless a friend of mine was throwing out. He's moving into a retirement flat in Five Ways soon and needed to get rid of lots of his possessions as there won't be room for all of them in the new apartment. I went to give him a hand and

spotted this old beauty in his spare bedroom – an EKCO from 1946. One of the valves needs replacing by the looks of it, so I've been tinkering with that. I'll get it all fixed and cleaned up, then I'll give it to the wireless club.'

'Did you have to go and see Alice at the shop?' I asked.

'Oh yes, she had exactly the right parts I need to get that valve working again. She said to send her best wishes to you, Adam.'

'That's nice,' I said. 'Please do send mine to her next time you go in. Listen, Grandad, I found the face in the clouds... at the Louvre... I saw the face you drew on the shisha tin.'

'What's that, my lad? A face in the clouds?'

'Yes Grandad, you told me to see if I could spot the face in the clouds, and I found it in *The Mona Lisa*. I can see it, I can see it right there!'

'Ah, the face in the clouds. Yes, of course. Wait a minute, I think I have a tin with it on the lid.'

And before I could stop him, he'd gone to try to find the tin that I was holding in my hand. He returned to the phone a short while later, as I tried to calculate roughly how much of my data allowance this wild goose chase was costing me.

'I can't seem to find it. I had a tin with the drawing I made on the lid.'

'I know, Grandad, I've got it here. You gave it to me to bring with me to Paris. Don't worry, I'm looking after it for you.'

'Well done my boy, well done. So you found the face in the clouds?'

'Yes, within half an hour of being in the Louvre. But is it really there?'

'That's the beauty of it, Adam, the face is a riddle.'

'But does anyone else know about it?'

'A few people might have seen it over the centuries, I suppose.'

'But if they did, why didn't they say anything?' I asked, perplexed.

'Sometimes people don't want to listen, and sometimes a mystery is more interesting than its answer.'

'So did you not tell anybody about the face that you could see in the painting?'

'I put a picture of it into the hands of millions of people around the world, Adam,' said Grandad, laughing. 'All of them smokers!'

'I guess you did, Grandad,' I answered, also seeing the funny side in his approach.

'I've got to go now, David, but it's been lovely talking with you. So you've seen the face in the clouds – you must tell me what you make of the horse when you get to that.' And with that, he hung up.

* * *

I spent the rest of the day, and all of the evening, in my room. I sat at the desk poring over one of the prints of *The Mona Lisa* I had bought. But how do

87

you write about a painting? Where do you start? It's just a woman sitting against a landscape – I mean, what more can you say about it? I started making some notes, but they were terrible. Nobody would take the idea of a face in the clouds seriously, let alone coming from me, just a teenager. After an hour or two of trying in vain, I was ready to give up. Maybe it wasn't even worth trying. How many words must have been written about her over the centuries? What more could I possibly add to that? I looked at my pen and the pad of paper in blank despair.

But one thought kept me going. I could see the face in the clouds clearly – as clear as day. And if nobody else had seen the face in all this time, surely I could at least find a way to write about it? Occasionally I would stand at the window, staring blankly outside, just thinking it all through. What was it Sebastien had told me just last night about it being better to think for longer about paintings before speaking about them? He'd also told me that I can describe the things I can see 'perfectly well – quite eloquently', yes, those were his exact words. And then my English teacher had always said I was good at describing things, so maybe that was the best place to start. Yes, I would just try to describe what I could see in the picture. I started furiously making notes.

I'm looking at a painting of a woman. A young woman. How young I couldn't say – perhaps as young as a teenager, perhaps as old as her early thirties. A young woman with her back to a landscape with sky, mountains, water, dry land and a bridge visible. So far so good. The painting is a portrait – she dominates the wooden panel on which she is painted. She is posed, as if sitting to have her portrait painted. She sits on a chair that faces pretty much straight out to the left of the painting, though her body is twisted a little towards us. Her face is then also twisted a little in relation to her body, so her head is almost facing us straight on. Her pupils are positioned to the left of her eyes, and these are the only parts of her body that are fully facing us. Her eyes are staring straight at us, exactly where the artist stands. We and the artist have the same point of view, and we are in her gaze. It's like her whole posture, the positioning of her body, is telling us about the physical process of her turning towards us to look at us and to engage with our gaze. Maybe this is a painting about looking, and being looked at.

I was getting into the swing of it now; although I didn't realise it at the time, what I was doing that evening was practical criticism, the process of thinking through a painting and trying to analyse it based on what you can see. I wanted to consider every visual aspect of the painting I could think of. I wanted to figure out how to think about a painting, how to order my thoughts about it, and before reading all the books.

I've looked at her posture – a kind of three-quarters profile. Her left arm is resting on the curved left arm of the wooden chair she's sitting on, her right hand gently clasping her left wrist. Her hands are soft, her fingers elegant and smooth. These are not the hands of someone poor, who has had to work hard since childhood. Her sleeves are golden and silky, the fabric designed to hang like ruffles, drawing our attention to the sheen of the fabric, the light contrasting with the shadows. This kind of cloth was presumably not the cheapest, though it doesn't look particularly luxurious. The sleeves are of a different fabric to that covering her upper body and chest; perhaps it is a kind of blouse underneath a loose dress. I can see that the dress itself looks black, and appears gently gathered to allow the fabric to flow down in ripples, which are picked up in light grey highlights. There is detailed embroidery around the neckline of the dress, a braid in golden thread – overlapping, interlocking rings, over and under, contained by tight little spiral hems above and below. Beneath the braid is more embroidery forming a loose oval pattern that dips every third cycle into a stitched cross shape. It is detailed, dainty needlework though it is not the most showy of dresses, especially for a formal portrait. There is something understated, almost funereal about her attire – perhaps she was a young widow or had recently lost a child. I need to research mourning clothes of the time. The neck of the dress is quite low, though not immodest, starting just beneath where her bosom begins.

She wears a translucent veil that serves as a delicate hairnet. It is black or dark brown, and so thin it is almost not there at all, an ethereal garment to match the ethereal landscape that can be glimpsed through, as well as around it. It spans the top of her forehead in the slightest of arcs, before falling down over the golden-brown, auburn ringlets of hair on either side of her head. Almost every hair is visible, painted with such care and precision the brush itself can't have had many more hairs on it than the strands depicted! The hair ends just shy of the top of her blouse. The veil, however, continues its downward journey, as if turning into a scarf or shawl. It twists from behind her left shoulder, over her neck and the top of her shoulder and carries on all the way down to her elbow. The light, golden silk sleeve can still be seen through the veil, as can the little white puckered sleeve at the end of her black blouse – perhaps there is even a tiny white bow there. A swirling, scarf-like swathe of the veil drapes over her shoulder, down towards her lap. At the other end, it trails down her back and flows over the outside of the arm of the chair and off the bottom of the panel. The veil can also be seen over her right shoulder, billowing like a flowing stream down her arm towards us.

This time, though, the end of the sleeve is thicker and bulkier than on the other arm, and the veil follows it around the curve of the top of her forearm.

What struck me as strange that evening – and still does today – is how everything is painted so very carefully, with such refinement and attention to detail, apart from the fabric that hangs underneath her right arm and covers where her lap must be. It is a strange, shapeless, formless mass. It doesn't quite add up or make sense within the painting, somehow. Maybe he never quite finished the painting. I got myself a glass of water before moving on to consider her face.

What to make of her famous face, of her features? She looks quite unusual to me. She doesn't look like most other women you see in old paintings. The absence of eyebrows makes her look a little strange from the outset, and her pallid olive complexion is presumably not helped by several centuries of light, dirt, decay and faded varnish, but even so, her features are unusual – those almond-shaped eyes with their deeply defined eyelids, her fleshy left cheek and of course, her famously enigmatic smile. Yes, it's true, it is an enigmatic smile. Look up close and the left-hand corner of her lips suggests the very faintest of smiles, but look on the right-hand corner and the smile appears much more pronounced. The very corner looks to be raised up higher. Stand further back, and the smile is even clearer, presumably due to the blurry shadow that sits just above the corners of the lips. It's as if our brains are trying to interpret slightly different signals from her smile at the same time – just how much is she really smiling at us? It's kind of important in life to be able to determine the degree to which someone is smiling at us, and the nature of the smile – people might smile politely, knowingly, confidently, nervously, proudly, contentedly, when amused, when bemused, when feeling smug or superior, out of genuine affection for friends and family, from sexual attraction, when suppressing other emotions or hiding other thoughts, or any number of other reasons. What does this woman's smile mean? What's her story? Why is she being painted? Who even is she?

I felt a real urge for more knowledge, to understand more about the painting, and what is known about its sitter. Reading stuff online can be useful, but it's also pot luck. I wanted to read proper books, written by art historians. But what could I say about her that night? I decided that the Mona Lisa seemed quite an unusual portrait subject to me. She is simultaneously unlike any woman we might encounter in real life, yet she is also deeply realistic, believable, human. She is not a caricature or a type and

her face actually looks different each time I look anew at the image. That long evening, that late night, I got to know every inch of the painting, every mark and every last crack in its surface. Or I thought I did. Every time I have looked since the whole painting seems different, I notice new things in it. It is so rich, so complex – there is so much going on within these few square inches of paint, you can keep looking at it and it will keep on giving you more. I walked around the room, pacing up and down. I felt better acquainted with the young woman now, that was for sure, though the longer I looked at her, the more I thought about her expression and what she might be thinking, and the less sure I could be about these things. Maybe I would never know. But perhaps the rest of the painting could yield more clues, shed more light on her personality.

Where is she, exactly? She sits in front of a balcony, presumably made of stone. It is hard to see if the two decorative features on the top of the balcony, flanking either side of the panel, are the bases of little, thin columns, though I think on balance they probably are. If so, she's sitting in a portico or colonnade, perhaps under an arch that is beyond the top of the painting. These pillar bases both seem a little translucent, as if the paint has faded away to expose the layer beneath. This fading has a ghostly effect, whether intended or not, that chimes with the creeping sense of uncertainty that unfolds the longer you spend with the painting.

So, if we're with her under the colonnade, how come her face is so brightly illuminated? The light source is clearly to the left of the painting as the shadows on her face and body fall to the right, and fairly acutely. Curiously, the same shadows do not fall on the bases of the thin columns. The light and shadows in the landscape sort of tally with those on the Mona Lisa herself – light from the left and above, shadows to the right, though the light on her face looks much more intense and immediate – more like from a lamp or fire than the sun. The light in the landscape looks more diffused, less intense. Either we are on a bridge or outdoor terrace of some kind allowing daylight in from the left, or she was painted somewhere with a different light source to the outside world. Maybe this was a real woman who actually sat for Leonardo, and then he painted everything else in around her, like a backdrop, a stage set. Either way, the column bases don't cast the right shadows, and Leonardo must have known this. Furthermore, the balcony seems to have been painted differently on her right to on her left. Do these things matter? Was it a deliberate, if covert, attempt to paint a painting that is outside of time, not beholden to the path of the sun?

Was I over-analysing the picture now? I lay down on the floor for a while before drinking some water and coming back to the print once again.

Now, the sky. Disregarding, for a moment, the face in the clouds, what else can the sky tell us? It looks generally to be blue, though it seems a bit discoloured over time, a yellowy-greeny-brown tint cast over the blue behind. This dirt or discoloration lends itself to ambiguity – it's hard to be certain what is original and what has been altered by the effects of time. The sky is definitely lighter closer to the horizon, suggesting this is either early or late in the day, an idea reinforced by the length of the shadows being cast from the rocks onto the water. The golden light of the painting – perhaps partly an illusion caused by ageing – makes me veer towards evening, as if we are witnessing the sun beginning to set after a beautiful day. Might it be that she herself is depicted by night, while the landscape around her is in daylight?

I didn't know, but I was enjoying thinking about the idea. I'd already come quite far in just a few hours. I'd never thought so deeply about a painting before, but I could feel that there was still a long way to go, and maybe there was no end to be reached.

The sky dissolves into the distant mountain tops. It's hard to say if it is cloud, fog or just the effect of light over distance. The mountains have a touch of the blue that you can see if you look at mountains far off. The sky peeks out around craggy rock formations that may be the result of some sudden geological event long in the past, or of gradual erosion by water and wind over the course of millennia. Yes, while the clouds feel very much in the moment, the here and now, mountains such as these are ancient. Clouds move quickly, rocks change slowly. The mountains behind her on the one side block the horizon, but on the other, the sea meets the sky. There are clouds here, I would say. The rock formations next to this flat passage of horizon are jagged – razor sharp, even. They are strange. Can mountains like this be seen in Italy?

While the painting gives a clear impression of what we might be looking at in the landscape – rock formations, lakes and streams, sinuous paths – there is actually quite a lot of ambiguity in terms of the details. Mountain tops blur into the sky, rocks elide with water, clouds might be mountains. While the Mona Lisa is sharply defined, it is as if the landscape behind is in soft focus, just like when we are looking at something near to us. Were there paintings earlier than this, or before Leonardo, that had backgrounds painted in soft focus, with such ambiguity? This painting captures a sense of how our eyes see in the real

world – things do become vaguer the further away they are or if we are not focusing on them; distant mountains can sometimes look blueish from far away; and in fog and mist things do become harder to discern. When edges and boundaries become fluid, unclear, this is the place where uncertainty can appear. Ambiguity begets the imagination.

Leonardo's painting encourages our imaginations, and in different ways. At the time of painting, the sitter's identity might have been known to any number of people, if indeed, it was a real portrait of a real, or single, sitter. Do people agree on who she is? But it is as if Leonardo is encouraging visual speculation here. It is as if he is asking us, what are you are looking at? And in very literal terms – what are our eyes telling our brains is going on in the landscape? Perception and cognition are not always stable. Perhaps the visual information in the background of *The Mona Lisa* is so ambiguous that our brains are either prepared to just accept that level of uncertainty, to live with ambiguity, or automatically fill it in to make sense of it. Are there any trees on the horizon, or only rocks? Where do rocks end and clouds begin? Why isn't the water surface flat on the right-hand side of the horizon? What happens to it on the left-hand side of the painting? Does it disappear behind rocks and then reappear at the very left-hand edge, a thin, almost horizontal line? Why does that surface look higher up than the land from which the water must flow down to it? The perspective feels different on the left-hand side to that on the right. Was Leonardo looking to paint a complicated landscape? One that was unlike any others painted before? One where the banks of the river and the coastline of the sea are not always clear, where mud and sand and rocks merge?

Yes, the ambiguity of the landscape increases the further away it is. Nearest to us, we can see quite detailed rocks, their valleys and crevices, their sharp peaks battered by the elements matched by the flowing lines of centuries of erosion from the tide. The winding path is so clearly defined we could almost be sure of our own footing on it. On the other side, the bridge is so precisely painted we could recreate it and walk across it, should the need arise. Having said that, it seems to me that there are unusual elements. That odd-shaped passage of red paint just beyond the balcony on the right – what does that represent? It is so strange, so far from depicting anything convincingly nameable. Beyond that things become less and less clear, as if we're moving from reality to the imaginary, from the known to the unknown, from the seen to the not quite visible. Here in the foreground, the Mona Lisa, alive and real, in the here and now, crystal clear; behind her the ancient world, an age-old landscape, slowly shaped by the forces of time and the elements, slipping

beyond the visible realm. As time passes, as distances are travelled, many things can become less clear – like memories fading, becoming confused. Myths and legends feed on the past. Could it be that Leonardo is telling us that we only see as far as our eyes can perceive, and beyond that perception turns to the unknown, to the imagination, to fantasy? I like the idea of a convergence between distance, time and perception.

I stood up and paced around the room, breathing deeply. I don't think I'd ever had thoughts as complicated as these before. Maybe it was all rubbish but it felt so urgent to me. My hand was starting to ache, but I couldn't stop writing. It was pouring out of me.

Leonardo takes us to the point where what makes sense to our minds, yet perhaps cannot quite be seen, tips over into the realm of imagination. It is a tipping point, though, and it requires a shift in how we are looking. To look for things in an image that are unexpected demands a certain kind of thinking. The brain is thinking laterally, looking to be caught out, or for things that are not quite as they seem. Sometimes our brains click into that frame of mind of their own accord when triggered by something unusual, something uncanny. Other times we are told that this is the aim of the activity, like a puzzle or a game, so we come to an image prepared to think in such ways. It's only a game if you know that you're playing. But the face in the clouds, that face in the clouds…

I sat staring at the face, then at the wall behind my desk, then back at the picture, then up at the ceiling, then back at the picture.

So faint it is almost not there. So brazen that it almost jumps out. At first, so hard to see, or to imagine they can be seen, the blue-green marks are just whispers on the horizon. These marks are more like smoke than clouds, just traces upon the sky, gone in a moment. This passage of paint struggles to convince as clouds, or as mountains. Then, out of the wisps of smoke, a face emerges, comes into sight, takes form. The forehead is almost pure sky, though it has the gently curving form of the skull that can make it human, familiar. The bridge of the nose is so clear, so convincing, the light continuing down in the slightest of highlights, widening as one would expect at the tip of the nose. Both eye sockets are in shadow, the light falling from above to simultaneously illuminate both cheeks. The face is puffy, like a chubby child, a cherub. The shadow carries on down the edge of the right-hand cheek, darkening at the jowls and jawline, curving round as you might expect when forming a chin. The mouth is pouting, as if blowing.

94

The left-hand cheek has the slightest of shadows that both defines the fleshy cheek and the clean outline of the face. It is brilliant, it is haunting, it is an enigma. Perhaps it depends on me, on us.

We don't see the face in the clouds because we're not looking for it and we're not expecting it. It makes no sense being there, unless we think of it as an angel, or, more compellingly, as the wind personified. This painting is a portrait, so we would perhaps not expect it to contain an allegory like this, though surely paintings throughout history are full of allusions and references to their sitters through symbolic imagery. Is there any way of being sure if there is a face in the clouds in *The Mona Lisa*? Is there any way of knowing for sure if Leonardo intended there to be a face in the clouds, or whether he was aware that this passage might look like a face in the clouds? Did he intend for a face to be visible yet to remain unseen? Has this face been staring out at us for hundreds of years, without us knowing, without us seeing? Could it be possible that Leonardo was painting the invisible? Or is it simply not there? Are my eyes and mind deceiving me? Does my mind instinctively want to seek out faces, to find hidden faces?

The next big question was whether there might be any other imagery of this kind within the painting. Grandad had mentioned a horse. I stared intently at the landscape, trying to allow my eyes to roam free, and to be open to suggestion. It was difficult. Nothing stood out or emerged from the landscape. Once again I was close to giving up and going to bed. But coming back once again to the painting, I must have become better attuned to this way of thinking, this way of seeing. Suddenly a door opened, a veil lifted, and imagery began spilling out of the shadows. Things started to look odd that had not looked odd to me before, though I now found it strange that they had ever looked normal, so strangely had they been rendered.

The landscape seems almost abstract; where clouds become mountains, where mountains become trees, where trees become rocks and coastline, and where coastline becomes water, are all so blurred. It is within this blurriness, this haziness, this ambiguity, that the imagination can run free. It is in the shadows that our eyes and minds start to doubt each other, and from here that the imagination stirs. Something has awoken deep inside. My eyes have conspired with my imagination, through Leonardo's landscape, to see things both curious and wonderful, as if I am hallucinating. The landscape has become as fantastical to me as Xanadu, full of drama, of mystery and glimpses of things coming briefly into focus only to disappear again. Thoughts half-formed, things half-seen, memories half-remembered. A flash, like a few frames of footage

that momentarily conjure an image but are gone before the eye and mind have had chance to be sure of what they think they have seen.

It seems to me that it is not simply a process of just looking more closely at the painting, however. It involves different kinds of looking, of subtle switches in focal range, of connections between neighbouring imagery, joined up in unexpected ways, more like patterns on a flat surface on some occasions, through and across perspective on others.

A pair of ghostly faces appears in the rocks on the left-hand side, around the height of the Mona Lisa's nose. They are green-blue, as if caught in some otherworldly half-light, perhaps illuminated by moonlight in the mouth of a cave. A long, male face in front, and a woman or child clinging to his shoulder, as if whispering anxiously in his ear.

Next to come into focus, an owl in flight, its wings spread out, its claws in front as if about to pounce; its eyes and beak, glinting like pearls and a silver blade, stand out against the darkness of the rockface behind. The owl is poised to fly out of the left-hand side of the painting, as if it has flown on a path from behind the Mona Lisa's head, right in front of the whispering couple. You can almost hear it screech as it flies by. Above the tip of its right wing, a man with hunched shoulders, a large nose and thick-set brow walks across the horizon where the mountains touch the sky. It is like he too is illuminated by night, though this time by candle-light, about to enter through a dark doorway. In his left arm, perhaps he carries a tray, and on it, some object that could be a pear or a bell. His right arm hangs by his side, his hand poised as if to open a door knob. But then, strangely, his head morphs into the chin of a larger, paler head, jutting up into the sky, like a projection. His features are strange, devilish almost, with a thin moustache and goatee beard and a sickly smile. His face is long, his nose long, his left eye small and pointed beneath the brim of a hat that pokes out over his ear. Stranger still, this face then morphs into an even larger, paler face, this time in profile. This face too is devilish, perhaps the same face as the last. It's a sequence of overlapping heads and faces, superimposing in such a way as to make each other more obscure, buried, harder for the eyes to identify, to separate out. You have no chance of seeing them if you're not looking for them, and can't be sure when you have found them.

And then it appeared, right there in the sky: out of these three strange interconnected faces the horse's head emerged. No wonder the facial features of the men seem so odd, they are combining to form the most delicate impression of a noble horse's head, its nose brushing up against

the side of the painting, its ears pointing to the heavens. The noseband, bit and martingale tell us this is no wild beast, galloping across the painting from right to left. It is completely, and unequivocally, ethereal. It is both so vivid and compelling yet so intangible, so close to not being there at all. I can see the most beautiful horse, but I can't be sure that it can be seen. I have seen an invisible horse.

The distant rocks suggest yet further apparitions, though they are so slight as to be fleeting thoughts – a man kneeling in front of a standing woman, a melancholic ghostly face like a lost soul trapped in the rocks. Nearer to us, on the near bank of the water, are monstrous faces, in toad-like green, facing up from the rocks towards the sky, like death masks on beastly tombs pondering their mortality for eternity. Their brows protrude, their noses are small, their chins pronounced. A vulture sticks its head into the mouth of one of these apparitions, and in front, a young woman, perhaps the Virgin herself, sits or kneels behind something that could, with just a small leap of faith, be the Christ child in swaddling clothes. The rocks flow like sheets of fabric down to the path below, illuminated with a glowing, golden light.

I allow my eyes to pan out from these rocks, and to my surprise, my imagination has been hit by the image of a giant field mouse, sitting on its hind legs, its front paws raised to its chin in front of its furry whitish underbelly. A tail comes out from beneath its body to merge with the path. It is sitting there as bold as brass. It's like the mouse is coming out in negative space, projecting forward out of the painting, though the rocks and path it is composed of recede towards the water. It is mind-bending, dimension-warping – where perception meets metaphysics. Did Leonardo find the holes in our perception, the gaps in our cognition? Can these things exist in the space between the eye and the mind? Can they have been hovering there over the centuries, never quite forming as thoughts? Can I believe my mind's eye?

In the rust-red rocks opposite, a man's face in three-quarters profile might be discerned. He looks quite young, and there is perhaps long hair or a hood on either side of his cheeks. His eyes stare downwards. The realism is quite unsettling. While other faces look like characters, or caricatures, this man looks like a man, and is all the more disconcerting for it. More faces threaten to appear but fade before they take form. On the right-hand side of the painting my mind reads the section of river with the bridge as a distorted skull, the bridge arches like teeth and a dark eye socket above. Continuing upwards, there might be phasms and phantasms, faces and traces of things not dead, not living. Faces emerge

from other faces. The face in the clouds triggers a cascade of one, two, maybe three more faces, facing in different directions. These could be the spirits of the dead, the underworld playing out its existence just below the surface of our vision, just beneath reality. Are we on the shores of Acheron? For those who believe, or those who wish to see, all of the enigmas, all of the mysteries, all that exists beyond mortal life, beyond the rational world, can be found here. These things, these strange illusions, are like ambassadors to another dimension.

Now with my imagination completely unshackled, these fantastical projections might even envelope the Mona Lisa herself. A vulture across her body, its head draped over her arm to face the floor; reversed it becomes a swan resting its head over her arm, nestling into her body. A hooded figure in her sleeve, a woman's face in her own hair, their hair shared. The painting leaves impressions deep in my subconscious of hands, beckoning, gripping, pointing, of things seen from behind, or from afar, or up close. The mind's eye is free to travel around the painting however it wishes, though always under the spell of the artist's hand. Our imaginations dance to the tune of Leonardo's brush. It feels mystical. It feels like I have entered another dimension. A man's face distorted in a crimson disc. While I feel illuminated, I simultaneously leave with only more questions than I arrived with. The painting asks: what do you think you can see? Leonardo asks: What do you think I can see? Or maybe he asks: What do I think you can see?

Yes, the eye and mind can conspire to find shapes anywhere, can invent imagery where it does not exist, but is it possible to believe that certain kinds of painting can encourage and invite us to project into them, and that certain artists are capable of shaping what we might project?

It was a long, incredible, mind-blowing night with *The Mona Lisa*. In the years that have passed since then, I have never experienced anything quite like it again. I can safely say that I have come across very few artworks that have the ambiguity and complexity of Leonardo's little painting. That night I was excited, mildly panicked, elatedly delirious, my eyes sore and my head spinning. I did not know quite what to make of it all. I felt as though I had been on some amazing, transcendental adventure, though I was no longer sure if I could trust either my own eyes, my mind or the images that surround us. My visual world had, in just one night, simultaneously become utterly unstable yet opened out into endless possibilities. Had I lost control of my senses, abandoned reason, gone on a flight of fancy, or was there something more to this, even just a faint possibility of some truth within it, something really, deeply, profoundly special? I crawled into bed, completely spent.

## MIND GAMES

I woke up at midday. I could only have had a few hours' sleep. I was ravenous, so I took a short stroll to The Crescent Moon – the Moroccan restaurant I had been to the other evening with Natalie and Amira. I was developing a taste for North African and Middle Eastern cuisine. It was another sunny day in Paris, and I was early enough to get myself a table outside under the shade of one of the olive trees. The same elderly waiter who had served us the other evening came over with the menu. He was a large chap, bald save for a few wisps of hair, though he had a stubbly beard and hairy arms. He recognised me and smiled. I picked a couscous dish with grilled meats – chicken and spicy merguez sausages. I had not been there long when Ammon appeared. It could not have been a coincidence, could it, that he should arrive in the same restaurant just a few minutes after me?

'Mind if I join you?' he asked.

'Of course, please do,' I replied. I was instantly on edge, but tried to act normal.

'So you like *Maghrébain* and *Mashriqain* food, do you?'

'I love it. I hadn't really had any before I came to France.'

'And what is it, exactly, that brings you here?' he asked, smiling. It was the first time I can remember him smiling, but I wasn't sure he was intending it to be friendly.

'I'm helping to organise an exhibition at a museum – I'm an art student.' He looked at me with his head tilted and his eyebrows slightly raised. I couldn't work out if he was just showing me that he was listening or was suspicious about what I was saying.

'I won a school competition, you see,' I continued, trying to sound as young and innocent as I possibly could. I'm not entirely sure why but this seemed the safest line to take in the moment. 'I'm exhibiting with other schoolchildren.'

He exhaled abruptly through his nose. It wasn't clear to me but it seemed he found this funny in some way.

'Okay,' he said. 'You're an artist! Of course you are.' The waiter brought over my tagine and lifted the lid off for me.

'Hey Mammoul,' he said to the waiter. The waiter turned to him and spoke to him in Arabic. They had a brief exchange and a couple of minutes

later he returned holding a shisha pipe. It looked really old, but the ones that you get in street markets also often look old – ornate metalwork, as if they are expensive and precious. He also had a large strong coffee, as thick as syrup. I had never seen a shisha being used before. I had seen Asian and Middle Eastern men sitting outside cafés with them, puffing away on the hoses that come out of them, but I didn't really understand how they worked. As he was smoking, I was trying to figure it out, but couldn't quite get to the bottom of it.

'And how do you know Youssef's sister, Amira?' He seemed quite direct, and I started to feel more uncomfortable.

'She's a friend from the foyer where I live. I think you happened to be outside the foyer in that café the other day, Le Violin Noir.'

'Oh yes,' he replied, his eyebrows raised once again. 'So I was.'

'Do you live near there?' I asked, feeling I had gained the upper hand in the conversation, momentarily. He paused.

'One of the chefs there is a friend of mine, so sometimes I go to take a coffee there when I'm in the neighbourhood.'

I nodded, not really knowing where to take the conversation from there. I sat eating, though his presence had marred the pleasure somewhat. He sat smoking. We carried on like this for some time, in silence.

'How do you know Youssef?' I asked, in return.

'I'm working for him and his partners,' he replied, 'as you already know.'

'Have you been working together long?'

'Oh, a little while now,' he answered, not giving much away.

'Were you born in France?' I asked, really just trying to make polite conversation.

'Let's just say I have an intimate relationship with France,' he replied. It felt like he was deliberately trying to tell me as little as possible, without being rude.

'How does the shisha work?' I asked, trying to find something I could say without annoying him.

'Well,' he said, seeming more comfortable with the topic of conversation and quite happy to explain. 'These sections all come apart. You put some iced water in this vase at the bottom. You take some shisha and spread it out evenly but lightly in this little bowl. Then you put this perforated metal dish over the top – or you can use some foil if you prefer, with tiny holes punctured in it. Put that on the top of the stem. Then you take a brick of charcoal – it's a little round disc. You heat it up until it glows red hot, then you place it on top of the bowl. After a minute or two, it's ready to smoke. You can hear the water bubbling up as you suck on the end of the hose, and then the smoke comes out. The smoke builds up after a while and you then you're up and running.'

He signalled to the waiter, who came over to the table.

'Mammoul, bring a pipe for my young friend here.'

'Oh no, thank you, I don't smoke,' I said quickly.

'One without tobacco, then, Mammoul.'

'Okay, I'll give it a try, thank you.'

The waiter soon returned with a pipe for me, for which I thanked him. I inhaled on the tube, which had some aluminium foil over a metal mouthpiece on the end, and immediately started coughing. Ammon just laughed. After I had recovered from my coughing fit, I tried again, and started coughing again. What a strange sensation, it's like cutting off all the air you need to breathe.

'And so this shisha stuff – this is what Youssef imports to France?' I asked.

'Yes, it is. It's this brand.' With that he pulled out a packet of shisha branded with the Face in the Clouds.

'Ah, okay, so that's what we were unpacking from the lorries the other evening.'

'Yeah, it's an old Egyptian brand, and now they make all different flavours.'

'I'll tell you something surprising,' I said. 'You might find it hard to believe but my grandfather designed the logo for the brand back in the 1960s.'

Ammon looked up at me, and his expression was definitely one of surprise.

'Oh really?' he said, and his face turned to one of confusion and mild disbelief. 'Your grandfather designed this?' He held me in his gaze for a moment, clearly coming to terms with my minor revelation. He seemed deep in thought for a moment. Then he called out to the waiter.

'Hey, Mammoul, you'll never guess what. This kid's grandfather designed the logo for Wajah fi Alghuyum!'

Mammoul came over to the table.

'What did you say?' asked the old waiter.

'I said this kid, his grandfather designed the logo for Wajah fi Alghuyum.'

The waiter seemed a little taken aback. Perhaps he wondered why an English boy's grandfather would have designed such an iconic old shisha brand.

'Well now,' he said, looking at me with curiosity. 'Isn't that interesting.' He looked back at Ammon. 'Can I get you men another coffee?'

'Sure,' said Ammon, 'why not. And you – sorry, I can't remember your name.'

'Adam,' I answered.

'Would you like a coffee, Adam?'

'Thank you, yes, that would be lovely. And then the bill please,' I said, looking at the waiter.

'Of course, young sir,' he replied, with a kindly smile.

We sat with our coffees and our pipes. I was starting to get used to the pipe, but didn't really see the appeal.

'Listen,' said Ammon, turning towards me and lowering his voice slightly. 'Youssef is going to text you this afternoon to see if you can come and work another shift at the warehouse. Can I recommend, with the utmost respect, that you do not take him up on his invitation?'

I sipped on my coffee and took another puff on the pipe, to try to look calm. Inside my heart was starting to race. I knew there was something not quite right.

'Why not?' I asked.

'It is not a place for young artists,' he replied. He was looking straight into my eyes, and I knew he was being completely serious.

'Okay,' I said, needing no further prompting. 'That's absolutely fine by me.'

'Good,' he said. He was smiling again, and nodded his head once, emphatically, as if to reinforce our agreement. He seemed to relax again, and carried on with his pipe, which seemed to last for ages, much longer than a cigarette. When the bill arrived, he put some cash down on the plate. I pulled out my wallet.

'It's fine, don't worry about it. It's on me,' he said.

'But I had lunch,' I protested.

'Really, it's fine.' And with that, we stood up and made our way out. I turned to the doorway of the restaurant and waved at the waiter to thank him. He lifted his hand in acknowledgement.

\*\*\*

Later that afternoon I made my way down to the Left Bank. I took the Métro to the Quai de la Gare before walking down from the Pont de Bercy towards the Pont de Tolbiac. This was the district known for all the French writers, theorists and philosophers. That was pretty much the extent of my knowledge about it. The FrendHub group message from Antoine simply said to meet on the maroon boat opposite the National Library. As I passed the Passerelle Simone de Beauvoir I could see it moored on the Seine – a long thin boat with a deck filled with plants and flowers, and lots of multicoloured garden chairs and tables. There were a couple of large parasols offering some shade. Some of the Eleven Associates were already there. Henry was sitting with an Old Fashioned cocktail in one hand and a cigarette pointing towards the sky in the other. Sebastien was sitting next to him, reading the newspaper. He was wearing a T-shirt, and it was the first time I had noticed just how ripped he was. He clearly worked out a lot. He was such a sweet guy – he looked up and greeted me with a big smile.

'Well hello there, Adam, come and join us. What would you like to drink?'

'Oh, thank you, Sebastien, I'd love a cola.'

'Surely,' said Henry, 'it is the time of day for something more refined – a pastis at least.'

'Ah, I remember my grandfather warning me not to have too many of those. What is it, exactly?'

'It's an aperitif – an aniseed flavour drink that goes white when you add water to it.'

'A bit like the absinthe we had the other night?'

'Yes, only you add a lot of water to a pastis, so it's not so strong. It was probably only invented so that old French men can carry on playing *boules* while drinking it.'

'Well, I suppose when in Rome,' I replied.

'Sebastien – get the man a pastis.'

'And you, Elodie, can I get you something now?' asked Sebastien.

'Oh yes, lovely, I'll have the same as Adam, thank you.'

Elodie was one of only a couple of members of the Eleven Associates I hadn't really spoken to yet. I discovered that she was twenty-four, was a menswear fashion designer from Toulouse, and ran her own independent label. As a fashion designer, she herself wore some beautiful clothes – today she was wearing a burgundy, green and grey stripy cotton sleeveless dress with a matching plain grey blouse with sleeves to the elbow, with little buttons running all the way down from her left shoulder to the bottom of the dress, which came down to just above her knees. With it she was wearing thick black ankle socks and some black leather hiker-style ankle boots. Her hair was brown and just reached her shoulders, and she wore thick black-rimmed spectacles. She was quite tall and thin, very softly spoken yet confident and clearly very bright.

'I wonder why Antoine chose this particular location?'

'This was actually my suggestion today,' said Elodie. 'In the summer this boat is one of my favourite places in Paris. You can sit up on the deck all afternoon, surrounded by these wonderful plants, then in the evening you can go down below deck and they have concerts and stuff. I love the National Library too – such an incredible place. Suzette will be performing some of her music tonight. Antoine might do some VJ-ing too.'

At that moment, Antoine and Alicia arrived, followed by Armand and Anne-Sophie. Hakim turned up but was in the middle of a long telephone call so he stood facing out onto the Parc de Bercy on the other side of the Seine. Suzette and Stéphanie were the last to arrive. From their bags I guessed they had been shopping. We had a long table at one end of the boat, facing up the river, so it felt like we had the place to ourselves.

'How did you enjoy the Nuit Blanche, Adam?' asked Stéphanie.

'It was a brilliant night,' I replied, enthusiastically. 'Mind-bending, actually.'

'I loved your dancing in the club at the end of the night,' she said, with a smile. 'I don't think I've ever seen dancing quite like it, in fact!'

'Oh no,' I groaned, 'I'm such a terrible dancer. I'm glad I was too drunk to be embarrassed.'

'Hakim was trying to teach you some of his moves – he's a very good dancer. You tried to follow but your body and brain were not communicating by then. It was so funny!'

'I'm glad I brought you all some light relief,' I replied, laughing.

'It was good of Hakim to take you home at the end of the night.'

'What? Hakim took me back to the FJT?'

'Yes. You mean you don't remember?'

'Not really. Now you've said it, I think it's coming back to me. I must thank him – he must think me so rude.'

'I'm sure he'll understand. But tell me, where did you go while we were in Le Bar de l'Europe? You were gone for nearly an hour.'

'I popped in to the Louvre. In fact, I've got something I'd like to share with you and the others if that's okay.'

'Of course. Fire away, Adam,' said Stéphanie.

I took my mobile phone out of my pocket and pulled up a close-up on the face in the clouds. It was cropped so all you could see was the area with the face in it.

'Well, it's a bit odd, but I wanted to ask you if you can see a face here?'

'I think so. Is it looking straight out at us?'

'No, it's in three-quarters profile staring out towards the front left of the frame. It's like a cherub's face, in strong shadows as if harshly lit. His lips are pouting, as if he's blowing.'

'Oh, I think I see what you mean. So the forehead is here, and this would be the right-hand cheek, and this the chin?'

'Yes, that's right, you've got it. Look away for a moment – look at me.'

Stéphanie stared at me, straight in the eyes.

'What is this that we're looking at?'

'I'll tell you in a moment,' I said, looking back at her with a smile. 'Right, now look again at the picture and tell me if the face is any clearer now.'

She looked at the image on my phone again.

'Oh yes, yes it is. I can see it now. Yes, it's like a baby face almost. A bald head, like a cherub, as you say. So what is this, some kind of sight test?'

'I guess it is a kind of test. I was interested to know if you can see it.'

'But what is it?' she asked.

'It's part of a painting you know well,' I answered, and swiped to the next picture on my phone – a full image of *The Mona Lisa*.

'*La Joconde?*' she asked, confused, her bottom lip pushed out, her shoulders hunched and her hands raised palms up in front of her.

'Yes, that's right,' I replied. 'Can you see the face now?'

Stéphanie stared at the picture. 'But it's right there,' she said, pointing at the horizon on the right of the painting. '*Mais c'est dingue! C'est complètement dingue!*' She was smiling but she was also sort of frowning, and she tilted her head as she looked at me.

'Is it a joke?'

'How do you mean?' I asked.

'Is it a photo editing trick? A special effect?'

'No, this image is from the Louvre's website. I bought some prints of the painting while I was at the Louvre yesterday.' With that I reached for my rucksack, which had a few A4 prints in it.

'Have you shown anybody else this?' asked Stéphanie, staring at the print I put in front of her.

'No, not yet.'

'Well you must show the others – you have more prints here?'

'Yes.'

'*Ecoutez mes amis!*' she called out. 'Listen, Adam has something really interesting to share with us.' She started passing round the prints.

'Wow, *La Joconde!*' said Henry, clearly taking the mickey. 'I hate to say this, Adam, but I think we've all seen this painting before.'

'Why are you showing us this, Adam?' asked Armand, clearly as confused as Henry, though less rude.

'Give him a chance,' said Stéphanie. 'Go on, Adam, tell them.'

'Well,' I said, suddenly feeling very much under the spotlight, 'while you were all at Le Bar de l'Europe the other evening, I popped in to the Louvre and had a couple of minutes alone with *The Mona Lisa*. I don't know if it was all the alcohol, or if I was hallucinating after all those absinthe cocktails, but when I looked at the painting, I could see a face in the clouds, blowing like the wind itself, the wind and clouds personified.'

'Definitely sounds like the green fairy speaking, my dear fellow,' said Henry.

'Shush!' said Stéphanie.

'If you look at the horizon on the right-hand edge of the painting, the face is there, like an angel or a cherub staring into the picture. Can anyone see anything there?'

There was a moment of silence as everyone dutifully looked at the prints. There weren't enough to go round, so some people were sharing and soon started talking with each other. After a little bit of muttering, Suzette suddenly shouted out:

'I can see it! Ha! There it is. How weird.'

'Isn't it?' replied Stéphanie.

'Hang on a minute,' said Henry. 'I can't see anything of the sort. Where did you say it's supposed to be?'

Stéphanie walked round behind the seats and leaned over his shoulder, pointing it out to him and Sebastien.

'Hmm, I can see something,' said Sebastien, 'but it doesn't really look like a face to me. It's hard to say what it is. Maybe there is a face, but it doesn't look like a cherub to me.'

'I'm not sure we're looking at the same thing,' said Stéphanie. 'Here are the eye sockets, here is the nose, here are the pouting lips. This is the left cheek, in shadow, here is the jawline and chin.'

'Oh, I see what you mean now. Yes, it's sort of coming into focus, though I'm not convinced. Plus it looks much older than a cherub.'

'What are you going on about?' said Henry, actually now seeming a little irate. 'All I can see are some blurry marks where some mountains and clouds are.'

'But what is that section of the painting actually supposed to be depicting?' asked Maya. 'Look at the rocky outcrop just behind her head – these look like rocks, albeit strange ones. This section where you say there is a face, it doesn't look like rocks and mountains. Yes, it looks a little more like clouds. There are whiter, billowy marks in between that are suggestive of rocks.'

'Yes,' said Sebastien, 'I see what you mean. That section of paint doesn't really depict rocks like elsewhere in the painting.'

'Can you see a face there, Maya?' I asked.

'I can see what you are describing to me as a face. Do I think Leonardo intended to paint a face there? No, I do not.'

'So you are saying that because Adam has suggested a face shape, you are able to see a face there?' said Armand.

'Yes, precisely. It is the power of suggestion. Like someone looking at real clouds in the real sky, and seeing a face there.'

'Those are known as aleamorphs,' said Sebastien. 'There's no reason why aleamorphs can't be painted.'

'But presumably the reason why nobody has seen a face there before is because nobody has suggested it. Now Adam has suggested it, some people, like you, will start to see a face there.'

'That's quite profound, Maya,' said Elodie.

'Well I suppose we've come to expect nothing less from her,' added Stéphanie. 'The thing for me, though, Maya, is that I can still see the face. It's really clear to me now. I can see it with my own eyes.'

'If it's that clear, why couldn't you see it before?' asked Armand.

'Can you see it, Armand?'

'No, no I can't, but then I'm colour-blind. I can't tell the difference between blues and greens, so I'm guessing this passage is painted in blues and greens, am I right?'

'Yes,' said Sebastien, 'with some bits of yellow and brown in there, possibly discoloration over the years. But can't you see the face in the clouds tonally at least? The face is all painted in a similar darker tone, with the highlights the same as the sky beyond.'

'No, I just can't see it. I can see there are some blurry marks but they don't form into a face for me.'

'Hands up who can see the face,' asked Stéphanie.

From the ten Associates around the table, five put their hands up.

'Where's Hakim?' asked Armand. 'We need him to cast the deciding vote.'

Hakim was just finishing his phone call and walking over to us.

'What's going on here – paint club?'

'Adam's suggested there is a face in the clouds in *The Mona Lisa*,' said Stéphanie.

'Why is that odd? Is it not supposed to be there?' replied Hakim.

'Well that's the question, I think,' said Anne-Sophie. 'We don't know whether there's a face there or not, and if there is a face there, we do not know if it is intentional.'

'Surely you can all use your eyes to decide if there is a face there?' he asked.

'The Associates are split down the middle,' said Stéphanie. 'Why don't you take a look for yourself?'

'Sure,' said Hakim, sitting down. 'Okay so a face in the clouds... let me see now...'

He looked at the sky for a few seconds. 'Is there something here?' he asked, pointing to the horizon on the left-hand side of the painting.

'There!' said Henry. 'He's not even drawn to the area with the face in it. Doesn't that prove that if you don't direct people as to what to see and where to see it, they don't see it?'

'Well, let's not be so hasty,' said Elodie. 'If it were that obvious, there would just be a face there in the painting, that everyone would have seen for hundreds of years. It would just be "in" the painting.'

'Are you suggesting,' asked Maya, 'that Leonardo might have been deliberately painting something that can be seen, yet that we don't see?'

'Hmm,' said Stéphanie. 'Now that is an interesting idea. Like Leonardo was painting the invisible? As you say, painting that which is unseen but which is see-able nonetheless.'

'I like this proposition,' said Maya. 'It's like everything we can usually see in the painting is in the realm of the physical, the rational, the real, but then there is this possible other visual world just beneath the surface – a world of dreams or nightmares, of subconscious thoughts, the afterlife, the spirit world.'

'This is freaking me out a bit,' said Alicia. 'Isn't anybody else freaked out by this?'

'It is odd,' replied Antoine. 'Very strange indeed.'

'It's interesting you should mention the subconscious, Maya,' said Sebastien. 'Freud did suggest that there was visual imagery buried in Leonardo's works that relates to the subconscious.'

'Oh yes, that rings a bell,' said Henry, nodding as if to give some ground on his otherwise wholehearted rejection of the idea. 'The vulture – or was it a kite? I can't quite remember.'

'That's right, it is said that Leonardo had a dream that he was attacked as a baby by a bird, which put its head in his mouth. The implication, though,

was that Leonardo was not necessarily aware of having painted a woman's robe in the shape of a bird – but rather that it was his own subconscious made manifest within the painting.'

'So all of that studying of art history has finally come in useful, Sebastien,' said Henry.

'I think Adam's face in the clouds is certainly something that merits further consideration by art historians.'

'Really?' I said. 'Do you think any of them will take it seriously?'

'I expect you'll have as many different reactions as there are people,' said Anne-Sophie. 'If we as a group are anything to go by – some of us can see it, some of us can't; some of us believe it might be there, some of us don't; some of us think Leonardo intended it, some of us remain to be convinced.'

'Surely this kind of childish trick is beneath Leonardo?' said Henry.

'It is a bit like an optical illusion,' added Armand.

'I think it depends how you look at it,' said Elodie. 'You might find it quite profound or you might find it silly. Are the implications of this face in the clouds philosophical, or trivial?'

'Well she is called "*La Gioconda*" – which means playful, joyful or jovial one. Maybe Leonardo did think of it as a kind of game – a visual experiment of sorts, a test,' said Sebastien.

'But was Leonardo the kind of person who would be playful? Sebastien – you are the art historian among us.'

'He was a real mixture, of course. I'm reminded of lots of his writings that were both playful and serious – they often sounded like austere statements or prophesies, but were much more like wordplay or witticisms...'

'Ooh, can you think of any examples of that?' asked Stéphanie, intrigued.

'One that springs to mind is, "Throughout the land people will be seen walking on the skins of great beasts." He was talking about people wearing shoes made from leather or ox-hide. He wrote fables too, and lots of short anecdotes relating to the characteristics of animals.'

'So these were kind of serious and ridiculous at the same time? Interesting,' said Stéphanie.

'Right,' said Anne-Sophie. 'So this face in the clouds could be both – it could be profound and playful. A cipher that speaks of the invisible, of the otherworldly, of the divine, and also a puzzle, a trick, a game.'

'Why do we have to make a picture such as this a puzzle, a riddle?' asked Henry. 'People always seem to treat *The Mona Lisa* like there's something to decode, to solve. Why can't we just let it be as it is? It's like people are desperate to find something in the picture that makes sense of it all.'

'I see what you mean, Henry,' said Anne-Sophie, 'though do you think it's possible that the reason why so many people are fascinated by this particular painting – above all others – is that the painting is triggering things in our subconscious that keep on bubbling up close to the surface, just like this face?'

'Are you suggesting that parts of our brains knew about this face in the clouds, but that the face had never fully formed into a conscious thought?' asked Stéphanie.

'Like a partially formed idea, an embryonic thought, an image that has been consistently coming into being for hundreds of years, never fully forming, never coalescing? That's really beautiful,' said Anne-Sophie.

'Exactly. So it's like an image waiting to be found by our imaginations. But we have to be able to imagine it to see it,' replied Stéphanie.

'That is really interesting,' said Maya. 'It leads us into some fascinating areas of perception, cognition and neuroscience.'

'Into visual theory,' added Armand.

'Into philosophy,' said Anne-Sophie.

'I confess I am struggling to understand how you can be getting so carried away by something that I can't even see,' said Henry, getting a little cross again. 'Presumably the idea of this face is not something that has been discussed by art historians – or by mainstream, academically recognised art historians, at least?'

'I don't know. I'd have to go and do some research,' Sebastien replied. 'It would be interesting to know. There is a lot of material around relating to optics and perception in the history of art – everything from the use of mirrors to images that can be seen in different ways – in reverse, upside down and so on. I think Leonardo is the first artist known to have documented anamorphs, for example – images that need to be seen from a different angle to everything else in a picture.'

'So he was interested in the idea of optical phenomena?'

'Oh yes, Anne-Sophie, he was very much interested in the science of perception, of how the eye works, how light works, how colour changes through distance and so on.'

'Could it be possible that a face in the clouds that can't be seen might have been of interest to him from a scientific perspective? At what point something can be seen; how much information, and of what kind, we need to be able to recognise something tangible.'

'It's certainly something I can imagine he would have been interested to consider. It's well known how inquisitive he was, and how much he relied upon his own senses as the starting point for trying to understand the laws of science. "Develop your senses," he once wrote. "Learn especially how to see."'

'That reminds me of something else I think he wrote,' added Antoine, speaking for the first time. '"The average person looks without seeing."'

'Yes, that's right,' said Sebastien. 'I believe he also said something along the lines of "There are three types of people: those who see; those who see when they are shown; those who cannot see."'

'Well that neatly sums us up here at these tables!' said Elodie, at which everyone laughed.

'Plus Leonardo famously described how looking closely at random stains or rock formations can stimulate the visual imagination. Wait, let me find the quote on the Internet.'

'I must say,' said Suzette, 'I can see the face in the clouds so clearly now. It's just there. I can't now imagine how I have never noticed it before, nor can I imagine how nobody else has seen it before. Can it be true that this face is not known about?'

'Oh, here it is,' said Sebastien. 'Are you ready? "Look at a wall splashed with stains, or rocks of different colours. If you need to invent a scene, there you can see things that resemble landscapes filled with mountains, rivers, rocks, trees, valleys and hills. You can see battles, strange figures in different postures, facial expressions – an infinite number of things … you should sometimes stop and look into the stains on walls, or the ashes of a fire, or clouds, or the soil – places in which, if you look closely, you can find wondrous ideas. The painter's mind is stimulated to new discoveries, compositions with battles of animals and men, landscapes and monstrous things such as devils … by indistinct things the mind is stimulated to new inventions."'

'That's exactly it,' I said. 'It's not just the face in the clouds.'

'What?' said Antoine. 'There's more?'

'Well, it's really strange. I spent yesterday evening and much of the night looking at the painting. I think I can see other things in there too – more faces, animals, strange creatures, landscapes within landscapes.'

'No way!' said Suzette, now rather animated by the whole discussion. 'Where?'

'Now I'm really getting freaked out,' said Alicia. 'Doesn't anyone find it really unsettling? You know, the idea that this weird face has been there all this time, and we didn't know it, couldn't see it. Who knows what else we might not see, what horrible things might be there, just out of sight.' Antoine put his hand on her shoulder, offering some comfort.

'I do find it a bit frightening,' I confessed. 'But I also find it super exciting. Some things are clearer to me than others – indeed, I can't really be sure about many, if any, of them, but what I do know is that my own imagination has been stimulated to see fantastical things in the landscape. Look here, on the left, just above the water – in my mind's eye I see an owl in flight, its wings spread and its legs stretching forward. It is so clear to me I can see its eyes and its beak. It's as if it is flying over the water and the land below, heading straight out of the left-hand side of the painting.'

'I think you've lost your mind, Adam,' said Henry, quite seriously.

'I wonder if I have, Henry. I really do,' I replied.

'Wait. No. No way. That's insane. I can see it Adam!' said Suzette. 'The owl! I can see it! Just as you describe it. It's all painted in the same pale blue-green. It is like a ghost, Alicia. It's transparent. It's like a special effect from a film, like it's painted on a transparency and superimposed over the

rockface. And it's so elegant, so graceful, so subtle – the owl, it's perfectly painted, completely believable but almost not there at all.'

There was a lot of chatter now around the tables, with everyone trying to see if they could see the owl in flight. Suzette was busy pointing it out to those on either side of her. Henry was holding his head in his hands, clearly annoyed by the whole conversation.

'What else is there, Adam?' asked Suzette.

'Well, where to begin? The thing is, it's not always literal. It's as if Leonardo is suggesting things to our subconscious – creating abstract imagery that's evocative of figurative things.'

'Like Rorschach tests?' asked Hakim.

'I don't know what those are,' I replied.

'They're abstract ink blots devised by a psychiatrist called Rorschach that were intended to help reveal the subconscious thoughts of his clients. People could read into the ink blots whatever they brought to them from their own minds, their own neuroses.'

'That sounds spot on, Hakim,' I said. 'The imagery brings out whatever your mind thinks it sees there. For me, there's a passage in the rocks on the left-hand side of the canvas that looks like a woman or a child clinging to the back of a man – just their heads and shoulders. It looks like they're scared, or whispering something. There are strange green faces staring upwards to the sky, like monstrous sculptures on ancient tombs; there's a giant mouse with a glowing underbelly right next to her shoulder, its tail curling underneath; nearby a vulture puts its head into the mouth of another grotesque beast.'

'Not unlike the story of Leonardo as a baby with the bird,' added Sebastien.

'There's a lady in the rocks in the middle distance,' I continued, 'not facing us, as if she doesn't know she's being watched. Where the river flows through the bridge on the right-hand side, I see a skull, distorted by water. I see faces – or traces of them. A black swan or a goose with its head nestling in the lady's arm. At first I thought I could see a hunch-backed man with a thick-set brow, a large nose and a beard, skulking in the shadows. Then his head looked like it was actually just the chin of a larger, stranger face above it – a kind of rustic, devilish face with the brim of a hat over its thin, pointed eyes – right opposite the face in the clouds. Looking around I could then see a face in profile, facing right into the painting. This face also has a beard, a goatee, with a more pointed nose. The face is quite long and thin, though more human than the one from which it emerges. Then I saw it – all of these faces are part of a more complex form – the head of a horse, there in the sky, facing out to the left of the painting. The noseband is the brim of the devilish face's hat, the horse's ears pointing upwards.'

'Madness!' said Henry. 'You sound totally barking mad. Just listen to yourself!'

'That does sound rather far-fetched, Adam. It's interesting though,' said Sebastien, 'you're not seeing anything contemporary in the painting.'

'You're right, I guess I'm only seeing the kind of things that could have been painted at the time,' I said.

'No satellites or cars or mobile phones...' said Suzette.

'You're led on a flight of fantasy, a kind of visual wild goose chase, only some of the things feel like they might be true,' I continued. 'The more you imagine, the more your imagination will find. And the harder it gets to make a rational decision about whether it might really be there in the painting. Some things are more convincing than others, and after a while it becomes harder to discern what you think. It's like an attack on your own common sense. It feels like Leonardo is playing with us, encouraging us to see things, then taking us to the point where we're lost within our own imaginations, unable to decide what our eyes are telling us.'

'Well,' said Maya, 'if that were the case it would be rather incredible. The idea that Leonardo was so accomplished a painter, within this single painting he was able to test the very limits of perception, and to explore the moment when our perception turns to imagination, when reality turns to fantasy, when the conscious turns to the subconscious.'

'No wonder she has such an enigmatic smile if this is the secret she has been sitting in front of for these past five centuries,' said Stéphanie.

'But maybe there is ultimately no answer – presumably we can each bring whatever we think we see to the picture – you might see a face or a figure that I don't. I might see something that you don't,' said Anne-Sophie.

'I guess the question is whether any art historical proof can be found that any of these things actually exist or were intended by the artist,' said Sebastien.

'Or if there's no proof, whether there's some kind of consensus that can be reached,' suggested Anne-Sophie.

'What, you mean if enough people believe they can see a face in the clouds, or an owl or a horse, then it kind of becomes real in the popular imagination?' asked Armand.

'I guess so. I don't know. Yes, well if enough people can see it, then it would presumably become a subject that would merit greater consideration.'

'But it's just another conspiracy theory about Leonardo and *The Mona Lisa*!' said Henry, almost shouting. 'Yet another crazy theory from the fringes. Even if enough people were to be convinced that they can see any of these things, that wouldn't mean that it's an idea that would merit consideration. Listen, there are plenty of people alive who still believe the world is flat. There are people who don't believe in evolution. Just because there are enough of them it doesn't mean they should be taken seriously.'

'But Adam's not some militant maverick. He's not even sure himself of what he is seeing,' said Anne-Sophie.

'No, but his theory is pretty far out,' said Armand. 'I mean, he's proposing

that there's a face in the clouds and a whole load of visual imagery hiding in plain sight in *The Mona Lisa*.'

'I'm intrigued by the kinds of suggestions he's making though,' said Maya. 'Maybe we don't see the face in the clouds because our eyes are not looking for a face there. We are not expecting it. Our eyes and our brains must piece together some visual information based on what we expect to be there. To be able to see his owl we would need to flick a switch in our minds that stops us reading that particular passage of paint as depicting hundreds of feet of craggy rocks on the edge of the water – we would have to read it as a flat image on the surface of the painting. It's as if we need to suspend our disbelief and replace it with a different kind of disbelief. The illusion of the landscape rendered in paint is being swapped for a different illusion – one that sits on top of the three-dimensional perspective of the landscape receding into the distance, on a flat plane. But if what Adam says is to be believed, the owl looks like it could also even exist within the three-dimensional space of the scene. It would mean that Leonardo is mixing up planes and perspective so that things slip through our regular perception, and yet can still technically be seen.'

'Like multi-dimensional painting,' said Suzette.

'It's just mind games – nothing more than Adam making us stare at the picture looking out for things that look like other things,' said Henry, emphatically. 'The power of suggestion, like a cheap clairvoyant.'

'You might well be right, Henry,' said Antoine, 'but don't you think it would be amazing if Leonardo was aware of such things, and was exploring them in a painting five hundred years ago? I mean, such optical devices can't have been normal in Renaissance painting, or in much painting until the modern era, can they, Sebastien?'

'No, I don't think so. It's certainly true that oil painting was still relatively new, especially in Italy, around the end of the Quattrocento. Leonardo could well have been testing out what the new medium could do that the egg tempera painting preceding it could not. What Adam has suggested today opens up a lot of questions about art history that I don't think have really been addressed in quite this way before. I certainly haven't ever really thought about such things. It makes me want to go back and look at more of Leonardo's paintings, and paintings by other artists. I want to look again at things I think I know well. I'm very interested by the possibilities that thinking about such optical phenomena might bring to our understanding of painting, and of what paint can do.'

'That sounds perfectly reasonable, Sebastien, of course,' said Antoine.

'But surely that would just open up the floodgates for anyone to claim to see anything anywhere in the history of art?' said Armand.

'Possibly, or maybe it would seem like that at first,' said Sebastien. 'But I'm open to the idea of considering such things. I don't want to just shut the idea down, dismiss it out of hand. I think there is a lot of thinking to be done.

The complexities of perception and cognition as they can be made manifest through the medium of paint are not things we should just turn our noses up at.'

'Especially when we're talking about Leonardo. I mean, he's not exactly your average kind of guy,' said Stéphanie.

'"The machinery of perception moves more readily than judgement" – these, apparently, are words from Leonardo himself,' said Henry, looking at an online list of quotes on his phone.

'Ah yes, but he also wrote, "Imagination is both rudder and bridle to the senses",' Sebastien replied.

'Here's a good one, if the Internet can be trusted,' said Anne-Sophie. '"Why does the eye see more clearly when asleep than the imagination does when awake?"'

'I like this one,' said Armand. '"The greatest deception people suffer is from their own opinions".'

'What about this one,' said Stéphanie. '"I awoke only to find that the rest of the world was still asleep".'

'Nice!' said Anne-Sophie. 'And it makes you think what it must have been like for him.'

'You mean being brighter than most people around him?' asked Armand.

'Well, yes, but I was also thinking about how he represented this new approach to science, based on observation and experimentation. The late fifteenth and early sixteenth centuries were this transitional period from the medieval to the Renaissance, from the very tail end of the Dark Ages to the modern world. He was both a medieval and a Renaissance man.'

'Maybe the face in the clouds was a critique of the irrational, of superstition and religion,' suggested Elodie.

'Perhaps,' said Anne-Sophie. 'Or maybe he was making a case for the existence of things beyond our perception and understanding.'

'Or maybe he was playing it tongue-in-cheek.'

'Like I said, I seem to remember reading that Leonardo used to perform in the court of Ludovico Sforza in Milan as a prophet or a soothsayer, sounding like he was making those great and terrible prophesies about the world, only to then reveal them as curious jokes or witty aphorisms,' said Sebastien. 'In fact, it's interesting somebody used the words "special effects" earlier on – Leonardo spent quite a lot of time producing theatrical performances and props for Lorenzo di Medici in Florence, including some rather dramatic – if not spectacular – stagecraft and special effects.'

'Listen to this one,' said Stéphanie. '"The artist sees what others only catch a glimpse of".'

'Love it!' said Elodie.

'Or this one. '"If the painter wishes to see beautiful things that charm, it lies in his powers to create them, and if he wants to see monstrosities that are frightful, ridiculous or truly pitiable, he is lord and god of them."'

'Adam, I think this is all amazing!' said Suzette. 'This is one of the weirdest and most interesting things I've ever experienced when looking at a painting. It's actually blown my mind.'

'Oh, thank you,' I said, blushing. 'But I can't take all the credit for seeing the face.'

'Oh really, why is that?' she asked.

'Because it's something my grandad saw fifty years ago when he was visiting the Louvre. Look.' I pulled out the tobacco tin I had been holding in my pocket. 'My grandad designed this tobacco tin using the face in the clouds that he saw in *The Mona Lisa*.'

'Your grandfather designed that tobacco tin?' asked Armand. 'Well, what an unusual family the Kings are turning out to be,' he said, smiling and shaking his head at the same time.

'That's super odd. The face on the tin does look quite a lot like the face in the clouds in *The Mona Lisa*,' said Suzette.

'And do you know what the Arabic text means?' I asked.

'A Face in the Clouds,' said Hakim. 'That's too strange; I've known that design since I was a child. It's quite famous in the Arab world. I think I can see what you're talking about in the painting now – the face in the clouds is over here. Now that you've shown me the drawing of it, I can see it easily, in fact. That is very odd.'

'So, Adam,' said Antoine, 'it is customary within our association for members to work on projects when there's something they are interested in. What are you going to do with your discoveries in *The Mona Lisa*?'

'I don't know,' I replied. 'I haven't really thought about it.'

'You could make a film,' said Anne-Sophie.

'Or a podcast,' added Stéphanie.

'Or write a play,' chimed in Alicia.

'Or a novel,' suggested Suzette.

'You could make a new artwork about it,' proposed Armand.

'Or write an academic paper,' said Sebastien.

'You could make a big billboard poster of just the face,' said Hakim.

'You could do anything you like, Adam, but you really should do something, and we'd be happy to help,' said Antoine.

'I'll get my thinking cap on,' I said. I hadn't started thinking about how to present the idea to the world, or even decided if I wanted to. I hadn't had time to digest what had happened to me over the past few days, or to finish thinking through my own thoughts about Leonardo and *The Mona Lisa*.

* * *

I got back to the foyer late and made my way up in the by now very familiar antique lift. I had got used to its sounds and its rhythms, and after an

evening of experimental sounds on the boat, was particularly attuned to it tonight. I hadn't heard anything quite like Suzette's performance before – just her and a laptop, making what she described as 'electroacoustic' music, made up of all kinds of weird and wonderful sounds. Indeed, she could well want to come and record the sounds of this lift. When I opened the door to my room, I saw a folded piece of paper lying on the floor. I picked it up. It read: *You are in danger. I am a friend. Meet me in the café at 26 Rue de Chaillot at 18.00 tomorrow, Monday evening. Turn your phone off before you travel. Destroy this message.*

Okay, I thought, this isn't funny. What had I got myself caught up in? Ammon had made it quite clear to me that I should not go to Youssef's warehouse again, so I knew there was something going on there from which I was being warned off. But I'd told him I wasn't going to accept Youssef's offer of more work there. Youssef had seemed quite keen for me to go. Why? It can't have been just because I'd worked hard the other evening. Maybe he was the threat to me, the danger. I thought long and hard about whether I should speak to Amira about this – I liked her and couldn't imagine that she was involved in anything dangerous or illegal. But I decided I would go and find out what this 'friend' wanted to say to me. What if it was a trap, and this was the danger? I would need to let somebody know where I was going, but because the note had said to switch my phone off before setting out, I made the decision not to text anybody. It was too late to go round to Natalie's room now. I would leave a note for her, yes, that's what I would do.

# THE TIME CAPSULE

The next evening I made my way after work to the Rue de Chaillot. When I looked on my phone map, I discovered that it was within walking distance of the museum, directly north in fact, so I switched off my phone and made my way on foot. The café was Asian, and when I arrived I was the only person in there. I ordered a pot of tea, and was a little surprised when what arrived was a tall glass of boiling water with a flower in the top. I thanked the waiter and stared at it for a moment. It looked boiling hot – too hot to drink. Then the petals slowly started to open. It was beautiful, and the smell was very delicate. It tasted aromatic, like something I had tasted before, but I couldn't quite put my finger on it. I liked it though. I looked around the café for any clues as to why I had been instructed to come here in particular. It was like a delicatessen – as well as things to eat, there were lots of intriguing and tempting-looking things to buy. A man in a tracksuit and baseball cap came in. It was bang on six o'clock. He nodded to the man behind the counter and came over to join me. I recognised him instantly – it was Mammoul from The Crescent Moon restaurant.

'Mr Mammoul!' I said.

'Thank you for coming, Adam,' he replied. He was smiling, and it was a warm smile.

'Did you know the note was from me?'

'No, I had no idea at all,' I said. 'Are we safe to talk here?'

'For a while,' he replied. 'Finish your drink, then I will take you to somewhere where we can speak freely. They are friends here, but it is a public place and what I have to tell you is not for public places.'

'This all sounds very mysterious,' I said, trying to think why I had become the focus of everybody's attention in Paris.

'Ah, so you like jasmine tea?' he said.

'If that's what this is then yes, I like it!' I said. I was experiencing a strange mix of emotions. I was anxious and I didn't know whether I could trust this man, but he had a calm air, and made me feel at ease in his company – more than I was with Ammon, at least. I left the money for my drink and he led me outside and in through a pair of dark blue doors right next to the café. We walked up a plain staircase and he pulled out a set of keys to open a door. I followed him in and was amazed to find myself standing in

an apartment that looked like it was from the 1970s. I couldn't believe it, all of the furniture, all of the furnishings, everything looked like it was from a vintage interiors magazine. There was an orange-red rug, curtains made of various orange, red and brown squares, a divider to match with some shelves containing books and decorative objects, and a wall made up of stones. A thin wooden lamp stand had a cylindrical textured fabric lampshade, and behind it was a groovy abstract wallpaper of yellow and orange swirls. There was an old-fashioned telephone and answering machine – I couldn't believe anyone still had one in use. Everything was immaculate. It was like a modernist show home, though if you looked closely you could see the signs of long-term wear and tear. There were wooden tables and some plastic chairs, a chessboard with red and orange glass pieces, but what caught my eye was an egg-shaped chair with a large yellow cushion built into the design. I turned my head slightly and could see into his bedroom – a Siamese cat was sitting on a white chest of drawers, staring up at the ceiling.

'Is this place for real?'

'What do you mean?' asked Mammoul.

'This room looks like it's from the 1970s,' I said, a little worried that I might be coming across as rude.

'You're right, Adam. It is.'

'But did you have it designed in this retro style?' He smiled as I stared.

'No, it is pretty much as it was when I moved in almost fifty years ago.'

'What?' I asked, in disbelief. 'This is all original?'

'Well, it's original to when I moved in, not to the building.'

'But why haven't you redecorated in all this time?'

'Why would I?' he replied, still smiling. 'It was all very expensive when it was refurbished, and it is all in very good condition. If it is not broken, why would I change it?'

As I looked round, it struck me that the proportions of the room were smaller than I would have expected.

'It's beautiful,' I said. 'Really cool. It's smaller than it looks from the outside, though.'

'You're a bright boy, Adam. And you know why that is?'

'No,' I said.

'That's because the walls to this apartment are made of concrete fifty centimetres thick. Right the way down to the basement.'

'That's unusual,' I replied, trying to figure out what exactly was going on.

'It is bomb-proof, Adam. It was built during the Cold War, to withstand certain forms of attack. I don't know how much use it would be with weapons today, but it would be better to be in here than in most apartments if any significant military attack were to take place.'

'That's terrifying,' I said. 'Why have you been living in a bomb-proof flat all these decades?'

'I will explain,' he answered, 'but first I have a few questions for you. You said that your grandfather designed the Wajah fi Alghuyum logo – is that really true?'

'Yes, it is.'

'And his name?'

'George,' I replied. 'George King.'

'Well now, George King, George King,' he said, shaking his head. 'Please, you had better take a seat.'

I did as he asked, though he stayed standing.

'Did he ever say for whom he designed the logo?' he asked.

'Yes,' I replied, 'he did mention it to me, just recently in fact. I think he said the man's name was Abdul.'

'So it's true. Well, Adam, I think I should probably let you know that I am Abdul, and I knew your grandfather when he used to work in Paris many years ago.'

'But your name is Mammoul,' I replied, confused.

'My name is Abdul Mahmoud,' he said, laughing. People call me "Mammoul" – it's like a nickname – it means "cookie". When I was at nursery school, a boy misheard the teacher call my name, and it has stayed with me all my long life.'

When he told me this, I just laughed.

'I did know that your grandfather's name was George King, though I had forgotten after all these years. He used to use the name William Roper back then, of course.'

'I am surprised to hear that Grandad used a different name, but I guess if he was delivering sensitive documents, it was a safety precaution.'

'Delivering documents?' asked Mammoul.

'Yes, he was a courier for the British government.'

'Is that what he told you?'

'Why, what do you mean?' I asked.

'Your grandfather was a senior member of the secret services, Adam. But perhaps you knew this already. Don't worry, I am a friend. Your grandfather and I used to share a lot of information – and drink a lot of coffee.'

'Honestly, I had no idea.'

'So did he send you here?'

'Oh no,' I said, quite surprised. 'I'm here to work on an exhibition – I have a painting in an exhibition.'

'So you're not working for anybody?'

'How do you mean?'

'Like, for the British government, for example?'

'Well, it is an exhibition sponsored by the British government, I suppose, but I'm not working for them as such.'

Mammoul paused for a moment and just looked at me.

'Really? So your grandfather didn't send you, and you're not working for the British government, and you just happen to turn up at my restaurant?'

'I guess it does sound like quite a coincidence,' I said. 'It was my friend Amira who brought me to your restaurant for dinner last week. I didn't know where we were going, or that you would be there.'

'Hmm,' said Mammoul, stroking his stubbly chin. 'And did your grandfather introduce you to Amira?'

'Oh no, no he didn't. Grandad stopped working years ago. He's in the early stages of dementia.'

'I see, I see. So why were you drinking and smoking with Ammon yesterday?'

'I met him through Amira, and from working with him at Youssef's warehouse.'

'You're working at Youssef's warehouse?' Mammoul's eyebrows were raised as high as they could possibly go.

'Yes, he needed some help the other evening, so I went with Amira and her friend Natalie. But why are you so surprised that I went to Youssef's warehouse? And why did Ammon tell me that I shouldn't go there again? What's going on?'

'You have,' he said, smiling, 'the same convincing air of innocence as your grandfather. Either you are completely unaware of what is going on around you, or you are very good at playing the part.' He burst into laughter. 'Genuinely, I have no idea if you are for real, Adam.'

'I don't know what you're talking about, Mammoul, I really don't.'

'Adam, you must tell me now – right now – if you are involved in this in some way. I realise that if you are, you need to keep it secret, but if you are not, you have no idea of the danger you are in.'

'What danger?' I asked, and I must have sounded pretty exasperated. 'Please tell me what's going on.'

'I need to think about this some more. It doesn't quite make sense to me… yet. But don't worry, Adam, we'll get to the bottom of it.'

'To the bottom of what?'

'Keep calm, my little brother, all will become clear. But let us not rush, things are rarely simple. If there's one thing I've learnt in life, it's that nothing is quite as it first appears. If you rush to the first conclusion, you risk missing all the other possibilities. Your thinking then fixates on the answer you reached, and you make everything fit around it, even if the fit is not the best one.'

'That all sounds very mysterious, Mammoul. Are you still working in intelligence?'

'Again, the answer is not entirely straightforward.'

'I'm guessing from what you're saying, and from this piece of paper, that something is going on that involves intelligence and which revolves around Youssef's warehouse.'

'Yes, that much is true.'

'Is Youssef doing something illegal?'

'Yet again, it's not quite as simple as that. Youssef is a good man, I'm sure of that. Amira is a good woman, I'm sure of that too. I have known them for some time. Amira is like a daughter to me, in some ways. It might sound odd but I like to think of her as a symbol of the bright future I have worked for all my life. I haven't any information to suggest she and Youssef are involved, or are even aware of what is happening.'

'And Ammon. Is he doing something illegal? I think he's been following me since the day I arrived.'

'If he'd wanted to follow you without your knowledge, he would have done so. He's been showing you that he is aware of you. He must have been unsure of you, just as I have been this evening.'

'So is he a criminal, or is he in intelligence too?'

'I'm pretty sure he's deeply involved in what is going on in some way.'

'He's Egyptian, right?'

'Yes, that's right, he is.'

'So are you both working for the Egyptian government?'

'There are several questions with several answers within that, Adam,' he said, a broad grin on his face. 'You said he warned you off going back to the warehouse?'

'Yes, he made that quite clear.'

'So either he knows that you are not involved, or if he thinks you are involved, he's warning you to keep clear all the same.'

'Involved in what?' I asked once again.

'The thing is, Adam, it would seem you are involved, whether you want to be or not.'

'But why can't you tell me?' I said, realising I was raising my voice a little.

'Adam', he said calmly, 'there are some questions I need answers to myself before I can speak further with you. Intelligence is as much about what people do not say as what they do, and you can't always take what they say at face value. It is also a question of who knows what. I need to think more about which questions to ask, because I have my suspicions that there are numerous people looking at this situation from differing positions, from different perspectives. As I say, it doesn't all add up... yet.'

'But what I am supposed to do, or not do, in the meantime?'

'I suggest you keep a low profile, don't go back to the warehouse, and don't go asking any questions of anybody. It could be fatal if you do.'

'I think I understand now why you have such thick concrete walls.'

'Yes! They are for security, and so that it is not easy to be listened in on.'

'But how did you come to be living here, in this weird flat?'

'Around half a century ago I was stationed here in Paris by the Egyptian intelligence services. The flat was state of the art – all the latest technology.

It is very near to the Egyptian embassy here in Paris, just around the corner, in fact. It was top secret, of course, only a small number of people knew about it, or me. I was registered as the owner by the Egyptian government. When the regime changed in Egypt at the start of the 1980s, there was nobody left who knew about it, or me, virtually overnight. I didn't realise this at first, of course – it became apparent over a period of months, then years. This apartment is basically a black hole, under the radar. I have continued to live here all these years.'

'It's like being in the past in here, or in a different dimension. I can't believe you've changed hardly anything in all this time.'

'I have not changed it as I have always felt that it is not mine to change, but I have looked after it well. If it is rediscovered, I may be forced to leave. I pay the bills, as I always have since the very beginning, and the French government taxes due on it each year.'

'That's incredible, Mammoul. You're living in a time capsule. But if the Egyptian government doesn't know about the apartment, or you, who are you working for now?'

'I became connected again to the Egyptian government in the late 1980s, as if from scratch. Only things are more complicated now than they once were. There are different issues today, new political parties, new agencies, new factions, new players. I work with certain people there – not so much nowadays; I am old and enjoy my work at the restaurant. I do what I can to help.'

'To help in what way?'

'It's not always clear, Adam; I wish it was. But I try to stop bad things happening, if and when I can. We could talk for many moons about what that might mean, and I hope we will have the chance to do so, one day soon.' He smiled at me with a warmth that I trusted completely. 'And as an old friend of your grandfather, I need to make sure you get back to him in one piece.'

'Do you think anybody other than Ammon is following me?'

'Who could say? It's certainly possible. Keep your wits about you, my little brother. Even people who are friendly can be deceiving us, and things we think we have known for years can hold secrets that may one day take us by surprise.'

'Okay, thank you Mammoul, I'll take your advice.'

'Please keep your mobile phone switched off until you get back home. If you need me, you know where to find me – I'm at the restaurant most days from morning until night.'

## A CALL FROM THE PAST

The next morning I was having a bowl of cereal in my room when there was a knock on the door. I opened it to find Natalie there, holding the note I had left for her the previous night.

'Hi Adam,' she said breezily. 'So what's all this about?'

'Oh, nothing, sorry about that. I was going to meet a friend in a café on the other side of town. I didn't mean to alarm you. I didn't know him very well, that's all. I was also a bit worried some guy had been following me for a few days, but I think I was just being paranoid.'

'Was it a special friend?' she asked, with a mischievous smile on her face.

'Oh,' I said, realising what she was implying. 'Oh no, no, nothing like that. No, he's just a friend.' I was blushing once again in front of Natalie. She always seemed so relaxed and confident. And now she thought I might be gay. Maybe it was for the best that she didn't suspect anything serious was going on. There was no need for her to get embroiled in whatever I had got myself caught up in.

'What made you think you were being followed?' she asked, sitting at the other side of my little table, staring straight at me.

'I kept on seeing the same guy around, that's all. Maybe he lives here in the foyer, I don't know. Anyway, I'm over it, I was just being silly.' Part of me wanted to tell her everything, especially as she had met Ammon and Youssef, but Mammoul had made me more cautious about what I said and to whom. After all, Natalie was friends with Amira, and if she wasn't involved in whatever was going on, perhaps it was best that I didn't burden her or Natalie with it. But if Amira and Youssef were involved in something dangerous without even knowing, surely they needed to know? I didn't know what to do for the best. I hadn't even finished processing the conversation with Mammoul from the night before. What was I supposed to make of Ammon now? Mammoul didn't seem to imply that he was a direct danger to me, nor did he suggest I could trust him.

'You do look a bit anxious, Adam.'

'Do I?' I replied. 'I think I'm just a bit tired. It's been such a busy few days and I've hardly recovered from the Nuit Blanche. I totally loved your performance, by the way. Were you pleased with how it went?'

'Yeah, yeah, it was fine. It could have gone better, but it could have been

much worse too. Listen, I've got to head off to class, but if you want to talk about anything, I'll be on my mobile, okay?' She put her hand on mine, which was resting on the table. 'Thank you, Natalie, that's kind,' I said. And she sprang up and dashed out the door. I stayed put to finish my breakfast. I had bought myself one of those little metal espresso pots that you put on the hob, and was getting accustomed to the continental way of doing things. It was partly because the tea here was so bad. I realised I hadn't even offered Natalie a coffee. I kept thinking over and over about what Mammoul had told me, and trying to figure out any possible reason why I had found myself in this position, and how strange it was that my grandad's work from fifty years earlier had resurfaced in the middle of my own life. And the tobacco tin — surely it was too much of a coincidence that Grandad had designed the logo of this particular brand, and here I was in Paris, friends with the sister of the man who imports it to France. I wanted to speak to Grandad, so I picked up my phone and rang his number. There was no answer, and it went to answerphone. That's odd, I thought, he usually has it switched on. Maybe he hadn't got his hearing aid on. I was a little concerned something wasn't right, but it was too soon to be worried and it was too early for me to call the social club or Stirchley Electronics so I decided I would call from the museum a little later on. I thought I'd send Grandad's community nurse, Sophia, a text, just to see if she was going in to visit him today. Within a few seconds of me texting, there was an incoming call from her.

'Hello Adam, I was just about to give you a call.'

'Is everything okay, Sophia? Is Grandad okay?'

'Well, I'm round at his house now – I came to see how he was doing and to sort the washing while you're away. The thing is, he's not here.'

'Might he have gone out somewhere?'

'Yes, but all the curtains are still closed. His bed was made and his pyjamas were still on the airer. I'm not sure he slept here last night.'

'That's strange.'

'That's what I thought. It's not like him.'

'And no note or anything like that?'

'No, nothing. He knew I'd be coming at eight this morning, and he hasn't forgotten before.'

'Well, let's see if he turns up,' I said. 'I'll try him later this morning. Please do let me know if you hear anything more.'

'Of course, Adam. Try not to worry – I'm sure he's fine.'

'Yes, my goodness, he'd survive a nuclear war!' I said, to reassure her. But I was worried.

No sooner had I ended the call then my phone pinged. It was from a number I didn't recognise, and it wasn't the length of a regular phone number – like it was from a robot or a company or something. It said simply: 'Message at reception'. I made my way downstairs. When I reached the bottom I went

over to the hatch to see if Madame Pompadour or Jean-Claude was there. I knew from the intense cloud of expensive-smelling perfume in the lobby that it was Madame Pompadour on duty.

'Good morning young Mr. King,' she said. She was smiling, but it was one of those smiles that you felt could turn into rage at any moment if you were to say the wrong thing. Her eyebrows were raised, and they were clearly thin black lines made up primarily, if not entirely, of make-up. 'What can I do you for?' she asked.

'Good morning Madame Pompadour. I think there's a message for me.'

'Why don't you try your mailbox over there – you have your key, no?'

'Oh yes, of course, sorry, I didn't think it would be that kind of message.' She stared at me sternly and seemed a little perplexed.

Sure enough, there was an envelope with my name on inside the old wooden mailbox on the wall. There was no stamp on it, so it must have been hand-delivered.

'Did you happen to see who put this in my mailbox?'

'What do you think I am? Some kind of spy? Okay, maybe a very glamorous, sexy spy, yes, I could see how you might mistake me for one – and what a front working my ass off here every day would be – nobody would ever suspect me... yes, you're right, Mr. King, I am a spy and I observe everything every one of you grubby young people does in this building. It's all very interesting to me, and terribly important, as you can imagine – "Oh, madame, my parcel did not arrive this morning, they said they delivered it but I can't find it... oh madame, my shower attachment is broken and I can't use the shower, please can you have it fixed for me? I am getting very smelly, please help me..."' She seemed to be impersonating us residents with increasing degrees of contempt as she carried on. I just had to stand there while she continued with her performance. '"Oh madame, I have a pimple on my nose, can you squeeze it for me?"' She paused for a moment and I took my opportunity to thank her kindly for her help.

I headed out onto the street and opened the envelope. Inside was a piece of paper with a web link accompanied by the following instruction: *Install this on your phone before you make any more calls.*

I was still connected to the wi-fi, so I stood there on the street downloading what it soon became apparent was an app. It was called Heorot, and purported to be a 'data security portal for the business community'. I figured if whoever it was wanted me to install some software on my phone, they would guess that I would suspect that it might be malware, and the fact that they didn't want me to use my phone to make calls without installing the software was surely an indication that this was for my protection. But what if this was a trap, and I was willingly falling into it? As I was standing there deciding what to do, a text came through on my phone, saying just 'do it now'. Okay, so someone was totally all over my life, completely on top of me.

They knew where I was, they knew what I was doing, and they were engaging with me in real time. I was totally freaked out, but tried to keep cool. I looked around to see if I could see anybody watching me, but nothing struck me as out of the ordinary. I decided to download the app and open it. It asked me for a password. Of course, I didn't have one. I carried on down into the Métro.

Having smiled and said good morning to the moody man at reception, I got to my desk at the museum. Emilie was already at hers. She had been off sick the day before – or maybe just pulling a sickie – so this was the first time I had seen her since the incident in the bar.

'Morning,' I said, being polite but deliberately not friendly. 'Oh, hi,' she said. 'Listen, if I seemed rude on Friday, I apologise, it was late and I'd had too much to drink.'

An apology was the last thing I'd been expecting.

'Not at all, it was very noisy in there – I couldn't really hear what you were saying, and I was pretty drunk too.'

'Oh really?' she said, her demeanour instantly getting lighter. 'Great, that's just great. It was a crazy night – the Nuit Blanche is always a lot of fun. Right, why don't you finish up on those last signed agreements that have come in. You've done really well getting those sorted. Then we need to get the last captions over to the designer and into the brochure layouts ready to go to print on Friday. There are still some missing image files too – can you see which ones we're still waiting on from the photographer and if there are any we have still to photograph?'

This was the most she'd said to me the whole time I'd been at the museum. And a compliment too! Maybe we'd turned a corner. I didn't know why she'd taken such a dislike to me from the outset, but I guess some personalities just clash, especially in an office environment. I think – and I can't be sure – she actually smiled at me that morning, and it almost seemed genuine. I'll take it, I thought. As I switched on my antiquated computer, I noticed a luminous yellow piece of paper stuck to the bottom of the monitor. It had a code written on it by hand: *CK72KPDP.* I wondered if this was the code for the new app I had downloaded. However had they got in here and placed it there? I was starting to feel completely paranoid, and for real now. Anybody and everybody around me might be a friend or a foe, and I still didn't know why I was at the centre of all of this. Why me? What could anyone want from me? I was neither any use nor any threat to anyone. I popped the note in my pocket and waited until a convenient moment to go the washroom, where I locked myself in a cubicle and typed the code into the app. A message appeared on the screen: *Welcome, Adam. This is a secure network. It will protect your incoming and outgoing data against a whole host of spyware and malware. This will replace, through a simulation operating system, all of your telephone calls, text messages and other messaging services until further notice. Each app will run as if normal through this portal.*

There followed a whole load of instructions about closing specific applications and disabling and enabling certain preferences and functions. Having done all the installs, I switched the phone off and back on. The screen looked exactly the same as it usually did, but there was now a small letter H next to the battery level indicator. I tried to call Grandad again. Still no answer. A message came up on FrendHub from someone I didn't know, called Boo2u2. It said: *William Roper is safe and sound. Stand easy.*

William Roper. That was the name Mammoul said my grandfather had used all those years ago. Why were they using this name now? And how did they know that I would know? Who was it, exactly, that was messaging me? And as for 'Stand easy' – that was an old army phrase that my grandfather said to me all the time, ever since I was a little boy. Was this a message from him – a covert signal that he really was okay? He wouldn't know how to use FrendHub. No chance. He didn't even do texts. Whoever had sent the message clearly knew that I was anxious to know if my grandad was okay, and they had kind of put me at ease, but it was all super weird. Were these people in touch with Mammoul? That might explain the William Roper connection, plus they already seemed to be in touch with him, or at least were in a position to know that he knew that I was in Paris. But why would any of this matter to anybody? I was tying myself up in knots. It had just turned ten in Paris so I knew that Stirchley Electronics would be open. I searched for the number online and called. Alice picked up.

'Hello Alice, it's Adam King here.'

'Oh hello Adam, how lovely to hear from you,' she said. 'How can I help?'

'I wondered if my grandad came in to your shop yesterday for some more wireless parts.'

'Yes, yes he did. He must have come in around midday. He said he'd timed it so he could go over to the club for a pie and a pint at lunchtime. Why? Is there something wrong?'

'It doesn't sound like he went home last night, so I'm a bit worried he might have had one of his funny turns and gone AWOL. He's done it before. Used his bus pass to travel to the edges of the West Midlands, decided not to tell anyone. I'm sure he's fine, but he's not answering his phone and I just want to make sure he's okay.'

'I see,' she said. 'Listen, I'll go over to the club myself when it opens at eleven and see if anybody there knows anything of his whereabouts, okay?'

'Thank you, Alice,' I replied, 'that's very good of you.'

'My pleasure Adam. How are you getting on in Paris?'

'Oh, not too bad, thank you. I think I understand at least half of what people are saying to me!'

'Three weeks in Paris in the summer – how lovely! And congratulations on winning the painting prize – your grandad told me about that. How exciting. Maybe you'll get to meet the royal couple!'

Hang on a minute, either the royal visit was the worst kept secret in the world, or somebody was messing me about.

'How did you know about the royal visit, Alice?' I asked.

'I saw something about it on social media. It's very hard to keep secrets in this day and age. Everyone's so connected with everybody else.'

'That's true,' I said.

'Speaking of which,' she continued, 'don't forget about those friends of mine, Push Le Button. I say friends, I don't know them very well apart from through FrendHub. They're playing in the eighteenth arrondissement on Thursday night this week. You got my message with the details, right?'

'Yes, I did, thank you so much. I will definitely be there.'

'Great! I think my favourite track of theirs is called "Fax me",' said Alice, giggling.

'I'll listen out for that one,' I replied. Of course, it would be an old technology joke that tickled her.

I went back to my desk and resolved to power through the admin I had ahead of me. There was a lot of activity in the offices that day and there was an email waiting for me telling all staff at the museum that we were to have a major clear-out of the offices ahead of the royal visit. The galleries too were being touched up beyond the usual work done to install a new exhibition. A whole load of flat-pack cardboard boxes arrived in the reception area of the offices and some of the managers and senior curators were leading the drive to sort out all the folders, files, books and general junk that had gradually accumulated over the past however many years. There was a pile for books and catalogues that were to be disposed of, and we were all welcome to take any of them that we wanted. I let all of the other staff have chance to look through first, and then when the flurry had died down, I went over and picked out a dozen or so publications that looked interesting. These were not flimsy little brochures, they were the kinds of books that I would never ordinarily be able to afford – large clothbound hardback books with hundreds of pages of colour reproductions. There were books on everything from prehistoric rock art to Renaissance painting, Indian miniatures to Chinese landscape ink drawings and calligraphy. Mlle Honfleur came over and spoke to me.

'Help yourself Adam, we just don't have room for all of these books. Take whatever you want, or that you can carry! Did you see this box here? It is full of miscellaneous things left over from projects that we have done with artists, schools workshops and so on. Come, take a look!'

I went over to the box that was next to her on the floor.

'What is that?' I asked, picking out a small but fairly robust box-shaped brown and cream fabric bag.

'Ah, yes, I remember – that was for a project we made with an Israeli artist back in 2006, I think. Have a look inside.'

I opened the zip and pulled out the handle of an old-looking machine.

'Is it some kind of camera?' I asked, seeing that it had a lens at the opposite end from the handle.

'Have you not seen one of these before?' she asked, amused.

'No, I don't think so. It has an eye-piece. Is it a video camera?'

'Yes, you're right – it's a Super8 – a kind of cine camera. They were very popular in the 1960s and 70s. They use 8mm film, and they are famous for the flickering quality.'

'Cool!'

'We are used to the power of our mobile phones today to shoot digital footage – it's at the tips of our fingers, instantly. But forty or fifty years ago, it was pretty special to have one of these and to be able to record your own life. It was not cheap to buy the camera, and the film was expensive too, not to mention the processing. You had to take the film to a chemist who would then send the reels off to a lab to develop them so they could be watched on a projector. The other thing is that each film would only last for three minutes, then you had to change it for a new one. I think we might have a projector somewhere too.' She wheeled her chair over to a corner behind the bookshelves and after a little bit of grunting and lifting, pulled out a larger box.

'There we go. This is a Super8 projector. And here is a bag of unused films. They do still make them, and process them, but there are not so many places that do these days. Another thing is that many of these cameras do not record sound – only images. They are becoming obsolete now, apart from people who are particularly interested in the quality of the film that Super8 offers. The Israeli artist wanted to recreate a scene from his family life in 1976, the year in which he was born. His father abandoned his mother three weeks before he was born. He just walked out and never came back. His grandfather filmed his mother coming in the front door to her flat in Tel Aviv for the first time with her newborn child. The artist restaged the footage in incredible detail – in a warehouse he built a set that looked just like the flat; he had a replica wallpaper printed, replica carpets made, and got a carpenter to make any items of furniture that they were unable to source. Even the pictures on the walls were painstakingly recreated. The lighting was restaged in the minutest detail. The actors looked identical, wearing clothes that were exactly like in the original. The only difference was that in the artist's film, his father was present, holding the door open for his mother and coming in behind her, smoking a cigar. The two films played side by side in the exhibition space. It was very powerful. All of the movements of the camera were the same, the positions, gestures and expressions of all the other family members timed to precision, the close-ups on the baby in its crochet shawl. It was utterly heart-breaking, in fact. The absence of a soundtrack was painful too, just the clicking away of the projector, and these bleached-out flickering memories alongside the reality he had dreamed of. Anyway, the camera and the projector

have been here in our offices for a long time, so if you'd like them, you'd be more than welcome to take them.'

I accepted at once. I knew instantly that this was how I was going to make my project about *The Mona Lisa* and the face in the clouds. I wasn't sure exactly how or even why, but I couldn't wait to tell the Eleven Associates. I would take some photos of the camera and projector and send them out on our FrendHub group. Maybe they could help me formulate a plan for what to do and how to do it.

A little later on, Alice called back. She said she'd spoken with some of my grandad's friends over at the working men's club, who had seen him yesterday lunchtime.

'Hubert said he'd ended up staying much of the afternoon, talking with different members of the wireless club. There'd been some kind of function on – lots of the members had come in especially for it. He'd last been seen with Margot and Cecily, twins in their early nineties – do you know them?'

'Yes, I've met them – they're lovely!'

'I tried to call him but his phone still seems to be off, or perhaps he ran out of battery. I can try calling the twins if you'd like.'

'That's okay, Alice; if you don't mind passing me their number I'll try myself.'

As soon as I put the phone down to Alice I tried calling but it went straight through to answerphone. I wondered whether Chris or Eddie might be able to help me out. I decided there was nothing else for it but to call them and ask. It was the school holidays so I knew they'd be lounging about the house and playing computer games.

'What's up Adam? Aren't you in Paris now?'

'Hi Chris,' I said. 'Yes, I am. I had a call from your mum earlier, she said she doesn't think my grandad made it back home last night, and I wondered whether you would mind going to the house of some friends of his who he was last seen with yesterday.'

'Er, yeah, sure, why not? We can do that.'

'There are two sisters, Margot and Cecily – they're twins, like you and Eddie. They live in Bournville in one of the old almshouses – you know, those pretty little houses in the quadrangle between Cotteridge and Bournville village green?'

'Sure. Why though? Do you think he might be there?'

'Do you remember Alice Bainbridge from junior school?'

'Yes, of course.'

'Well, you may know that she works at Stirchley Electronics now and she said he was last seen with them early yesterday evening, so even if he's not still with them they might know where he was heading at least.'

'Funny you should mention, Alice – Eddie and I went to the barbershop across the road from her shop yesterday. We were talking with the barber, Roy,

and his friends, and they said there had been a lot of activity at the electronics shop over the past few days – people going in and out. While we were there we saw some posh cars with blacked-out windows pull up outside. Alice came running out and sent them away. She seemed quite angry. We watched them turn around, go a short way down the road and then turn in through a little driveway behind a balti restaurant and some IT firm. I thought it was the car park for the restaurant in there.'

'Why would anyone in a posh car go to Stirchley Electronics?'

'Exactly. The people going in were wearing suits – men and women. All of them were sent back out and down the road within seconds of entering the shop. It was really strange.'

'It does sound odd. Maybe they were from a record label, or were rock stars looking for a Mellotron. But why would there be more than one car? Do you think Eddie would mind hanging out in the barbershop again to keep an eye on what's happening there while you go and see the twins?'

'No, I'm sure he'd be happy to do that. They let him drink cans of soda and eat chicken wings while he's there. And they play him old dub tracks on the record player they keep in the shop next to the fish tank.'

'Great, well if he's happy to camp out there for a while to see if he can figure out what's going on, that would be great. And when you've been to see the twins, maybe you could re-join him and see what's going on in the car park behind the restaurant.'

'It sounds like you're enlisting us as detectives, Adam!'

'Not far off, Chris. I'm beginning to wonder if what's going on there might be connected to what's going on here.'

'Why, what's going on there?'

'It would take me hours to explain, but I think I've got caught up in some international diplomatic issue. I might be in trouble. I'm not entirely sure.'

'That sounds totally cray-cray!'

'Totally. It's possible my phone is being tapped and I don't really know who exactly is listening in, so I won't say too much more now.'

'That sounds pretty heavy stuff, Adam.'

'Let's try and speak on landlines later on – maybe I could try calling you at the barbershop from a public pay phone, if they still exist. I don't think I've ever used one.'

'Okay, listen, I'm on my way to visit the twins now. Send me the address. Speak later on.'

\* \* \*

I got a call from Chris towards the end of my lunch break, so I headed outside to ring him back from a café down the road. I wasn't sure if I could trust this Heorot software yet. Chris was already back at the barbershop with Eddie.

'Did you find him?' I asked.

'No, but I did speak with the twins. You wouldn't believe their house, Adam – really old furniture, ornaments and pictures, like antiques, but things that were new when they bought them! They made me tea in a china cup and saucer and brought out biscuits on a floral plate. It was like being in some strange TV show. I asked if they'd seen your grandad. They said he'd come back to their house with them last night because he needed their help. I told them you were in some kind of trouble and needed to speak to your grandad, and that you were worried he might be in trouble too. I asked them what he'd needed their help with, and that's when they took me through to the back room.'

'Oh, why, what was in there?' I asked.

'It was insane. There was an old-fashioned switchboard, like a telephone switchboard. It was huge – it took up the whole of one wall. There was a desk with two seats, one for each of the twins, and there were cables and wires everywhere. There were two large headsets, one in front of each seat. I asked them if it was still in working order and what they used it for – listen to this – they said it does still work and they use it as a non-digital network. They're circuit switchers, using old analogue connections to reroute landline communications or something like that. Can you believe it?'

'That's incredible.'

'Yes, they worked at the Kings Heath and Kings Norton Telephone Exchange all their lives.'

'Are they using it for fun? Or is it for more important purposes?'

'They said your grandad had asked to use it, and needed their help with it. They said he needed to scramble a couple of calls, whatever that means. He also told them it was fine to let you know. He left a message with them for you. I have it written down here. Are you ready?'

'Yes, of course, fire away.'

*Adam. I've had a call from the past. An old emergency signal – one that was devised nearly fifty years ago. I have been trying to explain this to the British intelligence services, but they seem to think I am a prank caller or off my rocker. They have no idea what I'm talking about, and I can't seem to get hold of anyone senior enough to listen to me. People are looking and listening at the moment. I will tell you more when I can – I should really have told you a few things before you left. Sorry for all this. I hope you enjoy the concert. I am going off-radar for a few days. I'm not in any immediate danger, I don't think. Stand easy. I'm really enjoying those Middle Eastern biscuits you gave me.*

I was trying my best to take all this in. Had Grandad had some kind of breakdown? But there was way too much that made sense – well, was consistent with my experiences at least. How did he know he would get a message to me via the twins? Had he spoken with Alice since I had?

Presumably I could trust her. I certainly wanted to trust her. But if she had known about my grandfather needing to go off-radar, why hadn't she just told me? Maybe she couldn't. Maybe she was being listened to as well. And that thing about Middle Eastern biscuits – he must have been referring to Mammoul but must be worried even this message would be intercepted.

'What do you want us to do now, Adam?' asked Chris. 'Shall we go and explore around the balti restaurant and see if there's anything to report on there? I don't really understand what's going on or what we're looking for though.'

'Neither do I, Chris, but I'm sure all will become clear. It's hard to know how to communicate without being overheard. I'm standing in a café in the middle of Paris and I have no idea if anyone around me is listening in, or whether this phone is being tapped too.'

'Well it's no different to our mobile phones, I guess. We're kind of used to the idea that people are using our data, tracking our communication, movements and activity all the time.'

'Yeah, but there's a big difference between people trying to sell us new trainers and people wanting to follow our conversations.'

'Dude, they're totally in our heads all the time, and we've no idea if it's the Americans, the Russians, multinational corporations, criminal syndicates or lone-wolf hacktivists.'

'True, very true,' I acknowledged. 'I've got to go now. I'll call you later.'

The museum offices were now teeming with people I had not seen before. I recognised a couple of people come through the doors – one was that guy that Emilie was with in the bar the other evening. He saw me staring at him as he made his way through to an office at the back, and nodded at me without smiling. I raised my hand at him in a half-hearted wave. There was so much going round in my head I was finding it hard to concentrate. I'd arranged to meet up with Armand and Anne-Sophie this evening to go out to one of the HLMs for Armand's documentary. I wondered about cancelling, but then I reckoned I was probably better off in company and away from all the usual places, so decided I'd carry on as planned. When the end of the day came I made my way down the Avenue du Président Wilson and into another bar. It was old-fashioned and also still had a pay phone in it that accepted Euros. I called the barbershop. Roy answered and passed me on to Chris.

'Any news from your investigations?' I asked.

'Kind of. Me and Eddie went and had a look around – there's a courtyard at the back of the restaurant that's used as a small car park. There were three posh cars there. There's an IT firm in the offices on one side of the courtyard that backs on to Stirchley Electronics. We could see quite a few people in the offices – they seemed to be having meetings. Maybe they'd just turned up at the wrong address when they went to Stirchley Electronics – maybe their SatNavs took them there by mistake.'

'It would explain why Alice redirected them, I suppose. But why would she have been angry about it?'

'Well, the plot thickens. We went into the balti restaurant and sat at a table at the back with a view out of the window onto the offices. Before they closed the blinds, we saw Alice arrive in the room and sit down in one of the meetings.'

'In the IT offices?'

'Yes. And she hadn't left the shop. We'd seen her in the shop just half an hour before and she didn't come out of the front door – we'd been watching it. The buildings must be connected inside. It's the only explanation.'

'Why would Stirchley Electronics be connected internally to an IT firm?'

'Maybe the shop is just a front for other business activities.'

'Well, there's clearly more to Miss Alice Bainbridge than meets the eye.'

'So we still don't know where your grandad is, but it sounds like he doesn't want to be found right now. Is that it?'

'Yes, I think you're right. Thank you both so much for your help, you've been amazing. Say hi to Sophia for me and let her know my grandad's been in touch, if only via a message.'

'Okay dude, look after yourself. If you need us, you know where to reach us.'

<p style="text-align:center">∗ ∗ ∗</p>

I met Armand, Anne-Sophie and Stéphanie at a bus stop in the east of central Paris, right next to the *Périphérique* – a concrete ring-road that encircles the city like a heavy grey collar. When the bus arrived, we got on and sat there for almost an hour, heading in a sinuous route far out into the suburbs of Paris. During the ride, they explained to me a little of the history of the HLMs – the social housing scheme that had begun in France in the 1950s to try to create housing with affordable rents for those on low incomes. During the 1960s and 1970s the HLMs became synonymous with migrants and poverty, and while many have been run successfully, others were not so successful, fostering frustration and discontent. Some areas had almost become ghettos, and we were on our way to a place that had plenty of problems of its own – Départment 93.

'We're going to one of the cités,' said Armand. 'It's one of the large social housing estates that I've been working with over the past couple of years. A lot of the residents know me or recognise me now. I've interviewed dozens of them. Their stories are all so different, yet all so similar. At the bottom of it, integration has not been hugely successful here. The issues are complicated, of course, the solutions even more so, but the causes are quite clear. The poverty in some of these zones is followed by a sense of hopelessness, especially among young people, who feel there is little chance of upward economic and social mobility. Even if, as a kid, you manage to get some kind of an

education, there are few jobs, and little chance of getting one, especially if you don't have a French-sounding name. You're caught in a downward spiral.'

'But surely there must be plenty of organisations and initiatives to try to improve the situation?' I asked.

'Yes,' said Stéphanie, 'and there has been some progress, but if you'd visited some of the HLMs thirty years ago, you wouldn't see much difference today.'

'Sometimes the frustration flares up in riots, which of course does little to help with public opinion,' said Anne-Sophie. 'There is increasing alienation here – even only a short ride away from central Paris – it's like a different world. Armand's documentary paints a vivid picture of these two different worlds, of the disconnect between deeply entrenched attitudes towards immigrants, and diverse communities that are increasingly finding themselves either cut off from, or in opposition to, mainstream French society.'

We arrived at the *cité* in question, an immense housing estate of high-rise buildings. There was a smell in the air of bins, and a strange lack of noise. Considering the thousands of people living here, there were relatively few people walking around. We walked along a footpath that led to one of the blocks. Armand led us through an open doorway into the reception area. The lift was out of action. We took the stairs. There was a bit of graffiti on the stairwell, but not all that much, considering. It smelt of damp. The stairs just kept on coming.

'You definitely do not want to try to bring a pram up these stairs to the thirteenth floor,' said Armand.

We arrived on the top floor and continued out onto a balcony that spanned the length of the building, facing into a quad. It was a large quad, and not a picturesque Parisian one like in my foyer. It was bleak to say the least. There were a few kids playing football, and a few standing around or sitting on a basketball court, playing music from a phone. We carried on walking until we turned around the side of the building, arriving at the corner facing back out.

'I've brought us here because I want to get some footage of this site,' said Armand, pointing to a vast empty space surrounded by temporary fences with concrete bases. 'There used to be several other HLMs here, but they were demolished some time ago because they were deemed unfit for modern standards of living – there weren't even toilets or bathrooms in many of the apartments.'

Stéphanie pulled out a small but professional-looking digital camera from her bag and began filming, panning slowly from left to right.

'I realise it's not much to look at at the moment, but do you know what this is Adam?'

'No,' I answered. 'Do tell me.'

'This is the site where Antoine's mother is going to be building a new residential complex.'

'Oh wow,' I said.

'Yes,' said Anne-Sophie, 'she's been working with a really ambitious, forward-looking housing association to try to develop a new model of social housing.'

'How will it work?' I asked.

'Well, the basic principle is that it will be spacious, hi-spec modern housing, some as affordable apartments available for purchase by first-time buyers under thirty, and a substantial proportion will be for low-income households. Instead of paying rent, they will be buying a proportion of their home each month, so that gradually they will become the owners of the property. It's a kind of social housing mortgage scheme. It means the residents will have a sense of ownership and that they are investing in their own futures, with the value of the property eventually becoming their own assets. If they decide to sell, they would have to sell back to the association, but the money will be their own.'

'That's one side of the project,' added Armand, clearly enthusiastic. 'The scheme will also involve a proportion of the unemployed young people from the surrounding HLMs being trained to work on the building site, and others being taken on by the association as managers of the complex, to be part of the day-to-day running of the buildings. People will be paid to keep it clean, to maintain the fabric of the building, to work with many different civic and community agencies and organisations to help with social and economic development. There will be a restaurant initiative, for example, training people to work in kitchens, in food hygiene, in service, in procurement, in admin and so on. And the food will be heavily subsidised so people can afford to eat there regularly.'

'It sounds really utopian,' I said. 'Won't people from the surrounding old HLMs be jealous?'

'Well,' answered Anne-Sophie, 'a lot of the people moving in will be coming from there, and the plan is that once the new complex is open, they will demolish the old HLMs and build new complexes, new estates, new roads, and gradually work on the whole urban planning footprint of the zone to break it up, open it out. And Antoine is planning to introduce organic urban farming here as part of that regeneration, run as a cooperative with many of the residents.'

'This sounds incredible,' I said. 'Really incredible. And are those people down there surveyors?' I asked.

'Where?' asked Armand.

'Over there, by the perimeter fence on the far side.'

'Interesting,' said Armand. 'I wonder. Let's go down and take a look.'

We made our way back down and out around the fence. There was a small white van parked up, and two men with surveying equipment set up.

'Good evening,' said Armand as we approached the nearer man.

'Can I help you?' he asked.

'We're making a documentary about the redevelopment planned here for an independent production company. Can we interview you about what you're doing here?'

'Listen, we don't know anything about that. You'd need to show us your licence for filming and approval from the boss,' he replied, curtly.

'Which company is it you're contracted to?' asked Armand.

'I can't tell you that. Now if you don't mind, we have work to do.'

'No problem,' said Armand. 'We do have a filming permit, and we do have permission from The Marionette Regeneration Company to be here.'

'Well that's not a company that I am contracted to, so I can't authorise you to film us.'

'It's the company that is developing this site – it's possible they are using the name of the social enterprise company that is specifically managing the project.'

'Look, I am not authorised to give you any permissions, so please, let us carry on with our work, or I will need to call the police.'

'There's no need to threaten us,' said Armand, clearly becoming riled. 'We are journalists also just doing our job here.'

By now the other man had come over.

'What's going on?' he asked his colleague.

'Oh nothing, these guys are just leaving.'

'Come on,' said Stéphanie, 'I think I've got the footage we need for now.'

We made our way back towards the bus.

'I kept on filming,' said Stéphanie when we were out of earshot of the men. 'I had the camera on my chest, so it might not have been a great angle, but I think I got most of the conversation.'

'Oh great,' said Armand. 'I'd be very interested to get to the bottom of who those guys were working for. I wonder if Antoine and his mother know anything about them.'

'Maybe,' said Anne-Sophie, 'though they seemed pretty defensive, not the kind of people that Antoine's mum likes to work with.'

'Yes, that's what I was thinking,' added Stéphanie.

As we were walking, I spotted somebody standing on the balcony where we had been just a few minutes before. It was a woman with a camera to her face – possibly the same woman I had seen photographing us outside Montrouge during the Nuit Blanche. I was not imagining things.

When I got back to the foyer I called Chris to see if he had any more news. I was less worried about my grandad now that I had received his message, but still had many unanswered questions from the day. He and Eddie were pumped up from their detective work, and had plenty of questions for me too. I was feeling more relaxed about using my phone – not completely relaxed, I hasten to add, as I still didn't know who was behind this Heorot

app, but it felt like it was for my benefit, or at least not hostile. I took a chance speaking with Chris, all the same.

'So, Adam, the twins. I forgot to tell you, before I left, they said that if I wanted to help you and your grandad, I should go to the bowling alley in Stirchley on Friday around midday. I asked if Eddie could come too, and they said yes. So we're going down there. Eddie loves bowling, so hopefully we'll get to play a game or two.'

'I wonder what they want you to do?' I said. 'This is definitely turning into some TV drama. Keep me posted on what you learn. And take care.'

'We will, dude, we will.'

## THE ANGEL OF THE ANNUNCIATION

Wednesday was, thankfully, a relatively quiet day. I scanned the notes I had made about *The Mona Lisa* on the photocopier in the museum offices, and sent them directly to my computer, from where I forwarded them to Sebastien, who had asked to read them, as well as to my own email account so that I had a copy of them there. He had suggested some books to read, a couple of which I was able to download as e-books. Antoine had reminded me of his invitation to use his mother's library, and I had asked if that evening might be convenient for me to come round. He suggested I pop in after work, and then could join them for dinner, which sounded like a nice idea. He also suggested inviting Sebastien, if he was free.

The library was stunning. Floor-to-ceiling white-painted wooden shelves – the wood was thick and strong, as it needed to be to hold the weight of so many large and heavy books. The early evening sunshine fell through the giant windows that had been opened outwards onto the Avenue. They were the kind with a bar down the centre, and holes for the gorgeous, slatted shutters to be secured. There were books ancient and modern, from leather-bound series from bygone eras to some of the latest releases. There were monographs on old masters, anthologies on different movements in art history, and a whole wall of shelves specifically labelled 'Great Women Artists', with an exclamation mark after it. I just wanted to work my way through the whole library. So much knowledge, so much research, so much thought, and within the walls of one room. And not just that, but a visual record of so much art, so much visual culture that has been produced by humanity, across the world. It was humbling and inspiring.

I found a section devoted to Italian Renaissance painting, and pulled out a few titles I thought might be of interest. I started with one on Leonardo – a compendium of his drawings and paintings. I sat down at an elegant old wooden table in the centre of the room. I had seen some of these works before but hadn't looked closely at them. Several of them were rather odd. I pulled out my notepad and continued with my notes.

*The Virgin and Child with St Anne* – totally weird. Why would a fully-grown woman be sitting on the lap of another fully-grown woman? There is something unusual about St Anne, and not just her scale in

relation to Mary. She must be a tall, strong woman. The distant landscape is amazing, like rocks emerging from the sea, or mountains above the tops of clouds. How beautifully the rocks are defined in space, in distance, in perspective, and, at the same time, how little the landscape encourages my imagination in comparison with *The Mona Lisa*. And then there's *The Madonna of the Yarwinder* – either version – how weird is the perspective on the young Mary here? She's kind of flat, like she's coming into the painting from another dimension. It's like she's been painted through a lens, distorted through a filter. And as for *John the Baptist* – this androgynous character, which shares something of its countenance with St. Anne – suggests a love that once dared not speak its name, and more besides. Gender fluidity was maybe not an issue for Leonardo and some of his followers – especially in evidence in the *Monna Vanna*, which could have been created by a union between Hermes and Aphrodite! Yes, it is all most intriguing.

Then I came across an early painting by Leonardo, from around 1472, of *The Annunciation*. It looked older, in the sense of being in an earlier style than *The Mona Lisa*, though it was still unusual.

The trees, such distinctive shapes; the flowers, so carefully painted – almost as if a tapestry; the Angel Gabriel, so focused, with such realistic wings; the Virgin Mary, really still just a girl. I let my mind wander a little, just to see if anything triggers my imagination. Something is flickering away in the back of my mind, and I can't quite put my finger on it.

I stared out of the window for a moment, as I'd been concentrating on the pages of the book for some time. I took a couple of deep breaths, then returned to the double-page spread of this annunciation scene. Then it came to me.

A demon hovers in front of the face of the Angel Gabriel. Its face is the same size as his, and faces as if turning round towards him, to look him in the eyes. It's as if he's just flown in from behind the angel, to try to stop him announcing the good news. With the green sash draped around the back of the angel, there is even a sense that this demon, this devil, is wrapped around the holy ambassador, swirling around his body like a spirit trying to take on form and flesh. The Angel Gabriel, of course, has already made the transition from spirit world to our mortal realm to be able to appear to the surprised, frightened young Mary. The demon's face is, ingeniously, composed entirely of the white flowers – usually lilies, subsequently associated with Mary – and the gaps

between them. The dark foliage of the landscape behind serves as the shadow against the sickly half-light that the petals of the flowers represent on the demon's face. The demon has a long nose with a pointed hook at the end, its mouth an evil grimace coming right up under the nose. The eye cavities are small and empty yet piercing, the brow suggesting a deep frown as it stares at God's messenger, unable to stop him doing his work. Gabriel, holding in his left hand the very flowers that the demon has used to assume its form, looks straight through and past the demon, focusing only on Mary. It's brilliant, of course – Leonardo is depicting an angel, something that is usually invisible, for the viewer, and devout Christian. The invisible literally made visible. But beyond that, he paints a demon that is also from the realm of the invisible, who remains invisible, unless we conjure him into the real world ourselves.

Then something else hit me.

If it's not there, then it is the strangest thing I have never seen. Underneath the lectern on which the Virgin Mary's hand rests on the open pages of scripture, a transparent veil hangs down and trails from the top to the bottom in wispy folds. Some delicate golden-white embroidery can be seen, along with the shimmer of the light hitting the veil. There, emerging from the base of the lectern is the head of a bearded man. He is in profile, facing directly towards the Virgin, his face tilted slightly downwards as if in deep concentration. His forehead is brightly illuminated, his brow furrowed to add to the sense of focused thought. His beard flows in ringlets far beyond his chin, his neck caught by light from behind. This, to my mind, is God the Father, at the precise moment of the immaculate conception, willing His son into the Virgin's womb. The veil swooshes from behind His head, over His face and on through the end of the scripture directly towards Mary's womb, symbolised by the golden fabric sash she wears over it. The God the Father figure within the veil is painted in a translucent monochrome. It is from a totally different world – its own darkness, its own light, its own whole dimension. Perhaps, and my mind imagines more than the imagery allows, on the piece of veil hanging down behind the lectern, the embroidered pattern sparks the slightest of connections to Leonardo's drawings of the foetus in the womb. A foetal form within the uterus lining, contained within the oval womb. God literally conceiving his son in Mary's womb, a spiritual, metaphysical, miraculous, immaculate process. Why would the veil with the uterus be behind the Godhead? Ah, because it is shared with the Angel Gabriel, who in the physical world is announcing the news to Mary, the Word and breath of

God channelled through the Archangel's eyes and hands – God's eyes and mind are the first and last steps in this otherworldly chain. The veil acts as the curtain between the spirit world and the physical world, and as the medium through which the conception is brought to pass. Even the decoration on the side of the stone pedestal seems suggestive of the female body, of fertility and conception. I step back. The face of God in the veil could, of course, quite easily be a small bust, a statuette incorporating a man's face into the stand supporting the lectern – or even just a bit of embroidery over an otherwise graven-imageless stand. The manifestation of divinity is both there, and not there – its meaning and its resonance, its transformative power are all in the eye of the beholder. Am I completely alone in seeing these things?

Antoine knocked on the library door.

'Hey Adam, listen, dinner's almost ready and Sebastien's here. Why don't you come down for an aperitif with us?'

'Okay for sure, great,' I answered. 'Would it be okay if I bring a couple of your mother's books down with me to show you guys?'

'Of course, do you need a hand?'

'Here, you grab this one, it's quite heavy.'

We walked downstairs together and into his apartment. It was a lovely evening and he and Alicia had set up a beautiful table outside, with a jar of pink hydrangeas in the middle – just like in Grandad's garden. I wondered what he was doing right now, and what was going on in his head. Had there really been an emergency code activated, or had he just imagined it? Perhaps all would become clear. There was a jug next to the flowers filled with Vermouth, homemade lemonade, fresh lemons and mint. The garden was in full bloom and there was a cool breeze. It was the perfect way to begin yet another sunny evening in Paris.

'So, Adam, how are you? Have you had a chance to look into your Leonardo theories any more since last weekend?'

'Hi Sebastien, I'm good, thank you. You know, all that stuff has been going round and round in my head all week. I've just had a couple of hours in the library upstairs, and I've got a couple of things I'd like to show you and the others. Have you had any more thoughts about the face in the clouds and all that?'

'I've been looking into it a little and read through your notes this afternoon. There have been so many crazy ideas about *The Mona Lisa* and about Leonardo over the years that it's hard to get past them in some ways. There are also quite a lot of cases in which people – generally not academically endorsed art historians – claim to see things that are "hidden" within pictures. Some of them are more interesting than others, but often they aren't very convincing at all.'

'Do you think my ideas fall into that category?'

'I don't know, Adam, I really don't know. I'm worried that people will put your ideas into that category – into the dustbin of art history conspiracy theories.'

'Maybe that's the best place for them!' I said, laughing.

'But then again, as I think I mentioned, there is a long history of optical illusions within the history of art, and it's true that this area of practice and study is not generally considered to be of great significance. The things that you are proposing within *The Mona Lisa* are sometimes referred to as "cryptomorphs" – optical devices that people claim are hidden by artists within their works. They are related to anamorphs – which as you know are images distorted through perspective and by means of lenses – and aleamorphs, which are things such as clouds that look like faces, or rocks that look like monsters in real life. Cryptomorphs are, it would seem, more ambiguous and thus more contested, though presumably some anamorphs can also be cryptomorphs, and likewise for aleamorphs. If I understand correctly, what you propose is that the face in the clouds in *The Mona Lisa* was painted so that it is not seen but can be seen, so it is both an aleamorph and a cryptomorph, or maybe even an aleamorphic cryptomorph! It's also sometimes described as *pareidolia* – the tendency to see faces in all sorts of situations, whether paintings or loaves of bread. It's the thing that Leonardo himself describes when talking about gaining inspiration for imagery from rock formations. So you might not be completely wide of the mark.'

'So my notes didn't sound completely insane to you?'

'What I liked about your notes was the way they sounded like they were written by a poet, not quite in your own voice. It was as if the process of writing about these potential cryptomorphs had resulted in a different linguistic register in your head – like it's a poetic visual language that needs poetic written language to describe it. I confess I found what you're proposing pretty way out. I mean, it sounds like Aldous Huxley or Samuel Coleridge or something. It reminded me of something Salvador Dali used to call "the paranoiac- or paranoid-critical method". Dali is said to have asserted that "I believe the moment is at hand when, by a paranoiac and active advance of the mind, it will be possible to systematise confusion and thus to help to discredit completely the world of reality". André Breton, describing Dali's method, claimed that it "allows the paranoiac who is the witness to consider the images of the external world unstable and transitory, or suspect; and what is so disturbing is that he is able to make other people believe in the reality of his impressions". So if it can be said that you, Adam, are enacting Dali's paranoiac-critical method for picture analysis, there is no reason why some other people might not buy into the same visions as you.'

'Wow, that's so interesting, thank you Sebastien. I will have to get researching on the Surrealists as well, then, by the sounds of it.'

A waiter brought out a couple of bottles of natural red wine and filled our glasses, while Antoine and Alicia carried through a couple of trays filled with delicious food – confit duck leg with celeriac purée and grilled asparagus, with a freshly made tarte tatin for dessert. They were intrigued to hear what developments I had made with Leonardo and *The Mona Lisa*. I told them about some of my research that evening in the library, about the things that had been evoked in my mind by *The Annunciation*, and the things that Sebastien had told me. When the waiter had cleared the plates and brought out four glasses of dessert wine, I opened up one of the books.

'This is a book about depictions of the Virgin Mary in the history of art,' I explained. There was a picture of Leonardo's *Annunciation* in there, which I showed them to see if they could see the demonic face and the God-like face. Nobody could see them, disappointingly, but they were intrigued by my description, and the idea of it, nonetheless.

'Well, Adam,' said Antoine, 'your exploration into the arcane, esoteric side of Renaissance Italian painting is becoming more and more curious by the day.'

## THE DROP OF GOLD

The next evening, the night of the long-awaited gig, I made my way up past the Gare du Nord, alongside the railway tracks and up through a district called Goutte D'Or – the Drop of Gold. It was an odd mix of an area; some nurseries and schools, a Catholic church, some warehouses, and lots of little old streets, many of which looked quite poor. There were some fabric shops, the usual grocery stores. Judging by the number of restaurants offering traditional dishes from Cameroon, I got the impression that this was an area with a high proportion of residents of African origin. I eventually found the street on the message from Alice and followed the building numbers, where they were visible. I found myself staring at a run-down shopfront that looked as if it had once been a restaurant. It was double-fronted, with a door in the centre of either side, suggesting it had once been two shops. One of the doors had been filled rather unsympathetically with breeze blocks. Most of the façade was made of wood – thin, vertical, dark wooden panels that ran across the front of the building. There were four sets of windows, two of which had been boarded up some time ago and had fly-posters over them. The remaining sets comprised four grids of ten small panes of glass, two columns of five in each. The top and bottom rows had textured, coloured panes, alternating blue and red. Under the window ledges were panels made up of red bricks, and in the middle, next to a prominent waste water pipe, was an old wooden menu board with a glass front. A piece of paper inside simply read: 'Flipper'. I knew I was at the right place. There was no other signage, and in fact, very few clues that this establishment was open for business at all. I knocked on the door and it was opened for me.

A young woman was sitting at a desk by the door with a card reader and a stamp. I paid my fifteen Euros entrance fee and the woman stamped the back of my hand with the word 'Flipper' in red ink. Whilst there was still some light outside, it was very dark inside as most of the windows were covered up. There were a couple of dozen people already milling around, with the concert due to start in around an hour. I went to the bar and ordered myself a beer before taking a look around. It was pretty shabby in there, but kind of cool too. The bar was basic – it only had one type of beer, in bottles, some soft drinks and four giant bottles with optics – whisky, vodka, gin and rum. The front room was like an average well-worn bar with wooden tables and chairs,

then behind that the venue opened out into a small concert hall – maybe room for eighty or a hundred people standing up. The wooden stage was at the far end, and was set up ready for the performance, with synthesisers, an electronic drum kit and some other odd-looking bits of equipment, including the famous – and presumably now fully functioning – Mellotron. To the right of the stage was a door with a sign above indicating '*Salon du Flipper*', which I walked through. There was a kind of lobby area en route to the washrooms and green room, in which there were three old pinball machines. I put a Euro in a machine on the wall and five tokens came out, which I used to have a go on the machines. I'd never played one before, so the first couple of attempts were pretty disastrous – I watched the white ball roll in an almost straight line down the table into one of the pits at the bottom. It took me a while to work out that the objective was to keep the ball in play as long as possible, and to score as many points as you could by hitting various places around the table. By my last token, I was starting to get the hang of it. The table I was using looked like the oldest of the three, and was mostly made of wood, like a piece of old furniture. It had colourful clowns painted on the front and sides, and the screen at the end prominently displayed that this particular model was called the Chicago Coin Roll Down. It had beautiful round lightbulbs around the edges. It was quite addictive, and the sound effects were delightful, particularly the ping as the large white ball went down.

'Evening Adam,' said a voice over my shoulder.

'Suzette!' I exclaimed, nearly jumping out of my skin. 'What are you doing here?'

'I've come to see Push Le Button, of course.'

'I had no idea you'd be here,' I said.

'Well I'm glad to find you here,' she replied. 'How did you hear about the concert – are you a fan of the band?'

'A friend of mine from back home told me about them. She repaired their Mellotron, in fact.'

'That's cool,' she replied. 'You'll have to point it out to me.' She put some coins in the machine on the wall and got more tokens, some of which she gave to me. She jumped on the table next to me. It was called Strange World and looked to be from the late 1970s. The artwork on the backboard was bright and multicoloured – almost garish but in a fun way, like an old cartoon – depicting an orange planet with a red sun emitting purple rays, yellow curling waves which a woman in a red leotard was diving into, green bug-eyed monsters with matching lurid green toadstools, golden-winged classical goddesses and a man wearing a tight-fitting purple rubber superhero suit. Tricks of scale were a common feature, a yellow castle appearing both tiny yet dramatic and imposing. I decided that the strange swirling orange waves were actually part of some giant sea-creature, which would account for the weird abstract shape stretching out like an anamorph across the top left-hand

corner, and maybe also for the giant yellow-and-green eye buried in the opposite corner. It soon dawned on me that there was perhaps something in common between this superb popular illustration and how I had been looking at *The Mona Lisa* – both demanded that the eye engage with the imagery within as episodic yet overlapping – vignettes that required mental shifts in perspective and scale, as well as an openness to the fantastical. The eyes are waiting to be surprised. Part of the challenge was to work out what it is you thought you were looking at – I realised that we don't engage with many kinds of image in quite the same way – as if recognition and identification is done at a different station, or on a different level, in the brain.

The disc displaying the machine's title was glowing gently. Suzette was clearly no stranger to pinball machines and she gave me a silent masterclass in how to do it. It was amazing just how much control she had over where the ball went, directing it to hit all these different parts of the table and to ricochet so that three rows of numbered coloured circles near the bottom would light up. Other things were flickering, flashing and illuminating all around the table. The sounds were enchanting – really rather hypnotic – and listening to Suzette in action resulted in quite a symphony of clicks and pings, whirrs and dings, accompanied by the regular rumble of the ball down the table. So this is what young people did before computer games and mobile phones!

'How come you're so good at this, Suzette?' I asked.

'Now that would be telling,' she said, laughing. 'I grew up in Limoges, the youngest of five children. My oldest brother is twenty-two years older than me. My father bought a *bar-tabac* in the town centre, and in that bar he had this very model, so I know it inside out. He would give me a cola and a pastry if there was one left over from the morning, and let me play on the machine to my heart's content. This was in the mid-to-late nineties, so it wasn't like it was the heyday of pinball. Each of my siblings had done exactly the same – when we were old enough to come in to the bar, that would be our reward, and would keep us out of trouble, and out of our mother's hair for a couple of hours. So we're all very good at this game. And you know what? It's still there – it's over forty years old. My father still runs the bar, and the Strange World machine is still in full working order. When we meet up at Christmas we always have a tournament. I did win one year in recent memory!'

'No way, that's so great,' I replied.

At that moment, four women came out from the green room and made their way through the pinball lobby past us. I'd never seen anything like it. They looked awesome. They were all dressed in statement 1980s fashions – the first was wearing a shimmering green blouse with prominent shoulder pads over a dark purple leotard, a thick bright red belt dividing the two. The next was wearing a teal jumpsuit. The belt was exactly the same colour as the suit, with crisp pleats running from the waist down to the ankles. The sleeves

were billowing a little as she walked, the collar buttoned up to the top. She wore matching acrylic dangly earrings and her blonde hair was pulled back into a tight bun. The clothing of the third woman was more like streetwear, a simple baggy white T-shirt with the words FAX ME in bold baby pink on the front. She was wearing a denim skirt with prominent pockets and pairs of white buttons down the front, and had a pair of pink pixie boots. To accompany this she had a loose perm through her long dark hair accessorised with a plain pink headscarf and circular pink earrings that matched bracelets on either wrist. The last was wearing a bright red tracksuit with equally bright yellow, green and blue geometric shapes over it. The top had a zip down the middle. The make-up of each woman was stunning; there was a lot of colourful eyeshadow, a lot of eyeliner, blusher and lipstick. It was like it was too cool to be funny, and they carried it off perfectly.

'Hi,' said the first woman as we turned to stare at them coming through.

'Hi,' we both replied in unison, somewhat awestruck.

After they'd gone through into the concert hall, Suzette turned to me and said, 'They are so hot!'

'What,' I said, 'all four of them?'

'Yes!' she said, smiling so much her entire face scrunched up and her eyes shut. 'Though my favourite has to be Mira. She was the one in the jumpsuit.'

'Ah, okay, yes, I know – the second one. She looked amazing. Those eighties fashions are insane,' I said.

'Let's go get another beer before they start their performance,' said Suzette, pulling me by the arm, and we made our way back through to the bar.

We didn't have to wait long before the performance started. The lights suddenly went off and the audience noise rose in anticipation. An electronic drum beat started up, which Suzette informed me was from an old 808, and in time to this a sequence of red, green and blue lights flashed on and off above their heads, giving us glimpses of the four musicians standing motionless on the stage. As a sprightly melody kicked in from one of the synthesisers (a Jupiter 8, apparently), a smoke machine started pumping white clouds onto the stage around them. A second synthesiser joined in with a syncopated rhythm underneath the main melody, accompanied by a strobe light, and followed shortly after by a bassline played on a bright red Keytar. It was the first time I had seen a synth-pop band and it was everything I could have wished for that night. I felt transported back in time to yesterday's future – the moment when electronic music took centre stage in popular culture. But it wasn't my past – it belonged to other people; that scene was quite some years before I was born, and there was something deeply exciting about that. I loved all the warm humming, buzzing sounds, as if designed for some epic homemade spaceship. Pulsating bleeping, like signals from distant stars, analogue wailing and deep drilling, metallic beeps and caustic cascades.

The sounds were evocative of many things: the brain activity of insects, time-warps and toy robots, bells from another world, alarms from an ancient submarine, helicopter blades and the engines of distant factory machinery. All covered in a lot of reverb and echo, drenching a number of tracks in a hazy pool of electronic memory, an electric hall of mirrors.

The band's stage presence was incredible – they seemed so austere, so serious, so focused. They were all confident and strong with a sense of detachment and ethereality, somewhere between art-house cinema characters and man-machines. I wished I was as cool as they were. But where would you even start? How do you go about making yourself a coherent and meaningful identity, your own real-life avatar? Their performance was short – or at least it seemed so to me – and in no time they were coming on for an encore. The crowd was mostly made up of hipsters and nerds, so they weren't the types to go crazy, but they were clearly into the sound and enjoying themselves. Standing there in my normcore jeans and T-shirt, I felt an urgent desire to explore fashion more, and Push Le Button had given me the soundtrack I needed. It felt like my music. It's hard to explain. In them, or through them, I felt like I had found something special and profound, something stimulating and amazing. I mean, I'd enjoyed music before, but it was mostly chart music. This was something not in the charts. I didn't realise it, or couldn't articulate it at the time, but what I had found was a subculture I was into. I wanted to find more music like this, and go back through time to find the genesis of this kind of electronic music. Candy, the member of the band wearing the red tracksuit, stepped up to her microphone.

'Thank you all for coming tonight. It's been a blast. This last song is a request from a friend of ours from Birmingham England called Alice, and she has asked us to dedicate it to her friend Adam, who is here this evening. Assuming he made it here. Or hasn't fucked off already. Well, even if he's not here, this one's for you. The track is called *Fax Me*.'

I was embarrassed and pleased in equal measure. How nice of Alice to think of me. Suzette pointed both of her index fingers at my face with a big smile. I grinned and nodded back at her. The track was one that used the Mellotron, of course, and it was amazing to hear such an iconic piece of equipment. It was the instrument with which the song began, and sounded like a wonky old recording of a cello. I remember Alice describing the complex system of tapes connected to each note on the keyboard. As the tapes contained recordings of real instruments being performed by musicians, the sound quality was more sophisticated than your average sound from a note on a keyboard. It's the difference between something real and something synthesised I guess. But the recording process itself gave it a weird and wonderfully dated quality too. It's like hearing a bubble of sound from the past, the sound of a cello played on a cassette tape fifty years ago. I suppose listening to any recording is like an audio memory, a moment captured in

sound somewhere else, sometime in the past, but with the Mellotron it feels like that sound is being played in the present, re-performed each time a key is pressed and the motor drives the corresponding tape inside the instrument. And when multiple keys are played at the same time, as chords or in overlapping sequences, you get an even stranger quality – it sounds mildly out of tune, or fading, or warped and the result is haunting, like a memory being gently planted inside your head. I tried taking some photos with my instant camera; after each bright flash, the camera whirred and released a single photo. It started out white then an image gradually came into existence, in my hands.

As the band walked off stage to considerable applause, Candy looked at me and beckoned with her right index finger. I pointed at myself to make sure it was me she was signalling. She nodded, her expressionless face turning into the slightest of smiles. I think. I turned to Suzette, who had seen what had just happened, and she pushed me forward to follow them out through the door and back past the pinball tables. I turned round to check she was coming too.

We arrived in the green room, which was just a smallish room with a single light bulb in the ceiling, though even in that small space the light coming from it wasn't enough to reach the corners of the room. There was a wooden ledge along one wall, with a couple of mirrors side by side. This was clearly where any make-up and hair was sorted before a gig, though how anyone could see what they were doing, I do not know. A simple wooden wardrobe was where they hung their coats, and stacked up against the back wall was a load of sturdy boxes for their equipment. On the floor was a cardboard box full of bottles of water, one extra-large bottle of gin, and some tonic water. Candy passed round some plastic cups before opening the gin and pouring it out into everyone's cups.

'He's a bit young, even for you, Candy,' said Tara, passing round the tonic.
'Ouch,' said Mira.
'He is cute though,' replied Candy, with a wry smile.
It was as if they thought I couldn't hear them! I was standing right there.
'Anyway,' she continued. 'This is our special guest – Alice's friend Adam.'
'Ah,' said Tara, 'I see.'
'Wasn't there something we were supposed to give him?' asked Mira, lighting a cigarette as she pulled open the decrepit window onto a depressing backyard with a sad, broken washing line and some bins in it.
'Why do you think I've invited him and...' she paused, staring at Suzette.
'Suzette – Suzette Reboullet.'
'...him and Suzette, Suzette Reboullet, to join us for a drink?'
Tara clapped her hands. I'm still not entirely sure why. They poured us more drinks and invited us to take a seat on some small, rickety chairs. Mira put on some music on her phone. I didn't recognise it, but could see on the screen before it went black that it was an album by Roxy Music. Marie, the fourth member of the group – the one wearing the FAX ME T-shirt and the

denim skirt – was just staring at the floor. She didn't speak the whole time we were in there. Maybe it was her way of coming down after a gig.

'It was a great performance,' I ventured.

The band members nodded slowly in agreement.

'Not bad, not bad,' said Candy. 'I screwed up one section.'

'So better than usual,' said Tara, sniggering. Candy stuck her tongue out.

'And so nice to see the Mellotron fully operational again,' I added. 'Alice showed me the instrument just before she sent it over to you.'

'Alice is a star,' said Candy. 'I love her.'

'Yeah,' said Mira, 'she is properly cool.'

'Here,' said Candy, pulling out a spool of film from one of the boxes behind her. 'This is from Alice for you.'

'What is it?' I asked.

'Not sure,' Candy replied. 'I found a note in with the replacement Mellotron tapes asking me to give this reel to you here, now. It doesn't look like Mellotron tape. It's too long for a start.'

'It's Super8 tape – cine film,' said Suzette.

'That would make more sense,' said Mira.

'I wonder why she didn't just give it to me when she saw me the other week,' I said.

'Can I see your phone a moment, Adam?' asked Suzette, catching me completely by surprise.

'Er, yes, of course,' I said, pulling it out of my pocket. I unlocked it and passed it to her.

'Okay, that's great,' she said.

'You were looking for the H,' I said.

'Precisely,' she replied, with a big smile.

'Okay, so what's the story?' I asked. 'I'm guessing you know something that I don't?'

'Maybe we should leave these lovely ladies to recover from their performance, Adam. Let's go for a walk,' she replied, with a smile.

We said our goodbyes and made our way out of Flipper. We walked up the street until we arrived at the Jardin Poissoniers alongside the railway tracks. It was the kind of park that seemed to have been made out of a piece of wasteland that nobody knew what else to do with, and was the kind of park that was made for the local inhabitants rather than tourists – it must have been built at the same time as the adjacent blocks of flats. We sat opposite each other on a little see-saw in the middle of the park. The sun had set by this time and we were relying on the street lights to navigate our way.

'Adam, I am also a friend of Alice's.'

'No way!' I replied. 'Why didn't you say before?'

'She asked us not to say anything until tonight. Here's a note she sent for you. It's written in a cipher, for which I have the key.'

She pulled out a small envelope with a shiny metallic sticker that flickered with the spectrum covering the seal. The sticker had the words Stirchley Electronics emblazoned across it so it was clearly from Alice. Sure enough, it was a whole load of symbols and numbers that made no sense to the naked eye. Suzette pulled up her phone and snapped the note, and a few seconds later passed it to me. On the screen was a note in English that read:

*Adam, forgive me for the cloak-and-dagger message. I will explain everything soon. The British secret services have received some information relating to a terror attack on the royals. We have been working to build up a picture of what is going on and, indeed, have tried to share our research with them, but seem to have somehow now become a subject of the British secret services' scrutiny ourselves. I don't really know why, yet. It looks like they might be putting our operation here on hold, temporarily at least. We need you to help us find out what this film means. You can trust Suzette and the other Associates – they are your guardian angels.*

I was gobsmacked. Was this really the same Alice who repairs old keyboards and radios? What was she doing involved with British intelligence?

'Do you know about all of this, then, Suzette?' I asked her directly.

'A little,' she replied. 'We know that you are in some kind of danger, and we know that there are different intelligence services involved. Something is going on.'

'Who are they? What is this "operation" that Alice is going on about?'

'All I can say for sure is that Alice is one of the directors of a data analysis company in Stirchley. They work with large organisations to analyse vast quantities of digital data – global communications by means of all kinds of technology – and filter it for their clients' requirements.'

'But why is it all so secretive?'

'Because so much of what they do is sensitive. It's not the kind of work you go round shouting about.'

'Fair enough. So are they spies?'

'I'm not really sure what that means today, Adam. They are sometimes employed by the government – or by a government – to obtain and analyse data for them, but they are not part of the government or working for the Crown as such.'

'And how do you know all this, if it's all so secret?'

'Because I am one of Alice's employees.' She smiled again. 'I am one of a small team of people who work for a branch of the company here in Paris.'

'What is it you do for them?'

'I work on the Heorot platform – the simulation operating system you have on your phone. As you've probably already worked out, it's a piece of software that enhances data security. I got you set up on it earlier this week.'

'Oh,' I groaned. 'Was it you who dropped the instructions off at the FJT?'

'It was one of my junior colleagues.'

'Okay, so tell me this. How did they know that I would meet you guys? I only happened to bump into Antoine on the street that evening last week.'

'Or rather Antoine bumped into you.'

'How did you know that?' I asked.

'Antoine was asked to bring you into our group.'

'You mean he deliberately knocked me over?'

'Yup. He knew exactly who you were when he bumped into you.'

'I feel a bit… well, you know, I thought he and the Associates just liked me. It makes me a bit sad to think you've been tasked to take me in. Does everyone in the group know?'

'Sort of, though we knew less than what you now know from Alice's note. It's actually caused quite a bit of tension among the group for one reason or another. But please don't feel like you have been deceived – we do really like you, and think you are great. Your ideas about *The Mona Lisa* blew us all away at the weekend. Some of the Associates are a little bit concerned about being caught up in something unknown that is both political and potentially dangerous, but we agreed that we would do what we can to help you.'

'Well that's very nice of you, Suzette,' I said. 'I just feel like I can't be sure of who's being genuine with me, and who has ulterior motives. What people say isn't always what they mean. I don't get it – most people I know are just who they are, they say what they think. I feel like I can't trust my own judgements any more. The adult world is complicated. I really hope not everything is going to be like this as a grown-up.'

'It does seem like you've had a lot put upon you, and you're still so very young – you're just a baby Adam! But the question now is what you think you can do to help Alice and get to the bottom of whatever it is that is so serious.'

'Yes, you're right. But I don't really know where to begin, or what to do.'

'I think I'd start with that Super8 tape,' she said, laughing.

'Why Super8? And how did Alice know I'd be able to watch it – that I'd have a projector?'

'You have a friend at the museum, Adam.'

'It would have to be Mlle Honfleur – why else would she have encouraged me to take the old projector?' I replied.

'You're right! Yes, Juliette. She is a very close friend of mine, shall we say, and a friend of our agency.'

'And presumably that's how the access code magically appeared on my computer screen yesterday morning.'

'Keep this under your hat, though, Adam. It might be important that the connections between you, Juliette and me are kept quiet for the time being.'

With that we made our way across the road and along the Rue des Portes Blanches and turned left into the Métro Marcadet Poissoniers, where we took our respective lines home.

My nearest station on this line was Pigalle, so I found myself walking through the district of cheap hotels, cabaret clubs and sex shops. While it was a bit seedy, it was still beautiful and evoked a sense of the nineteenth-century avant-garde, of painters and poets meeting and eating and drinking, watching concerts and going to dance halls and circuses late into the night. Grandad used to tell me stories of how the early Impressionists would try to get their paintings into the annual Salon, but were usually rejected, so they just started their own – the *Salon des Refusés*. I liked that idea. If the institution rejects you, just do your own thing, and make it more interesting.

I got back to the FJT before midnight and couldn't resist putting the film into the projector Juliette had given to me to see what was on it. I set it up pointing at the wall, which was as good as a screen. It started up with a flicker and some Arabic text came on the screen. It was really grainy and there seemed to be a haze of black surrounding the edges of the frame. It looked like it was a film of a film – the Super8 camera was filming a television screen. A picture appeared, though it looked completely abstract, some gently undulating lines, like waves across and up the frame. Then it became clear that the footage was not abstract at all, but a very poor-quality image of a desert landscape. The sky was basically indistinguishable from the horizon and the bare, sandy land below. The clearest undulating lines were those flowing up the screen, and I eventually worked out that this was a road, of sorts, and that we were driving along it. The camera started shaking more violently for a while, as if going over bumpy terrain, and then panned round. A group of people – maybe a dozen or more – were crammed into the open back of some kind of truck. It was a mixture of women of differing ages, old men, and a few children. At the front was a man in his late thirties or early forties in a military uniform holding a rifle. Next to him was a boy who could not have been more than four or five years old. I could just about make out two more soldiers at the back of the truck, also holding rifles pointing straight up in the air. Everybody looked exhausted and miserable. The young boy at the front wiped his eyes with the back of his forearm – perhaps it was dust in his eyes, perhaps tears. The man put his left hand on the boy's shoulder, as if to comfort him. The camera zoomed in a little on his face.

But no. Surely not. It looked a bit like a much younger Mammoul! Could it have been him? The camera then bumpily moved on from his face to that of the boy, before moving off to the bleached-out landscape. Whoever was operating the camera was clearly trying to capture something in the distance. It was a bumpy ride, and the bad image quality meant I couldn't be sure, but it looked to me that on the horizon a cloud of black smoke could just be made out. It was hard to say for sure, but between the sandy ground and the bright sky was a strip of beige-coloured buildings, and it was these that were belching the plumes of black smoke. The camera panned up and something flickered across the sky – perhaps a helicopter. Each time the film ended,

I rewound the tape on the spool and played it again, over and over, trying to glean any further information I could from the imagery in front of my eyes. One of the soldiers at the back also looked a bit like a younger Mammoul, so I wondered if this was just a representative look for men from that area. All the time I was trying to figure out what the footage was telling us. Had these people been rescued from a village in the desert? Was that their homes on fire? Or were they prisoners, being taken away by the soldiers? Right at the end of the film, a flash of light, as if the camera's light setting was adjusting to the screen going dark, gave a glimpse of the monitor. It had a video slot underneath the screen, and was surrounded by book shelves. The film ended.

I switched the projector off and lay in bed with a hundred thoughts going through my mind. The footage on the screen looked like it was from the late 1980s or early 1990s – their clothes, their hair – and if so, why had it been re-filmed on Super8 – an older form of film that was pretty much defunct by that time? How had Alice got hold of the reel of film, and how did she know that I would meet Mammoul, if indeed it was him in the footage. And what did they think I might do with it anyway? And why couldn't they have just sent me a link to a digital file of the film? Surely it would have been simpler than going to all the trouble they had to show me an old cine film on an old projector? If this Heorot software was any good, surely it would be safe enough for me to view on my phone?

∗∗∗

The next morning I heard a knock on my door. It can't have been much past seven. I opened the door in my pyjamas. It was Amira.

'I haven't seen you for days, Adam!' she said, beaming.

'Come in,' I said, 'I'll put some coffee on.'

'So how are you doing?'

'I'm okay,' I said. 'It's been a busy and strange few days.'

'Why strange?' she asked.

'I don't know, lots of people telling me stuff and I'm just trying to take it all in.'

'What's that for?' she asked, pointing at the projector.

'Oh that; a woman at the museum gave me the projector and then a friend sent me a tape reel to watch on it. I'll show you if you like.'

I played her the footage.

'Is that Mammoul?' she said, within seconds.

'I wondered if it might be, but then look at the guy at the back.'

'Oh yes, that also looks like him. Maybe it's one of his brothers. This must have been during his years of service in the Egyptian army. And is that a very young Ammon sitting next to him?'

'What?' I said, caught completely by surprise.

'Yes, look, there's a small mole above the boy's lip, on the left-hand side. His eyes are the same, the curls of hair. It has to be him.'

'What do you know about him, Amira?'

'Not much. He's only been working with my brother for a few months, since they've been working on the tobacco imports. Before that I used to see him around at The Crescent Moon – he drinks mint tea and coffee, and smokes shisha with people there, including Mammoul, when it's not so busy.'

'So what was he doing before he started working with your brother?'

'I'm not sure. I'll ask Youssef – I'll be seeing him later.'

'Well if that is Mammoul, and that is Ammon, in the footage, it looks like there is a long history there – a story that would be interesting to hear.'

'Why don't you ask Mammoul. Natalie said you'd been round to his flat the other evening.'

How did Natalie know that I'd been round to Mammoul's flat? I never told her who I had visited that evening. Perhaps I had already said too much to Amira. Maybe I shouldn't have shown her the footage. But then Mammoul had said that Amira was like a daughter to him, so presumably they were actually quite close.

'That's right, he invited me over for a cup of tea after work. He's such a nice guy. You've known Mammoul for some time, right?'

'Yes, he's an old friend of my father's. My father used to take me to the restaurant when I was little, when my mother was away – he wasn't one for cooking much, and he was so busy with his job that he just used to bring me and my brother to the restaurant to eat. Mammoul's always there – everybody knows him.'

'And you knew he was in the Egyptian army?'

'Yes, he and his brother both served a couple of times, I think, firstly when they were very young men, and then some twenty years later they were called back in. That must have been in the late 1980s.'

'Did you know that Mammoul had known Ammon since he was a little boy?'

'No. No I didn't. It would be very interesting if it is both of them in that footage.'

'And how long have you known Natalie?'

'You have a lot of questions for me this morning, Adam! I've known Natalie since she moved in to the FJT last autumn. We hit it off straight away. I remember our first encounter quite vividly. I was in the common room, looking at my phone. It was empty apart from a couple of us. She came over to me and asked if I would film her doing a dance routine on her phone, and I was happy to oblige. We got chatting and became friends.'

'Oh, that's nice,' I said. 'She's got so much energy – I like her spirit a lot.'

'Me too. But I have a question for you, Adam.'

'Of course, fire away,' I replied.

'Why has one of your friends got this odd bit of footage of Mammoul and Ammon, if indeed it is them?'

'I'm not entirely sure,' I answered. 'Maybe I can find out. I'll ask Mammoul about the film and see what he has to say about it.'

'Cool, well let me know what he says – I'm intrigued,' she said, standing up. 'Listen, I need to head off to a meeting – I've got lots of BoBos departing for their dream holidays over the next couple of weeks. The summer season is well under way and it's naturally a very busy time of year for me.'

'Great to see you, Amira, look forward to seeing you tonight!'

'What's happening tonight?' she asked.

'We're meeting for dinner and you and Natalie are going to help me with my special project!'

'Oh yes, of course. See you there.'

As I sat finishing off my espresso, I looked at the instant photos I'd taken the other evening at Flipper. They were dark and clear now, the contrast between black and white clear and sharp. Some of my shots were heavy on the flash, however, the faces bleached white, the features washed out; others had resulted in silhouettes, the people's faces entirely in shadow against the bright lights of the stage behind. My favourites were the ones where you could just about make out a face through the clouds of artificial smoke that filled the club. I was struck by how the instant camera had brought into existence an image and how you could watch it forming, from light to dark, from blankness to figuration, abstraction to reality, nothing to something, in front of your very eyes. It was as if I had created a picture out of thin air. What was before me in the room, in the moment, had become a document, a record, a physical trace – something I had seen that others could now also see, and in the future too, maybe even forever. I pulled out my notepad and made detailed plans for my special project. I wanted to make faces in the sky for myself, and in real life.

## SHOOTING GHOSTS

As I strolled up the Avenue du Président Wilson, I was delighted to see the banner up for our exhibition, with my painting cropped on it. There was Grandad, dressed as the ringmaster of a circus, for all of Paris to see. I was so proud.
I took a picture of it and posted it to FrendHub, with the caption: *My painting on a banner outside the Museum of Contemporary Art in Paris! Can't wait for the private view on Wednesday!* It was an insanely busy day at the museum. We had just a few days until the launch of our exhibition, and there was still a lot to do. I was relieved to have finally finished all the paperwork for the participating artists and works, and we had now received the last deliveries of works, ready to begin installing. I had seen Juliette Honfleur briefly in a meeting about invitations, press passes and VIP RSVPs. She had smiled at me, and I could tell from the smile that she knew I had met with Suzette and received the film. I smiled back and nodded at the same time. Soon afterwards we were called into another meeting starting at ten. There were some faces I didn't recognise there, as well as some of the people from the meeting at the British Council of the Arts last week, including Antonia Black, Susan Farnsworth and Andrew Lakeland. Emilie was in charge of updating the spreadsheets when people sent through their RSVPs, but the deadline was now up and we still hadn't received replies from almost half of the people invited. A reminder email was scheduled for release that afternoon. There were representatives of both French and British security services at the meeting, making sure they had information about everybody who was being invited, and who had confirmed they would be coming. Susan smiled at me across the table and raised her eyebrows as she mouthed 'hello' to me. Andrew showed no sign of recognition, but then he didn't seem to show any signs of acknowledging anybody at all, so I didn't feel singled out for this blanking. Antonia had a face like thunder, and her glasses were resting towards the end of her nose. They had a piece of string, like a necklace, attached to either side, and she regularly moved the glasses down to her chest or on to her head, normally coinciding with a large exhalation, as if constantly annoyed or exasperated with everyone.

'Right,' said Antonia. 'We have been alerted to a potential security threat. It is extremely serious and so both the British and French security services have been placed on high alert. A communication has been intercepted of some possible terrorist suspects, in which they speak of an imminent attack on the royal couple.' Everybody gasped.

'It means, of course, that security here at the museum will be stepped up, and everyone is to keep extremely vigilant and must report anything unusual or suspicious in the run-up to the launch of the exhibition and during the rest of the royal visit to Paris. It goes without saying that not a single word must be uttered to anybody outside these four walls. I might remind you that you are all under legal instruction to keep this matter entirely confidential, and if anyone – *anyone* – leaks anything to the press, action of the most severe kind will be taken against you. Do I make myself clear?'

Everybody nodded, in silence. Antonia passed some sheets to Susan Farnsworth, Mme Béchour and Claudelle Laroche.

'Metal detectors will be introduced at all entrances and exits to the building, and body searches may be undertaken at any time. There will be additional surveillance equipment installed today, and you may be required to answer security questions to assist the security services in their investigations. Thank you all for your understanding.'

And with that the meeting was concluded. So this development tallied with the message I had received from Alice – a potential terror attack on the royal couple. Susan was reading through the document she had just been given. Juliette and Emilie were still in the room, talking to each other, and I was tidying away the chairs and collecting the used water glasses from the meeting. Andrew Lakeland was in the corner tapping away at his phone.

Susan took in a deep breath.

'Are you okay, Susan?' asked Juliette.

'Oh, yes, thank you, I'm fine. It makes for chilling reading.'

'What does?'

'The briefing notes from the Foreign Office about the attack. There's a transcript of a conversation that was captured. The notes state that "The translation of this exchange involves a series of letters and numbers that we have not yet been able to decipher. The teams over at GCHQ are working on it.

Man 1: It's getting tricky.

Man 2: Yes, I'm getting a little anxious.

Man 1: Do you think they know what we are planning?

Man 2: Possibly. We need to strike quickly before it is too late.

Man 1: You must attack the royals.

Man 2: What, both at once?

Man 1: It might be our only chance, and the only way.

Man 2: But the enemy is already behind our lines and they will soon take us down.

Man 1: Yes, which is why we must attack now. They won't be expecting it while they think they have us cornered.

Man 2: Okay, thank you for your counsel. I will do as you say.

Man 1: Good luck – I know you can do this. Bring us glory."'

It did indeed send chills up my spine hearing the transcript read aloud. There was an intense atmosphere among us.

'Was this a phone conversation that was intercepted, or an email exchange?' Juliette asked.

'It doesn't say. Why?'

'I was just wondering if there was any further information about where the conversation is thought to have taken place, or how the letters and numbers were communicated and whether we might be able to see them.'

'They have included the sequence of letters and codes here, not that it will mean anything to any of us.'

'If they have a team of intelligence officers using computer algorithms to try to figure it out, I suspect they might have a better chance than us,' said Emilie.

'Of course,' said Susan, 'you're probably right.'

She and Andrew then left, leaving Juliette, Emilie and me to carry on working on the exhibition. We were all thinking the same thing – the terrorists are going to try to attack the royal couple while they're opening the exhibition and the centenary celebrations for the British Council of the Arts. It felt like we were now preparing for an assassination attempt as much as making an exhibition of art by schoolchildren.

* * *

As soon as the buzzer sounded for the end of the working day, I grabbed my bag and ran downstairs. I had to dash to make it to the art materials shop before it closed. I just made it in time. I picked up some packs of acrylic paints, a couple of plastic palettes, a pack of assorted brushes, some thick charcoal pencils, some large sheets of card, some sticky tape and some thin sticks. I paid and then made my way up to Mammoul's restaurant to meet Amira and Natalie. I had enlisted them both to help with the preparations for my project with the Eleven Associates early the next morning. Natalie was there already, drinking a large glass of watermelon juice with lots of ice. On a hot summer evening this looked like a good idea, so I decided I would have the same.

Mammoul came over to the table where I was standing unpacking all the art materials. He gave me a hug. It was really sweet of him.

'How is my English grandson?' he asked, with a big smile.

'I'm fine thank you Mammoul. How are you doing?'

'Another day older, another day none the wiser!' he laughed. 'Now what can I get for you? Some food? Something to drink?'

'Just a watermelon juice to start with, please.'

'No problem. So what's going on here? Are you both doing some painting?'

'We sure are!' replied Natalie. 'Adam's going to film a performance tomorrow morning and we're making the masks and signs for the actors to carry.'

'Well doesn't that sound like fun!' he replied.

We wasted no time in getting everything out. Mammoul brought us some jars we could use for water for our brushes. I got Natalie busy making signs with short slogans on them while I got to work on painting some of the imagery from *The Mona Lisa* as best I could. We were already well under way by the time Amira arrived, so the task of starting to attach the sticks to the masks fell to her. They had been made in a bit of a hurry but they would do the job. We made several masks – the face in the clouds, of course, the devilish face on the opposite side, the owl in flight, the field mouse, the whispering couple, and one of the green monstrous characters facing up towards the sky out of the rocks. The slogans and short texts were to give viewers some direction but also to encourage responses and more questions. They were things along the lines of '*Ceci n'est pas une chouette*', '*LHOOQ*' (that was Sebastien's idea – a reference to Marcel Duchamp's moustachioed version of *The Mona Lisa*), 'Do your eyes always tell the truth?', 'Perception or Deception', 'Making the Invisible Visible', 'You won't believe your mind's eye' and so on. The three of us, spread out over three small tables, must have looked like some kind of arts workshop, but Mammoul didn't seem to mind at all. Some people were watching what we were doing, and others stopped to look or to speak to us as they went past. I was pretty pleased with the end results, considering the budget and deadline for our undertaking. When we had cleared up, Mammoul brought us each a tagine and some side dishes. As the sun was setting, I remember thinking that I could quite get used to this Parisian lifestyle and food from the Maghreb, minus all the drama that seemed to have been enveloping me over the past fortnight.

'Are you both ready to go back to the FJT?' asked Natalie.

'I think I'm going to stay, have a pot of mint tea and review my notes for tomorrow morning. You carry on. I'll catch up with you over the weekend.'

'Okay, Adam,' said Amira, who I think knew I was planning to try to speak with Mammoul. 'Good luck with your project tomorrow!'

'Thank you, and thank you both so much for your help tonight, I really appreciate it.'

'No worries, Adam, it's been fun to do something different.'

The restaurant was starting to empty, with people now finishing their meals and ordering coffee and shishas. I went through to the kitchen and saw Mammoul loading up the pot wash – the industrial dishwasher. I offered to help.

'Sure, Adam, we are a bit short staffed tonight, so that would be great. You can wipe all the crap off the plates and hand them to me to load up.'

'Mammoul,' I said, after a few minutes.

'Yes, what is it my son?' he asked.

'There's a lot that's been happening since we last spoke.'

'Oh really? Are things getting any clearer?'

'Not really. Totally the opposite, in fact.'

'That's often the way. Don't be downhearted though, it will all turn out for the best. You've not found yourself in any dangerous situations, have you, or threatened by anyone?'

'No, no I haven't. I'm confused by the things people have been saying to me, though. It doesn't all make sense. I wanted to show you something.'

'Oh yes, what's that?'

'It's some film footage I was given. I wondered if you might be able to shed some light on it.'

We rinsed our hands before drying them on some nice clean towels. I pulled out my phone from my pocket and loaded up the film for him to watch.

'Forgive the poor quality,' I said, 'I believe it's an old film that was re-filmed on an older piece of technology, which I've then filmed digitally on my own phone.'

Mammoul watched in silence. He sat down on a chair next to some industrial-size sacks of couscous and tubs of harissa.

'Where did you get this from?' he asked when it had finished.

'From friends – well, I think they're friends.'

'Why do you think they gave it to you, Adam?'

'I think they must know that I know you.'

'I see. What do they think is to be gained by it?' He seemed saddened.

'I've no idea. But naturally, I'm interested to know what is going on here. Is that you sitting at the front with the boy?'

'You really remind me of your grandfather, sometimes, Adam,' he said, completely calmly. 'Yes, it is me.'

'And the boy with you?'

'Yes, it's Ammon. I presume you had guessed that?'

'I thought it might be. And the man at the back?'

'You are a perceptive boy. It is my younger brother, Sami.' He raised his eyebrows as he nodded to himself.

'Were you rescuing the other people, or taking them away as prisoners?'

'Both, in a way. I was working in the special forces on an operation in a small village. There was a small terrorist cell using the village as a cover. Some of the villagers were sympathetic to the terrorists, others were simply terrified and had no choice but to accommodate them. The operation didn't go as planned. The terrorists had somehow managed to obtain some ground-to-air missile launchers that we didn't know about, and as our helicopter went overhead on a reconnaissance mission, it came under attack, so it retaliated. It hit the village badly, with dozens of civilians killed. We were on the ground, and went in to secure the village. We took out the enemy militia and did our best to get the injured out. We couldn't be sure who was supportive of us and who hostile – it's always possible that the insurgents try to escape as civilians in such circumstances. Ammon's parents and sisters died that day. He had

no-one. When we got back to our base, the army officers were suspicious about the civilians and they were imprisoned for questioning. As I unloaded the people, I kept Ammon in the truck, under a blanket, and managed to get him away to safety. I had papers made for him by a friend to say that he was my nephew, and I brought him to Paris. He lived with me in the flat for a few weeks until I could place him with a decent family here – a young Egyptian man with a French wife. He calls them mother and father, and me uncle. It's a bit of a paradox. He knows that I was partly responsible for killing his family back in the village that day, but he also knows that I saved him and helped him start a new life in safety.'

'That's so sad, so very sad,' I said. 'So what was he doing before he started working with Youssef – you must know.'

'It's not for me to say – at least not here, not now,' he said, looking around the kitchen as the remaining staff were busily scrubbing the surfaces down.

'Okay, but why didn't you tell me about this when we were talking the other evening?'

'I didn't think it was something you needed to know.'

'But I thought he might be a threat to me.'

'I couldn't be entirely sure he was not, or you to him.'

'Me? A threat to him?' I couldn't believe Mammoul thought I might be a threat to anyone. He could see I was agitated and swiftly added:

'You might be a danger to him without even realising, Adam.'

I didn't know quite what to make of that. Why was I so important to everyone? I didn't even know what I was supposed to be trying to achieve.

'Well, now you know all about us, Adam, does it help with your own investigations?' He looked worn out. I felt sorry for him, like I'd exposed him somehow. I had just opened up a very large and painful old wound.

'Yes, I think I can answer their questions now. I'm sorry, Mammoul, I didn't mean to upset you, or to pry.'

'It's okay, I understand. My goodness, I've done enough probing into other people's lives during my life. And it's true, Ammon is not entirely as he might appear, so you are right to be wary of him. Be careful though, Adam, the deeper you look, the more dangerous it can become. If it was up to me, I would send you straight home. But you are only here for another week or so, is that right?'

'Yes, that's it. After the exhibition opens at the museum next Wednesday, I'm due to head back the following weekend.'

'Good, good. I think that is for the best, at least until this has blown over.'

'I still don't understand what "this" is, Mammoul. Can't you explain to me?'

'I'm not sure I know myself, Adam, but I am also doing my best to find out exactly what is going on. I have my suspicions about a couple of things, plus there is a lot of chatter at the moment.'

'What do you mean, "chatter"?'

'Why, it's when there is an increase in communication and surveillance relating to a potential threat to national security. Have you not heard of that?'

'No, I didn't know. But how do you know? I mean, how do you get to hear the chatter?'

'Again, let's talk more another time, Adam. I'm just an old man trying to run a restaurant these days.' He smiled, kindly.

'Of course,' I said. 'I'll be in touch over the weekend.' I took off my apron and handed it to him. He stood up and rubbed my head, ruffling my hair in the process. 'They'd shave that off you if you were in the army!' he said, laughing.

As I stood up, I looked at the many photographs and postcards on the kitchen wall behind where Mammoul had been sitting, depicting scenes in countries including Morocco, Algeria, Tunisia and Egypt. There were old holiday snaps from historical sites and tourist destinations, views of towns and villages, everyday street scenes, but one in particular had caught my eye. It was the same postcard of the Sphinx in Giza that Grandad had received the other week. I walked over to it and took it off the wall. Mammoul watched as I did so. On the reverse it had exactly the same message: OPEN THE DOORS / WHOSE KEYS? I looked at Mammoul, the postcard still in my hands.

'You're good, Adam, very good. I shouldn't have put it up there – I must be getting sloppy in my old age.'

'Who's it from?' I asked.

'I don't know,' he replied. 'Though I have some ideas.'

'What does it mean?'

'It's an old call sign – a signal that was used at a very particular moment in time when Egypt was at a political crossroads.'

'The stamp is Egyptian, and it's been franked. Looks like it was posted just a couple of weeks ago.'

'Yes, yes, and yes again. Something has stirred that should have been left undisturbed, something that had been buried in the dark depths of history.'

'You seem worried, Mammoul.'

'I'm worried that some alliances have been forged – alliances that are no good for anyone.'

'Between whom?' I asked, frustrated about never seeming to get a direct answer from him. 'Can't you tell me what happened all those years ago?'

'Be patient, young master. All will become clear. I hope to have some answers soon.'

\* \* \*

As I was walking back to the FJT, I called Antoine. It was late but I really needed to speak with him, and fortunately he was still up.

'Adam, are you okay? Is everything alright? More Renaissance revelations for us today?'

'Yes, thank you Antoine, I'm fine. No, no more cryptomorphs today. I've been chatting with Suzette. She told me about quite a lot of stuff, including about how we came to know each other.'

'Ah, okay. Sure, well we've been looking out for you, Adam. We've got your back. We're not sure why we need to, or how we need to, but however we can help you, we will.'

'That's very good of you,' I answered, deciding in the moment that it would probably be for the best not to mention my disappointment about him not being straight with me.

'Listen, tomorrow I'm going to go down to the south of France to see the progress on my farm. Why don't you come with me – after your film project, of course – we can take the train together. Pack an overnight bag. We can stay at my aunt's house. It's where I usually stay when I'm working down there. It will be really chilled out, and we can talk through everything, if you'd like, or not at all, if you prefer.'

'Thank you, that's very kind. It would be nice to get away from everything here for a couple of days – it's all been getting quite intense. I think I have the information they wanted me to obtain, not that I know why they wanted to know.'

'Great, well that's settled then. See you in the morning.'

I got back to the FJT, put my bag of masks and signs by the door ready for the morning, and got myself ready for bed. Just as I got into bed, I received a call from Chris.

'Dude, oh my days, we've had the strangest afternoon.'

'You're sounding more and more like Eddie, Chris!'

'Listen up. Me and Eddie went down to the bowling alley in Stirchley at midday, like the twins told us to. It's so cool in there – I hadn't been for years, and was too young to realise how cool it was last time I went there as a kid. Have you been recently? It's like a 1950s American bowling alley – everything's been restored to how it was when it first opened. Melamine table-tops, leather upholstery, beautiful wooden bowling lanes, and paper score cards!'

'What, no electronic screens?'

'No, just a set of lights that ping up to show you how many pins you hit and how many you missed. The music is all old-school rock'n'roll – Eddie loved it. And the American diner there is incredible – the biggest burgers you have ever seen, totally authentic hot dogs, amazing milk-shakes, and the cheesecake – the cheesecake!'

'Okay, I get the picture, so what happened there?'

'Well, when we arrived, Alice was standing at the ticket desk. She knew we were coming, and gave us passes to get in. She said it was the Stirchley

Electronics summer outing. I thought she was being funny, not least as it's only a ten-minute walk down the village high street to get there, but when we got upstairs, there were a whole load of old people from the social club. We went and got our bowling shoes and went over to join them. There must have been almost two dozen of them – they took up four lanes – and they were from three or four different societies, including your grandad's wireless club. The twins were there, and they invited us to join them on their lane, which was sweet of them. They loved Eddie! Some of the society members were using that metal rail thing that helps you to bowl your ball; some of them were too frail to bowl at all, but seemed happy cheering and laughing at everyone else's successes and failures. And some of them were bowling like professionals. They didn't half make a racket, not least because I think the ambient noise and music blaring out made it quite hard for them to use their hearing aids and implants. But this didn't seem to spoil their fun, it only added to their hilarity. Eddie did really well – four strikes and four spares.'

'Well it sounds like you all had a fun time, but presumably the twins weren't just inviting you there to increase the chances of the Kings Heath and Kings Norton Telephone Exchange beating the South Birmingham Model Railway Society at bowling?'

'I'm getting to it, I'm getting to it. Jeez, Adam, patience is a virtue! So after we'd played a couple of games, Alice took us over to the diner for our lunch. We had burgers, fries, waffles, chocolate fudge cake, you name it, we had it. They even offer vegan food, Halal options, and Kosher too, which was lucky as there were a couple of Muslims among the group. I didn't recognise them. I asked Margot whether they were members of one of the societies, and she said that they worked for Alice's IT company. She said that Alice is the director of a data and information analysis agency just behind Stirchley Electronics – so we were right!'

'Yes, yes you were,' I answered. 'I found out myself about her business just last night.'

'So these people who work for Alice, around a dozen of them – some of them were recruited not just for their IT skills but also for their language skills – between them they speak tons of languages – Arabic, Berber, Swahili, Urdu, Mandarin, Russian, French, Italian, Portuguese, Hebrew, Czech, German... There are Muslims, Hindus, Sikhs, Christians, Jews, Buddhists, people of all faiths and none.'

'Well that's Birmingham right there in a nutshell – the whole world in one city.'

'Listen! So we're all sitting together around tables having our lunch. I ask Alice if they all get together often – the IT team and the social club members. She said they'd never had such a summer outing before, but it was proving so successful that she would consider doing it annually. She seemed to find this funny. We were in the back corner of the restaurant. Alice looks around to

make sure nobody is listening – there was nobody else in there, just a couple of bored members of staff behind the counter – and then she tells us what we already knew from the twins – that the reason your grandad has gone off radar is that he was worried he was being watched. I asked Alice if there was any chance he was just being paranoid – I mean, you've said he has some funny turns sometimes. She said there was at least some truth to it, and that he had mentioned an old emergency security code to her and he'd had some odd phone calls. She'd been trying to help him get to the bottom of it through some contacts at her information agency. I asked if she could shed any light on it. She said your grandad had been trying to warn the British intelligence services that there was a terrorist cell active, but that they weren't taking him seriously. She had been looking into the terror threat to try to help. Can you believe all of this?'

'If you'd told me a month ago, Chris, no, I wouldn't.'

'Well you'll never believe what happened next.'

'Go on,' I said, intrigued.

'So, after we've all finished our lunch, Alice passes round a list of email addresses and phone numbers. Everybody there seems to know what's going on except us. All her employees, and all the social club members started emailing, texting and calling these contacts from their phones. Right there, in the middle of the American diner!'

'But why? What were they doing?'

'They were all reporting their concerns about a number of threatening communications relating to a terrorist group from the Middle East that was thought to have disbanded decades ago. Honestly, it was so funny – they were all giving their names and addresses, it took ages. The security service receptionists can't have known what had hit them!'

'Ha! That's amazing!' I said. 'But why did Alice decide to do that?'

'She said she'd had her contract suspended by the British intelligence agencies earlier that week. It was clear she was pretty furious about it. She said she suspected that somebody didn't like what they were doing.'

'Wow. But I still don't understand what she hoped to achieve by getting everyone involved like this.'

'Alice said that if a certain number of people contacted all the different contact addresses in the relevant governmental departments, firstly it would result in the issue coming to the attention of multiple people and hence raised to a higher level of assessment, and secondly, would result in more chatter within the intelligence community.'

'Ah, I see – that's clever. She's making their system move regardless of whether they want it to or not.'

'Exactly. I told Alice you were worried about your grandad. She said if we wanted or needed to contact him, we should go to the balti restaurant in the courtyard behind Stirchley Electronics at precisely five to six on Tuesday

evening. She also asked if we were willing to help in the coming days and weeks if needs be – we didn't really know what she wanted us to do, but as we know you're in some kind of danger over there, we said we would do whatever we could; we need something to keep us occupied during the holidays.'

At that moment I had a call coming in to my phone from Alice, so I thanked Chris and said I would be in touch soon. I just caught Alice before it rang off.

'Adam, great to finally speak with you.'

'Alice – I've got a hundred questions for you,' I said.

'I'm sure you have,' she said, laughing. 'But first, tell me, did you manage to work out what was going on in that tape?'

'Yes, I think I did.'

'Is the soldier at the front a man called Abdul Mahmoud?'

'Yes, it is.'

'Okay, great. And do you know the identity of the boy he's sitting with?'

'Yes, he's called Ammon. I've met both of them here in Paris. Abdul is an old colleague of my grandfather's.'

'You have been doing well, Adam,' she said. 'So I need to tell you that a VHS of this footage was borrowed from Ammon's flat a couple of weeks ago. I received the processed cine film the day after you left, in fact. I had a suspicion it might be connected to the emergency security code your grandfather had just received. I decided to send it back over to you and Suzette on the ground in Paris – via Mellotron.'

'One question, Alice. Did you invite Chris and Eddie along today just to tell them that if they needed to find my grandad, you could help them?'

'Ha! No, I wanted to put some reinforcements in play for next week – we might need their help. And as our work has been suspended by the British intelligence agencies, we are presently unable to continue with our research, at least by the usual means, so I thought we'd all go bowling, and enlist the help of our friends from the social club to enact our communications campaign.'

'Why? What's happening next week?'

'I think we may have our chance to get to the bottom of a few things, though we might only have one shot at it. I'll let you know as soon as I do.'

'Okay, so my next question for you – you asked the Eleven Associates to look after me while I'm in Paris – Suzette explained this to me – but do you know anything about me being watched by anybody else in Paris?'

'Yes, I believe you might be.'

'Do you know who by?'

'Possibly by a number of people – hard to say.'

'Why me?'

'I'm afraid you are, whether you realise it or not, the link between every-one's different agendas, Adam, and while you have no vested interests of your own, you might be the only person in a position to help resolve the situation.'

'My main concern is trying to get out of here alive!' I said.

'Fingers crossed,' said Alice. I'm not entirely sure whether she was joking.

* * *

The next morning I had an early start. I'd asked as many of the Eleven Associates as possible to join me on the Pont des Arts, just at the back corner of the Louvre, at seven. I had sent a group message on FrendHub and a few of them had responded to say they would definitely be there, a couple to say they would do their best, one or two who couldn't make it, and a couple who hadn't replied. I grabbed my rucksack and the bag of art materials, the Super8 camera and a couple of blank film cartridges, and made my way to Louvre-Rivoli station via Champs-Elysées. From there it was a short walk down the Rue de l'Amiral de Coligny. I arrived at the quay running alongside the Seine, named after former president François Mitterrand. There wasn't much traffic yet at this time of the morning, and that was why I'd asked everyone to be there so early. I wanted to be able to make a film without too many people around.

When I arrived on the near end of the bridge, Antoine, Sebastien and Anne-Sophie were already there. They didn't seem to be too thrilled about the early wake-up call, but they tried not to show it. Antoine pulled out a thermos of strong coffee, a bag of croissants and *pains au raisins*, and some apples from his rucksack, and passed round some little paper cups. We all gladly tucked in to his makeshift picnic breakfast. Gradually some of the others appeared – Suzette, Hakim, Elodie, and, just before we were about to start, Maya and Henry, both of whom were wearing shades, Maya because she was like a Hollywood star, and Henry because he had a hangover.

'So what do you want us to do, exactly, Adam?' asked Anne-Sophie.

'I've prepared some notes for everyone,' I answered. 'Hang on a moment.' And now I knew who was here, I could allot the different roles to each of them. I sent them out on FrendHub one by one. 'So the idea is to do a short – three minutes to be precise – performance here on the bridge. Everyone will either have a mask or a text sign to carry around, or both. I would like you all to walk around in front of the Louvre, taking it in turns to come up to the camera to show your masks and signs.'

A few people had questions, but without much further ado, I pulled out the camera, inserted the film, put my eye to the viewfinder, and pulled the button on the handle to start it going. It made a beautiful sound and you could feel the film whirring inside, next to your cheek. Henry was the least shy and most theatrical, so he was quite happy to put the mask to his face and start roaming around the bridge. He was playing the Face in the Clouds, of course, and with gay abandon. The others soon followed his lead. I was shouting instructions from behind the camera, trying to direct as best I could. Everyone started off in silence, and they were all taking it pretty seriously,

moving around slowly and sombrely as if in a funeral march, but as the seconds ticked away, they started laughing as they bumped into each other, and began interacting in silly ways. I liked this a lot. Like *The Mona Lisa*, I felt the performance was both serious and yet light-hearted – meaningful and ridiculous at the same time. Hakim pretended to be a variety of animals, most notably a sloth, which was neither in the script, nor on my list of possible animal apparitions within the painting, but why not! I particularly liked his enthusiasm and initiative as it didn't seem to be in his usual personality to mess around like this. Anne-Sophie and Sebastien were busy with their signs, carrying them in the air as if out on a protest. I should probably have practised with the camera first as there was some pretty ropy filming – not always in focus, some wonky panning and wobbly stills, and occasionally I would just stop filming by mistake and have to press the button again. I guess it was all part of the authenticity of the project – Sebastien described it as 'lo-fi', and suggested I'd turned the Eleven Associates into an artist collective. I wasn't entirely sure what this meant, but I liked the sound of it.

As the clock ticked closer to the three-minute limit of the film in the camera, I asked everyone to come together and to hold the masks as close as possible to where they appear in the painting. We used the bridge sides as the balcony, and Elodie pretended to be the Mona Lisa herself. Henry had the face in the clouds on the horizon to the right, the mask standing out against the real-life sky. Maya had the mask of the devilish face and horse on the opposite side. Anne-Sophie was holding the owl in flight, Hakim the field mouse, and Antoine the whispering couple. Right at the very end, Suzette was crouching underneath the camera, and held up one of the signs, which read: *A Project by The Young Baron*, which was the avatar that Henry had given to me in the limousine the other day. I put the camera down and everybody clapped and cheered. It had been short but sweet and a lot of fun. I couldn't wait to see the footage and work out how to edit it and then what to do with it.

'Thank you so much, everyone. And especially for coming out so early on a Saturday morning!' I said as the group started dispersing. I managed to catch Suzette to tell her that I had spoken with Alice and relayed the information about the film footage. She seemed relieved and smiled at me with a nod.

'Would you mind sending this to Alice for me, please, Suzette?' I asked, popping the Super8 film in a pre-addressed padded envelope.

'Sure, no problem,' she replied.

'Come on, Adam,' said Antoine, 'let's go back to my apartment. I need to pick up a few things on our way to the station.'

## ALTERED STATES

When we got to the apartment on the Avenue du Président Wilson I noticed a number of smart black cars parked outside, all with blacked-out windows. I had decided this was the kind of district where diplomats might live, or barristers or ageing movie stars. As we approached the door, it opened automatically and Antoine's concierge was waiting to greet us.

'The boxes have arrived for your aunt, sir,' she said.

'Oh, okay, good,' said Antoine.

'They are just here behind the reception desk, along with the other things you wished to have prepared for your journey.'

'Thank you, Luba, that's great.'

'Is Alicia coming with us?' I asked.

'No,' replied Antoine. 'She's having a quiet day by herself, and then wants to visit a new restaurant that's opening tonight here in Paris.'

'Cool,' I said, a little disappointed she wouldn't be there too.

'We're on the nine forty-five fast train,' said Antoine, 'so we'd better get a move on.'

The concierge called to someone over a walkie-talkie, and a woman appeared at the door a few moments later. She was wearing a chauffeur's uniform, and she picked up our rucksacks, popped them on a small trolley, and took them off to the car. Sure enough, it was one of the smart black cars.

'Can you grab one of the boxes, please, Adam?' asked Antoine. 'I'll take the other.'

'Sure,' I said. As I was getting in, I was suddenly reminded of the evening the week before last when I felt like I was being followed by one of these cars. The chauffeur waited for me to be seated before closing the door for me. As she did so I just caught a glimpse of somebody on a bench in the central reservation of the boulevard taking a photo of us. While I was sitting there, waiting for Antoine, I scrolled through the photo album on my phone. There it was. I was sure I'd taken a picture of the car that was following me. It was a bit blurry as I'd taken it on the move, but I could zoom in on the number plate enough to see the letters and numbers. I asked the driver what the registration number was for the car we were sitting in. She duly replied, and it was clear I was now sitting in that very car.

'Is this the car you always drive?' I asked.

'Yes monsieur,' came the reply.

'Do you drive the car for any other clients, or only for Monsieur Marionette?'

'I'm afraid I'm not at liberty to discuss the affairs of my employers, sir, I do apologise.'

'Oh, yes, of course, I'm sorry,' I said. 'I didn't mean to put you in an awkward spot.'

'Not at all, sir,' she replied.

Antoine soon jumped in the other side of the car. We sat in silence for a moment. He was texting, and I was taking in the beautiful details of the upholstery and interior of the car. It was a light beige and felt like real leather. There was a panel of electronic buttons for a variety of functions you would need a manual to navigate. The windows were spotless, the floor immaculate, and the air conditioning was perfectly set to counteract the warmth that was starting to build up outside in the morning sunshine.

'Antoine,' I said.

'Yes, Adam?'

'I hope you don't mind me asking, but on the night of your dinner, did you have me followed to make sure I was safe?'

'Yes, Adam, I did. In fact, Suzette and the driver have been keeping track of you for much of your time here.'

'Don't you think that's a bit creepy?'

'Ha! Well, I suppose so, but listen, if you had got yourself into any real trouble, we'd have been able to help.'

'That's nice, though it does feel a bit like I've been spied on.'

'Yes, I can appreciate that. I'm sorry, I promised to do what I can to help look after you. You are our guest of honour while you are here – remember that,' he said with a friendly smile.

'So what's in the boxes?' I asked.

'Oh, that's for my aunt. She's having a party for some of her friends next weekend. She's obsessed by orientalism and has heard that shishas are all the rage at the moment, so she asked if I would take delivery of some boxes of molasses for her and bring them down with me this weekend.'

'Why couldn't she have had them delivered directly to her?'

'Yes, I wondered the same thing. Maybe it's because she lives in such a remote hamlet. It's not even on most maps, and couriers often have difficulty finding her. She also knows there's always someone in at reception at my mum's place. Plus she probably used one of my mum's accounts to pay for it, so this would be the registered delivery address.' He smiled, accompanied with a small roll of his eyes, suggesting his aunt regularly took liberties with his mother's wealth and generosity. He pulled a Swiss Army knife from his pocket and proceeded to cut a line through the tape on the lid of one of the boxes between us on the seats. 'Look, it's this stuff.'

I couldn't help but laugh as he pulled out a tin of Wajah fi Alghuyum.

'What's funny about that?' he asked.

'My grandfather designed that logo back in the late 1960s. Didn't you hear me tell the Eleven Associates on the boat last weekend?'

'Oh no, I must have missed that.'

'It's even more surprising when you know that the face on the tin is inspired by the face in the clouds enigma in *The Mona Lisa*.'

'So your grandfather knew about the face before you?'

'Yes, and he let me figure out for myself which painting it was in.'

'These are all super-odd coincidences, Adam.'

'Yes, well I'm beginning to wonder if they might not be coincidences after all.'

'How do you mean?'

'Well, don't you think it's strange that I coincidentally make friends with the man who asked my grandfather to design the logo? And that I happen to end up helping the guy who imports this brand of shisha tobacco into France at his warehouse one night?'

'What?' said Antoine. He was smiling, but it was one of confusion and bemusement.

'You mean you don't know about all that? Your driver followed me out to the warehouse, so I assumed you must know all about it.'

'No, I had no idea. Perhaps Suzette knew more about it, but I understood our only role was to make sure you don't come to any harm. I knew you had returned home that evening, so that was all I needed to know.'

'Oh,' I said, realising I had just blurted out lots of confidential information to Antoine and his driver, who would otherwise have been none the wiser.

'So is there a connection, do you think, or is it just a series of unusual coincidences?'

'I'm not sure. There are a couple of guys who work at the factory I'm not sure about. One of them seemed quite aggressive, another looks a bit shifty, and the other seems to just always be around acting all moody and mysterious.' I took the tin from Antoine's hand. It was larger than my little old tin, and was rectangular rather than round. It was one of the black and gold tins, so I knew from my shift at the warehouse that this one was opium-flavoured, which was also prominently displayed on the tin. It was beautiful. I noticed that it had a small red sticker that stretched from the top of the tin down the side, presumably to keep it sealed until opened. I took a photo of it with my phone and posted it to my FrendHub page with the caption: *Shisha heaven – you might find your head in the clouds.*

'Did you have me followed down to the Asian café the other day too?' I asked, wondering if they knew where Mammoul lived. It's strange, although Antoine was my friend, and I know he was acting on the request of Alice, I felt a bit protective towards Mammoul and Ammon too.

'You'll have to ask Suzette – she's kind of been the main liaison for you.'

'You make me sound like a client or something,' I said.

'Sorry, yes, that did sound a bit corporate,' he said, laughing.

We soon arrived at the Gare d'Austerlitz – an imposing mid-nineteenth century neo-classical building in the familiar creamy stone that is ubiquitous around Paris. The thing that struck me most, though, was the way in which some trains came in via a bridge suspended in the air straight into the middle of the building. It was like a long steel funnel leading into a giant architectural mouth. We walked through the large ticket hall with our rucksacks on our backs and the cardboard boxes in our arms. Passing through into the cavernous steel-framed interior to find our train, I looked up at the tall thin windows that lined the sides of the main hall. Decorative and with many panes within panes, they gave the impression more of being in a cathedral than a train station.

'We're on a super-fast train, Adam. It should only take us about four hours to get there, then a twenty-minute taxi ride at the other end.'

The train departed bang on time. Antoine had booked us first-class seats – I'd never travelled first-class anything before. The seats were certainly a lot cleaner, more comfortable and more spacious, and there weren't any screaming children, but it did feel less friendly somehow. I could see a smartly dressed elderly lady looking us up and down. She must have thought we were a pair of broke backpackers from our clothes. But then I suppose I kind of was. Antoine, however, was definitely a prince in pauper's clothing today – he was in his skater clothes, baggy jeans, a big pair of trainers, a T-shirt with a graffiti-style slogan of 'No sleep 'til bedtime' on it, and a body-warmer over the top. He had a baseball cap on to complete the look. He seemed his most relaxed when dressed this way. The ticket inspector also seemed a little surprised to find us in the first-class carriage and made sure to check our tickets thoroughly.

'Tell me about your aunt, Antoine.'

'Well, her name is Philomène, she's three years younger than my mum, and couldn't be more different. I don't think she's ever worked a day in her life. She loves partying, loves fashion and shopping, enjoys nothing better than a cocktail and a sunset, spends as much time on a yacht as she does at home, has no idea where the vacuum cleaner is kept, and has never read one single book as far as I'm aware. She's kind of out to have as much fun as she can in this world. My mum is too generous with her sometimes, but they've always been close – they were as thick as thieves when they were growing up,' Grandmama used to say.'

'What does she think about your organic farm business?'

'She calls me her "little farmer"! She seems to think it's all very sweet, but she's really not very interested in the ideology behind it, and what we're trying to achieve. I mean, we want to help change the whole system of global agricultural production at the end of the day. Several years ago I told her she

needs to buy organic and support local farmers, so she told her housekeeper that is what she wanted, so that's good at least, though I expect she's forgotten she's even eating a lot of organic produce.'

'Your mum is such a hard worker – doesn't she feel your aunt ought to work too?'

'My mum's main concern is that her sister is happy and well. I think she's concerned Philomène might overdo it sometimes with the drinking and what have you, but no, she never puts pressure on her to actually do anything. I think my mum feels that they are both free to choose the kind of lifestyles they want to lead, and she doesn't judge my aunt for her choices.'

'And what about your father, Antoine – are you in touch with him?'

'Not so much – from time to time.'

'You told me he's American.'

'Yes, that's right. Well, his family roots are in Russia, then they lived in France for several generations, but he mostly grew up in New York and still spends a lot of time there. He and Mum separated when I was young. I decided to take my mother's family name, Marionette. He works in finance – in global investments. And you, Adam, what do your parents do?'

'My parents both died in a car crash just over two years ago.'

'I'm so sorry to hear that. I had no idea.'

'One morning they were there, that afternoon they were gone.'

'That's terrible.' He stared down at the table.

'They were in their prime. They both enjoyed their jobs and had active social lives, you know, the usual things, small dinner parties with friends, my mum did pilates, my dad liked to cycle. They were good people – mum used to help out at the food bank in Stirchley one evening a week, and dad ran a five-a-side football team for kids with disabilities. It doesn't seem fair, somehow, that such decent people came to such a tragic end. But then I guess life isn't fair, and lots of people don't even get to enjoy the quality of life that my parents did.'

'True, but that doesn't make it any easier to come to terms with,' Antoine replied.

'You're right. I miss them so much. I don't even feel angry, just empty.' I could feel my eyes welling up, so I looked out of the window and tried to think of something else.

At that moment, Antoine's phone rang.

'Yes? ... What? ... How? ... Have they taken anything? ... Fuck ... Right, I'm on my way – I'll be back in a couple of hours.'

'Whatever is wrong, Antoine?'

'Somebody's broken into my apartment.'

'What?'

'Yes, and they must have known what they were doing. I mean, you know what the security system is like there.'

'Will you have anything on the security cameras?'

'I'm going back now to find out. The train will be stopping at Châteauroux in just a few minutes. I'm going to get off there and take a train back to Paris.'

'Shall I come with you?'

'No, no, it's fine. You carry on. I'll sort stuff out at the apartment and then I'll jump on another train later this afternoon. I'll see you at my aunt's house tonight. I'll text you the address and the number for the taxi firm I use there – tell them to charge it to my account. Oh, and make sure you get off at Brive La Gaillarde – it's where the train terminates, so you'd have to be asleep to miss it.'

'Okay, I'll do that, thank you. Leave your box with me. I should be able to manage that one too.'

'Great, thank you. I'll be on my mobile, though you might struggle to get a signal down in the hamlet. There is a landline in the house, so if you need me, call me from that.'

It was awful news about the break-in, and a shame we couldn't carry on the journey together. I had so many questions for him – about Suzette and Alice and everything. Maybe I'd get a chance to speak with him tonight or tomorrow. While I was alone on the train, I scrolled through my feed on FrendHub to have a look at what my friends had been up to, and to see if anyone had responded to my posts. Chris and Eddie had posted some pictures of their burgers from the diner at the bowling alley, which I 'liked' and added some emojis. I could see a few likes for my posts at the bottom of the screen, so I clicked to see who had liked what, and if they had left any comments. There had been just three likes for my tobacco tin post from earlier that morning and no comments. There were around a dozen likes for my post of the face in the clouds from *The Mona Lisa* now, and one of my friends from school, Nadeem, had left a comment: I don't understand what I'm supposed to be looking at? So I typed a response back. Can you see a face in the clouds here, Nadeem? I realised that it wasn't clear from the image I had posted what was going on. So I edited the post to include another image of the whole of *The Mona Lisa* alongside the close-up, and changed the caption to read: *Does anybody see a face in the clouds here in The Mona Lisa?* That should make it more obvious as to what people thought they were looking at.

I got myself a cup of tea and sat looking out of the window for much of the rest of the journey. It was a beautiful landscape – such incredible countryside. We were effectively travelling in a straight line down the centre of France, and I loved it. I had a lot of thoughts going through my head – so many unanswered questions, so many things that didn't quite add up. Why hadn't Alice just spoken to me about what she wanted me to do for her here? How did she come to have this footage of Mammoul and Ammon? Why had it been stolen from Ammon's apartment? Why did the British intelligence

agencies have a problem with Alice and her IT firm? These questions, and many more, kept on rattling around in my head, like the ball in the pinball machines I had been playing just the other night. In fact, it felt like a good analogy for my life here in France – just being catapulted around from one place to the next and back round again, not really knowing where I was going, or what was going on.

I did some texting for a while – one to Chris to see how he and Eddie were doing today; one to Sophia to say hello, and one to Natalie and Amira to let them know how the performance filming had gone that morning, and to say that I wasn't going to be around until the following evening. Chris texted first – no further developments there so they were back to their video games. Then Sophia; there was no sign that my grandad had been back to his house. She said Chris had shown her my pictures from the museum, from the Nuit Blanche, from the FJT and from The Crescent Moon on FrendHub. She said she was pleased to see I'd made some friends, and that I looked to be having fun. If only she knew the half of it.

<div align="center">✳ ✳ ✳</div>

The taxi picked me up from the station in Brive La Gaillarde, on the top of a hill overlooking the town. The driver didn't say a word for quite some time after we'd got in the car. We reached the countryside fairly quickly, and were driving down winding roads with lots of beautiful woodland all around. I liked it when the trees arched over the road and met in the middle, forming a kind of canopy. We went through a village called Collonges-la-Rouge, where all the buildings were made from pink stone. It could easily have been from the middle ages. We travelled on for another few miles, then the driver said, with a curious accent:

'You could have shared a taxi from the station with the people behind us.'

I turned round to see who he was talking about. There was a taxi just a couple of hundred metres behind us.

'Really?' I said. 'They've been behind us all the way from the station?'

'Exactly,' he said. 'Anyway, it is good business for us drivers, I suppose.'

We were by now in a densely wooded area, and I had not seen any villages, farms or properties for some while. It was verdant, so they clearly got a lot of rain here, but it was a lovely sunny day and the light was making the place seem like a dream. The driver suddenly braked.

'I nearly missed the turning,' he said. 'I knew it was around here somewhere, but I've not been here for some time.'

We turned off the road and the car was facing a large stone wall – it must have been close to ten metres high – and an immense pair of iron gates. Through the gates I could see a long drive, and at the far end, an impressive-looking château. In my mind, of course, I'd imagined a little country cottage or

something of that nature, but no, this was a full-blown castle. As we made our way in, the car that had been behind us also turned onto the drive. We parked and the driver got out to get my bag and the boxes from the boot. The other car pulled up alongside us, and a very glamorous woman – she must have been in her early fifties – got out and swept a long silk scarf around her neck. She looked a little surprised when she saw me, but carried on up the stone staircase to the front doors of the château. A young woman greeted her before coming to collect her bags. I was relieved to know that it wasn't someone following me for a change. The two drivers clearly knew each other, and from the labels on the sides of their cars, worked for the same company. I could hear them laughing, presumably about having travelled in tandem all the way from the station. I had given the man Antoine's account number, and gave him ten Euros as a tip, which had only served to heighten his mood further. Just as I was almost out of earshot, I heard the other driver say:

'And would you believe, Jacques was only a hundred metres behind me too. He carried on past us, back down towards the valley. What are the chances of that? Maybe there's some event happening here this weekend.'

I didn't catch what they said after that, in part because the young woman who had come to collect the older woman's bags was asking if she could help me. I don't think she meant could she help me with my boxes – she meant why was I there! I explained that I was a friend of Antoine's and that he would be arriving later on. Fortunately, she did seem to know about his visit, and that he was bringing a guest, so thankfully I was invited in.

The château was insane. I had never seen anything like this in my life. I mean, we'd been on school trips to see stately homes, and my mum and dad had taken me to some National Trust places, but never had I seen something of this kind, and entirely in private hands. It was all based on styles and fashions from China, Thailand, Japan, but it soon became apparent that although it looked like it was all from the distant past, everything inside the house was modern, new – nothing was actually vintage or antique. It was replica, designed to look old. I was taken past some giant 'oriental' vases in the hall through into a large reception room. The woman who had come in before me was at a desk, speaking to a young woman who was wearing a slightly medical-looking outfit, as if she was a nurse. Her hair was pulled straight back into a band at the back of her head. I sat down in a vast armchair with storks woven in gold thread into dark blue shimmering fabric. The wallpaper was also along the same theme of oriental aquatic birds, though in a light pastel green. It was beautiful, if a little over the top. As their conversation continued, I gathered that there was a spa on site, and the woman who had just arrived was booking the different treatments she wanted to have over the course of the weekend. She booked in a hot stone massage, a pedicure, a manicure, an exfoliating face mask and a leg wax. The spa worker smiled and said that she looked forward to seeing the lady in half an hour for her first treatment, and

made her way out of a door at the back of the room. The woman made her way back out into the hall without acknowledging me and was led upstairs by the young woman managing the front of house.

I must have sat there for nearly forty minutes, and I wasn't even sure what I was waiting for, as nobody had said anything. Through the window to one side of me, I noticed a number of vans and cars arriving down the front drive, but every single one of them went around the side of the château, and nobody else came through the front doors. I wondered if I'd given the impression that Antoine would be arriving shortly after me. He was going to be at least another few hours by my calculations, so I asked the front of house manager if Antoine's aunt was at home. The response came back that she was getting ready for a party, and was unable to come to see me at the present time. I asked if there was somewhere where I could have a rest, and she said that one of the guest rooms had been prepared for me on the attic floor. I couldn't quite fathom why she hadn't told me sooner, but I suppose I hadn't asked so she hadn't told me. I informed the young woman that I had brought two boxes of tobacco for Antoine's aunt from Paris, and she suddenly seemed more interested.

'Ah, okay, now I understand,' she said. 'Please leave them here and I will take them through.' Then she got out two fifty Euro notes and offered them to me. I was somewhat taken aback.

'Oh no, I think they've already been paid for,' I said.

'Yes, of course. And this is your tip,' she replied, with a tilt of her head.

I think she must have thought I was some kind of delivery boy.

'That's kind,' I said, 'but really, it's no bother at all.' And with that she smiled and put the money back in a drawer.

I had been impressed by the staircase in the FJT, but the one here was in a different league altogether. It was wide, made of solid stone with an elegant wood- and brass-topped iron handrail, and had a carpet runner with intricate jasmine-flower patterns over it – well, they looked like the flower in the tea I had enjoyed in the café underneath Mammoul's apartment the other day. There were kimonos in giant thin wooden frames on the walls up the staircase, and plant stands with exotic flowers on each landing as I made my way up. When I reached the attic floor I was a little out of breath. The room was small but nicely appointed, and I was pleased to see it had an en-suite bathroom (complete with Chinese-style wall tiles depicting fantastical landscape scenes), so I was able to take a shower. I checked my phone. There was no signal whatsoever. I tried to connect to Wi-Fi but only one network came up and it was locked. I lay on the bed and must have drifted off for half an hour or so. I was woken by a knock at the door.

The front of house manager popped her head round the door.

'Monsieur, Madame requests the pleasure of your company for aperitifs on the terrace.'

I thanked her. That sounded posh. I hadn't really come prepared for a smart occasion – I'd thought I was coming to see a farm – so the best I could do was to take my T-shirt off, button up the shirt I had been wearing over it, and tuck the shirt into my jeans. I was directed through to the back of the château where there was a large terrace with views onto a beautifully landscaped garden. On the terrace was a line of very good-looking young people – mostly boys though there were a couple of girls not much older than me. Each was holding a tray filled either with champagne flutes or canapés. There were clusters of outdoor chairs and tables, like you might see at a holiday resort, and there were a number of other guests sitting down or milling around. All of the other guests were well-groomed women in their late forties and fifties. I took a glass and started walking away, and as I did so I caught clouds of strong perfume – a different one every couple of metres. A lady wearing a bright pink kimono came towards me, and I guessed this was Philomène.

'You must be Adrian,' she said.

'Adam,' I said. 'Very pleased to meet you.'

'I had a call from Antoine to say he would be joining us later this evening. You are most welcome to enjoy the party – there will be plenty of food and wine, some beautiful music, some wonderful guests, and some splendid entertainment. I don't know what your preferences are, but I'm sure you'll find something to your liking.'

'Thank you,' I said, ignoring the oddness of her expression, 'you are most kind.'

'Please, let me introduce you to some of my friends.' With that she took my arm and led me over to one of the tables where three women were seated.

'What have you brought for us?' said one of the women, who had a wide-brimmed summer hat on, and wavy, salon-fresh dark hair.

'This is Adrian,' said Antoine's aunt. 'He's a friend of Antoine's and has brought us the special pipe tobacco from Paris.'

'Ooh, I say, how wonderful,' replied the woman in the hat. 'I can't wait.'

'Well you're going to have to – at least for a little longer. Now I can see that your glasses are nearly empty. I have no idea what I'm paying these waiting staff for.' She hailed the nearest waiter and gesticulated vaguely at the women and their glasses, which he replenished, before she left to go and greet another guest who had just arrived.

'And what it is you do, young man?' asked one of the seated women I was still standing rather awkwardly next to.

'I'm an art student,' I replied. The woman responded with seeming enthusiasm, though it soon became clear she was not interested in me or my studies, but rather was passionate about her own art-related stories. I liked the fact that she was an art lover, but she proceeded to describe a painting holiday she had been on in Tuscany several years ago. Again, in itself, there was

nothing wrong with that, but it was a monologue that lasted for several minutes. The other woman, who had moved off during her friend's performance had returned with a bottle of champagne that she had seconded from one of the waiters, and topped up everyone's drinks.

'We'd better start as we mean to carry on,' she said, winking at me.

'What do you mean, start?' asked the woman with the hat. 'You started at lunchtime, and then carried on in the spa.'

'Merely a preamble,' she said, laughing gaily. 'So you're not part of the entertainment?' she said, turning back to me.

'Er, no,' I replied.

'A pity,' she said, turning back to her friends. 'He is not without charm.'

'Oh, come now,' said her friend in the hat. 'He's young enough to be your son.'

'Well they don't call her the queen of the cougar club for nothing!' said the third lady, throwing her head back with laughter.

Once again I had the impression that I was being talked about as if I wasn't there, or couldn't hear. I decided the best thing to do was to smile as if I was also enjoying the joke.

'Don't be so silly,' replied the other woman, sensing that I was not quite sure of what was going on. 'I was simply suggesting he might have come here to dance or to sing for us.'

'Well he doesn't have the right kind of clothes on to be a stripper,' said her friend.

'Come now, ladies,' said the woman in the hat, 'we are not at some British hen-do.'

The waiters kept coming around with more champagne and trays of delicious nibbles – they described what was in each of these extraordinary creations, which looked more like pastry origami or savoury jewellery than mere *hors d'oeuvres*. I couldn't follow all the details as each canapé seemed to involve many different elements and ingredients – slow-roasted this, pulled that, marinated the other. I had also put several in my mouth before I realised what exactly I was eating, so discovered I had tried a number of things I wouldn't have instinctively reached out for had I known – chopped up raw steak, snail and anchovy tapenade, smoked trout and crab mousse. Each was, however, a taste sensation. This French gastronomy was certainly quite different to the supermarket frozen canapé selection boxes we had back home. I was trying to ascertain what each of the women I was standing with did – something I never really got to the bottom of that evening. There was something about a perfume business, something about the fashion world, and mention of *foie gras*.

The evening dragged on, and with waiters continually topping up your glass, it's hard to keep track of how much you've had to drink. I was certainly feeling quite light-headed and the guests around me, who must have

numbered more than a dozen, were also merry. The volume levels had increased. Dessert wines were brought out – I discovered, in this instance, that these were like white wines, only sweeter and more syrupy. With them came tray after tray of warm chocolate brownies and chocolate cupcakes. They smelt incredible and I must have had two of each. The taste was also out of this world. The three women had by now taken me under their wing, and it was like being with three aunts who occasionally let their hair down. Assisted by the alcohol, they were laughing and smiling a lot by now, and I found myself getting the giggles. I wasn't sure if this was because I found them amusing company, or because I had no idea what had happened to me over the past couple of weeks. One moment I was speaking to my teacher, the next I was standing in the middle of a swanky women-only party at a château in the south of France. After everything that had been going on, what with the museum, the intelligence service business and the face in the clouds, I was perhaps just letting off steam – the giggles a symptom of nervous energy.

The evening air was starting to cool as the sun set, and Antoine's aunt summoned everyone inside with a small golden gong. We were led into a large lounge, the likes of which I had never set eyes on before. The room was ornately decorated, and almost entirely symmetrical. The whole space seemed to be divided into zones encased by black wood with panes of glass inlaid – circular and oval panes – like stained glass, though not like anything you would find in a church. There were flower shapes, and glass made to look like it was shattered, panes in the shape of oriental fans and pagodas. Every surface was covered or decorated in some form. There were patterned screens and chaises longues all around, as well as lots of small round side-tables with matching black legs. At the far end was a bed-like piece of furniture in front of a series of hanging banners filled with Chinese calligraphy and scenes of lakes and cloud-covered mountains. It was like an exotic Victorian fantasy of the Far East, that's the only way I can describe it.

'Wow, what is this place?' I asked Antoine's aunt, who was standing by the door.

'This is my Pearl River Flower Boat,' she said, beaming. 'My very own smoking room.'

In the corner there was a man sitting with a two-string violin-like instrument, wearing a traditional Chinese changshan made of dark blue silk embroidered with dragons and flowers. He began to play a melancholic yet beautiful tune, sliding up and down the fingerboard, which he held vertically in front of him with his left hand while using a bow in his right. I later discovered that this instrument was called an *erhu*. The music changed the dynamic among the guests almost instantly, who switched from being a bit tipsy and giggly to becoming more chilled, more serene. Everybody started finding seats, with most adopting the position of lounging on their sides on the chaises longues.

Not long after all the women had got settled, the waiters started bringing in large shisha pipes and trays of rolled cigarettes. It was obvious, of course, if I'd thought about it. I had brought the shisha tobacco for the women to smoke at the party. The air was filled with a curious yet wonderful mixture of aromas, which I assumed was due to the different flavour tobaccos. A waiter brought one of the shishas over for me after all the women had been given theirs. Having tried one with Ammon the other day, I thought to myself, why not. No harm to join in just this once, as everybody else seemed to be. It was an unusual taste, a bit nutty, a bit like caramel. It was kind of nice. I wondered if it might be opium or hashish flavoured. I was definitely beginning to feel very relaxed, and in a way I never had done before. Maybe this was what a headrush felt like. The room was filling with a haze of smoke, hit by the last golden light of the sunset from outside. The faces of the women started to disappear into the depths of the room. I caught flashes of light on a cheek, a forehead, a nose, and I could hear voices speaking gently against the sound of the erhu. Some of the women were evidently no shisha novices, with one or two effortlessly blowing rings into the air.

As the time passed, I began to feel increasingly peculiar, and was starting to wonder whether everything was entirely as it should be. I could feel myself getting anxious but told myself I just needed to stay calm. I vaguely remember the waiters bringing in yet more trays, this time with mother of pearl inlay and covered with different smoking apparatus – strange long thin pipes with a ceramic bowl at the end, miniature lanterns with ornate metalwork bases and a glass bell over the top, little tools and trinket boxes. The waiter took some dark substance from a lacquered box, cut it up using two little knives and worked it in his fingers. He picked up a beautiful pair of scissors, the handles in the shape of a heron, and cut the wick of the lamp. I couldn't see exactly what he did next, but it involved using another miniature tool that looked like a needle, before putting a small amount of the mysterious black substance into the pipe bowl. The lamp glowed and he passed the pipe to me, positioning the bowl in a very specific spot above the flame of the lamp. I inhaled – it seemed more like a vapour than smoke, and it tasted delightful. Whatever it was, it was quite special. I was lying on my side, smoking the pipe for some time, just staring at the intricate pattern of birds and figures on the base of the lamp. I felt sensations I had never had before. I think I must have been becoming delirious, and was hallucinating faces and strange animals in the smoke around me in the room. It was hard to tell if I was completely awake, or, in part at least, dreaming. For a short while I felt amazing, like I was on a different plane, staring back out at the world.

Then I suddenly felt extremely nauseous. I got up to find a bathroom, but must have got up too quickly, and fell to my knees, from which ungainly position I just started throwing up. There was absolutely nothing I could do about it. It was quite violent and lasted some time. I could taste those canapés

again, and, having been blitzed up with champagne in my stomach for the past hour or two, they were definitely not so good the second time round. It was pretty ugly. I have a vague memory of two of the waiters coming to my assistance, but really I was out for the count.

\*\*\*

The next thing I knew I was being held by my head. I opened my eyes and, once they had focused, realised that I was staring at, or being stared at by, Antoine.

'Drink some water,' he said.

'I'm fine, I'm fine,' I croaked, trying to close my eyes again.

'Drink some water,' he repeated. 'Sit up a bit and try to drink.'

I took the glass and drank what I could.

'I'm so sorry Adam. I had no idea Auntie was having one of her parties tonight. Just look what they've done to you.'

'What time is it?' I asked.

'It's just before midnight. My train only got in a short time ago. I came as soon as I could. Man, you look a mess.'

'I don't understand – I thought I was smoking Wajah fi Alghuyum. What did they put in it?'

By this time I was sitting upright. The room looked like a bombsite. There were bodies on the floor, some of them half undressed, there was a woman snorting powder off a waiter's bare chest, and I didn't really want to know what was going on at the other end of the room.

'What kind of party is this?'

'Yeah,' said Antoine. 'They can get pretty wild. I thought Auntie had calmed it down a bit over the last year or so, but judging from this evening, it doesn't look like it.'

Antoine picked up one of the tins of shisha tobacco and sniffed it before poking around. He put it down and went and found another, from which he pulled out a small aluminium packet, inside which was a small plastic bag containing what looked like a small black brick. The tin next to it also had foil inside, only this time it contained a bag full of pale, brownish powder.

'There we go,' he said.

'There we go what?' I asked.

'This is presumably what got you and everyone in such a mess. We've got ourselves a drug cocktail right here. Look – this is cannabis, this is heroin, and this, my dear young friend, is opium. The old-fashioned stuff.'

'Oh shit,' I said. 'I thought I was feeling a bit peculiar.'

'You didn't happen to have any chocolate brownies or muffins earlier, did you?'

'Erm, yes, I had a couple.'

'Oh no. Auntie's space cakes. I thought she'd stopped making those back in the nineties.'

'Ah, that would have been when I started feeling odd.'

'Listen, you smell of sick and you look like a dog's arse. Why don't you take a shower and get into your pyjamas?'

When I got out of the shower I found Antoine sitting at the foot of my bed with a cup of tea in his hands, and another on the bedside table.

'English tea, Adam, thought you might like that.'

'That's so thoughtful of you,' I said, doing my best to sound like an actual human being.

I had odd dreams that night, needless to say, full of phantasms and bizarre ideas. I woke up several times hot though in a cold sweat and mildly panicked. I went to the bathroom more than once, and must have drunk a litre of water. At least I had worked out that drugs weren't for me. As I lay there in the darkness, trying to get back off to sleep, waiting for my heartbeat to slow down, it started to dawn on me that the drugs must have been hidden inside the Wajah fi Alghuyum tins. There could, however, be no way in which all the tins of Wajah fi Alghuyum contained drugs – I mean, I had unloaded thousands of tins that had presumably been legally imported. But if some of that consignment had contained drugs, what better cover than a tin saying 'opium-flavour tobacco' on it? It would explain why certain people didn't want Natalie and me working at the warehouse, and the menacing atmosphere with the men while we were there. So was this Ammon's secret? Could he be a drug dealer, or part of a smuggling ring? It would make total sense in some ways, that was for sure – him following me around and warning me off. But if so, was Mammoul aware of what he was doing? I thought through some of the things Mammoul had said to me. I couldn't quite reconcile what I knew of Ammon, and his background, with this image of him as a hardened criminal, but I couldn't rule it out, and the evidence did seem to be pointing in that direction.

Furthermore, if there is a drug smuggling operation going on, I thought, presumably that is what the intelligence services are so interested in, and why Alice wanted me to see that old film footage. I resolved that Alice, and perhaps the British secret services too, wanted me to find out who was behind the drugs ring, and how it worked. But if so, why hadn't anyone told me this? Why the constant guessing game? I really wanted to speak to Alice or my grandad again. And I really wished my parents were still alive. They would have known what to do. I could tell them anything, they would always understand and support me, no matter what. I was so glad Antoine was there with me now, as otherwise I think I would have felt very alone indeed that night.

## WIRELESS FIDELITY

The next morning I woke to find Antoine standing at the door with a round
bowl of tea for me.

'When you've had a chance to come round, why don't you come down
for some breakfast? You can try some of the beautiful food we produce on
the farm.'

I looked at the clock. It was around ten. I felt very low, needless to say.
Agitated, uncomfortable, embarrassed, dirty. I'd never had those sensations
before, not all at once anyway. I didn't like the idea of having done something
illegal, for starters. I'm not sure whether the fact of not knowing that I had
been taking drugs at the time made it better or worse. Was I really so naïve?
I showered and packed my few bits back into my rucksack, ready for the day
ahead. I made my way downstairs where a member of staff guided me into
a beautiful, airy dining room. It was set up as if in a hotel, with several round
tables dotted around the room. There were beautiful blue gingham tablecloths
and white bone-china cups and saucers with matching plates and side-plates.
I could smell bacon – I think for the first time since arriving in France – and
it reminded me of my mum, making a fry-up on a rainy Sunday morning.

'We have fresh eggs, sausages, mushrooms, bacon and our own home-
made version of your famous baked beans, Adam,' said Antoine, grinning.
'It's almost a classic full English breakfast, in fact.'

'It looks incredible,' I said, as a plate filled with the most beautiful food
landed in front of me.

'There are pastries made from our own flour and butter too,' he said,
gleefully. 'Oh yes, and our honey and jam to go with them, if you like.'

Around the room were a handful of other guests. Antoine went to speak
to some of them. I recognised two of the women who I'd been standing with
on the terrace, and they waved at me to which I smiled politely. Honestly,
seeing the scene in the dining room you'd have had no idea of the decadence
and depravity I had become a part of the night before. It was as if absolutely
nothing had happened.

After three glasses of water, two of freshly squeezed orange juice (from
Antoine's land, of course) and two more cups of tea, I finally felt ready to take
the world on again. Antoine took me outside and we began a tour of the estate.
I had no idea of the scale of the farm. I had imagined it was like a large

allotment, or maybe a small field with a greenhouse and perhaps a barn. But what he showed me around was field after field, extensive orchards, endless vineyards, bounteous olive groves and dense woodland filled with truffles buried beneath the trunks of trees. He showed me a giant glass building as tall as a house that was filled with orange trees, as well as overflowing with lemons, limes, cherries and bougainvillea, just because his aunt liked those for the house. In the sunny yellow morning light Antoine's farm seemed to me like a new dawn for the future of the world.

'And everything is organic here?' I asked.

'Everything. And the wine we're producing is natural as well as organic. We're putting a lot of time and energy into the idea of "precision farming" – we use technology to monitor all the factors affecting the growth of our produce – water content, soil acidity, humidity and so on. I've been interested by what the Dutch have been doing over the past twenty years, reducing the resources they use to farm with while increasing the yield. You know they're the second biggest exporter of food in the world in terms of value, second only to the USA? Don't you think that's impressive for such a small country?'

'It sounds incredible.'

'Doing what they're doing, and others exploring similar farming and agriculture models around the world, like vertical farming, is the only way we're going to be able to provide enough food for everyone without using up all of the Earth's resources. It's not just some hippie vision, it's the basic economics of the future.'

As the tour continued, Antoine blew my mind with facts and figures, information about progressive technologies, seed production, land usage and so on. He had an entire valley filled with bamboo and glass buildings covered with solar panels. These were his greenhouses – a far cry from the little garden structures I'd envisioned.

'We've now got around sixty people working on the farm, and I'm keen to keep on expanding. We're still in our infancy as a business – obviously many of the things we grow have been grown here for centuries – we're just the latest custodians of them. Other things we've introduced.'

'Are the locals supportive of what you're doing?'

'For the most part, yes. Many of the farmers round here are really interested in what we're trying to achieve and help us out with advice on certain crops. I'm developing a co-operative strand of my business with some of the neighbouring farms who are already organic, or are keen to make the transition to organic farming. It's like partnering up to increase what we can produce and sell. A couple of people aren't so keen on all the technology and don't like how the valley looks – I call it "solar valley" – but I've put it here so that it's not too obtrusive in the wider landscape of the area. I guess it does look a bit like what an evil agricultural corporation would build, but we're the good guys, I promise.'

'I'm amazed by everything you're doing here, Antoine, I really am, but you haven't told me about the incident at the apartment yesterday,' I said as we walked around the brow of the hill looking down into the solar valley.

'Oh yes, of course. Well, it was all very odd. I got back to discover that my apartment had been broken into, and that the security system had gone down just a few minutes before the break-in is thought to have taken place. My concierge had just popped out on some errands – there's usually someone on the premises at all times, but as both me and my mother were away, the housekeeper had been given the day off. He had tickets to see the rugby and wanted to take his granddaughters to watch the match.'

'So it looks like it was carefully planned. Or was it just opportunist?'

'Definitely the former. They must have taken the electricity down to the entire building. They then also knew how to disable our computer server, which has a small back-up generator in case of power cuts. The security cameras went down with that so we can't really be sure what they did or where they went once they were inside.'

'Did they steal or damage much?'

'No, that's the thing that makes it even stranger. Nothing was damaged – the only sign that they had been in at all was a very carefully drilled series of holes in the French doors at the back, which had taken out a crucial part of the lock mechanism so that they could get it to open sufficiently to get in. There was quite a bit of cash left out on the side for the housekeeper to do some shopping this morning, and it was still there. They must have seen it.'

'So it wasn't about money.'

'No, though I can't for the life of me think what they were looking for.'

'And what about your mother's apartment – did they get in there too?'

'No signs of them having got in there, though one thing I don't know is whether the electronic doors to her apartment automatically unlock in the event of the system shutting down, in case of fire or whatever and people need to get out. By the time I was there the electricity had been back on for some time and the doors were locked as usual.'

'Well I'm glad it wasn't anything worse, not that that makes it any better. Nobody was hurt. I wonder if it's connected in some way to everything that's been going on?'

'It would make sense, though I still can't imagine what breaking in to my apartment would achieve. Speaking of which, what exactly has been going on? I know that you're here for some matter of national or international security, and Suzette has told me that you've infiltrated a suspected criminal gang. There's much more to you than meets the eye, Adam.'

'Is there?' I asked, in all honesty. 'The thing is, Antoine, when I arrived I had no idea that I was even here for anything other than the exhibition at the museum. I've somehow become involved in something that I don't really understand, and everyone around me seems to know something about it.'

'Well that's it. We all know something about what's going on, but none of us knows everything. It sounds like you're the person who's supposed to piece it all together.'

'Me? I've had no training, no briefing, no instructions, no nothing. I'm not even being paid.'

'You do seem to have been thrown into the middle of things.'

'You do realise that we carried two cardboard boxes filled with drugs halfway across France for your aunt?'

'What?' said Antoine, and I could see he hadn't already made the connection. 'But I thought it was just tobacco in the boxes we were carrying. I mean I know people sometimes take drugs at Auntie's parties, but I didn't know we were her mules. Shit.'

'I was taking drugs last night without even realising.'

'I thought she was having her party next weekend. I'm so sorry, Adam. If I'd realised it was going to be last night I never would have let you carry on the train journey without me. Speaking of which, we should probably start making a move to get to the station. I need to be back in Paris by early evening.'

<p style="text-align:center">✳ ✳ ✳</p>

The carriage was beautifully air-conditioned, which was a blessing as it had turned out to be a scorching hot day. We had a carriage pretty much to ourselves again. Antoine had brought a flask of smoothies made from fresh fruit from his farm, blended with ice. I switched my phone back on, hoping that there would be decent Wi-Fi on the train. There was signal, but the phone was buffering, like it was trying to download data. Nothing had come up in my messages or alerts, so I just put it down on the table and carried on chatting. I told Antoine everything about Mammoul and Ammon, about Youssef and Amira and Natalie, about our night at the warehouse, the film clip and all the rest of it. I felt I could confide in him. I also thought it was important that if anything did happen to me, somebody would be up to speed with what had been going on. I hoped he might even be able to help me in some way.

'So you need to let Suzette and Alice know that somebody is importing illicit drugs into Europe, using Wajah fi Alghuyum as a front.'

'Yes,' I replied.

'And you need to find out if Youssef is aware that his import and wholesale business is being used by criminals in this way.'

'Yes.'

'Then you need to find out if Ammon is the leader of this gang, or at least is involved at this end.'

'Yes.'

'And after that you need to establish if Mammoul is involved – maybe even behind it all?'

'Yes, though I just can't picture that as a scenario.'

'But you told me yourself that he's been working in intelligence for around half a century – he knows what he's doing and how to play people.'

'I suppose so, but I still don't believe he'd be involved as a criminal. Perhaps he's keeping them under surveillance.'

'Maybe, which begs the question, did your grandfather know that you'd become embroiled in all of this? I mean, he gave you the tobacco tin.'

'Do you know, I'm just not sure,' I replied. 'It does seem too strange a coincidence. But if he did intend me to find Mammoul and the group, he didn't give me much to go on.'

'And if he was involved from before you arrived, what is his relationship with Alice?'

'Well he's certainly known her since she was a baby. He was very good friends with her grandfather, and he spends quite a bit of time in her shop, Stirchley Electronics.'

'Sure, but do you think he's also involved in the data and information analysis company that Alice runs?'

'I'm guessing there must have been a connection at some point – she said she was trying to help him out with some secret call sign from the past. Why else would he go underground for the last couple of days? But what could he possibly know about things going on over here these days? He struggles to remember what day of the week it is sometimes. But tell me, do you know Alice yourself, or was it Suzette that asked you to bring me into the Eleven Associates?'

'Suzette. I don't know Alice.'

'And did you know that Suzette and Alice are involved with the British intelligence agencies?'

'Yes, though only in as much as they work with lots of different agencies and organisations. I only really found out on Friday just how involved Suzette and Alice are in what's going on.'

'But nobody seems to be able to say what is going on!' I said, almost exasperated. 'Everyone knows that something is going on, but nobody knows what it is.'

'I know, but think about it – you know a lot more today than you did when you arrived.'

'That's true, I suppose. I guess it's all starting to make some sense. So does the face in the clouds have any significance beyond having been Grandad's cryptic puzzle and his design for Mammoul and his brothers' tobacco brand? His brothers... yes, his brothers. Of course, the other man in the back of the truck. What happened to him? And what exactly happened to the tobacco company?'

'It sounds like you've the next questions to find answers to, Adam.'

'Yes, and I think it will start with a visit to Youssef.'

As we passed Châteauroux, my phone pinged. It was a message from Sebastien along with a picture. It was another painting by Leonardo, *The Virgin of the Rocks*. The note read: 'Hi Adam, I have been thinking about our conversation the other evening, and in your notes you mentioned a woman in the rocks as a possible cryptomorph in *The Mona Lisa*. It made me think of this painting – there are two versions, this is the one in the Louvre. The concept of the painting doesn't really have any precedents in earlier painting, you know, like Annunciation scenes, or Crucifixion scenes. It's always struck me as a rather odd painting – the rocks are so strange, so fantastical. It's a painting with a peculiar vocabulary, a weird syntax. But then, what you're suggesting for *The Mona Lisa* is the weirdest kind of syntax – you are inviting us to re-read the painting using a different visual language. I confess, I can't see any woman in the rocks in *The Mona Lisa*, but it struck me as interesting that you raise it as something that the landscape evokes in your mind, or in your imagination, perhaps. I don't mean "imagination" in a pejorative sense, like you're making it up, I mean in the sense that imagery has the power to evoke the imagination. Anyway, I thought you might find it interesting.'

I did. All of the figures in Leonardo's painting of *The Virgin of the Rocks* seemed to be pointing around in some kind of interplay, as if something was going on among them – between the Virgin, the infant Jesus, the infant John the Baptist and the Angel Uriel (as I discovered). Like with *The Annunciation*, across the different lines of communication, everything seemed to revolve around the Virgin's womb, a black void, with the Virgin's hand seeming to signify restraint, or some kind of metaphysical blessing.

As I was looking around online at various Renaissance paintings, I'd received a few more pings on my phone – messages and alerts coming through. Having sent a message off to Sebastien I now turned to have a look at these notifications. There were messages from Amira and Natalie, from one of my old school friends, but then messages started coming in from people I didn't know. They were mostly FrendHub messages, and their comments were a strange mix. I wondered what they were so interested in. I opened the app, which again started buffering. There were comments in response to a few of my latest posts – some of the other school leavers who were being featured in the exhibition had posted responses to my first pictures of the exhibition space; some of the Eleven Associates had posted various replies to my post of the face in the clouds from *The Mona Lisa*; and Amira had liked the picture I'd posted of the tobacco tin lid. The buffering carried on and on. I wondered if I needed to switch the phone off and back on again, or whether the wi-fi was just weak. We were very close to Paris when my phone started going nuts. It kept on pinging and buffering, pinging and buffering. I had to switch the volume off because it was pinging almost every second that it wasn't buffering.

I could see that there were a lot of people responding to my post of the face in the clouds. The likes and comments just kept on growing. It had passed a hundred by now – that's more than double the number of followers I had. Up and up, the count just kept on going. The comments were flashing up before being superseded by the next incoming comment. People seemed to be going wild about the face in the clouds. I mean, really wild. Some people seemed to be amazed, others seemed surprised, yet others were angry or aggressive about it. There were a lot of people I didn't know, and when I started checking on their profiles, they didn't have anybody in their networks that I was friends with. Where were all these strangers coming from to find my picture? The count kept on getting higher and higher – three hundred, four hundred, five hundred and counting. Antoine was laughing.

'So they found your face in the clouds then?'

'Who did?' I asked.

'The social media universe, of course!'

'I guess so. There are a lot of people I don't know posting messages and comments about my picture. I seem to be gaining a lot of new followers too.'

'It looks like your *Mona Lisa* post is going viral.'

'Really, is that what's happening here?'

'It looks like your phone is struggling to process all of the responses to your post. What is the count up to now?'

'There – it's up to twelve hundred now. That's so strange. I don't think I've had more than forty likes before.'

'People are obviously re-posting it – look, there are lots of re-post signs, as well as people following your profile. You're going to be a social media star, Adam.'

'Oh goodness. I'm not sure that's something I want to be,' I said, imagining a daily routine of eight hours a day posting pictures and responding to comments. 'I don't think I'm destined for a career in social media.'

'Look, the buffering has stopped, and now your count is going up in real time.' Sure enough, the counter was now going up in ones and twos, every few seconds. 'There are people looking at your face in the clouds all over the world!'

'It's hard to conceive of such a thing. I guess I've looked at enough posts that are trending to know that this is what can happen with social media, but it feels really odd to have posted something so popular myself. It feels like I'm under attack.'

'What are people saying about it?'

'It looks like quite a spectrum of responses. Listen to some of these:

*OMG WTF?*
*Is this for real?*
*I can't see what you mean.*

*This is frying my brain.*
*Is this a known thing?*
*JOKES!*
*So beautiful!*
*Super weird.*
*Photoshopper!*
*Is there meant to be a face here?*
*The Mona Lisa?*
*So cooool!!!!*
*The Real Da Vinci Code?*
*NO WAY!!!!!*
*I don't know what I'm supposed to be looking for?*
*What is this?*
*You need your eyes tested mate...*
*Just another conspiracy theorist.*
*Deepfake da Vinci!*
*Did Leonardo paint this?*
*Is this the original painting?*
*This freaks me out.*
*What are you talking about?*
*FAKE NEWS!*

'And then there are a lot more that are quite rude – threatening even. It's just a picture of an ambiguous face in a painting. Why are there people threatening me?'

'They're afraid, Adam.'

'Afraid of what – an optical illusion?'

'Yes, but it's more than that, isn't it. I mean, this is the most famous painting in the whole world. People have been looking at it for hundreds of years, so if you suddenly tell people they can see a face in the clouds and some of them can actually see one there, then you've taken them completely by surprise – you're likely to have unsettled some people.'

'Sure, I can see why some people might feel unsure about it, or uneasy about it. But I don't see why people are threatening to poke my eyes out. It's a bit extreme.'

'It's sad to say but it's just par for the course when you reach such a large audience of strangers who don't have to be particularly accountable for what they say to other people. Imagine all those people who get abuse for their gender, or race, or sexual orientation, or political opinions. It never ceases to amaze and disappoint me what people will say to other people, especially remotely, even more so anonymously.'

'I'd never even think of saying something nasty to someone I don't know.'

'You're a nice boy, Adam. Not everyone in the world is like you.'

'How do some people grow up to become aggressive and nasty?'

'It's human nature. But what I would say is that for every person that makes a threat, there are twenty people who would stand up for you.'

'Do you really believe they would?'

'Why don't you read some of the threads of conversations between people in response to your post? I bet some are supportive and others are arguing among themselves.'

'You're right, Antoine. There are huge long threads here, with people arguing for and against the idea, among other things. Some people do get wound up quickly. It's interesting how people sharing opinions can escalate into a row so fast. Within just a few exchanges. I'm glad to see that people are interested in the idea though.'

'Yes, that's amazing Adam. You've done it – even before you've had a chance to develop your Super8 footage and edit it – you've managed to get your idea out into the world and for it to be discussed.'

'There are a lot of people who don't seem to be able to see a face in the clouds.'

'You'll have to analyse all the responses and organise them into a graph.'

'What, like for, against and undecided?'

'Yes, and then a category for responses that don't fall under any of these, or categories within them.'

'That would be interesting. Look, the count's over two thousand now!'

'I wonder how popular your post will grow to be.'

'Maybe it'll peak soon and fizzle out. People tend to move on to the next trend pretty rapidly.'

We arrived at the Gare d'Austerlitz, and after saying our goodbyes parted ways for the evening.

\*\*\*

I dropped off my rucksack in my room before heading straight round to see Amira. I knocked on the door. I heard her voice telling me to come in.

'Adam!' she said, smiling at me. 'How are you?'

'I'm okay, I think.'

'What's going on with that weird face you posted on FrendHub? I saw that loads of people had liked it.'

'Oh yes, that – all very strange. I thought the idea was interesting so I posted it. I had no idea that so many people would see it and want to respond to it. Anyway, there's something I really need to speak with you about.'

'Of course, take a seat. Whatever is it?'

'Well, there's been quite a lot of stuff going on over the past week or so, and I think there might be some criminals using your brother's import and wholesale business to smuggle drugs into France, and possibly beyond.'

'What?' she said, looking completely shocked.

'I stumbled across some drugs by complete accident, and they were hidden inside Wajah fi Alghuyum tins.'

'Oh no, please no,' she said, looking petrified. 'My brother, not my brother.'

'I need to know if he's involved, Amira.'

'Of course not – he'd never do anything like that. His business is growing, it's doing really well, and he doesn't need to take a risk with something like drugs.'

'Not even for the chance of becoming really rich?'

'It's just not who he is – or who we are as a family – that kind of thinking isn't in our DNA. He's hard-working, and honest. He would rather starve than eat food paid for with drugs money. He knows the misery drugs bring.'

'I mean, I don't know him at all – I only met him once, though he did seem like a genuinely nice guy. So these people he recently started doing business with for the tobacco imports – it's likely they're behind it.'

'What Ammon and Hager?'

'Yes, perhaps, and are there others?'

'Yes, there are other guys that work in the warehouse that were brought in for this particular job and partnership.'

'And Asim?'

'He's an old friend of my brother's. I can't imagine he would be involved. But then I can't believe Ammon would do something bad like that, either.'

'I'm not quite sure what to make of Ammon yet.'

'We need to speak to my brother right away.'

'Do you know where he is?'

'I'll be meeting him at The Crescent Moon restaurant in half an hour or so. He's probably there already. Why don't you come with me and you can ask him yourself?'

'Okay, I will, thank you. But what if he is involved and I'm just asking him outright?'

'Adam – he's not involved, I'm telling you now.'

'But what if he has no choice but to be involved?'

'Well if that's the case, this will be his chance to tell us, and maybe we'll be able to help him.'

\*\*\*

We arrived at the restaurant and I waved at Mammoul as we walked through the doorway to the courtyard. He was serving at a table, but he stopped what he was doing momentarily to wave and to give me a big smile.

'Find yourselves a nice table in the shade!' he called.

Amira had spotted Youssef in the meantime. He was standing up next to a row of four tables for two, all side by side. On the opposite side were four children, aged between around ten and their early teens. On the table, in front of each of them was a board game – two were set up for draughts, one for chess, and the other for backgammon. Youssef was moving between all of the different games, taking it in turns with each child to play the next move. They each had a glass of fruit juice and there were plates of food for them all to share.

'Youssef loves playing games with Asim's children,' said Amira. 'The kids love that he wants to play games with them. He can't usually get anyone of his own age to play with him!' she laughed.

'Why don't they play each other?' I asked. 'There are four of them.'

'They all want to play him, that's why!'

'Oh, I see, right – they all *like* him.'

'Yes, of course. And Asim's wife Lateefah likes the fact that Youssef is keeping them all busy and out of trouble for a while. Look – there she is having some food on the round table to the right in peace and quiet.'

'That's really nice,' I said, looking round. This scene of Youssef and his colleague's children certainly wasn't the mental image I would conjure of a drugs baron, but then, I guess even drugs barons might like hanging out with friends and family. Lateefah was clearly enjoying a bowl of meat and couscous but there was no sign of Asim. Amira went over to Lateefah's table.

'I'm guessing Asim's still at work,' I heard Amira say.

'That's all he seems to do these days, Amira. He hardly sees the children at all.'

'That's not like him – he lives for those children.'

'You're right, he does. He just doesn't seem himself these days – it's like he's always busy with work or with his own thoughts.'

'You should tell Youssef – maybe he can find out if there's something troubling him. Or I can mention it if you like.'

'I'd appreciate that, Amira. I know Youssef wouldn't want him to burn out just as Asim wouldn't want Youssef to worry about him.'

'Of course not – he'd be mortified to think he hadn't noticed his friend getting too tired and stressed. Leave it with me.' She smiled before calling out her brother's name as she walked back over to where I was sitting.

'Oh hey Amira, hey Adam,' he replied. 'I'll be with you in just a minute – actually, give me five minutes and I'll be done here.'

'Sure, we'll get some food and drinks in. Join us when you're ready,' she added.

'I'm just coming over to take your order, Amira,' said Mammoul from the doorway into the restaurant.

Youssef joined us as the first plates were arriving at the table.

'Good to see you Adam,' he said.

'And you too, Youssef. I'm sorry I couldn't come to help at the warehouse last weekend – I was a bit caught up in other things.'

'No problem, Adam, though we could certainly have done with your help. We seem to be getting busier and busier.'

'That must mean business is good?' I asked.

'Yes, it is. It's growing so fast we keep on needing to take on more and more staff.'

'And is that you taking on more people, Youssef, or your partners?' asked Amira.

'Well, I guess we're splitting the costs of their salaries.'

'Sure, but is it you who's finding these additional members of staff?'

'Why do you ask, Amira?'

'I'm interested to know who's finding these men – where they're coming from.'

'Well if you really want to know, the answer is I'm not entirely sure. Hager and Asim have been taking care of staff and rosters. I've been spending less and less time on the warehouse floor, and more and more dealing with client orders. I have noticed quite a few of our old workers have left recently, though, which was a shame – some of them had been with us for years.'

'So you'd usually be more hands-on in the warehouse?' I asked.

'Yes, like the other night when you came to help out. I usually like to check that what's coming in is what we've paid for. Once stock has been unloaded, it's very difficult to then go back and say that you're missing a few boxes or whatever.'

'But now you're doing more in the offices?'

'Yes. Look, what is this, the Spanish Inquisition? Why are you both so interested?'

'We're just interested to find out how it all works,' said Amira.

'You're not planning to start a rival import business are you?' he said, smiling. 'Because I know,' he said, turning to me, 'that if my sister were to put her mind to running a rival import business, she would make more of a success of it than me.'

'That's not true,' said Amira. 'I've learnt everything I know about business from you.'

'You are a good and kind sister, Amira,' he replied.

'Have you noticed anything different or unusual since you've been working with these new guys?' I asked.

'I can't help but feel that you two have an agenda here,' he said, looking slightly less at ease.

'Please just answer Adam's questions, Youssef. It's important.'

Youssef looked at her directly in the eyes. His expression turned to one of confusion and mild concern.

'Well, yes, I suppose there's a lot that's new and different when you start

working with new partners. They do some things differently to me, and as it's a collaborative process, I don't always have the final say in everything.'

'What kinds of things?' asked Amira.

'Oh, you know, they like to organise the shipping themselves. I like working with the shipping company I have always worked with, but they have their preferred company too. They reschedule things at the last minute, which they say is because they can get better rates that way, but I don't like changing imports at the last minute – it complicates the paperwork. I mean, a lot.'

'And is the relationship going well? Are they easy to work with?'

'Well, I wouldn't say it's all plain sailing. And you're right, some of the people who they're taking on are a bit on the rough and ready side.'

'But nothing that seems odd, strange, out of the ordinary in any way?'

'Now I come to think of it, I have noticed the couple of times I've been on the floor during deliveries, that the number of boxes of stock has been higher than what we have on the packing lists and commercial invoices – more stock than I have ordered in.'

'And that's quite unusual is it?'

'Yes; sometimes we're boxes short, but we don't usually have too many.'

'And what was the reason for this?'

'Hager tells me that some of the consignments have been split across multiple deliveries, so other lorries have fewer boxes, some have more. It's to do with the last-minute shipping changes, which is why I don't like it. It's harder to keep track that what has come in is correct, and in which shipments.'

'Are the books tallying?'

'The accounts? Yes, I think so. Asim tells me everything is up to date and that there have been no significant problems. So maybe I'm worrying for nothing. I just like to do things my own way so that I know they are being done right, if you see what I mean.'

'Of course, of course,' I said, reassuringly. 'And do you ever check the accounts and the bank statements?'

'Yes, absolutely. What kind of a director would I be if I didn't check my own company finances on a regular basis? But tell me, what is this all about?'

'Adam discovered some drugs hidden inside a box of Wajah fi Alghuyum, Youssef.'

'There must be some mistake,' he said, turning his head at an acute angle in disbelief and shock.

'It's true,' I said. 'It was opium, prepared the old-fashioned way, as well as heroin.'

'But this must have been hidden in tins after we have imported it – who would risk bringing drugs into France through regular shipping companies and shipping routes?'

'I'm sure people try to get drugs in to France by every means possible,' said Amira.

'And what better way to hide opium than inside tins that say they contain opium-flavoured tobacco?'

'I'm sure the sniffer dogs can tell the difference,' said Youssef. 'So let me get this right. You're saying that the people I'm working with might be importing drugs in with the regular shisha molasses?'

'Yes, precisely,' I replied.

'Well there's only one way to find out. We shall have to go and open the stock in the warehouse.'

'Isn't that a bit dangerous? If the people you're working with are criminals, or there are criminals among them, surely you need to be careful not to make it known that you've found out,' said Amira.

'Why don't you just go straight to the police?' I asked.

'Can you imagine?' asked Youssef. 'My whole business would be destroyed.'

'Surely not if you go to the police and tell them what you think is happening.'

'I'll need to think about it. It could be disastrous for me.'

'It'll be more disastrous if the police find out that you know and you haven't told them about it, surely?' I replied.

'Perhaps. I just need a bit of time to think about how to deal with this situation – and I need to know who is behind this. That could also be dangerous. First I need to speak with Asim.'

'Okay,' said Amira. 'But you promise you'll call me in the morning to tell me what you've decided to do?'

'Yes, yes, I promise. Thank you both for bringing this to my attention.'

Amira and I walked back to the FJT together. She was worried for her brother. I was too, though I also wondered whether I had done the right thing in speaking to him about it. I was reminded of what Mammoul had said to me about keeping a low profile. I needed to speak with Suzette or Alice pretty soon. I walked Amira to her door, said goodnight then went back to my own room.

Before I had even switched on the light and closed the door to my room I felt an arm around my neck. I was pushed against the door so that it shut. I could feel something hard pressing into my spine.

'Lock it,' said a voice next to my ear. 'Now.'

I did as he said.

'Give me the key.'

I held the key up in my left hand and he took it with his.

'Give me your mobile phone.'

I took it from my trouser pocket and held it in the air. He took it.

'Now I'm going to turn you around, and I want you to go and sit on the end of the bed. If you make a noise, I will silence you.'

I did as he said. When I reached the bed, I sat and turned to face him.

I already knew who it was from his voice. It was Ammon.

'What the hell do you think you're doing?' he asked. He looked furious.

'What do you mean?' I asked.

'You know exactly what I mean. Did I not tell you to stay away from Youssef and his business activities?'

'I thought you told me not to go back to the warehouse,' I said.

'Don't play the fool with me. You know I didn't mean just that. You have no idea of the danger you are in, and of the danger you are putting your friends in.'

'So you mean you're not the danger then?' I said, surprised by my own nerve.

'Of course I'm not the danger – have you not worked that out for yourself?'

'It wasn't clear to me whether you were part of the gang or not.'

'You would probably not still be alive if I was part of the gang.'

'But why didn't you give me more information if you're not one of them?'

'You don't seem to realise just how dangerous it is for us both. This isn't some kind of game. Why the hell did you post that picture?'

'The face in the clouds?' I asked, thinking of the painting and all the responses it had generated.

'Yes, the tobacco tin,' he said, clearly referring to the picture I'd posted of that. 'It was as if you had sent up a flare for the gang to see. Why did you post a picture of one of the tins filled with drugs? And what did you mean by writing that caption for the picture? You even put a load of hashtags on it. You couldn't have sent a more direct message out to them.'

'I didn't know it had drugs in at the time I posted that,' I said, truthfully.

'You posted one with the red security tape on it – the regular ones have transparent tape on them.'

'How could I know that?' I said.

'Have you not seen the messages that came up in response?'

'No, I haven't.' I had been so swamped by alerts and comments that I hadn't noticed what people had posted in reply to that picture.

'They have told you to take the picture down. Look, open up your app and look at the comments and messages.'

He threw me my phone and I opened up the app. Sure enough, there were several direct messages waiting for me from someone called Osiris3000. They told me that I had to take the picture down instantly or they would come and make me take it down.

'Might I suggest you take that picture down right now?'

I didn't need asking twice. I deleted it.

'Shall I send a reply, apologising and saying I didn't realise I had done anything to upset them?'

'That might not be such a bad idea. It might at least make them think that you don't know as much as they have assumed you know. It's a pity your caption gives the impression you know exactly what was inside that tin: *Shisha heaven – you might find your head in the clouds…*'

'I was referring to the face in the clouds of smoke – not to drugs.'

'Well, whatever – you properly rattled their cage. And you know what?'

'What?' I asked.

'They know everything about you now. They know your name; they know you are working on an exhibition at the museum that opens this week; they know you live here in the FJT; they know who all your friends are. It's all there on your profile and feed, for everyone to see. Have you got a death wish?'

'Quite the opposite,' I assured him, beginning to realise the predicament I was in.

'They even know that they have met you. You posted a selfie – a picture of your own face, for goodness sake!'

'I see. Yes, well in these circumstances, I can see that I have left myself quite vulnerable.' I realised that my use of social media had inadvertently turned me into a sitting duck. Alice, Suzette, my grandad – they had none of the latest information that I had for them, but I had just put my head into the lion's mouth.

'So tell me, Ammon, are you working for the intelligence services?'

'If I was, would you be able to manage to keep that a secret, or would you put that up into the digital universe for everyone to see?'

'I would keep it a secret, Ammon, I really would.'

'Well you better had better learn to be more cautious or you can add me to the list of people looking to kill you!' He laughed. 'Sorry, I didn't mean that to sound like a threat. Mammoul told me you are a good kid. You're lucky – I just found you a pain in the ass, hanging around, sticking your nose in. If he hadn't spoken up for you, I might have made things less pleasant for you myself!'

'So you're working with the gang to try to find out more about them?'

'Yes, I'm trying to establish just how wide their network stretches, who is involved and how, at what levels, and how the money is being moved around. If we follow the connections through all the way, we can hopefully trace the big players pulling the strings on this.'

'Of course,' I said. 'That makes perfect sense.'

'What I don't understand is why you've been planted in the middle of my operation. You've clearly not been trained for this.'

'No, I've not been trained. I don't think I've been planted here – I think I'm here by mistake.'

'Well, we'll see. Some people know some things, that much is clear.'

'What kind of things?'

'Listen, kid, I'm not going to start telling you everything I know – that's

not the way intelligence works.'

'Sure, but I remember Mammoul telling me how he used to share information with friends in other intelligence services – that's how they managed to collaborate.'

'So you know about Mammoul's past life,' he said, raising an eyebrow. 'He did say you're very good at getting people to speak – maybe you're not as naïve as you look, kid.'

'And I know you and he go back some way,' I said, wondering if I was overstepping the mark.

'You do, do you? Well I know for certain that he would never have just volunteered that information to you. I think I'm going to end this conversation here.'

I wondered for a moment if he meant he was going to kill me. But his body language didn't seem to suggest he was about to turn violent. And what would that achieve anyway?

'It's okay, Ammon, I'm not trying to make things harder for you.'

'Well you have by blabbing to Amira and Youssef tonight.'

'How did you know about that?' I asked.

'Kid, you were in an open-air restaurant, next to a wall with railings in it. Any passing pedestrian could have overheard every word of your conversation this evening. If you are working for the British government, they've taken quite a gamble trusting a novice like you. Either that or they aren't as impressive as they once were.'

'Do you think the gang will come after me now?'

'It's quite possible, yes. If they think you are a threat. They might suspect that they have been rumbled, in which case it's very hard to know what they will do next. And if Youssef starts digging deeper to find out for himself, that could destabilise the whole operation. It's been two years of careful surveillance and infiltration at points throughout the chain. Have you told anybody else about what you've discovered?'

'Just a couple of close friends. But I think other people have their suspicions.'

'Like who, exactly?'

'I think there are other intelligence services who've worked out that there's something going on. I'm not entirely sure who or how, but there is "chatter" – that's the word Mammoul used the other day.'

'I had come to the same conclusion myself. There are other people undertaking surveillance – I've been aware of that for some weeks now. It's getting complicated. Thinking about what you said, yes, I am concerned for your safety. Maybe we should think about getting you out of this FJT, just as a precaution.'

'Really?' I said, anxiously.

'Yes, but there's not a lot I can do for you tonight. Maybe I should sleep

here, then tomorrow we can get you to somewhere safer. Pack your rucksack in the morning, and take it to work with you. I will meet you at the restaurant at six thirty and take you to a safe place.'

'Oh, right, well, okay, if you say so.'

'Head to toe?' he said, with a smile.

'Fine by me. I just hope you don't snore.' He patted me on the back, removed his shoes and got under the bedspread. I actually felt glad he was staying in the room with me that night, though it was kind of weird.

The last thing I remember was staring at the instant photographs from Flipper that I'd taped to the wall by the side of the bed. With the bedside lamp off and the only light provided by the streetlights outside, the photos seemed fainter now, as if they had started to fade. When you take a photograph, you think it's captured that moment for ever, just as it is, but so many images change over time. People, fashions, places, aesthetics – everything changes; even the image itself. Things change around an image, and what we see changes as we change. Our thoughts about an image can change. We notice different things or remember things differently to how they might seem to us now. Pictures are not always static – they can often be dynamic, whether the gradual slide towards decay and entropy, or becoming more animated, more highly charged, as time passes. *The Mona Lisa* has done both, I thought.

## LOOSE CONNECTIONS

The next morning I woke to find over twenty thousand likes on my phone.
The messages kept on coming. It was quite overwhelming. People were now
messaging me directly, wanting to ask me questions, or talk with me, or tell
me stuff. There were messages from bloggers, art lovers, art historians, teachers,
people wanting to share their own stories, angry people, people taking the
piss, people accusing me of being a shyster. There were death threats in there,
for heaven's sake! One of the messages read: *You can't see a face in the clouds!!!*
Don't tell me what I can't see, I thought. Another asserted: *You are a terrorist
against pictorial sense!* That was a bit extreme! *Part of me always knew it was there,*
said one woman in Canada. Most people seemed to think it was some kind
of hoax, or joke, or that I was a crazy conspiracy theorist. Maybe I was.
But surely the questions the face in the clouds raised were so interesting
they deserved to be considered and discussed, calmly and rationally. Like
Sebastien had said to me the other day, just dismissing a new idea doesn't
sound like a great approach to it, just as it would be wise to treat such radical
thoughts with caution.

I was soon sitting at my desk in the museum. In front of me, Emilie
seemed kind of fidgety, which was perhaps due to the opening being just two
days away. I opened my emails and found a request to attend a meeting at ten
in Mlle Honfleur's office, so when the allotted time arrived I made my way
through the open-plan office to her room at the back. I had not been in there
before. It was filled floor to ceiling with books and files; there was a desk with
three chairs on one side, and on the other, room for her to steer her wheelchair
into position. She smiled at me before inviting me to take a seat. As I did so
I caught sight of a television monitor with a VHS slot underneath the screen.
It flashed across my mind that I had seen it before, and just an instant later
I realised it was on the Super8 footage of Mammoul and Ammon on the truck.
A VHS monitor in front of a wall of books. It must have been filmed off a VHS
on this screen, in this room, and presumably by Mlle Honfleur. Well that
would explain how it was transferred to this medium, at least, if not why. It
would also explain by whom. If Mlle Honfleur was the partner of Suzette, and
Suzette was working with Alice, that must have been the link that would have
seen the film recorded in here – perhaps using the very camera I now had in
my possession – and then sent over to the UK for Alice to have processed and

to see before coming back to me inside the old Mellotron. Mlle Honfleur saw me staring at the monitor. Suzette must have brought her up to speed with our conversation from last Thursday night, but had she or Suzette already spoken with Antoine to know what I had found out over the weekend?

'Why on Super8 and not just recorded on a mobile phone?' I asked.

'Do you know, at the precise moment I had access to the VHS, my cloud storage was full. It was for the best, though, I think, as there was a much greater chance of it not being intercepted this way,' she said, breezily. 'I had the old cine camera to hand, blank film cartridges, and just a few minutes while the tape was in my possession.'

'Where did the film come from?'

'A colleague.'

'So are you working for the intelligence services?'

'Oh goodness, no. I'm just helping to join some dots. I'm a curator!'

'But why is the museum involved in a drugs investigation? I mean, apart from you working here and your connection with Suzette?'

'Drugs? That's news to me,' she said, looking more than a little confused.

'So what did you think the footage was about?'

'Something to do with an emergency code. Suzette told me that I should send it on to Alice as she needed to see it. I gather that it was then sent back to Paris specifically for you to see.'

'Yes, that's correct.'

'And you say it is related to drugs?'

'Possibly. I'm not sure if the footage is connected to drugs, but there are people working undercover to try to expose the criminals – presumably once they've gathered enough evidence.'

'That all sounds very cinematic,' she said. Again, I'd probably said too much, or assumed she knew more than she actually did. 'And your colleague – can you tell me who that is? How did they come to have the VHS in their possession?'

'That I can't tell you. I'm sorry, Adam.'

'I understand,' I said. 'Thank you so much for the information you've given me, it's a great help.'

At least that finally made sense of why all the peculiar old media formats, and the story of its journey, or most of its journey. I wondered if I would ever find the missing piece of that section of the jigsaw puzzle – who 'borrowed' the VHS from Ammon's flat, and why did they give it to Juliette? But I had to focus on the exhibition – we were in the midst of installing all the works of art with a team of gallery technicians. There were stepladders and tins of paint, filler and spatulas, tape measures and spirit levels all over the place. I was working on the labels and wall text, much of which had been printed as vinyl. It was exciting to see everything coming together, the works being brought out and unwrapped, laid against the wall roughly where Juliette

and Emilie envisaged them being hung. The brochures had arrived and looked great, and there was also a gallery guide, listing the names of the artists, titles of works, media and dimensions, and the schools they represented. I couldn't wait to see my painting of Grandad finally up on the wall.

\*\*\*

After work I made my way straight up to the restaurant with my rucksack to meet Ammon. There was no sign of him. Mammoul saw me standing in the courtyard looking around. He came over to me.

'It seems like you have been finding answers to some of your questions, little brother,' he said, smiling.

'Yes, well, to some of them, at least,' I replied. 'And you – have you made any progress?'

'I have been making some enquiries. Things are more complicated than even I had imagined. And I know that you are now in danger more than ever. Here is a note for you, from Ammon.'

He handed me a piece of paper with an address on it.

'You must go to this apartment, and not return to the FJT,' he said, sternly. 'You must also not come back here again, to my restaurant, at least not until this is all over.'

'I understand. But how can I contact you, if I need to?'

'You've got Heorot now?'

'Yes.'

'In which case, just call me.'

I didn't even have time to ask how he knew about Heorot, but I assumed he also had it.

'I spoke with your grandfather, Adam. It was good to hear his voice after all these years.'

'Did you speak about the postcards?'

'We did. We both received the same code – it was the second part of a red alert and we both knew what it meant.'

'Can you tell me what it means, Mammoul?'

'I can tell you what I know, but not here, and not now. Listen, you must go right away – you will be safe with these people.'

'Okay Mammoul, you take care.'

'You take care too, Adam. Now hurry.'

\*\*\*

I arrived at the address some forty minutes later. I passed the Centre Pompidou on the way from the nearest Métro station, Rambuteau. The Rue Quincampoix was a narrow, densely packed street with cobbled stones. It was

a mixture of fancy boutiques and little galleries, cafés and apartments, and I found myself waiting outside a set of black, wrought-iron gates. A voice came through the intercom, instructing me to go to the third floor, on the right.

I made my way up the staircase, which was of grey stone. As I arrived, a plain modern door opened and I was astonished to see Susan Farnsworth waiting to greet me.

'Hello Adam, come on in,' she said, smiling.

'Mrs Farnsworth!' I said.

'Please, call me Susan. So you didn't know we were going to be your new hosts?'

'Erm, no,' I said. 'But I'm very grateful to you for having me.'

'You might as well take your bag straight through to the spare room,' she said, holding her hand to guide me through the lobby.

'Are you hungry?' she asked.

'I am quite hungry, yes.'

'My husband Shakir will be home from work soon and we'll eat together.'

'Thank you,' I said.

I looked around the sitting room – it was quite sparse but homely enough, a decorative African mask on one wall, a bookshelf with a lot of travel and cookery books, novels and a number of picture books on art and photography.

'I gather there was some problem at the foyer?' she asked, staring at me.

'Er, yes,' I said, thinking on my feet, 'there were some people there who were making me feel uncomfortable.'

'I'm sorry to hear that, Adam. I thought it would be simplest if you just came to stay here with us for the next few nights, until the end of your internship.'

'That's very kind, thank you,' I said, still trying to figure out how this arrangement had been made.

'Come, sit down, would you like a beer? It's aperitif time.' And with that she went into the kitchen before coming back with a couple of small bottles and a bowl of crisps. My brain was working overtime, trying to figure out what she might know, and what she might not. At that moment, her phone started ringing. It was on the coffee table in front of us, and before she could pick it up, I could see the name of the person calling – Natalie. Susan looked up at me, without moving her head; I looked at her, and she knew that I knew it was Natalie from the FJT. She took the call.

'Hi, listen, can I ring you back a bit later, is that okay?'

I could hear Natalie's voice on the other end of the line.

'Thanks so much,' replied Susan, before ending the call.

'Does Natalie report to you?' I asked, almost accusatorily.

'In a way, yes, I suppose she does,' Susan replied, regaining her composure almost instantly.

It suddenly clicked in my mind. Natalie works for Susan and she'd been tasked with monitoring me. She'd been waiting at the top of the elevator for me on the evening I arrived, for heaven's sake! I sat there continuing to make sense of things. Was it also Susan's intention that I meet Amira? Did Susan even know of Amira?

'So, Natalie has been looking after me?'

'In a way, yes. I mentioned you'd be arriving and that she should keep an eye out for you.'

My mind kept on whirring. If Natalie had been assigned to keep tabs on me from the outset, did it mean that someone – Susan perhaps – had had some purpose in mind for me before I had even arrived in France, beyond the exhibition?

'Was it you who arranged for me to stay in the FJT?'

'The British Council of the Arts often places students and interns there to stay for short periods – it's ideal.'

Susan wasn't giving much away, that was clear, and she made everything sound completely reasonable. She knew that I knew that she knew more than she was letting on, but wasn't going to give much ground. When her husband arrived, we ate together. It was a simple meal of tortellini. The conversation was a little slow and there were periods of silence that verged on the awkward. As soon as I felt it appropriate to do so, I took my leave, telling them how tired I felt. As I lay in my new bed, I couldn't stop thinking about everything. Despite the progress I had made, lots of things still didn't add up. I was holding Grandad's tin in my hand, idly twisting it round as I mulled over Natalie's role in all this. My phone had been continuing to go crazy with people responding to my post on *The Mona Lisa*. It really did seem that opinion was splitting into two camps: those who could see the face in the clouds, and those who couldn't. While there were many interesting comments coming in on my feed, the overwhelming dynamic was a simple one: for or against the idea, yes or no, black or white. For me the face in the clouds was very much grey and blurry, quite literally. As I was turning the tin in my hand I dropped it and it rolled under the bed. I put my hand underneath and patted around to try to locate the tin, but having no success, I got out from under the duvet and down on all fours. It was pitch black under there, so I grabbed my phone and switched on the torch. I could see the tin poking out behind a small pile of what looked like books or thin boxes. I pulled the pile out so I could get my arm in to grab the tin, and as I was reaching I could see that on the top of the pile was a framed family photograph – the kind taken in a studio. I couldn't believe it. In front of a younger-looking Susan and Shakir was a teenage boy, and that boy, unmistakably, was Ammon.

\*\*\*

Early the next morning I received a call from Alice. I wasn't even awake when the phone rang, but I answered all the same.

'Don't tell me you were still asleep, Adam,' she laughed. 'It's nearly six thirty!'

'Exactly,' I said, 'it's six thirty!' Alice, of course, was one of those people who only needs four hours of sleep a night. I guess you would have to in her line of business.

'Well, we don't have any time to waste. Late last night I had a call from a contact at MI5 in London – someone we've been doing data analysis for. He's the person that put our work on hold the other day – or at least who told us that our work had been put on hold – citing "sensitive information relating to a terror enquiry".'

'Oh yes, and what did he have to say?'

'He told me in no uncertain terms to stop meddling in Paris. He said that he knew all about the "guerrilla telephone stunt" we staged last week, and that he would have us arrested if we interfered again.'

'So maybe MI5 has this covered, and they're worried you're going to damage their operation.'

'It's possible, Adam, but I've never completely trusted him. Plus the thing that annoyed me most is that he was so very rude. He said that "some bumbling old fool has been trying pathetically to scramble telephone calls here, there and everywhere like it's still the Cold War" and that his team had been inundated by "a bunch of decrepit idiots and some ragtag bunch of half-witted Brummie office workers" – my social club members and my highly qualified staff! Not to mention your grandad. I mean, how dare he?'

'You did know your plan of direct action would wind them up, though, Alice, to be fair.'

'Sure, but there's no need to undermine my team and the work that we do. They've been taking digs at my company any opportunity they get over the past few months – it's been really weird, actually. What I also don't understand is why they won't listen now to the information we're trying to give them. Is it not in their interest to at least find out what we want to share with them?'

'What is it that you want to share with them, Alice?'

'Several things. For a start we've analysed a lot of data from the hauliers that Youssef's company has been using to import the drugs...'

'Ah, so you already knew about the drugs?'

'Yes, of course. So we compared this with data we obtained from the customs paperwork. We've been able to pin down when and how they've been bringing the drugs into port in Marseille. They set their dates, and change their shipping slots, to coincide with the shifts of just one senior customs officer in Marseille. It is the same signatures on every single bill of lading and import certificate.'

'Oh wow, so not only could they catch others responsible further down the line, but that same corrupt customs officer might be involved in other criminal operations.'

'Precisely.'

'This information would be really useful for Ammon. He's trying to follow the gang's chain back to its source.'

'Ah, that's useful to know. We have very little data on Ammon – just his credit card payments, visa history, TV streaming history, stuff like that.'

'That's rather terrifying, Alice.'

'I suppose it must all seem very Kafkaesque from the outside, but really it's just the norm these days.'

'You're using people's own private information to spy on them.'

'We only access data like this when it's for national security. It's an important part of the information that the security services rely on to be able to do their job.'

'So you're working on the terror attack case?'

'Yes, well, we were. The thing is, the data we compiled doesn't sit neatly with the intelligence provided to us, and it was just at the moment when we were putting more of our time and energy into this and starting to make some headway that we were shut down.'

'Do you think there might be corruption involved?'

'Maybe – there's certainly something going on that we haven't yet understood. Plus there are numerous different agencies involved now – Interpol, MI5, SIS, the DGSE and the DGSI to name just a few, which makes things more complicated. Not everybody shares the information they have, or at the time that it would be of most use, so things can easily slip through the net, or get miscommunicated. You often find one agency chasing after information without realising that another agency already has it, for example. Even internally – something that might be apparent to one department could be missed by another.'

'And is the terrorist attack linked to the drugs ring?'

'It's possible, but again, they won't let us pursue our research to be able to help with this line of enquiry.'

'So you knew about Hager and the drugs ring long before I found out this weekend?'

'Yes, we've been following data on Hager Nazari for some weeks at MI5's request.'

'One thing I wanted to ask you, Alice...'

'Sure, fire away.'

'... what did you want me to achieve among all these people?'

'Of course, sorry, I realise I never got to speak to you about that. When I discovered you would be coming to Paris, I thought you might be able to help.'

'But why didn't you just tell me?'

'It was better – safer – that you didn't know anything. I thought you should approach the situation without any expectations or preconceptions. Plus, it was possible we might not have needed to involve you at all, and we certainly weren't expecting you to find out so much so quickly. You were down at the warehouse within just a couple of days of arriving in Paris! We hadn't anticipated that, nor how quickly you'd start piecing things together for yourself. Anyway, it doesn't matter, that's the reason I'm calling you now: to give you a brief.'

'What, now?'

'Yes! We need you to get hold of Nazari's mobile phone.'

'Isn't that something you can do remotely these days?'

'There seems to be some very good digital security on his phone. He's on a network that we can't yet penetrate. It will be much easier if we can get the physical phone. We have his PIN from accessing the security cameras in the warehouse, so it should be like taking candy from a child.'

'Well it sounds dangerous to me. Can't somebody from MI5 or SIS do this?'

'It was originally discussed with them that you would be tasked with this, so Natalie was given the job of introducing you to Amira as a point of entry. Even though my agency has now been frozen out of this by MI5, my feeling is that we really need the information from that phone while we can still get at it, and the window is closing fast.'

'Isn't this something Natalie could have done herself before I even arrived?'

'Natalie's only job is to keep up with Amira. She's not a spook, just an assistant really. The British Council of the Arts sponsors her degree and she does some liaison, hosting and research for them in return.'

'I see, that makes sense now. But what about Ammon? He seems more than capable of doing this for you.'

'It's not yet clear where his allegiances lie, Adam. He's a risk for us. We just need to get access to Nazari's phone for a few minutes. If MI5 is right about him, it may also hold information about the terror attack.'

'Presumably MI5 are following Nazari under their own steam?'

'Yes, undoubtedly, though the French are leading on that now.'

'So they won't be happy if they see me snooping around.'

'We've got to move fast. You'll pick up a package arriving downstairs in the reception of the FJT at eight thirty this morning, containing a phone that looks the same as Nazari's. You will then go to the warehouse at ten thirty, swap out the phones and take Nazari's to the back of the warehouse, through the office fire escape, where Suzette will be waiting in the back of a white van. She will take the phone from you, copy its data over, and give you the phone back.'

'There's just one problem with all this, Alice,' ignoring, for a moment, that I was not currently staying in the FJT.

'Oh really, what's that?'

214

'I think Hager and his gang already want to kill me.'

'Ah, the FrendHub post about the tobacco tin, yes, we did see that. You'll just have to style that one out.'

'What? You still want me to go back there?'

'Well Nazari doesn't know that you know that the threats on FrendHub were from his gang.'

'I suppose not. But why can't Natalie do this now?'

'She's not answerable to me and I currently have no input into the British government's actions there.'

'But why can't you ask Susan Farnsworth? Surely you must have been working together in some capacity to plant me among the group?'

'You'd have thought so, wouldn't you, but actually, I gather that Farnsworth didn't want you to stay at the FJT at all. It was Antonia Black I discussed the idea with, and it was she who instructed Natalie to introduce you to Amira.'

'Interesting. Okay, well I'll do my best, Alice.'

'Thank you, Adam, I knew I could rely on you.'

So that was it – that was what all this had been for: a mobile phone. At least I had an answer. In a weird way it was a relief just to know; the uncertainty had been the cause of much of my anxiety. I showered and threw on some clothes from my rucksack. As I left my room, Susan was just putting out a bowl of hot chocolate and some breakfast biscuits on the dining table for me. I sat down in silence as she was in the middle of a conversation with Shakir. I noticed that there wasn't even a hint of an English accent.

'Your French sounds perfect, Susan,' I ventured when she turned to greet me.

'Ah, well that's because I grew up in France, you see. When I was thirteen I went to boarding school in Devon; I had a wonderful time there. The English think I'm English and the French think I'm French. My name is actually Suzanne, but I've always preferred Susan.'

That explained why Mammoul had thought that Ammon's adoptive mother was French. Susan was smiling at me, but I had the impression it was a little bit forced. It crossed my mind that she might not be terribly pleased that I was staying with her, and that Ammon had effectively dumped me on her doorstep!

\*\*\*

I arrived at the FJT shortly after eight thirty, and made my way over to my post box.

'*Eh, beh voilà! Mr King!*'

I turned round to see Madame de Pompadour glaring at me through her hatch.

'Well, it is quite some trouble you have been making here, you dirty little English stop-out!'

I had no idea what she was talking about, so just looked back at her, confused.

'I'm sorry, Madame, I don't know what you mean.'

'Oh, is that so? Listen to me. Late last night, Jean-Claude was on duty, trimming his toenails or whatever it is he does while he is in my office. Judging from the number of clippings I find, I assume that is what he does. He sees a young man come in who he has never seen before. Having said that, he does not recognise the people who live here, so it makes little difference to him if it is not a resident. He thinks nothing of it and carries on sitting here watching TV. Then this person appears at the hatch, saying, "I cannot find my friend's room, can you let me know which number it is? His name is Adam King." And Jean-Claude, ever security conscious, just tells him the floor and room number. The young man carries on upstairs, and Jean-Claude decides it is a good moment for him to go on his nightly rounds. As he reaches the fifth floor, he notices the same man on the floor below, leaving your room carrying a box. Jean-Claude leans over the bannister and calls out to him: "You found your friend okay, then?" The young man looks up at him and starts running down the stairs. Jean-Claude ran down the first flight and could see that your door had been forced open, so he gave chase. Now Jean-Claude is not a young man, nor a fit man, so the odds were never in his favour. But he does have a very good aim, and, throwing his still-smoking pipe from the second-floor landing, managed to strike the young criminal below on the back of his head. It did not stop him, but it would have hurt. The pipe smashed on the floor, so you owe Jean-Claude a new pipe. He was most upset.'

'Oh my goodness!' I replied. 'I'm so sorry for the trouble. Did he call the police?'

'The only thing Jean-Claude hates more than himself is the police, ever since they charged him for drunk driving thirty years ago.'

'Was he innocent?'

'No.'

'Oh, I see. Well, of course I'll pay for the damage to the door.'

'Yes, you will, Mr King. Jean-Claude will put a new lock on shortly.'

I thanked Madame de Pompadour for her help, got the parcel out of the post box and made my way up to my room. I didn't have much in there, but they'd clearly had a look through everything before taking the projector. It must have still had the film spool in, and it was this that they were after. I should probably have destroyed it or given it to Suzette after I'd finished with it. Who knew whose hands it was in now?

XVIII

## FACES IN THE CLOUDS

By the time I got to the warehouse it was nearly ten thirty. There didn't seem to be many people around, so I just kept my head down and walked in through the front door, across the warehouse floor and into the offices at the back. I noticed that there was a fire exit as Alice had described, and parked just outside was a white van with a blacked-out windscreen, which I guessed must be Suzette. I propped the fire escape ajar with a small fire extinguisher, allowing some air into the stuffy room. I heard voices speaking in French coming towards the office, so I just dropped to the floor behind some boxes of office supplies by the fire exit. They shut the door behind them as they came in. I recognised Youssef's voice immediately.

'Keep your voice down, Asim. The others will be here any minute. I need to speak with you in private.'

'Of course, Youssef, tell me what you need to know.'

'The accounts, Asim, you tell me everything is correct, but is it really true?'

'Everything is correct, Youssef, you can see the summaries for yourself.'

'And the stock? Every time I notice more stock arriving than I have signed off orders for.'

'I checked that – it's all correct, there were just some last-minute changes on the shipping consignments. Hager and his team are really good at cost-saving and logistics.'

I could see the two men through a crack between the boxes. Youssef put his hand on Asim's shoulder.

'How long have we known each other, Asim?'

'Why, since we were boys, you know that.'

'So do you think I can't tell when something is up? Look at you, Asim, you're always tense these days, anxious, sweating, pasty.'

'I'm just a bit tired, Youssef, we've put in a lot of hours recently with all the new business.'

'Amira was speaking with Lateefah the other day – she says you are exhausted and not sleeping at night. I want you to know that you can tell me anything, brother. You can confide in me. I am your best friend. Whatever happens, I'm always there for you, and if there is something troubling you, you must tell me, so I can help you. You need to stay strong for your family – for your wife, and for your beautiful children.'

Asim looked into his friend's eyes and burst into tears.

'I'm so sorry, Youssef, they made me do it.'

'You've been covering up for them importing drugs through our company – is that it?'

'How did you know?'

'It doesn't matter. What matters is how we get out of this situation.'

'But I can't, Youssef. They said that either I could keep my mouth shut, make good money and help them in their work, or they will kill my children first, then my wife, then me.'

'I think you're overdue a holiday, Asim – you've been working so hard of late. It's still the school holidays, so I have asked Amira to book a holiday for you and your family – you will leave the warehouse this very minute, go home and pack. You will take a month off to rest and relax, and when you return, this will all be over, okay?'

'That's so kind, but I can't leave you alone to face them. They will kill you.'

'A man who has Allah in his life is never alone, Asim. Go now, before they get here – they will be coming in for the new delivery soon, and to organise the warehouse workers as they begin arriving for the afternoon shift.'

'What will you tell them?'

'Why, that you're on annual leave, of course. I will tell them that I am covering your work for a week or two.'

'You are a good friend, and a good man, Youssef. Thank you.'

'Why are you still here? Go, now!'

And with that Asim picked up his briefcase, hugged Youssef and left. I saw Youssef sit down at his desk and hold his head in his hands. He took a deep breath and exhaled slowly.

'So, almighty Allah, it's just you and me now. Please show me the way.'

I wondered whether to let Youssef know that I was there but decided it would be best if I could get out of there unseen rather than having to explain everything, so I just stayed put. All I could hear was the sound of Youssef typing away at his keyboard for what felt like an eternity. Then I heard lorries arriving and a number of cars. I could hear echoing voices in the warehouse as staff started showing up to unload the pallets from the lorries. After a short while I heard Hager's voice at the door to the office. It now sent a chill up my spine. He and Youssef spoke in Arabic for a while, and I could hear that they were talking about Asim. Hager became more aggressive in tone, which was presumably his frustration that Youssef had let Asim take a holiday. With Youssef taking on Asim's work, Hager would now have to think quickly about how to prevent Youssef 'discovering' what Asim had been keeping hidden. Would Hager threaten Youssef too, or try to continue with the deception?

I heard footsteps coming towards where I was kneeling and through the crack between the boxes I saw Hager put his phone down on the table right in

front of me. Youssef then said, 'We should go and oversee the unloading of the new delivery, and do the stock check together.'

Hager agreed and I heard them walking out of the office and onto the warehouse floor. I knew that this might be my best, if not only, chance to get my hands on the phone, so I stood up, swapped his phone with the one I had been given, and swiftly made my way out of the fire exit. The side door of the van slid open and inside was Suzette and a young Muslim woman wearing a traditional plain black burqa, the kind that covers not just the face but the whole body.

'Get in!' she said.

I handed over the phone and Suzette plugged it straight into a laptop.

'This might take a few minutes,' she said, typing in Hager's pin.

It was warm inside the van, which had a small rack of electrical equipment along the opposite wall. There was no natural light in the back, only LEDs, and everything was illuminated by a stark, clinical blue glow. I sat in silence as Suzette concentrated on extracting the data from the phone. There were prompts in Arabic on the laptop screen and this was clearly what the young woman was there to help with. I looked more closely at her eyes and I did a double take. No, surely it couldn't be...

'Amira?' I said. She lifted her head to look at me and I could see her eyes smiling as she replied, 'Yes, now shush!' and she looked back at the screen. She had no make-up on, which was a first for her. Time seemed to proceed agonisingly slowly as I waited for them to get what they needed. Very few words were exchanged, but Suzette clearly knew what she was doing, and Amira was on the ball, responding swiftly when asked. I was getting anxious as I had no idea when Hager would return to the office and how long I had before he noticed the phone on the table wasn't his.

'Are you almost done?' I asked.

'We need another minute, just hold on.'

I could see my hand shaking in front of me. What was I doing here, in this position? All I'd wanted to do in Paris was visit a museum or two, try the famous *jambon-beurre* baguette and improve my French a little, and here I was in the back of a van on an industrial estate fearing for my life. I could feel my heart racing and hear my own breathing. Suzette disconnected the phone and handed it back to me.

'Put the phone back, then come and get in the van so we can all get out of here,' she said.

Amira opened the door to let me out, and I took the few steps back to the fire escape. I had a quick look to make sure the coast was clear and seeing nobody in the office, made my way back in. I was a couple of metres away from the desk, and could now see the backs of Youssef and Hager just on the warehouse floor. I could see the dummy phone on the desktop so walked as calmly and quietly as I could towards it. I was within spitting distance when

Hager's phone started to ring in my hand. Hager turned round to face the office door, and saw me just standing there with his phone in my hand. He immediately walked into the office, with Youssef just behind him, shouting at me in a mixture of Arabic and French.

'Get your hands off my phone!' he yelled.

'I'm so sorry,' I said. 'I must have picked up the wrong one.'

I held his phone out to him as by now he was standing right in front of me. He took it with his left hand as he lashed out at my face with the back of his right hand. It really hurt, but I was stunned more than anything. I don't think I'd ever been hit before. I could feel a trickle of blood run down from my nose and over my lips into my mouth.

'It was just a mistake,' I said, as he landed a second blow on my cheek. His ring must have caught my lip, as that then also started bleeding. I was, however, much to my surprise, still standing. Youssef called out, 'Hager, come now, brother, it was a simple mistake – you can see his phone looks very similar to yours.'

Hager looked down and could see that Youssef was right.

'Why is he back here anyway?' Hager asked, calming a little and turning to Youssef.

'I just came to collect a delivery of shisha tobacco for The Crescent Moon restaurant,' I said, seeing Youssef's blank expression and realising I needed to take the initiative here.

'I think we have that ready for you,' said Youssef, taking my lead. 'It was three boxes of regular, two strawberry and one apple, right?'

'Yes, that sounds correct,' I said, wiping my face with my sleeve.

Hager looked at me, then at Youssef. He was clearly suspicious.

'Let me go and find that for you,' said Youssef, leaving the office. 'I won't be a minute.'

While it was just the two of us in the room, Hager took the opportunity to come right up to me, point his finger in my face, right between my eyes, and murmur in my ear, 'If you ever touch my phone again, I will kill you, understood?' I nodded, and I believed him.

Youssef soon returned pushing a small trolley from the warehouse floor with the six boxes of Wajah fi Alghuyum.

'Is that your van outside?' he asked.

'Yes, that's right,' I answered.

Hager watched us both as we made our way to the fire exit. He followed us out and waited for me to open the side door to the van. I looked into the window of the passenger's seat and could see Amira sitting there, and Suzette on the far side in the driver's seat. Amira looked understandably surprised as she saw my bleeding face peering in. 'I'll just load the boxes into the back,' I said. Hager was now standing behind me, looking in at Amira. She saw him and lowered her eyes. He smiled. I didn't know what that

meant. Maybe he was glad to see a Muslim woman in a full burqa, or perhaps he was happy that she wasn't driving. Who could say? He then turned round to watch me open the side of the van. I pulled the handle and slid the door across. The wall of electrical equipment was covered with a black curtain. All you could see was a rug on the floor of the van. Youssef and I lifted the boxes of tobacco into the van and when we had finished I turned towards him and Hager.

'Apologies again for the mix-up with the phones,' I said, 'and thank you for the tobacco, Youssef.'

Hager lifted his head in a single passive-aggressive nod. I jumped into the back of the van and was relieved to hear Suzette start the engine and feel the van pull away. Through the blacked-out back windows I could see Hager standing there with his phone to his ear. We came to a stop at what I imagined must be the front gate, where there was sometimes a barrier in use when consignments were arriving or leaving. As the lorries had just arrived, I assumed the barrier must now be in use. A small security box was manned to check vehicles coming in and out. We were held for longer than I would have expected, and I leaned forward to hear Suzette speaking with the security guard. I could hear him saying that he needed to see either an invoice or receipt for collection of the tobacco, which of course she didn't have. She suggested he radio through to Youssef, who would confirm everything was in order, which he duly did. It was, however, the voice of Hager that came through on the radio intercom, speaking in Arabic.

'Please,' said the security guard, 'drive back to the front of the warehouse and you can pick up the receipt.'

I heard Suzette protest that Hager would also be able to confirm that the order and collection were approved, but he insisted, so she backed the van up and drove to the front of the warehouse. Everything went very quiet, and then I could hear the driver's door and the passenger's door opening. The side door was opened from outside, and I was greeted by two men holding semi-automatic rifles in their hands. One of them ushered me out with the front of his gun. I was a few steps behind Suzette and Amira, who both had their hands on their heads, so I did the same. The men led us inside the warehouse and I could see them looking around to see if anybody nearby had seen them.

As we reached the offices at the back, Hager was standing there waiting for us.

'Put them in the secure store room,' he said, pointing to a room next to the office we had just been standing in. 'Put him in there as well,' he added, pointing into the office at Youssef.

'But I don't understand, Hager,' said Youssef. 'What's wrong?'

'I know you took the delivery to The Crescent Moon last night, Youssef. It's right there on the wall, on your delivery schedule. You always drop it off

yourself and you stay for dinner with your friends, or with your sister. Doesn't he, Amira?' he asked, staring at her. 'I'm surprised you didn't greet your own brother outside just now.'

'What?' said Youssef, confused and shocked.

'Oh, you didn't realise she was here?'

Youssef came further out of the office and looked at Amira. He could see straight away it was her.

'You don't usually wear a full burqa, Amira.'

Amira's eyes couldn't disguise her exasperation.

'I do sometimes, brother,' she answered, 'you know that.'

'Well it's a good thing you will have a little time together to discuss how you came to confuse your collections and deliveries,' said Hager, directing us into the store room. And that is how Youssef, Amira, Suzette and I came to find ourselves locked inside a small store room. We had to hand over our mobile phones, though at least I was quick enough to give them the dummy rather than my real phone. The bad news was that the walls were so thick to this secure room – concrete breeze blocks within the warehouse – that I had no signal whatsoever.

'What do you think they'll do now?' I asked.

'Who knows,' said Youssef.

'They know that you know,' said Amira. 'About the drugs, I mean.'

'Yes, I suppose Hager must have come to that conclusion. I think he must have expected I knew. I mean, you can't keep something like that secret for long, under my own nose.'

'And now he will kill us,' said Amira.

'Surely he wouldn't do that? These men are drugs traffickers – why would they want to get mixed up in murders, dealing with dead bodies and so on?' he said, trembling. I sat contemplating how drugs trafficking and murder probably go hand-in-hand quite often, but decided not to say anything.

'We are a huge danger for them now, Youssef,' said Suzette. 'I think there's a very real chance they will shoot us before they leave.'

'How do you mean, leave?'

'Well they're not going to stay around for long now. They know their cover has been blown. I expect they'll take what they want and be out of here before you can blink.'

'Shush a moment,' said Amira, with her ear pressed against the door. 'I can just about hear Hager talking to his men.' We all sat in silence. It went on for some time.

'Well, Suzette, I don't think you were far off. I couldn't hear everything, only when he was shouting instructions to them. I think they're clearing out the stock, at least some of it. Oh yes, and the safe, they've emptied that.' Youssef's eyes rolled backwards and his eyelids flickered.

We could hear some noise from the warehouse floor, plus the rumble of

lorries coming and going. It went on for hours. We were getting very hot and thirsty in the little room. There was just a small air vent at the top, which did not supply us with enough fresh air.

'Will Alice know what's been going on?' I asked Suzette.

'Maybe; she or one of the team will probably have been watching on the security cameras here in the warehouse. I just hope they didn't stop monitoring when they saw us leaving in the van. It could take some time before they realise something is wrong if so.'

Sure enough, nothing changed in our predicament as we sat on the floor for what must have been several hours, dozing and chatting intermittently. Then, suddenly, the door was unbolted. Nobody moved a muscle. Hager was standing there with two of his men, both of whom were holding small machine guns.

'Look in here, brother,' said Hager, tilting his head first behind him then towards us. A familiar voice replied.

'Well, well, well, who have we got here?'

It was Ammon. I don't know if I was more relieved to see him or that the door was open and letting in some oxygen. He looked a little surprised to see the four of us in there, and shook his head several times.

'Ammon,' said Youssef. 'Let us out of here – I don't understand why we are being held here. We have done nothing wrong.'

'Quiet, brother, your part in this story is now over.'

'You do realise that the secret services have been keeping these premises under surveillance for weeks?' I said, looking at both Ammon and Hager.

'Is that so, little man?' said Ammon. 'In which case it seems that they are very slow off the mark to come and help you, does it not?'

'What are you going to do with us?' asked Amira.

'Yes, what is the plan, Hager?' added Ammon.

'We will soon finish clearing out what we want from the warehouse. I am just in the process of moving the funds out of the company's bank account and transferring them to one of my own.' He had a big smile on his face as he said this. 'You will stay here with two of my men for security, Ammon, then later tonight, when we have finished, my men will start a fire, so that there is nothing left of this warehouse. This will give us time to get far away from here. You and these men will take the van that these nuisances brought here. They will drop you off and you are then free to leave my service. They will give you your final payment.'

'Thank you, brother, just call me if you need me again,' replied Ammon.

I presumed Ammon was acting, playing the role, but something in my head was asking me if he had been deceiving me all this time. I was the one being held captive, and he was outside taking another payment from the gang-master. Maybe his allegiances were only to himself after all.

'But why do you have to set fire to my business?' asked Youssef,

exasperated. 'Why can't you just take what you want and go?'

'Oh, Youssef, you are such an innocent fool. I can't do that, I'm afraid, there must be no trace of us ever having been here. We must be like ghosts – mere figments of your imagination. Here in France, nobody can be sure that we even exist. The paperwork is being shredded, the computers wiped and initialised. My men will then dismantle the server and the security system entirely.'

While he was talking, I put my mobile phone behind Suzette's back and prepared a short text for Alice: *security cameras warehouse*.

'Can I go to the toilet? Please, I'm desperate.' I asked. Hager told one of the security guards to escort me there and back.

'Don't take your eyes off him for one second,' said Ammon.

Standing at the urinal I hoped I'd got some signal and pressed what I thought was the send button on the message from inside my pocket. I washed my hands, drank some water from the tap, washed the dried blood from my face and was escorted back. I could see the warehouse was looking a lot emptier now. I could also see that boxes and packaging were being deliberately left in a higgledy-piggledy continuous line, which I realised was so that the fire they were planning would spread throughout the building rapidly.

'Anybody else?' asked Hager. Amira and Suzette both took the offer up, before we were all locked up in the store room once again.

'Do you have a lipstick with you, by any chance, Amira?'

'Yes, always,' she replied, and pulled one out of a small handbag she had by her hip. I had already spotted a box of printer paper in the store room, which I went and opened up. With the lipstick, I wrote: *R U THERE?* and held the piece of paper up in front above my head to face the security camera in the corner of the room. After just a short moment, the camera moved up slightly, and then down, up slightly, then down again. It was a nod. My text message to Alice had worked. I turned the sheet over and wrote on the other side: *Tell Antoine to bring 11As.* The camera nodded one more time. I gave Alice the thumbs up and made the thank you sign with my hands.

We sat there for another couple of hours – it was now past seven o'clock and we were getting hungry. Youssef banged on the door. There was no response, so he just kept on banging. Eventually Ammon came to the door, with the two security guys standing right behind him.

'What do you want?' asked Ammon, gruffly. He looked at me momentarily, and I swear he gave me a small smile, his eyes twinkling.

'Can we please have some water, and some food? We've been in here for almost seven hours now.'

'Nobody move,' he replied, and passed through the gang members to return shortly after with a packet of petites madeleines and some bottles of water.

'Thank you,' said Youssef. 'At least you have some humanity in you.'

The door locked on us yet again. While it had been open I could see that lots of shredding had been piled up on the warehouse floor, and the computer

server was now smashed into a thousand pieces. I looked up at the camera and could see that the red light on the side had gone out. They must have cut the security system off by now. We sat in silence for another half an hour, and then, without warning, the lights went off. We could smell smoke coming underneath the door. It was the scent of tobacco, the clouds of smoke snaking their way through the air around us. At least it's only tobacco, I thought – the guards must be having a smoke. The clouds continued to get thicker, however, and everybody began to cough.

'Of course,' I said, 'they were lighting the tobacco to start the fire burning throughout the warehouse. The building is on fire!'

Youssef began banging on the door, screaming Ammon's name.

Ammon opened the door, the guards right behind him.

'Why can't you just let us go? Do you really want blood on your hands, brother?'

Ammon looked round at the two guards, who did not flinch. There was to be no negotiating with them. At that moment, however, we could all hear the sound of vehicles arriving out the front of the warehouse. Ammon and the men turned their heads to see what was going on. There was a mixture of fire, smoke, daylight and headlights beaming in through the tall front doors, which were still open.

'Shit!' said Ammon. 'It must be the security services. We need to get out of here.'

The guards and Ammon took a step back and we leapt up to the door of the store room to look out. There at the front doors to the warehouse were six cars – three white limousines and three posh black cars. Through the smoke, I could make out faces in the clouds. A good number of the Eleven Associates were there, all dressed in suits, wearing shades. Armand was carrying a film camera. Maya and Henry seemed to be aiming guns inside the warehouse. I couldn't believe it! They were all just standing there next to the car doors. Stephanie was holding a phone up to her face as if it was a walkie-talkie. Hakim was holding a megaphone and shouting something at them in Arabic. The gang members didn't fancy their chances, and turned to us, covering their faces with scarves and waving their guns to tell us to get back in the store room. They then pushed Ammon in with us.

'Hey, what are you doing?' shouted Ammon as they locked the door. We could hear the padlock being attached. They really were going to let us burn in here.

The smoke was getting pretty thick by now and we were starting to choke.

'Get down on the floor,' said Ammon. 'You will get most air there.'

We could hear the sound of someone trying to smash the door down with something heavy. The flames must have been pretty unbearable out there by now. It sounded like whoever had been trying to break the padlock or bust the door had had to give up and get out. That was the last I could remember.

## DIFFERENT WAVELENGTHS

I woke up with no idea where I was. It was only a matter of moments before I could piece things together, however. I had some breathing apparatus on, was lying flat on my back staring up at white ceiling panels, and, from the corner of my eye, could make out the bedside apparatus and thin turquoise curtains surrounding the bed that you'd associate with a hospital. I was on a ward; there was a lot of noise surrounding me. I just lay there for a while. I didn't know whether I was allowed to move, or to get up. Some time passed before a nurse came and drew back the curtain. He could see me looking at him, and he came closer to the bed to help me take the breathing mask off.

'There you go, Mr King. Just put it back on if you're feeling short of breath.'

'What happened?' I asked.

'You were rescued from a warehouse fire and have been recovering from smoke inhalation. Apart from that you're not in bad shape – a few cuts and bruises, that's all,' he said, smiling.

'And my friends, where are my friends?'

'They are all safe and sound – the Muslim girl was worst affected by the smoke, so she's going to be kept in for a while longer, but once the doctor's been round to see you, you should all be good to go home. I'll fetch your breakfast for you in the meantime.'

'Are the others on this ward?' I asked.

'The men are on this ward – well, one of them left much earlier this morning, but the other one's still here. The woman with the auburn hair is over on the women's ward on the other side of the corridor, along with the Muslim girl. Don't worry, they're not far away.'

I manoeuvred myself out of the bed to discover I was wearing a weird sort of plasticky-paper gown that was tied up in a bow at the back of my neck. I opened a packet of slippers that was on the floor, put them on and made my way out onto the ward. I looked on either side to see if I could spot Youssef (it had to have been Ammon who had already left). A couple of the beds had curtains drawn, so I gently called out Youssef's name behind each one. On the third attempt I received a 'yes' in response, so pulled back the curtain to find Youssef sitting up in bed with a tray of breakfast on his lap.

'Adam!' he said, beaming. 'It is so good to see your face at the foot of my bed.'

'And you too, Youssef, how are you feeling?'

'Much better now that I know my sister and everyone else is okay. Who was that woman she was with, by the way?'

'Suzette? She's a friend of mine. She's been helping to obtain information about the gangsters you managed to get mixed up with.'

'Like police?'

'Sort of, yes; well, helping the police anyway. Did you see Ammon before he left?'

'No, he'd long gone by the time I was awake. I'm glad I didn't see him. I mean, what would I say to him after his treachery?'

'Don't be too hasty in judging him, Youssef – he might not be all that he seems and may still have a role to play.'

'What do you mean? It's all over, isn't it? I mean, my business is ruined and the criminals have left without a trace.'

'Yes, but we know what they all look like, so we might be able to help the police catch them. Plus...' As I was standing there thinking about it, I wondered whether the gang had always planned to clear out of the warehouse last night regardless of us. If they were involved in the attack on the royal family, it would make sense that they were taking their money and leaving. And of course, today was the day of the private view. How could I have forgotten? I guess there had been a lot going on. I needed to get to the museum. It was mid-morning and they would be getting ready for the royal visit that very evening.

'Plus what?' asked Youssef, waiting for me to finish my sentence.

'Oh, I was just thinking aloud. Listen, I'm going to get dressed and get out of here,' I said.

'Are you sure you're feeling well enough already, Adam?' asked Youssef.

'Oh yes, I'm fine. Really.'

When I went back to my bed, I found a tray of breakfast waiting there for me. I was starving so I was tempted to sit down and eat it, but first I wanted to find my clothes and my phone. I found both in a small cupboard behind the bed. As I put my rather smoky clothes back on, I could see that my phone's battery was dead. I didn't have a charger. Maybe they might have one at reception, I thought, and I can eat while it's charging up. I walked down the centre of the ward towards the double doors where there was a small reception desk.

'Excuse me, do you have a cable so that I can charge my phone, please?' I asked the woman sitting there.

'Let me see if we have the right one – we have a few behind here,' she said, leaning to one side to look under her counter. 'Pass me your phone a moment... there we go, yes, that one's working.'

'Oh, thank you so much,' I said. 'Please do thank the nurse for my breakfast too,' I added.

'I've only just started my shift,' she said. 'Which one was it?'

'It was a guy in his mid-thirties, about one metre seventy-five, dark hair.'

'There aren't any male nurses on shift at present,' she said. 'Let me see who was on this morning's shift.'

She looked at a white board behind her with a list of names on.

'Well isn't that funny,' she said, turning back to me. 'There weren't any male nurses on shift in this ward this morning, either.'

'But he was bringing breakfasts around to people,' I said.

'Well it certainly wasn't a man this morning,' she said, quite adamantly.

I turned and ran back down the ward to Youssef's bed.

'Don't eat that breakfast!'

Youssef looked up from his bowl of cereal at me.

'Why ever not, Adam?'

'Just don't touch anything.'

'But I've nearly finished it now...'

'Oh god,' I said. By now the matron from reception had almost caught up with me.

'Whatever's the matter?' she said, frowning at us both.

'Did a male nurse deliver this breakfast to you, Youssef?'

'Yes, yes he did. Pleasant chap. Why? What's going on?'

'Matron, I'm worried the food might have been poisoned.'

'Whatever makes you say that, young man?' she asked, now clearly rather annoyed.

'My friends and I have been threatened by some dangerous people. Is there a way to get this food checked?' She looked blankly at me. I realised I wasn't going to make much progress on this tack. 'Listen, if my friend here, or either of our friends in the women's ward, shows any signs of getting sick, please make sure they get straight to the poisons ward. Please, it's very serious.'

'Well, alright, I'll keep an eye on them, but please keep your voice down, you're causing a scene and making everyone on the ward worried.'

'I'm sorry,' I said. Perhaps I was getting paranoid now. 'I have to get going, Youssef. If you feel at all ill, tell the matron immediately, do you promise me?'

'Sure, but I feel fine. It did all taste a bit odd, but then all I can smell and taste is that acrid smoke from the warehouse still. It really stays up your nose.'

I stopped off at the reception desk on my way out to collect my phone, which had charged just enough for me to use it and get back to Susan's flat where I could get showered and changed into some fresh clothes. As I switched it on, I could see messages starting to come through – a voicemail from Alice, a text from Chris and Eddie asking me to call them, and a missed call from Emilie presumably wondering where I was, not to mention another two thousand notifications from complete strangers about the face in the clouds. I wished I'd never posted the damned picture.

As I made my way through the doors I found myself facing Antoine, who was sitting right in front.

'Antoine,' I said, 'you're here! Thank you. How long have you been waiting?'

'All night,' he said, smiling. 'I came in the ambulance with you.'

'You must be exhausted,' I said.

'It's okay, I've been dozing on and off.'

'You guys were incredible last night! Thank you so much – you saved our lives.'

'It was fun, you know, as well as terrifying.'

'You were all so brave. They could easily have showered you with bullets – you were all completely exposed and vulnerable.'

'It's lucky we missed the part in Alice's message where she warned us of the possibility of them being armed!'

'Presumably you called the fire brigade?'

'They were already on their way, along with the police and the ambulances. We could hear their sirens coming along the road. There were all sorts of people there pretty quickly, actually. It was hard to tell who was who – some must have been press. Armand tried to smash the lock on the storeroom before they arrived, but the heat from the flames was too much for him, so he had to just get out.'

'Did some of you have guns?'

'Goodness no – they were microphone stands!'

'Brilliant! You couldn't tell the difference from a distance, and with all that smoke. I need to go and get changed before the private view later this afternoon. Do you think the gang are going to try to assassinate the royal couple, Antoine?'

'I have no idea, Adam. I'm the wrong person to ask. Why don't you speak with your friend Alice – she'll know if anyone does. You carry on, I'll stay here until Suzette and Youssef are discharged and we have more news on Amira.'

Before I'd had time to give Antoine a hug, the double doors swung open and a bed was wheeled out at break-neck speed. We could see instantly that it was Youssef; he was having convulsions on the bed, vomiting.

'Get Suzette and Amira down into the emergency department too,' I said. 'I need to speak to Alice, and with Ammon.'

'Go!' said Antoine. 'I'll deal with the situation here. I'll call you.'

\*\*\*

I came out of the hospital and didn't have my bearings in the slightest. I followed the signs to the nearest Métro station, Gambetta. I had no idea where that was but discovered from the map that it was just a few stops east of Réaumur-Sébastopol, and I knew I could walk from there to Susan's place. I put my ear-phones in and called Chris and Eddie back.

'Adam! You're alive! We've been trying to call you for hours. Man, you'll never guess what happened here last night.'

'Tell me,' I said. 'I think the last I heard from you guys is that you were going to go to the balti restaurant next to Alice's offices at a specific time yesterday evening.'

'Exactly. We turned up at the balti house at ten to six. We're standing around like a pair of idiots in front of the bar area when this guy comes out of the kitchen with a bag of take-away tubs. There's a woman behind the bar and she says: "For Stirchley baths." The guy carrying the bag nods and puts his helmet on. The time is precisely five to six, the time that Alice had said. Anyway, Eddie says to me, "Aren't the swimming baths derelict?" I said to him, "You're right." So we jumped on our skateboards and followed him on his moped along the Pershore Road. He goes round the back of the building, where there's a hole in the wooden fencing. A hand comes through the fence and takes the bag from the delivery guy, and then the other hand comes through with a tip! We're standing on the opposite side of the road, and as soon as the delivery driver has gone, we jump over the fencing into the back of the old baths. We're just in time to see a metal panel being repositioned over a fire escape, so we go and knock on the metal panel with our fists. I call out: "Hello! Is anybody in there?" There's a moment's pause, then an eye appears through a hole in the door. I can see it through the mesh. "Ah, it's you two. Listen, keep the noise down will you, there's a good pair of fellows." It was your grandad, Adam, hiding in the old Stirchley baths!'

'Well I'm glad to hear you found him, and that he was okay. Was he looking alright?'

'He looked a bit tired, but otherwise fine. Said he'd been camping out for a few days as he was being followed. I asked who by, and he said he wasn't sure. He took us inside and into the old staff changing room, where he'd got himself a makeshift bed, a flushing toilet and a working shower. We sat on a bench opposite while he ate his balti. I asked if it wasn't a bit extreme to have broken in to this dilapidated old building – I mean, there could have been crackheads or anything in there. He said that the information he has is too sensitive to risk getting into the wrong hands, and no sooner had he tried raising the alarm to let the intelligence agencies know, than he found himself being followed and photographed. "I used to swim in this pool when I was a lad," he said. "I hope they get round to doing it up again one day soon – same for the baths in Moseley." The moment he said this a smoke grenade comes through a broken window on the other side of the changing room. We all looked at it spinning on the floor, billowing out smoke into the room. Your grandad immediately moves over to the window, lifts up his walking stick, waits three seconds then pokes it through the window with quite some force. We heard somebody curse just outside. "Got him!" he says, smiling. "Now follow me," he says, and, limping a little, he leads us out through the smoke

around the side of the empty pool, past the curved reception area and into a side room. In there, he bends down, lifts up a round metal drain cover and tells us to get in. We do exactly as he says: Eddie climbs down first, then me, and he follows, pulling the drain cover back into place after us. Our feet soon reach a solid floor. We hadn't been expecting that. It was completely dry. "It doesn't smell bad for a drain," says Eddie. "This isn't a drain," I said. Your grandad pulls out a torch from his pocket, shines it in our faces and says, "You're right, Chris, it's an old well, originally for keeping the pool topped up. Now keep very still and very quiet." He switches the torch off. We wait for a couple of minutes, then hear two pairs of feet walk over the drain cover. They stop for a moment and we hear a muffled voice say, "They must have got out the back," then we hear them walk back in the direction they'd come from. We waited quite a while longer, maybe half an hour or more, before climbing back up the side of the well. "This is doing nothing for my poor old knees," your grandad says, "nor for my blood pressure.'"

∗∗∗

Chris went on to describe in great detail how the evening panned out. Having evaded whoever had tried to smoke them out of the old public baths, they then made their way outside and jumped into a private hire car – appropriately enough a company called Royal Ambassador – which took them at Grandad's bidding back up the road to the Stirchley Social Club. As they went through the front doors they could see that the club was full to bursting – every table and chair was packed with members of all the different societies. Tuesday was bingo night, so the club was usually pretty busy then, only nobody was playing bingo. The first thing Chris and Eddie noticed was the silence. Strangely, everybody in there was sitting quietly with their drinks wearing headphones and holding small personal radios. Some were the latest digital radios, others were personal stereos from the nineties, cassette-radios from the eighties, transistor radios from the seventies and even a children's build-it-yourself crystal radio from the sixties. There were notepads and biros on the tables, alongside bowls of pork scratchings.

'What are they all doing?' asked Eddie, bewildered.

'They're listening to the radio, my boy,' said Grandad.

'But why?'

'They're trying to help Adam and his friends in Paris. Oh yes, and to save the young royal couple from assassination.'

'How can listening to the radio help?'

'Why don't you let these two ladies explain,' said Grandad, spotting Margot and Cecily making their way towards them across the room.

'Good evening Christopher, good evening Edwin,' said the elderly twins in unison.

'Good evening Margot, good evening Cecily,' replied Chris and Eddie, smiling and trying likewise to say it in synch.

'So, you two young men want to know why we've got everybody here listening to the radio. Well, that's because earlier this week Alice and her team intercepted some intelligence from Paris relating to certain amateur radio frequencies being used by suspected terrorists. While the French are using computer systems to monitor this range of frequencies and to track these men, Alice decided it would be best just to listen in for ourselves. Anybody who picks up a new signal – any communication at all – notes the frequency and passes it on to our crack team upstairs, headed up, of course, by our supreme leader Edward.' The sisters looked at each other and giggled. 'Come and see.' And with that they led Grandad, Chris and Eddie upstairs, where they discovered Edward and Timothy sitting in front of some more serious-looking radio equipment connected to recording gear. When they turned round to see who was visiting them, Chris and Eddie could see that they were both wearing T-shirts with the words 'decrepit idiot' printed on them.

'Ha!' said Grandad, 'I must get one of those with "bumbling old fool" on!'

'Ah, our favourite hamateur!' said Edward. 'And looking like he's been dragged through a bush backwards.'

'So,' continued Margot, 'anything that is passed on to these two gentlemen is then tuned into on these radios, and the reel-to-reel tape recorders capture audio or data being received.'

'Anything they record is then noted on a list with a brief description of what kind of communication it is, for Alice to review,' added Cecily, 'and anything that is in a foreign language is also passed on to Alice's team down in the basement for translation before being added to the summary list. Why don't you go down to say hello to them?'

Chris and Eddie headed on down to the basement, where, in front of the illuminated Compton Organ, Alice and her employees from the agency were sitting in front of laptops. Alice was monitoring some surveillance footage of a road with some vehicles coming in and out, and, just as the boys arrived, she received a call on her mobile.

'Hi Antoine, great to hear from you. So they got out alive? Amazing! Well done you guys – I can't believe how convincing a performance you gave. Brilliant! Keep me posted on their progress. Oh you are? Awesome, thank you, well please give me an update from the hospital when you can.'

It sounded like the brothers had been standing beside Alice in Stirchley while we were being rescued from the warehouse in Paris the previous night.

Chris and Eddie stayed at the social club until late into the night, helping to man the radio frequencies. Many of the members had to go home, but others arrived to do a night shift. Alice filled them in on everything that had been going on in Paris, and they told Alice what had happened to Grandad down at the baths.

'Has anybody heard anything of any significance from listening in to all this radio stuff?' Chris asked Alice.

'Why don't you have a look at some of the highlights from today?' she asked, passing him a list that contained summaries of the different interactions they had overheard. There were lots of code letters being exchanged between people who seemed just to want to talk about the quality of the reception and their locations. Quite a few people were doing quizzes and playing games remotely with each other. Some people were chatting about amateur radio apps for their mobile phones, which completely confused the brothers, others were passing on information about hurricanes, and others still were talking about who they had spoken to earlier that day.

'I don't understand why people want to use this instead of just using their phones,' said Eddie to Margot, who was waiting for a taxi to take her and Cecily home.

'This technology *was* the mobile phone, it *was* the Internet, long before those words had come into existence. Early text messaging, long-distance calls, image messaging and even moving image transmissions were done this way several decades ago.'

'But why are they still doing it now, when our phones and apps can do all of that?'

'Ah,' said Cecily, 'because when the satellites go down, when the pylons are destroyed, when the telephone networks are hacked and brought to a standstill, when the Internet just stops and when natural disasters strike, when the nuclear apocalypse comes, you will always find an amateur radio enthusiast still broadcasting. Radio waves are the cockroach of communication in the digital era. And, of course, because these people are the kind who enjoy it! Nice to see you both – good luck and take care!' And with that they were gone.

Grandad was by now fast asleep on a chair at the back of the room. Chris covered him with a blanket that the bar staff had brought down for him.

✳✳✳

Chris finished his account of the previous night and I thanked him for all his help. When I ended the call, he and Eddie were still at the social club listening in to the radio, bless them. I picked up Alice's voicemail, which simply said: 'Adam, have you read the papers in Paris this morning? Try to keep cool today, whatever happens. Speak in a bit.' I pulled up the news feed on my phone and scrolled through. There was a news item about the warehouse fire from last night. I read it in utter disbelief.

Yesterday evening a fire broke out in a warehouse on the Second Empire Industrial Estate in the Rosny-sous-Bois area north-east of Paris. Firefighters on the scene describe arriving to find the warehouse

completely ablaze. Investigations are continuing into the cause of the fire, though a source close to the investigation who wished to remain unnamed has commented that the fire was 'almost certainly started deliberately'. The owner of the factory, who was rescued from the blaze, has been arrested on suspicion of arson and is currently being treated for smoke inhalation at Hospital Denon.

Either they were completely misinformed, or somebody was trying to frame Youssef for torching his own business. It made me absolutely furious. How could anyone dare to even try to do that? There were so many witnesses – it would be easy for us to blow this false news open. Wouldn't it? I called Antoine immediately.

'Antoine, how are Youssef, Amira and Suzette?'

'They're not doing too well, I'm afraid to say. You were right – all three of them have been poisoned in some way and are currently in intensive care. They're fighting for their lives, Adam.'

'Are the police there?'

'Yes, the intensive care ward has been evacuated apart from the three of them, and the two wards upstairs have been locked down while the source is pinpointed. I heard one of the detectives ask if there was any chance that nerve agents had been used.'

'Oh my god, that's too terrible to think about. What's going on, Antoine? Everything seems to be going insane around us.'

'Yes, normality does seem to have fallen off a cliff edge, doesn't it?'

'And Youssef. The newspapers say he's been arrested – is that true?'

'That's news to me. He hasn't been in any fit state to speak to anyone since we saw him leaving the ward earlier this morning.'

'So either the newspapers have made a mistake or there's been a concerted attempt to suppress the truth about what happened at the warehouse yesterday.'

'It does sound that way, Adam, yes. But don't you need to get to the museum for the private view and royal visit this afternoon? You might need to help stop that assassination attempt, no?'

'I do, and yes, I might, and I'm not even showered yet,' I replied. 'Listen, let's speak later on and please let me know if anything changes with Amira, Suzette and Youssef.'

'I will, and good luck for later. Some of the Eleven Associates are planning to be there for your big event and to help out if you need them, and I'll get there if I can, though I might well still be here.'

As soon as Antoine had hung up, I sent a message to Alice: 'Did you know Suzette is in intensive care with Amira and Youssef?' I could see her typing.

'No, what happened?'

'Poisoned at the hospital.'

'What?'

'I know.'

'I'll take a look into this right now. Which hospital, and which wards were you all on?'

'Denon – wards D and E. A man posing as a nurse brought breakfast trays round to us all, between a quarter to ten and a quarter to eleven I reckon. Maybe you can search on the CCTV?'

'Sure, I'll see what we can do.'

'We're way out of our depth here, Alice. Things have taken a dangerous turn and we're in no position to take these people on.'

'Stay calm, Adam, it'll all work out okay, you'll see.'

I wanted to believe her, but I was struggling to see how. I was almost certainly in shock at that moment. I was drained, frightened and really just wanted my mum and dad.

## THE PRIVATE VIEW

It must have been after half past two by the time I made it in to the museum, and it took me another twenty minutes to get through the queues for the security checks. They were leaving nothing to chance. I went past reception, said hello to the grumpy receptionist, and made my way up to the offices. As I swiped my pass and walked through the doors, I saw Emilie look up at me from her desk. She immediately got up.

'Very nice of you to show up, Adam,' she said, with evident sarcasm. 'Any particular reason you haven't bothered coming in since Monday?'

'I'm so sorry,' I replied. 'I've been in hospital, and only got out this morning.'

'Oh,' said Emilie, modifying her tone slightly. 'I'm sorry to hear that. Well it still looks like you're due for a proper telling off – Madame Béchour told me she wants to see you in her office as soon as you get here, so you'd better go on in and explain yourself to her.'

I made my way over, knocked on the door and heard an '*Entrez!*' from the other side.

'Oh, Mr King. Whatever happened? It was all going so well – Mlle Honfleur had been telling me only the other day how well you had been getting on with your work here, and that you were the perfect intern – polite, punctual, diligent. Then, you go absent without leave, abandoning your poor colleague Emilie in the final stages of preparation for the exhibition, and, what's more, I have the British and French security teams wanting to speak with you. Goodness knows what that is about. Anyway, now that you are here they can come and ask you whatever it is they want to know.' Madame Béchour's secretary picked up the phone. A few minutes later Antonia Black came in to the office with her entourage, followed shortly after by Claudelle Laroche and her coterie, some of whom I recognised. While the office was a decent size, the number of people in the room made it feel pretty cramped. The door had only just been closed when Susan Farnsworth came in and shut it again behind her.

'Can I ask what the purpose of this meeting is, please?' she asked.

'Well,' said Claudelle Laroche, 'we have some questions for your young intern here. Quite a few questions, in fact,' she said, with a stern expression. 'Madame Béchour, would you and your PA be so kind as to give us a few minutes together, alone?'

'With pleasure,' she replied, trying not to look put out at having to leave her own office. When they had left, Laroche continued.

'Some of our colleagues have provided us with some very curious information about you, Adam, which we'd really like to understand. Alain, the photographs, please.'

With that, the French security guy I'd seen with Emilie in Le Bar de l'Europe during the Nuit Blanche stepped forward with an A4 manila envelope labelled '8 x 10s', out of which he pulled a number of photographic prints. The one on the top was a picture of me unloading boxes of Wajah fi Alghuyum from the back of the lorry at Youssef's warehouse. It was a close-up on my face and upper body, holding a box in my hands.

'Perhaps you might like to explain to us, Adam, why, within just a couple of days in Paris, you were seen unloading boxes containing illicit narcotics from a lorry on an industrial estate on the outskirts of Paris.'

Susan Farnsworth looked shocked. Antonia Black adjusted her spectacles.

'I can explain,' I said, trying to think how best to do so. 'I should say right away that I had no idea I was lifting boxes containing drugs at the time.'

'Oh really? Do tell us more.'

'I can imagine it sounds surprising – but really I thought I was just helping out a friend for a bit of cash.'

'Presumably you realise that you would need to apply for a permit to be paid for occasional work whilst in France? You need to have a *permis de travail* to earn money while you are here.' Turning to her colleagues, she said with a smile, 'That's another offence you can add to the list.'

She took the first photograph and put it to one side, taking the second image in her hands and showing it around to the assembled people.

'So please can you explain, if you weren't aware that the box contained drugs, how it is possible that after unloading the boxes, you are then responsible for carrying, by hand, boxes to those purchasing the drugs?' I could see it was a picture of me on the platform at the Gare d'Austerlitz. It was just me in the picture – no sign of Antoine, even though he had been standing right next to me. Laroche continued through the pile of prints – there was an image of me on the train alone with the box, of me getting into a taxi in Brive La Gaillarde, with the box, and entering Antoine's aunt's house, with the box. It kept on getting worse. There were photographs of me eating the space cakes, smoking a shisha pipe, and then the opium pipe. There were detailed shots of the man preparing the pipe for me – I could see I was in real trouble here. When she held up a photo of me on my knees throwing up, Susan and Antonia both pulled expressions of disapproval and disbelief.

'Well, Adam,' said Antonia, 'our French colleagues do seem to have some rather unexpected surveillance of your time in France.'

'I know it sounds hard to believe, but it was only after that evening that I realised these were real drugs. Until then I thought they were just flavoured

tobaccos, like you get for vapes.'

'Well good luck trying to convince everyone of that,' said Laroche, laughing as she spoke.

'I thought I was helping to break the drugs ring.'

'Oh, I see,' said Laroche, turning to her people. 'He was trying to help break the drugs ring. Well now, a British schoolboy comes to Paris and turns into a have-a-go hero, just like that; how marvellous.'

As she carried on through the pile, I noticed that all of the photographs were just of me. Not one of them featured Ammon or the Eleven Associates. Why weren't they asking me about them? Eventually she came to one of me and Youssef standing together at The Crescent Moon.

'Okay, so tell me, do you know this man?'

'Yes, that's Youssef Gamal.'

'And this is the man you were working for at the warehouse?'

'Well, yes.'

'Okay, great, thank you. We're getting somewhere. And do you know this woman?'

'Yes, that's Youssef's sister, Amira Gamal.'

She then pulled out the next photograph, of Amira sitting in the passenger seat of the van at the back of the warehouse just before our failed attempt to leave.

'And here she is with a van full of boxes from the warehouse?'

'Yes, though it was definitely only tobacco, and she was trying to help break the drugs ring too – that's why she was there.'

'Interesting,' said Laroche. 'So she's trying to break the drugs ring that her brother is the head of? Well that makes no sense at all to me, I'm afraid.'

'But he isn't the head of the drugs ring – that's Hager Nazari!' I exclaimed, relieved that I'd finally managed to get that out there.

'I don't think I've heard that name before. Anyone?' she asked, once again turning to her team, who looked blankly at her or shook their heads.

'But there must be photographs of him among those your photographer took – he was standing right next to the van at the time this photograph of Amira was taken.'

Laroche continued to flick through the photos until she reached the last couple of images.

'And then this is an interesting twist,' she said. 'Here is an image of you leaving Denon Hospital shortly after eleven this morning, leaving your boss and his sister in a critical condition in the intensive care ward.' Turning to Antonia Black, she added, 'They'd been poisoned, but curiously, Mr King here was not.'

I could see what was happening here. I mean, I didn't need a degree in espionage to figure out that I was being framed, just as Youssef and Amira were. But I had so many people who could pull apart this false, fabricated

path through the truth. I mean, Alice, Mammoul, Ammon, the Eleven Associates, Natalie – even Susan Farnsworth, perhaps. But there was also a sense that Laroche was playing with me, and that Black was playing along.

'Okay,' said Laroche, 'I think we should continue this conversation tomorrow more formally, and after this royal visit is over. There is, however, one further thing we need to ask you now, and your answer to the following question is of vital importance, so please answer honestly and fully.'

'Of course, however I can help.' I felt I had no choice but to comply with their questioning, even though I wanted to scream.

'I need you to tell me if you recognise either of the following voices.'

Laroche nodded at Alain and he put a digital speaker on the desk in front of Madame Béchour's empty chair, facing out into the room. He had a mobile phone in front of him, from which he started a recording playing. I could hear a voice speaking Arabic. The sound quality wasn't great; there was quite a bit of hiss, but I could hear it was the voice of a man, speaking slowly and with pauses in between. While it was hard to be one hundred per cent sure, this was not a voice that I recognised. I shook my head slowly so that they could see that the voice meant nothing to me. Then a second voice started speaking, also in Arabic. This, however, was indeed a voice I recognised. It was, without a shadow of a doubt, Mammoul. My heart sank.

'Yes, I do recognise that voice. It's a man called Abdul Mahmoud. Who's he talking to?'

'We were hoping you might be able to tell us. We have tracked the signal to two devices here in Paris, one of which is in the Egyptian Embassy.'

'What are they saying?'

'I think you have probably already seen this transcript,' interjected Black, handing me a sheet of paper. 'It's the conversation intercepted between the two terror suspects we received at the security meeting here last week.'

I was gobsmacked. There was absolutely no way Mammoul would have been plotting an attack on the royal couple. Just no way. But, on the other hand, this was a man who had spent his working life in intelligence and the military, and had worked for the Egyptian government – or certain political factions – at various times, and here he was on the recording, there was no denying it. I stared at the transcript. It listed the commencement time as being shortly after one in the morning, the radio frequency and the call signs used between the two men. It was there in black and white.

'And how do you know this man?' asked Laroche.

'He is the owner of a restaurant near the Sacré-Coeur, The Crescent Moon – well I think he's the owner. It's the restaurant where your photographer took that picture of me with Youssef.'

Laroche looked at me with an expression of surprise and disbelief.

'So there is a connection between the drug dealer for whom you were working and this Abdul Mahmoud?'

'Yes, well, they know each other, but then most people seem to know Mammoul.'

'Mammoul?'

'It's Abdul Mahmoud's nickname, ever since he was a child.'

'You seem to know a lot about him,' said Laroche.

'I've eaten in his restaurant several times over the past couple of weeks and got to know him a bit.'

'So you are a point of contact in common between Youssef Gamal and Abdul Mahmoud. Do you have any information relating to the terror attack on the British royal couple that you'd like to share with us?'

'Honestly, I know nothing about the terror attack, and I just can't see that Abdul would be involved in a plot to kill members of the British royal family. The only way I could imagine him being mixed up in this is if he's working undercover to help prevent any such attack.'

'What makes you say that?'

'I believe him to be a good man.'

'Well thank you for your character assessment,' said Laroche, sarcastically. 'Okay, well, Antonia, Susan, is there anything you'd like to say?'

'It does sound like Adam has managed to get himself caught up in things well beyond his knowledge or understanding,' said Susan, much to my relief. I'd wondered if she was going to hang me out to dry, as it looked like Black might be doing.

'I'm wondering if, as he is a guest of the British Council of the Arts here in Paris,' she continued, 'we could also be present during the questioning tomorrow.'

'It would be a generous gesture,' added Black, to my even greater relief, 'so if you could consider Susan's request on behalf of the British Council of the Arts, we would appreciate that. As you know, the British intelligence services have agreed to follow the lead of the French agencies in the drug and terror plot investigations, and to put their own on hold at your request, Claudelle.'

'Your request has been noted. We do need to continue the interview with Mr King more formally, however.'

'Of course,' said Susan, 'I quite understand. For now, though, Adam is our poster boy for the private view this afternoon. He's due to meet the royal couple and receive the prize for his painting.'

'Hmm,' said Laroche. 'Don't you think it could be a possible embarrassment for the royal household if it surfaces that Adam has been embroiled in a drugs scandal while here?'

'Again,' said Susan, 'it would be much appreciated if Adam could attend the ceremony as planned. It is a significant moment in the royal couple's schedule for the centenary celebrations and for their personal work with British schools.'

'It is possible that Adam was unwittingly connected to one of our teams' investigations into the drugs ring until this went on hold,' said Black. Thank the heavens! Antonia had finally backed me up. What had taken her so long?

'Well if you're willing to take personal responsibility for him, we're happy to leave him in your charge today,' replied Laroche, looking at me with mild curiosity.

At that very moment there was a knock on the door.

'Not now!' bellowed Laroche. Whoever it was who had been knocking opened the door anyway and popped their head around.

'I'm so sorry to interrupt,' said the museum's young press officer, sweating, 'but there are a lot of members of the press outside wishing to speak with Adam King.'

'How the hell did they find out about his involvement?' said Laroche angrily. 'None of the press should know anything about this.'

The press officer looked confused. 'I'm sorry, Madame, but I don't understand. Two of them are here because of him winning the schools painting prize, but the rest of them want to interview him about *The Mona Lisa.*'

It was now Laroche's turn to look confused, and, looking round at Susan and Antonia's faces, they seemed just as bewildered as she was.

'What about *The Mona Lisa*?' asked Laroche.

'Well, Madame, Adam King has become something of an internet phenomenon this past week.'

'In what way?' asked Black.

'Why, for his post about the controversial face in the clouds in Leonardo's masterpiece – surely you must have seen it? It's been everywhere – everybody's talking about it. You know, can you see it, can't you see it?'

'This is news to me.'

'He's had over half a million likes in response to his post of a detail from *The Mona Lisa* on FrendHub, around twelve thousand comments and has gained around sixty thousand followers across the world in the space of just a week. There are a couple of dozen international journalists waiting to speak with him in the lecture room downstairs.'

'Can you show us this post, please, Bertrand?' asked Susan. Bertrand pulled up the picture on his tablet and passed it round for everyone to see.

'So what is it we're looking at and for, exactly?' asked Laroche.

'It's a section of the horizon in Leonardo's *Mona Lisa*,' I said. 'If you scroll through you can see the original painting in full. Though I'm not sure, I think I can see a face there, in the clouds, blowing like the very wind itself. I was interested to know if other people can see it too, and whether they think Leonardo intended for it to be there.'

'That sounds most odd,' said Laroche, peering closer at the mobile phone. 'Hmm, I'm not sure – anybody else want to have a look?'

The tablet was passed around and everyone took turns looking at it.

There was the by now usual mixed response among the people present, who instantly began discussing the visual riddle.

'You have had a busy couple of weeks in Paris, Adam, haven't you,' said Susan. 'It's a wonder you found any time at all to work on our little exhibition here,' she added, laughing.

'If it's okay with you, I'd like to take Adam down to the press room,' said Bertrand. 'Along with the royal visitors arriving shortly, this will ensure the Museum of Contemporary Art is on every screen of every electronic device, and in every newspaper and magazine around the world this week.'

The gathered security teams looked at each other, bemused, and Susan gave the nod. 'It sounds like our prize-winner needs to go out there and do his bit to promote the museum and the British Council of the Arts to the world,' she said, not waiting for anybody else to disagree.

'Okay,' said Laroche. 'Please do us the courtesy of coming in to talk with us at our offices tomorrow morning at nine, Mr King. Understood?'

'Of course,' I replied, 'I'd be happy to help in any way I can with your investigations.' I was learning that it is sometimes better to play the game than to try to fight.

* * *

Bertrand, wearing a cool, preppy Japanese suit, led me downstairs into the lecture theatre where I found a room half full of people sitting on chairs with cameras, microphones and recording devices in front of them. There was a small stage at the front, on which was a low coffee table with some bottles of water and empty glasses along with table mics. Juliette Honfleur was sitting behind the table in her wheelchair looking very elegant in an evening dress and sparkly jewellery. She smiled as I came in and was directed towards one of three empty chairs next to her. I leant over to her and whispered, 'How is Suzette now?'

'She's not in a good way, Adam, but thank you for asking. I'm going to go to the hospital as soon as the private view is over.'

'So sorry to hear that, Juliette. It's been a horrific couple of days, I can't even begin to tell you.'

'I hear you've done brilliantly, Adam, well done.'

We were joined on stage by Susan Farnsworth and a woman I had not met before but had seen in the offices. Bertrand took a microphone and addressed the audience.

'Many thanks for coming to our press launch today. It is my pleasure to introduce Susan Farnsworth, Head of Visual Arts at the British Council of the Arts; Eliane Dupuis, Head of Exhibitions here at the Museum of Contemporary Art; and Juliette Honfleur, curator of Portraits in Paris, an exhibition of paintings by schoolchildren from across Britain, organised as part of the British Council of the Arts' Century in Paris celebrations.'

My mind was already drifting off as he and the other panellists continued speaking. I hadn't had a minute to process the revelation about Mammoul being one of the people in that terrifying radio conversation. I kept on going over what I could remember of the transcript of the conversation in my head, with their voices saying the words in English, just trying to make sense of it all. At a certain point Susan Farnsworth began talking about the schools competition and my painting, and I was soon after introduced and called upon to speak about the painting I had made, so I told them about Mr Stoner and my grandad, about how they'd introduced me to lots of French painting of the nineteenth century, and how I'd come up with the idea for my picture. The assembled press listened politely.

Then Juliette said: 'And of course, it was while you were here in Paris on your internship at the museum that you visited The Louvre, and it was there that you had what can only be described as a very strange encounter with one of the world's best-known paintings.'

I answered as best I could before the panel was opened up to the floor. I was absolutely inundated by questions.

'Yes, but is this some kind of a hoax?' asked one.

'Only in the sense that we cannot be sure of what our eyes are telling us,' I answered.

'Do you really believe what you say we can see?' asked another.

'I believe in the ambiguity of the image, and in our capacity to decide whether to believe it or not,' I replied.

'How likely is it that you, an art student, should make such a discovery five hundred years after the death of Leonardo da Vinci?' scoffed one.

'Highly unlikely!' I said, smiling. 'Almost inconceivable.'

'If a face is there, how come nobody else has seen it before?'

'I'm sure people have seen it before me. It was my grandfather who tipped me off, so there's at least one person, plus somebody suggested to me that Marcel Duchamp might have known. You might also have seen it on the branding for a popular Egyptian tobacco.'

'Some critics suggest if you look at almost anything for long enough you can start to imagine other things within it.'

'I imagine there's a lot of truth to that,' I said.

'Do you believe Leonardo intended to paint a face that we wouldn't see?'

'Do you believe it's possible he *could* have done that?' I replied.

'But it's the most looked-at picture in the world,' he added. 'Surely somebody would have noticed it and shared it with the world by now.'

'We live in an age of instant global communication. Imagine how many people might have seen it in the past and tried to get other people to listen to them.'

'Don't you think this is all a bit too trivial for a mind such as the great Leonardo?'

'It might help to think of it this way: imagine a spectrum, and at one end of the spectrum there are jokes, and as you move along the spectrum they become gradually more serious – games, then puzzles, then riddles, and at a certain point around the middle, they become mysteries and enigmas, then slide into the realm of questions of optics, perception, matters of cognition, psychology, poetry and finally philosophy (before coming back round to jokes again). We are welcome to position the face in the clouds wherever we choose on this spectrum.'

'Are there other things lurking beyond everyday sight in Leonardo's paintings?'

'If there is a face in the clouds, or in our minds, it is perhaps merely an ambassador for others – maybe even for a whole domain of the painterly invisible, a visual history of the unseen and the hidden.'

'Wouldn't that pull the rug out from under everything we see?'

'Only in the same way that special effects, computer animation, digitally enhanced imagery, face distortion apps and deepfake technology do. These things are fascinating, impressive and problematic all at the same time, and you can't just ignore them.'

'Can you give us any historical proof that the face in the clouds was consciously painted by Leonardo da Vinci?'

'I am not an art historian,' I replied. 'I'd be interested to know what art historians think – and I know that some of them are rightly highly sceptical of my suggestion. I'd love to know what neuroscientists and psychologists think too.'

'You are right to say that some art historians are not very impressed by your "revelation" – how would you respond to them?'

'I completely understand that this is a contentious, emotive and divisive kind of visual phenomenon. I think some artists, especially some painters, might have their own thoughts about the idea. I'd like to hear their views too.'

'How can you convince people who do not see the face in the clouds that it exists?'

'How does someone of faith explain their god to someone who does not believe and does not want to believe?' I was quite proud of that one.

'Why would Leonardo want to paint something we don't see?'

'Why would one of the greatest minds in the history of the world not engage with the challenge of painting the invisible?' I answered.

'Do you feel you need to try to convince people there is a face hidden in the painting?'

'I can't know what another person sees, or how their brain interprets what they see, but I am aware of the human capacity to convince other people that they can see something they once couldn't. It is harder the other way round.'

The questions continued and I just kept on answering them as well as

I was able. I felt I had really taken on board some of the comments and thoughts from Sebastien and the Eleven Associates, and that I had finally managed to formulate some of my own verbally too. Some of the journalists clearly wanted to expose or mock me, others wanted to undermine or unpick the idea, but some were obviously just curious, or excited even, by the concepts involved. The press were, it seemed to me, just as divided as the general public.

'What do your parents think about you being at the centre of this viral controversy about *The Mona Lisa*?' asked one journalist.

'My parents are … are no longer with us,' I said, faltering for the first time. 'But I'm sure they would have been really interested, both in the idea itself and in the world's reaction to it. If you can think of a response, it's out there.'

'One last question, if I may,' asked the same journalist. 'There are rumours that you have joined some kind of cult since arriving in Paris – is that true?'

'What?' I said, in disbelief. My instinct was to be angry, but I managed to smile and laugh it off. 'That's absolutely ridiculous! I've certainly met some interesting people here, but there's no cult, no conspiracy to be uncovered, I can assure you, no Hollywood movie or online box set to follow. What I would say is that the face in the clouds is not something black and white, and wherever there is uncertainty or ambiguity, people can be tempted to jump to extreme conclusions or dogmatic positions.'

Sensing that the press conference might be taking a turn for the worse, Bertrand stepped in to wrap it up, inviting the journalists and photographers through into the gallery in readiness for the arrival of the royal couple who would be taken on a private tour of the exhibition before the guests arrived.

'Wow! You did really well, Adam,' said Juliette. 'I'm so impressed by how far your thinking about painting has come in just a couple of weeks.' I smiled and thanked her.

<p style="text-align:center">* * *</p>

It was now getting close to half past five, when the doors would open to the invited guests for the private view. I had just a few minutes to myself. I spotted Antonia Black talking with some of her security staff outside the closed doors of the gallery space and made my way over to her.

'Excuse me, Mrs Black?'

'Yes, Adam?' she asked.

'Sorry to interrupt when you must be busy, but I wondered if I could have another look at that transcript of the radio conversation you showed us earlier, please?'

'Er, yes, of course. Bear with me a moment.' She opened up her bag and pulled out a folder. The document was still on the top, and she handed it to me.

'Do you mind if I take a photograph of it?'

'This document is highly confidential, Adam, I'm afraid you can't.'

'Of course,' I said, 'my apologies'. I looked at the document for a moment and did my best to memorise the call signs, which both began with the letter F, followed by a combination of letters and numbers. I re-read the conversation and handed her the sheet back, all the time repeating the call signs over and over in my head until I could get them into my mobile phone. I did my best, but it's strangely hard to remember just two short sequences like that. I was much better at remembering dialogue. Then it came to me.

'It's not black and white,' I said, suddenly.

'What's that, Adam?' asked Susan, who happened to be standing nearby.

'Why, "it's not black and white, and wherever there is uncertainty or ambiguity, people can be tempted to jump to extreme conclusions or dogmatic positions". It's what I just said to that journalist about the face in the clouds, but it might also be true for the terror attack.'

'I don't quite see what you mean,' she said, looking perplexed.

'If you'll excuse me a moment, I need to contact a friend.' I went off to the toilets, which were being patrolled by armed police officers with sniffer dogs. When I was sitting in the cubicle, I texted Alice:

'Have you picked up any communication from people using the following call signs during your campaign at the social club this week? I'm not sure I have the codes quite right, but it's something along the lines of FD243XR5 and FT2RG67L.'

'Give me a moment,' she replied, almost instantly. I waited for no more than half a minute.

'We have a communication between two call signs very similar to these just after one o'clock this morning. Both French call signs. The conversation was in Arabic. The notes from our translator say that the men were playing a game together.'

'I knew it!' I said, almost shouting. 'The terror attack transcript – listen:

Man 1: It's getting tricky.
Man 2: Yes, I'm getting a little anxious.
Man 1: Do you think they know what we are planning?
Man 2: Possibly. We need to strike quickly before it is too late.
Man 1: You must attack the royals.
Man 2: What, both at once?
Man 1: It might be our only chance, and the only way.
Man 2: But the enemy is already behind our lines and they will soon take us down.
Man 1: Yes, which is why we must attack now. They won't be expecting it while they think they have us cornered.
Man 2: Okay, thank you for your counsel. I will do as you say.
Man 1: Good luck – I know you can do this. Bring us glory.

'They're playing chess with a third party over the radio – it's correspondence chess, something people do on ham radio for fun! It's like King Hussein of Jordan – he used to use the amateur radio waves for pleasure as well as more serious matters. These men are just planning their next move in the game! Do you have a recording of the conversation from last night in full?'

'I'll see if I can get hold of that. It's quite possible it's made it onto our summary lists via Edward and Timothy. I'll call you back.'

I made my way out of the toilets and towards the gallery.

'Ah, there you are Adam,' said Susan. 'It's time for us to go on through for the official opening of the exhibition, and for you to receive your prize.'

'Mammoul isn't a terrorist, Susan,' I said. 'He was just playing a game of chess.'

'That sounds rather implausible, Adam. Listen, we can speak about this afterwards. Let's just try and get through the launch, and without the royal couple being assassinated, shall we?'

'Yes, of course,' I replied. And with that we made our way in.

The gallery looked amazing – polished light-grey concrete floors, bright white walls illuminated by spotlights from above, and one hundred paintings by British schoolchildren hanging on the walls. In pride of place, in the middle of the long side wall, was my painting of Grandad, within a halo of light from the lamp above. I was so pleased with how it looked. I only had a brief moment with my painting before the guests started coming into the gallery and it soon filled up, getting steadily noisier and hotter. Some of the other prize-winners featured in the exhibition had been able to come over for the launch event, so I went over to speak with the ones I had spotted. Juliette was making her way among the assembled people in her wheelchair, gracefully managing a glass of champagne as she went. She caught me looking at her glass.

'I never spill a drop!' she said, with a broad smile. 'Well congratulations, Adam, the exhibition looks great, and your painting looks fantastic up there on the wall.'

'Thank you, Juliette, you're very kind. It's been a pleasure working with you...' at that moment, Emilie joined us '... and Emilie,' I added, 'over the past couple of weeks.'

Emilie was smiling at me – it was only the second time she'd done this, I think, but I knew it was only for show because Juliette was there. She couldn't bring herself to like me, and I didn't think she ever would. Anyway, what did it matter, we'd got the exhibition up. I looked around to see if I could spot any of my friends. I could see Natalie talking with Susan nearby, and by the doors I spotted several of the Eleven Associates just arriving. I was so pleased they could make it. I went over to speak with them about their life-saving performance last night. Anne-Sophie was the first to give me a hug, followed by Alicia, Sebastien and Stéphanie.

'It's your big night!' said Hakim. 'Congratulations!' Everybody raised their glasses to me, and in that moment I felt so proud and happy. For all that had happened during my time in Paris, I had at least met these amazing people. I could see that they were worried, however, and knew they would all be thinking about Suzette. Elodie was looking particularly upset.

'Has there been any more news about Suzette and my other friends this afternoon?' I asked her.

'No, no further news. Antoine has been there all night and all day. He's coming straight here for the private view, then he'll take a shower and grab some sleep before going back in tomorrow morning. I've been to Suzette's flat to pick up some of her clothes to take in to the hospital, and to feed her cat.'

At that moment Maya came in looking like a celebrity, as usual, and it was not surprising that many of the press photographers chose to feature her in their crowd shots.

'Where's Henry?' I asked.

'He's on his way – couldn't get out of work and across town any earlier.'

'Of course,' I said. 'And Armand?'

'He's been caught up in something, I'm afraid. He was hoping to be here,' replied Anne-Sophie.

'Is everything okay?' I asked, detecting something in her expression.

'I'm sure it will be fine,' she said. 'He's just been having a bit of trouble with some people about the documentary he's working on.'

'Are "some people" not happy with him investigating the current housing problems?'

'Precisely, and I think those people have been trying to put pressure on him to stop filming, or at least to stop filming them.'

'That's terrible,' I said.

'Yes, it's not very nice – he's received threats this week.'

'Oh my god, how awful.'

'Isn't it? Still, he was fully aware that his film might rub some people up the wrong way, and he's not afraid of them.'

'Do you think they might be dangerous, or just trying to bully him?'

'Not sure yet. Let's hope for the latter, anyway,' she said.

'I'll drink to that,' I replied.

A number of security staff then came through the doors behind the Eleven Associates and cleared a path through the guests towards a raised platform in front of my painting. Behind them came another cluster of people dressed in black and looking pretty serious. I recognised Alain among them. He didn't seem to see me as he went by, even though he passed right by me. Just behind him, I caught my first glimpse of the young royal couple. I'd only ever seen them in pictures before. They were as handsome as everyone said, super stylish and incredibly popular with the public, so needless to say they were a hot ticket for newspaper and magazine editors. The paparazzi went

crazy in the galleries, snapping away and jostling to get the best angles as the royal pair made their way to the podium. Susan had moved over towards me and took me by the arm.

'Come on,' she said, 'we'd better get into our positions.' I didn't know what she meant as I hadn't received a briefing, not having been at the museum for the past couple of days. She led me through the crowd in the slipstream of the royal couple's entourage. Madame Béchour was on the podium, in front of the microphone, and addressed the audience.

'Ladies and gentlemen, good evening and welcome to the Museum of Contemporary Art in Paris where you join us for the official opening of the centenary celebrations of the British Council of the Arts in France, and of our new exhibition, Portraits in Paris, developed in collaboration with the British government, to mark this special occasion. It is a great honour, and a privilege, to welcome Their Royal Highnesses the Duke and Duchess of Clarence to officially open the celebrations for us here this evening.'

The audience clapped as the flashes of the press cameras spread their momentary light on the royal couple as they stepped onto the platform. All eyes were on them, though standing beside the stage, I had the chance to look around at the guests. I'm sure almost half of the room was security staff from the various agencies that had been involved over the past couple of weeks. There were diplomats and politicians, celebrities and socialites, sponsors and benefactors all dressed smartly and looking terribly important. I could also see the security cameras in the corners of the room, panning slowly around. I wondered if anybody present was a potential terrorist, or if there would be any attempt made on the royal couple. I imagined a lone marksman in the audience, or hidden in an air vent, attaching the silencer to their gun, lining it up and taking aim at the stage. But if the only intelligence relating to a terror attack on the royal couple was based on a misunderstanding, on misinformation and misinterpretation, then surely there was no terror attack at all? Maybe the royal couple were in no more danger than on any other day, or during any other royal engagement.

The Duke and Duchess began their address to the public, taking it in turns to speak.

'It is a pleasure for us to be here on such an auspicious occasion as the centenary of the British Council of the Arts in France.'

'It is an organisation that does so much to promote cultural exchange on the international stage, to support the work of artists, musicians, actors, dancers, writers and creatives of all kinds, and to share their work with audiences old and new.'

'That the arts play such an important part in international relations is never more apparent than at times when those relations become strained.'

'Friendships, partnerships, collaborations and the capacity to listen,

to understand and to care for our neighbours, however far away they may be around the world, are the bedrock of civilised society and of the advancement of humanity.'

'Great art is something that can be shared and enjoyed across borders and across boundaries. Great art outlives us all; it speaks across generations, passes down the centuries and becomes ever richer over millennia.'

'Even when there are disagreements, differences of opinion, and even fundamentally opposed worldviews, the arts extend a hand of friendship that can help to restore partnerships that have grown weak, to renew old friendships and start new ones.'

'Great art offers something for everyone, opening eyes, minds and hearts to the wonders of human accomplishment and to the wonders of life itself.'

'Great art can touch the lives of those of all ages and cultures, from the very young to the very old.'

'This exhibition, which we are delighted to open this evening, is proof of the power of art to inspire children in schools across Britain, whatever their backgrounds.'

'It is proof of the importance of encouraging children to make art, of helping them to discover the pleasures that painting and drawing can bring, and how thinking about art can enrich our understanding of each other, of the world, and indeed, the universe.'

'It is, therefore, our pleasure to present this award for first prize for a painting inspired by the art of France from the end of the nineteenth century – a period in which the avant-garde fought for the art they believed in, for the styles of art they felt reflected the modern world around them, often in the face of an art institution – and a public – that was more interested in looking backwards to a romanticised vision of its own past. Sometimes art has an important part to play in moving our thinking forward, prompting us to reconsider what we think we know, or even what we see. Many congratulations to the first prize-winner, Adam King.'

Susan gently pushed me forward to step up to accept the certificate that the Duchess was holding out towards me. I smiled, did some weird half bow, half curtsey, took the envelope and thanked them. The audience was applauding, and I just had a moment as I turned away to take in all the smiling faces in the room looking at me. It was in that very instant that there was an almighty explosion. It sounded nearby, and just behind us. It seemed to last for many seconds. The gallery shook and the lights flickered. The walls stayed up, however and nothing fell in on us, but as there weren't any windows along the gallery walls or skylights in the ceiling, there was no way of seeing beyond the room we were all standing in. The lights then went off completely and we were left standing in total darkness. Everybody screamed. There were two pairs of illuminated emergency exits at the far end of the

gallery which were immediately opened by the security staff. People were panicking, and there was a huge surge to get out. A number of security staff had immediately surrounded the royal couple like a roman legion in tortoise formation and were making their way to the emergency doors along with everybody else. I was swept up in the crowd pushing to get out and in the darkness could just about see some of the Eleven Associates looking over to see if I was okay. As we neared the daylight I caught Antoine's eye – he must have just made it in before they closed the doors for the speeches – and we looked at each other with a combination of surprise and dismay. The screaming grew louder as we got closer to the doors – there were people being trodden on who had fallen down, and others being crushed against the walls and each other. It had descended into a stampede and chaos.

As we passed through the doors, carried along as if swept up in a river of people, the crowd was spilling out and down the steps away from the building. It was a steep incline down the hill towards the Seine and the Eiffel Tower, and there was somebody with a megaphone instructing everyone to assemble at the bottom by the monumental pond, which was flanked by elevated grass borders and rows of miniature trees. I could see police running along the bank of the river from either side, and there was a convoy of smart black cars, presumably waiting to escort the royal couple and their team to safety. The royal group was not much further ahead of me, and a number of the Associates were not far behind. As we made our way briskly down the landscaped garden towards the pond, I turned round to see a building ablaze where the explosion had been, just a few buildings down from the museum. My heart sank. I could feel myself trying to swallow and tears were already welling up. I looked round at Antoine just as he was taking in what had happened. His mother's block had been the target of the explosion, with huge plumes of black smoke coming out of the roof. I saw his face crease up, his mouth wide open, and after a moment of staring, he bent over with his hands covering his face. I saw Alicia putting her arms around him, offering whatever consolation she could. One by one the Associates clocked what had happened, and they gathered around Antoine. I heard him shout, 'My staff! My staff! I need to see if they're okay.'

I saw him try to fight his way back up the hill towards the courtyard where I had first met him with his skateboard. The museum buildings looked so austere on the horizon, impressive but also quite foreboding, their gravitas somehow becoming fused with the tragedy of the situation. I was standing right in the middle, underneath the pond, my back to the Eiffel Tower, looking back up. The view was perfectly symmetrical, and for a split second, I must have been standing along the centre of this axis of symmetry. I felt like I was in a weird plane, just beyond reality. The whole thing felt surreal. Above all the noise, cutting through everyone else's voices, I heard someone shouting loudly in the near distance and I turned round to see a man in a balaclava sprinting

towards us from the road that runs alongside the Quai de la Seine, the Avenue de New York. Just ahead of him, about twenty or twenty-five feet up in the air, I could see a drone flying towards us. My first thought was that this must be a camera, filming the event, but as it got closer it started to fire bullets. There were armed police arriving around the pond who had spotted it in the air, but in all the chaos it didn't seem that they had clocked the man shouting and running. At first it looked like he might be running towards the royal couple, but within just a few metres it became clear he was heading towards me and the Associates.

'Get down!' shouted the man. There was nowhere for us to go so we all just crouched down next to the stone sides of the pond and covered our heads. As the bullets began to rain down, the man launched himself on top of me, protecting me. He screamed as a line of bullets went up the back of his leg and continued up his back. He was also by then being shot at by the police, though once they realised he was not heading towards the royal couple, they focused their energy on stopping the drone, which was now circling round in the air above the pond ready to have another go. The police deployed a large net from a kind of cannon – like a ground-to-air missile launcher resting on one shoulder – which impressively captured the drone on its first attempt and brought it down into the pond.

Of course, I thought as I lay there underneath this masked man's body, the drugs gang really does want the four of us who had been imprisoned at the warehouse the previous night dead. There was a terror attack planned for that evening at the museum, but the plan had only been made today, and the target was not the royal couple – it was me.

'Thank you,' I said to the man in the balaclava. 'We must get you to an ambulance.'

No sooner had I said this than the police jumped on us. They were quite rough; in hindsight I appreciate they didn't know we didn't pose a threat in that precise moment, and the wounded man on top of me was wearing a balaclava, which was perhaps not the best idea with all those guns trained on him.

The police surrounded us, pointing their guns at us, and ordered us all – me, the Associates and the masked man – onto our knees with our hands behind our heads. Once they had established that none of us was armed, and had put us all in handcuffs, we were led single-file towards police vans. I could see the Eiffel Tower right behind – this was not the mental image I had expected for my trip – a row of police vans lined up waiting to take me and my friends away. The masked man was taken in a separate van for medical assistance. I was surprised he was still alive after taking those bullets, but the blood only seemed to be coming from his leg, not from his jacket. It would have had to be bullet-proof to withstand the drone's attack. I had caught his eye as he was being pulled off me a few minutes earlier, and it was no surprise to me to discover, just before he was assisted into the van and they pulled his

balaclava off, that the man was none other than Ammon. He saw me and nodded with a smile, though it might have been a grimace. I made the thank you sign with my hands, which was, appropriately enough, one of the few things I was able to do while wearing handcuffs.

* * *

Finding myself in a police cell was not how I'd expected my internship in Paris to end. I must have been in a state of complete shock. I struggled to comprehend what had happened to me and my friends that week. I was kept in the cell for a couple of days, under anti-terror laws, during which time I just kept on replaying everything that had happened. Poor Antoine, his mother's beautiful house destroyed – all those incredible works of art, all of those amazing books. It was an utter tragedy. I had no news on Youssef, Amira or Suzette, no word about Ammon, and had no communication with the Eleven Associates during that time. I was periodically taken out of the cell into an interrogation room for questioning by various people, though it was not until dinner on the second evening that I was given a newspaper with my tray. The headline was unimaginable: 'Radical left-wing student gang arrested over royal terror plot'. Somebody was stitching us up good and proper.

I was, to my surprise, released on bail – presumably Antoine or his mother had footed the bill, and having been given back my phone and bits and bobs, including Grandad's Wajah fi Alghuyum tin, I walked out into the reception of the police station. It was with tears of joy that I saw, sitting there on a bench, waiting for me, my grandad.

'How are you, lad?' he asked, leaning forward with both forearms on his walking stick.

'Oh Grandad! I can't tell you how happy I am to see you!'

'Well, I couldn't just leave you languishing here in a police cell, now, could I?'

My phone, now switched on, was starting to bring through all my messages and missed calls.

'Look, Grandad, here's a message from Alice, just coming in now.'

'Oh yes, and what does the young Miss Bainbridge have to say?'

'She says: "Yes, a chess game. Look at what came through after their conversation last night. Lots of letters and numbers corresponding to the moves of various pieces on a chessboard, followed by this – it's something I had the perfect bit of kit for in Stirchley Electronics..."'

Attached to the message was a video clip of a piece of paper on a roll slowly coming out of an old, polished wooden box. It gradually became apparent that it had an image on it – it was grainy and had lots of streaked horizontal lines on it, but, quite clearly, it was a chessboard with pieces on, with the game well in progress.

'What technology am I looking at, Alice?' I messaged her, and just a short while later she replied: 'Radio fax!'

'Wow,' I said, 'pre-Internet image transmissions, by any chance?'

'Yes!' she answered. 'Not over the telephone lines like fax machines of the 1980s and 1990s though – over the radio waves. It's technology almost as old as the telegram. People have often been much further ahead in terms of understanding images than we might sometimes think.'

'Just like Leonardo,' I said, accompanied by a smiley face emoji.

'How is Suzette?' I asked.

'Still alive, thankfully. She's stable, which is the best we can hope for at the current time – Youssef and Amira likewise.'

'And Ammon?'

'I've no means of finding out at present, sorry.'

'When you two have stopped playing games with each other,' said Grandad, 'I need to speak with you quietly for a moment, Adam.'

'Of course, Grandad, fire away.'

'Well, it seems like you've got yourself in a bit of a pickle here, my boy. It's going to take some time to sort everything out – for you to be able to explain yourself.'

'Thank you, Grandad, yes, I realise I'm not in a great situation, and to make matters worse I'm not sure people necessarily want to know the truth.'

'I know, Adam, I know.' His expression became very grave all of a sudden. 'I discovered something the other week that I must share with you – a little while ago I got in touch with an old friend at the traffic camera control centre in Birmingham. He managed to get hold of the footage I was after and sent it through to me just the other day, while I was hiding out in Stirchley.'

'What was the footage of, Grandad?'

'It was of the accident in Edgbaston on the day your parents died.'

'When the lorry's brakes failed?'

'Yes, only, the thing is, Adam, in the footage it looks like the lorry is accelerating to hit the car as it crosses the lights.'

'What are you saying, Grandad?' I asked in disbelief.

'Well, I'm not convinced the death of your parents was an accident, Adam.'

'Oh Grandad, what have we all got ourselves mixed up in?' I asked, looking into his eyes.

To be continued...

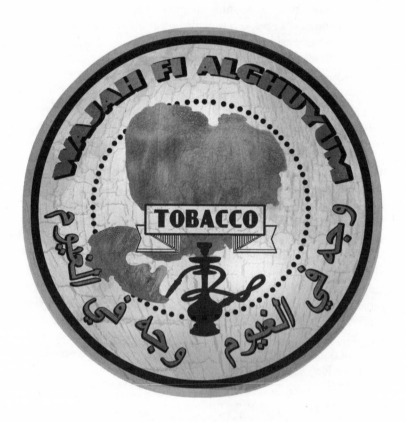

*Smoking kills. Anomie Publishing does not encourage smoking of any kind.*